Introduction to Art

David S. Nateman, Ph.D.

University of New Mexico

An American BookWorks Corporation Project

McGraw-Hill, Inc.

New York St. Louis San Francisco Auckland Bogotá
Caracas Lisbon London Madrid Mexico City Milan Montreal
New Delhi San Juan Singapore Sydney Tokyo Toronto

David S. Nateman holds a faculty appointment in the College of Education's program in Art Education at the University of New Mexico in Albuquerque. Previously he served on the faculty of Teachers College, Columbia University, where he coordinated the M.A. and Ed.M programs in Art Education, and before that, he was an assistant professor of Art and Art Education and Director of Art Therapy at Indiana University of Pennsylvania.

To Judit and Ari for their patience and support, and to my parents for their constant encouragement.

Many thanks to Fred Grayson at American BookWorks Corporation for his invaluable technical assistance; and to Dr. Kenneth Marantz, who many years ago taught me the significance and value of looking beneath the surface of things.

Reproduced on the cover: MATISSE, Henri. *The Red Studio.* Issy-les-Moulineaux (1911). Oil on canvas, 71¼″ × 7′2¼″(181 x 219.1 cm).The Museum of Modern Art, New York. Mrs. Simon Guggenheim Fund. Photograph © 1993 The Museum of Modern Art, New York.

Introduction to Art

1 2 3 4 5 6 7 8 9 10 11 12 13 14 15 16 17 18 19 20 DOC DOC 9 5 4

ISBN 0-07-045912-6

Library of Congress Cataloging-in-Publication Data
Nateman, David S.
 Introduction to art / David S. Nateman.
 p. cm.
 "An American BookWorks Corporation project."
 Includes bibliographical references and index.
 ISBN 0-07-045912-6
 1. Art—History. I. Title.
N5300.N33 1993
701'.1—dc20 92-30872
 CIP

Preface

This volume, as the title says, is an introduction to art. It is not a comprehensive history of art, but rather a broad view of art history, focusing on the major trends and movements that have occurred in the visual arts from prehistoric times through the modern era. It may be used as a primary, brief text; as a core text around which a course can be structured; or as a text supplement for initial study, reference, or review. It is written in such a manner as to make the visual arts easily accessible to the reader.

Introduction to Art begins with a discussion of the language of the visual arts and then proceeds chronologically, exploring the role the visual arts have played at different times in different cultures. The introduction to each chapter sets the stage for what is to follow; chronologies preceding each of the history chapters provide orientation and perspective. The chapters are grouped under four broad historical periods: the ancient world, the Middle Ages, the Renaissance, and the modern world. At the end of each of the main parts of the book will be found a list of recommended readings for those individuals who wish to pursue further study of specific topics.

In this compact volume it was not possible to include illustrations of all the works of art discussed or even to illustrate all the periods and movements in art history. The works reproduced in this book were chosen for their general interest; more than half of them belong to the twentieth century. Students in an art appreciation or art history course will likely find reproductions of most of the works mentioned in this text in the department files of their school or library. Other good sources

of illustrations are history of art textbooks such as H. W. Janson's *History of Art* and H. Gardner's *Art Through the Ages.*

It is my hope that this volume will serve more than an academic function—that it will lead the reader to become more actively involved in the visual arts, for engagement in the visual arts is not a passive activity, but an active one. In many cultures, there is no separation between daily life and those artifacts that we in the West call art. It is our Western culture that has taken these objects out of mainstream life and placed them in repositories of culture that we call museums. The relegation of "serious" art to museums, and the diverse styles and forms to be found there, account for the discomfort so many people feel when viewing art, especially forms of contemporary art with which they are not familiar. Unquestionably, knowledge of art styles through the ages and an understanding of the role that art has played in the past can enhance our appreciation of the art of our day.

David S. Nateman

Contents

List of Illustrations

Part I

The Language, Materials, and Processes of the Visual Arts

Although the act of seeing an object is a physiological process, the perceiving and understanding of that object involve cognitive and mental processes within some cultural and social context. We identify the things that we see by labeling them with words that we, as a society, have agreed upon for convenience' sake. Without the appropriate vocabulary to call up images and describe them in terms of their qualities, we are handicapped, for this vocabulary provides us with a mechanism for making sense of the visual world in which we live.

The vocabulary of art begins with the visual elements—line, shape, color, and texture. Familiarity with the elements of art coupled with an understanding of the various art media and processes can help us develop confidence in approaching and engaging with works of art. These are the subjects of Chapters 1 and 2. Being social creatures, we are not always satisfied simply to experience things. We also have the desire to share our thoughts and feelings with others, as well as the tendency to judge and evaluate. Art criticism, the verbal or written response to works of art, is discussed in Chapter 3.

Part 1

The Language, Materials, and Processes of the Visual Arts

CHAPTER 1

The Elements of Art

A work of art, whether two or three dimensional, can be constructed, and thus perceived and described, in terms of certain visual elements. These basic elements are line, shape, color, and texture. A working knowledge of these elements provides the basis for organizing one's thoughts when confronted with a work of art. The more familiar one is with these elements, the easier it is to analyze a particular work of art and to gain a deeper understanding of it.

Line

Characteristics of Line

Lines can be short or long, thick or thin; these characteristics are referred to as the *measure* of line. Lines may be of a particular *type*; they may be curved, angular, straight, or any combination of these, in addition to being short or long, thick or thin. Lines may move in a particular *direction* horizontally, vertically, or diagonally, and this direction contributes to the movement of the eye of an observer around and through an image. We may say that the eye is led by the line. Another

characteristic of line is its *location*, because a line, by reason of its touching or even nearing another form, may serve to link that form with others and thus unify one composition with another.

The Character of a Line

The character of a line refers to the medium with which the line is made or the method in which the medium is employed. The character of a line may be described as being bold, tenuous, crisp, or fragile and determines to a great extent the various emotional states that may be expressed by line. Lines and the forms they create can convey complex emotions, but communication of these emotions is dependent on the sensitivity and perception of the viewer. Primarily, we recognize these various feelings in an abstract sense; we may not attach them to a definite object, place, or figure. If we insist that the form created by lines be representational in the form of a person, place, or thing, we limit ourselves unnecessarily and miss out on the subtleties and power of abstract forms and their expressive qualities.

Shape

Basic Types of Shape: Geometric and Organic

Shapes are generally of two basic types: *organic* (or biomorphic), resembling the free-curved forms found in nature that may be extremely complex or subtle and difficult to describe, and *geometric*, in which case they are shapes that are possible to measure mathematically and may be simpler in form. (For example, Cubism is a style of both two- and three-dimensional artistic expression that grew directly out of an attempt to reduce or simplify all forms to their basic geometric components.)

Dimensionality

Both organic and geometric shapes may be of two types: *decorative* and basically *two-dimensional*, decorating or dividing the picture plane; or *plastic* and *three-dimensional*, occupying and surrounded by space, forming a shape having volume. In the case of the two-dimensional arts,

plastic shapes may be said to represent the illusion of volume—height, width, and depth. A *plane* is a two-dimensional shape that operates in its relationship with other shapes to give the illusion of the third dimension. For example, the plane of the ground, having only height and width (or length and breadth), gives the illusion, in many cases, of the third dimension. Positive shapes may be described as the *figure* in an image, whereas negative shapes are referred to as the *ground* (the space surrounding the figure); oftentimes this is called the *figure-ground* relationship.

Composition and the Use of Shapes

There are fundamental principles of composition that determine the use of shapes by artists. Shapes are used to produce the qualities of balance or imbalance within a composition. Because each shape has a particular weight (not an actual weight, but rather one that is felt intuitively), shapes may be manipulated within a composition to serve the ultimate aim of the artist, producing a degree of harmony or imbalance.

Shapes may appear to be heavier when they are darker in color or value or are defined by a thick line. Conversely, they may appear to be light in weight when they are lighter in color or value or are defined by a thinner line. By using shapes as forces within a composition, the artist can control the attention of the viewer by providing paths and blocks for the movement of the observer's eyes. The eyes may be permitted to linger or pause at certain points by the placement of shapes intended to achieve the effect of dominance in the areas to which the artist wishes attention to be directed. This is generally implemented by treating the areas that are intended to be dominant with the greatest visual contrast. Ultimately, decisions of this nature are subordinate to the organization of the work as a whole.

Color

Colors have an immediate sensuous appeal. There are those colors to which we are drawn, and those that we reject simply because of our negative emotional response to them. Color comes from light produced by a natural or artificial source. We perceive colors from light waves of

different lengths that vibrate at different speeds and are interpreted in the human mind as colors. When passing a beam of white light through a prism onto a white surface, one can see the spectrum of colors: red, orange, yellow, blue, indigo (or blue-violet), and violet. These do not appear as distinct bands of color, but merge into one another. The transition is a gradual one, and it is possible to perceive several intermediate colors in between. However, the colors in paint and printers' inks are dependent on colored pigments and should not be confused with the effect of colored light.

There are three characteristics of color: hue, value, and intensity.

Hue

The term *hue* refers to the *color name* used to differentiate one color from another color. The hue of a color may change when mixed with another color. There are three *primary colors*—colors that cannot be made by mixing other colors together. These primary colors are red, yellow, and blue. *Secondary colors* are created by mixing the various primary colors together. The secondary colors are orange (red + yellow), violet (red + blue), and green (yellow + blue). Another range of colors are called *intermediate* or *tertiary colors* and are produced by mixing a primary color with its neighboring secondary color (for example, red + orange = red-orange or orange-red). The resulting intermediate hue will depend upon the proportions of the colors used in mixing the combination. If more red is used, a red-orange will result; if more orange is utilized, then the result is an orange-red. From the three primary colors, then, a limitless variety of hues may be made.

If one imagines the three primary colors forming the points of an equilateral triangle, with secondary and intermediate hues placed equally around to form a circle, then one can identify opposite each primary color on this wheel the color that affords the greatest contrast with that primary color. This opposite is referred to as the color's *complementary color*. This principle applies to secondary and intermediate hues on the color wheel as well.

Value

Colors vary in terms of value as well as in terms of hue. The *value* of a color refers to its lightness or darkness and may be varied by adding

various proportions of black or white. The addition of black or white to any color will modify its value but not its hue.

Intensity

Perhaps the most difficult characteristic of color to explain is that of intensity. *Intensity* refers to the level of saturation of a color. The purest or reddest red, for example, may be said to be red at maximum intensity. In other words, the purest sensation of red is received from its surface; that is, no interference from any other hue contributes to the production of this color, and it is seen at maximum strength. By simply adding to this pure, intense color any other pigment, we diminish the intensity of the color. We may change the intensity of red by adding a little of its complementary hue, green. This has the effect of graying the red because the pure red rays of light have some green rays intermixed with them. As more of the complementary hue is added, the resultant hue comes closer to and eventually becomes neutral gray. This method produces a change in the intensity of a color but not in value.

Texture

Texture describes the perceived quality of a surface, whether real or simulated. We do not experience the world only through our sense of sight, but through other senses as well. Among them is our sense of touch. When we are young, we are compelled to touch things in order to become familiar with them; we rely a great deal upon our tactile sense. As we grow older, we develop the ability to recall and imagine the feel of things that we perceive but cannot or should not touch. Our perceptions oftentimes incorporate associations with tactile experiences. We may associate a highly polished surface with modern technology or the notion of fine craftsmanship and consider a roughly hewn surface to represent a more organic or natural primitiveness or poor craftsmanship. We may even make culturally based associations and connections between texture and gender.

The surface treatment of two-dimensional images and three-dimensional objects conveys much information. In images where objects and forms are represented, one can examine the surface quality created by the artist. One can also investigate the texture of the medium. The actual

tactile sense of the texture is determined by its surface elevation. Finally, one can discuss how the artist has used and manipulated the medium in order to create actual or simulated texture.

CHAPTER 2

The Materials and Processes of the Visual Arts

Familiarity with the various art processes and techniques and with the limitations of art media and materials leads to a greater understanding and appreciation of art. While one may not necessarily be attracted to a particular work of art, an understanding of the material and technique which were utilized to create the work allows one to still appreciate the mastery of the artist who has created it.

Drawing

Drawing, the act of producing an image by making lines upon a surface, is either done with a dry medium or wet medium. When rubbed across a surface, *dry media* tend to deposit pigment at the point where contact and friction occur upon the surface. *Wet media* consist of pigment mixed with some liquid solution and are usually applied with pen or brush.

Charcoal

Charcoal is a dark, usually black, porous carbon made by charring wood in a kiln from which air is excluded. Charcoal may be very soft or very hard, thus allowing for a wide variety of types of line, value, and texture. Charcoal is a dry medium.

Crayon

Crayons, popular because of the wide range of colors available, consist of pigment held together by a greasy binder. The term *crayon* refers to wax crayons of the type with which most children are familiar, as well as to crayons that have been developed for specific media, such as those made for use on lithography stones and plates used in printmaking. Crayon is a dry medium.

Ink

Inks come not only in black, but in many other colors as well and offer a quality of fluidity in drawing that dry media typically do not. Traditionally, ink is applied with pen or brush. Not only does the artist have a choice as to the manner in which he or she uses the point of a pen in order to create a variety of types of line, but there is also the choice of type of pen tip (nib). In the Far East, the brush has been used for centuries for writing and drawing. There are many different brushes and many different techniques available with brush and ink. Ink is a wet medium.

Pastel

Pastels consist of pigments that are held together by nongreasy binders. They are available in many colors and, though fragile, can be blended together and offer much flexibility in use. Pastel is a dry medium.

Pencil

Pencils typically have a core of graphite, a soft black polished carbon, which, like other dry media, leaves a "trail" when rubbed against a surface. Drawing pencils are frequently numbered, indicating

the hardness or softness of the "lead." Pencils also come with colored leads, some of which are water soluble. Pencil is a dry medium.

Painting

Painting is probably the visual arts medium that most people think of first when the word *art* arises in conversation. Paint, the stuff that paintings are made of, consists of *pigment*, either synthetic or ground from natural elements, which is suspended in a liquid *medium*. The purpose of the medium is to carry the pigment and allow the artist to apply it to some surface, such that it will adhere to that surface. If the artist wants to thin the paint so as to be able to affect its texture and thickness, then a *solvent* is mixed with the paint. If the artist is using a *water-based paint* such as acrylics or tempera, then water may be used as a solvent. If he or she is using an *oil-based paint*, then other types of solvents are utilized.

Although the stretched canvas is the most familiar surface upon which artists paint, artists frequently paint on wood, paper, plastic, and glass as well. In fact, it is unlikely that there are very many types of surfaces upon which artists have not painted at one time or another. However, the artist usually has to *prime* a noncanvas surface with gesso or some other material so that the paint will adhere to it.

Acrylic

Water-based acrylic paints, developed only during the past forty years, offer a wide range of colors, adhere well to a variety of surfaces, and use water as a solvent and thinner. They also dry much quicker than oil-based paints.

Egg Tempera

Egg tempera, a paint that uses egg yolk as a medium for pigment, was the primary paint medium utilized by artists until the fifteenth century, when oil paint began to become popular. Although egg tempera is quite resilient, it does require patience in application, as it must be built up in layers using small brush strokes.

Encaustic

Encaustic painting involves mixing pigments with hot beeswax and resin and applying while still hot.

Fresco

Frescoes are paintings done on walls of freshly spread, moist lime plaster. The water-based paints used are applied before the plaster dries so that the color is absorbed as the plaster sets. This technique requires that the artist be well-prepared and work very quickly once the plaster is at the proper stage of moistness.

Gouache

Gouache is opaque watercolor paint. Whereas watercolors are translucent, gouache is not because white has been added to the paints. They do not lend themselves to subtle blending or layering, but are applied so that areas of color border one another. Like watercolors, gouache is worked with fairly quickly.

Oil

Oil paint, very popular since the fifteenth century, offers much flexibility for the artist. With pigments based in such mediums as linseed oil, it can take quite a while for oil paintings to dry, as long as several months. Oils do, however, allow artists to continue to rework their compositions. They also lend themselves to the very sophisticated blending of colors, as well as to the application of pigments as translucent layers. These layers, called *glazes*, can be manipulated to create subtle, yet intense, sensations of depth and luminosity. Traditionally, artists paint a layer of varnish over their oil paintings in order to protect them.

Watercolor

Watercolors consist of water-soluble pigments that are suspended in gum arabic, glue, or casein.

Printmaking

Printmaking involves the production of a single image in multiple editions. The artist does not manipulate the work of art directly, but rather works upon a surface from which the artwork is printed and reproduced. Whether the edition (the number of copies made) is ten or one thousand, each print, which is usually numbered and signed by the artist, is considered to be a work of art and an original.

Intaglio

Intaglio involves engraving or incising the surface of a hard material below the surface of the material so that, when inked, an impression from the design yields an image in relief. In intaglio, the image or design to be printed lies below the surface of the printing plate. The etching of the plate occurs through the use of sharp tools and acid. Ink is applied to the plate and rubbed into the etched areas. After the surface of the plate is wiped clean, a damp piece of paper is placed on the surface, and the paper and plate are run through a press that forces the paper to come in contact with the etched areas that are inked.

The intaglio method of printmaking includes such techniques as aquatint, drypoint, engraving, and etching.

Aquatint does not produce lines, but rather areas of value similar to watercolor washes. Usually, it is used along with other intaglio methods of printmaking. The aquatint process involves applying resin to the surface of a printmaking plate, which is then left to sit in an acid solution. The density and thickness of the applied resin and the length of time the plate is left in the acid solution contribute to the degree of lightness or darkness that may be printed from the area being worked on.

Drypoint is done with a tool that has a steel or jeweled point called a drypoint needle. It is the burr that results from the drypoint needle being drawn across the surface of the metal printing plate that "holds" the ink for printing.

Engraving involves cutting or gouging into a metal plate. The primary tool of engravers is a burin, with which they can produce very fine lines as well as heavy thick lines. By creating various textures upon the surface of the plate with the burin, engravers can produce the effect of shading and value through the use of line alone.

Etching refers to a process that makes use of acid as the vehicle for "biting into" the surface of a metal plate. By first applying an acid-resistant material such as asphaltum to the surface of the printing plate and then scratching away areas of lines through the asphaltum, the artist can control where the acid will bite into the metal plate when it is placed in the acid bath.

Lithography

Lithography is the printmaking process whereby the plane surface of a stone or metal plate is treated in such a manner that the image to be printed is ink-receptive and the blank area is ink-repellent. Based upon the principle that oil and water do not mix, an image is drawn or painted upon the surface of a lithographic stone or plate with a grease-based crayon, pencil, or liquid medium. After the image is completed, the surface is "fixed" (or set) with a light acid bath and then rinsed with water. After this treatment, the grease-based image on the surface will only accept ink, whereas the rest of the surface rejects ink and only accepts water.

Relief

Relief prints are the product of printing processes that involve printing from a raised surface that is inked. *Linocuts* are made from linoleum, a fairly soft material to work on. Another popular printmaking relief medium is the *woodcut*. Both linocut and woodcut tools have varying-sized nibs that come in different thicknesses and widths, allowing great flexibility in the type of line created on the surface of the linoleum or wood. Whether doing a woodcut or linocut, the artist first draws his or her image on the surface of the wood or linoleum. Then, using a variety of tools, the artist gouges out everything but the image that was drawn on the surface in the beginning. When ink is applied, it is to the raised surface, and when paper is placed against this raised surface and rubbed, the inked image is transferred to the paper.

Serigraphy

Serigraphy, also known as *silk screening*, is a process whereby printing occurs by pressing pigments through a silk screen with a stencil

design. The artist blocks the portions of the screen that he or she does not want to allow the ink to flow through. As with the other printmaking processes, if the artist wishes to produce a multicolor image, then a separate screen must be made for each color's application.

Sculpture

Sculpture refers to three-dimensional works of art, that is, works that possess depth. There are three primary processes by which sculptures are created. There are *additive*, or constructive, processes, where materials are brought together and added to one another in order to create the work. There are *reductive*, or subtractive, processes, which involve starting with some material that the artist removes portions of in order to create the work. Then there is *casting*, which is a process whereby the artist creates a mold in which he or she pours a liquid that will harden within the negative space of the mold. Once hardened, the mold is removed.

The Additive Process

Modeling is a primary technique of the additive process of sculpture. Used especially with media such as clay, modeling involves pinching, pulling, and adding clumps and bits of clay, for example, to some shaped clay form. When the clay object has dried completely, it is ready to be fired in a kiln. Once fired, it is sometimes referred to as *terra cotta*.

Another additive form, *assemblage*, involves the use of found objects as the raw materials that are combined in order to make the work of art. Other construction techniques involve welding, glueing, and nailing, to name a few of the many options that artists have at their disposal.

The Reductive Process

Most people are familiar with the reductive process of *carving*. The two materials used most often in this process are wood and stone. The artist, using various tools, shapes the material by chipping and gouging away at it.

Casting

Casting is a process whereby a liquid is poured into a mold and allowed to harden. When "cured," the mold is removed, and one is left with the work of art. Casting may be done with such materials as plastic, bronze, steel, aluminum, plaster, and even clay (in liquid form, called *slip*). Depending upon the size and complexity of the form, it may be cast as a whole or cast in separate pieces and then assembled for completion. There are various casting methods, including *solid casting*, which results in a solid cast form; and the *lost-wax* method, which results in a hollow form.

CHAPTER 3

Art Criticism

Art is created within a cultural and societal context. Artists, being members of society, cannot help but be influenced and affected by their immediate and/or global environment. Nor can they predict or control how their work will be received. Even if a work of art is created for purely personal reasons, when viewed by the public, a social response occurs. When one looks at a work of art, one is faced with a physical presence with its own history. However, the sense of meaning and the pleasure gained from the work are based on the perception of the viewer, and this perception depends on what the viewer brings to the work of art in experience as well as knowledge.

In this text, art criticism is simply a written or verbal response to one or more works of art. However, all things considered, an informed judgment is preferable to an uninformed judgment. In order to enhance the experience of viewing or engaging with a work of art and to convey one's thoughts and feeling about it in a meaningful way, one can do two things. First, for a deeper intellectual involvement, one can seek knowledge about the visual arts. Second, for a heightened sensory experience, one can look at and expose oneself to as much art as is possible.

Few people hesitate to judge particular works of art as good or bad, yet when pressed to state their criteria for excellence, they balk. A useful and accessible model for engaging with and judging works of art takes the viewer through the steps of description, analysis, interpretation, and, finally, evaluation. To identify the appropriate criteria upon which to judge a work of art, it is suggested that one turn to philosophies of art. Through active engagement with a variety of art media and art styles, it becomes apparent that certain philosophies of art lend themselves to the evaluation of certain styles of art. Each philosophy bases its evaluation upon different criteria that may be found within the work of art, and each offers its own justification, as well, as to why a particular work is successful or not. The steps involved in a systematic analysis of a work of art and the philosophies of art that might best serve as criteria of evaluation will be presented in this chapter after a brief discussion of the purposes of art criticism.

The Purposes of Art Criticism

There are probably as many approaches to art criticism—writing or talking about art—as there are art critics. Each approach serves a different function and has its own purpose.

To Inform the Public

In the media, both printed and electronic, the purpose of art criticism is to inform the public of exhibitions. This type of art criticism typically involves a description of the artwork and the critic's judgment of it. Beyond the description and evaluation of an exhibition, justification for a particular rating may also be provided. In cases where it is not, the evaluation seemingly is based upon the personal authority of the reviewer.

Scholarly Identification

The identification of artworks, typically carried out in many art history classes, usually consists of the chronological presentation of projected images of works of art. In a session sometimes referred to as "art in the dark," students sit in a darkened room and look at the images while being informed as to the work's title, the artist, the medium

employed, the date the work was created, the style of the work, and sometimes some background information concerning the era in which the artist lived. However, the study of these exemplars of art in terms of their origins and styles is probably inadequate preparation for individuals who, when confronted with the diversity of materials and styles of art that exist, wish to have the background necessary to understand (at least) and appreciate (at best) the works that they encounter.

Communication

Being social creatures, we possess an innate desire to share our thoughts and feelings with others. Familiarity with different types and models of art criticism can provide us with the language, structure, and conceptual understanding needed for sharing thoughts and feelings about visual works of art in a meaningful way. We also have the tendency to judge and evaluate what we experience, and a knowledge of art criticism can be useful toward the formation of informed judgments about works of art.

The Steps in Art Criticism

In talking about art, or performing art criticism, the goal is to share one's perceptions, understanding, and enjoyment of the work and frequently to judge and evaluate it as well. In order to accomplish this, it is oftentimes useful to proceed "through" a work of art in a systematic fashion.

Description of the Artwork

The first step in this process involves *description*, where the viewer takes account of what is visible in the artwork. If the content or subject matter is representational in nature, one should find it fairly easy to describe what one sees. If, on the other hand, the subject is nonrepresentational, then one is left to using descriptors that refer to the quality of line, shape, color, and texture, for example, that make up the composition. In either case, one also needs to be cognizant of the medium and materials that are used as well as the style or manner in which the artist

has manipulated them in order to achieve particular effects. The description should not include any type of evaluation or judgment, but should at this stage be based purely upon what is seen.

Analysis of the Components

After one has taken as complete a visual inventory of an artwork as is possible, the next step is to *analyze* the components that make up the composition. How the elements that form a work of art are analyzed depends a great deal upon the viewer's perception. The goal is to become aware of how the various lines, shapes, colors, and textures affect and interact with one another.

What does the form of one element do to another because of its proximity or distance from it? How does a particular large area of color affect a smaller form that it seems to overlap? How is one's eye led through the composition? What areas seem to be dominant? How has the artist achieved the sense of balance or imbalance, rhythm or contrast, that is portrayed? These are the kinds of questions to which one seeks the answers in analyzing a work of art.

Interpretation of Visual Evidence

Having described and analyzed the "visual evidence" of a work of art, one is now in a better position to look for some *meaning* in it. This is not to say that a judgment is at hand, because an understanding of the purpose of the work, that is, what it does, must be achieved before one can determine how successful it is. One way of doing this is to look at the work of art as a solution to some question or problem. The viewer's responsibility, then, like that of the detective, is to arrive at a solution (in this case in the form of a question or problem), to which the work of art is a response or answer, based on the visual evidence at hand.

One must also keep in mind that the precise interpretation the artist might have intended while creating the work is likely to elude us, even if we know how and why he or she produced it. Such knowledge may contribute to a greater appreciation of the work, but in the end, the particular interpretation of meaning for the viewer takes place on a personal level. As long as one can justify and explain how and why a particular interpretation has been arrived at, there is room for numerous interpretations in response to a single work of art.

Philosophies of Art as Criteria for Evaluation

In order to formulate a personal *judgment* based upon the description, analysis, and interpretation of a work of art, one still frequently requires some means of gauging its level of excellence or success. Historically, a number of philosophies of art have evolved that represent various standards of judgment. Each bases its evaluation on different criteria within a work of art, and each offers its own justification as to *why* a particular work is successful or unsuccessful.

Imitationalist Criticism (Imitationalism)

From the point of view of imitationalist criticism, also known as mimetic criticism, that art is best that most accurately represents the world around us in the truest sense. It is the subject matter and how that subject is presented—as real—upon which a judgment of excellence is based. How the artist achieves the effect (i.e., through the use of the formal elements of art) and the effect the work has upon the viewer are given little attention in this approach. Again, in imitationalism, the critical factor is how accurate the work is in its depiction of reality as we know it through our sense of sight. What is depicted is not as important as how it is presented to us.

Formalist Criticism (Formalism)

Formalist criticism disregards the subject of the work of art entirely and focuses the viewer's attention on the visual elements of the composition. Judgment is based on how well the artist has manipulated the medium in which he or she is working in order to create formal relationships between the parts that together make up the "whole" of the artwork. The notion of craftsmanship plays a significant role in this approach and, along with form and organization, sets the standard for excellence. The problem with this philosophy is that it is difficult to clearly identify a criterion of formal excellence that goes beyond simply feeling when the elements seem right. It also denies the value of an intellectual or emotional response and maintains the focus of attention on the organization and relationship of formal elements that make up the work of art.

Expressivist Criticism (Expressivism)

Expressivism is not as concerned with the subject or formal elements of a work of art as it is with how the work of art affects the viewer by conveying significant feelings or ideas. For the expressivist, that work of art is best that has the ability to evoke intense feelings in the viewer.

Instrumentalist Criticism (Instrumentalism)

According to instrumentalist criticism, the successful work of art serves the purpose of conveying an attitude that is political, economic, or moral in nature. This attitude should affect the individual in such a way that a change in behavior occurs. Here art is judged according to how well it serves a particular social function. Where much religious art of the past was intended to convey moral doctrine to the masses who could not read, we today are bombarded by electronic and printed imagery in advertising that espouses differing points of view. The goal of this imagery, however, remains the same: to change our behavior in publicly observable ways.

Recommended Reading for Part I

The Language of Art and Art Criticism

Albers, J. (1975). *Interaction of Color*. New Haven, Conn.: Yale University Press.

Arnheim, R. (1974). *Art and Visual Perception: A Psychology of the Creative Eye*. Berkeley: University of California Press.

Berger, J. (1977). *Ways of Seeing*. New York: Penguin Books.

Broude, N., & Garrard, M. (1982). *Feminism and Art History: Questioning the Litany*. New York: Harper & Row.

Chipp, H. (1979). *Theories of Modern Art: A Source Book by Artists and Critics*. Berkeley: University of California Press.

Clark, K. (1979). *What Is a Masterpiece?* London: Thames & Hudson.

Ehrenzweig, A. (1976). *The Hidden Order of Art*. Berkeley: University of California Press.

Elsen, A. (1972). *Purposes of Art*. New York: Holt, Rinehart, & Winston.

Feldman, E. (1987). *Varieties of Visual Experience*, 3rd ed. New York: Harry N. Abrams.

Goldwater, R., & Treves, M. (1974). *Artists on Art*. New York: Pantheon.

Gombrich, E. (1972). *Art and Illusion*. New York: Pantheon.

_____. (1984). *The Story of Art*. Oxford: Phaidon.

Hughes, R. (1981). *The Shock of the New*. New York: Knopf.

Jones, L. (1985). *Research Methods and Resources: A Guide to Finding Art Information*. Dubuque, IA: Kendall/Hunt.

Lauer, D. (1985). *Design Basics*, 2nd ed. New York: Holt, Rinehart & Winston.

Margolis, J. (1965). *The Language of Art and Art Criticism*. Detroit: Wayne State University Press.

Ocvirk, O., et al. *Art Fundamentals: Theory and Practice*. Dubuque, IA: Wm. Brown.

Piper, D. (1984). *Looking at Art: An Introduction to Enjoying the Great Paintings of the World*. New York: Random House.

Richardson, R., Coleman, F., & Smith, M. (1984). *Basic Design: Systems, Elements, Applications*. Englewood Cliffs, N.J.: Prentice Hall.

Sayre, H. (1989). *Writing About Art*. Englewood Cliffs, N.J.: Prentice Hall.

Stolnitz, J. (1960). *Aesthetics and Philosophy of Art Criticism: A Critical Introduction*. Boston: Houghton Mifflin.

The Materials and Processes of the Visual Arts

Doerner, M. (1949). *The Materials of the Artist*, trans. Eugen Neuhaus. New York: Harcourt, Brace.

Goldstein, N. (1979). *Painting: Visual and Technical Fundamentals*. Englewood Cliffs, N.J.: Prentice Hall.

Lucie-Smith, E. (1981). *The Story of Craft: The Craftsman's Role in Society*. Ithaca, N.Y.: Cornell University Press.

Seitz, W. (1961). *The Art of Assemblage*. New York: The Museum of Modern Art.

Wittkower, R. (1977). *Sculpture: Processes and Principles*. London: Allen Lane/Penguin.

Part II

The Ancient World

Because works of art occur as part of, or in reaction to, some artistic tradition, it is helpful to have a basic understanding of the history of art, to know something of the various styles and functions the arts have served in different cultures throughout history and prehistory. If any distinction can be made between the art of the ancient world and the art of today, it is one of degree only; in what we refer to as the ancient world, the role of art was more apparent to the peoples of the time.

CHAPTER 4

Prehistoric Art

Chronology

c. 35,000–8000 B.C.	**Old Stone Age (Upper Paleolithic period)**
c. 27,000 B.C.	Earliest Paleolithic art
c. 18,000 B.C.	Cave paintings with colored pigments
c. 13,000–8000 B.C.	Largest body of cave art
c. 15,000–10,000 B.C.	*Venus of Willendorf*
	New Stone Age (Neolithic period)
c. 8000 B.C.	In the Near East
c. 5000 B.C.	In Europe
c. 7000–6000 B.C.	Walls of Jericho

c. 7000–6000 B.C.	Tinted plaster skulls of Jericho
c. 3000 B.C.	Earliest Western European megaliths
c. 1650 B.C.	Stonehenge

The making of symbols and images was a hallmark achievement in the evolution of humans as intellectual beings. Though the form and style of the artifacts made by our ancestors may seem crude, these objects nonetheless reflect a significant advance in humans' capacity to manipulate materials toward a desired end, well beyond instinct.

The arts and artifacts of prehistoric and ancient peoples were created to be used; they were functional in the culture and society within which they were produced. Though the arts of earlier times may certainly be different from the arts of today, it would be an error in judgment to assume that the cognitive processes involved in artistic creation were any simpler. In fact, modern humans have removed the arts from mainstream life and placed them in repositories where they may be visited and viewed.

Paleolithic peoples, at the mercy of natural forces and relying on migratory game animals and available plant foods, tried to influence their circumstances by making images of their world on cave walls and in sculptural form. Neolithic peoples found they could attain a greater degree of control over their lives by growing crops and domesticating animals. A more settled way of life led to the building of permanent communities. With a division of labor came a sense of leisure time; with the development of various cultures, a sense of continuity, one generation following another; with this evolution of culture, customs and ceremonies along with the need for tangible objects and structures that have special significance.

The Old Stone Age

The Old Stone Age refers to a period of time also known as the Upper Paleolithic period, which lasted from approximately 35,000 to 8000 B.C. The best-known examples of cave art from this period have been found in the Franco-Cantabrian region (southwestern France and northern Spain); animal forms dominate the subject matter of the images

found thus far. Images that appear on the cave walls are typically painted and/or engraved; sculptural figures are carved out of bone, ivory, antler, clay, and stone.

Cave Paintings

The cave paintings from this period are typically located in deeply recessed areas that were most likely used as ceremonial chambers and not as living spaces. The fact that these areas are generally difficult to get to and are far from cave openings where there would have been natural daylight suggests that these images did not serve a decorative function. Additionally, because the animals represented in these paintings were probably the food animals upon which Paleolithic peoples relied for sustenance, it is thought that these images were related to the hunt as a form of magic and an attempt to gain power over the animals.

The earliest Paleolithic art, dating from 27,000 B.C., is in the form of simple finger tracings and engravings of animal forms etched into stone. These early images, though sketchy in appearance, are identifiable as representing specific species of animals.

Though there seems to have been an increase in the range and type of imagery depicted between 25,000 and 18,000 B.C., it was not until approximately 18,000 B.C. that cave art was painted with colored pigments. Ochers (mineral oxides) allowed Paleolithic artists to color their magical images with reds, browns, and yellows. To obtain the color black, they used manganese and charcoal. Color was applied in several ways. By mixing the ochers with fat, a paste could be made and applied to the wall surface; hardened, the ocher could be rubbed on in stick form; and by rubbing the ocher into dust, it could be blown onto the wall, similar to today's airbrush technique.

The largest body of discovered cave art has been dated between 13,000 and 8,000 B.C. The quality of imagery represented reflects a careful study of the subjects depicted, and the visual evidence suggests an increase in the amount of detail of the animal forms represented. The artist of the time must have had a highly developed visual sense and a keen memory to have been able to retain the animal image and then render it under the light of a candle made from tallow or oil.

Examples of cave paintings from this period include those found in Altamira, in northern Spain, where a forty-six-foot-long ceiling painting presents the images of over twenty animals, including deer, wild

boar, and bison; some of the figures are life-size, reaching lengths of seven feet. In Lascaux, France, there are numerous cave chambers and galleries where paintings from throughout this period can be found.

An unusual image found in some of the caves is that of a "negative" handprint. This image was created by splattering, painting, or blowing red or black ocher over a hand held against the cave wall. Speculation as to the meaning of these handprints ranges from their playing a role in magical ritual to their being signatures of individuals who visited these special sites.

The cave art of the Old Stone Age was based on what Paleolithic peoples saw around them. The images of animals, both standing still and in action, are natural-looking. Because they are located in somewhat inaccessible areas of the caves, it is felt that their function was not decorative, but magical and ritualistic in nature.

Sculpture

Sculptures that have been found in these caves, frequently near the cave paintings, are not as numerous as the images on the walls and ceilings. Although most of the sculptural forms are of animals, a number of female figures called *Venuses*, with exaggerated breasts, hips, and abdomen, have been found as well. Most famous of these Venuses are the *Venus of Willendorf* (pre-dating 15,000 B.C.), a four-and-one-half-inch limestone figurine found near the Danube River in Austria; and the *Lespuge Venus*, found in southwestern France. The significance most frequently attributed to these female figurines is that of fertility symbol.

The New Stone Age

The New Stone Age, or Neolithic period, began sometime around 8000 B.C. in the Near East and about 5000 B.C. in Europe. Whereas the lifestyle of the earlier Paleolithic peoples had been a nomadic one in which their survival depended on their success in hunting migratory wild animals and the availability of plant foods, the contemporary Neolithic peoples of this period began to realize that they could attain some level of control over their quality of life by planting and harvesting crops (primarily grains) and domesticating animals that could then be milked and butchered.

Social Evolution of Neolithic Peoples

During this period of time, though still relying on stone as a major source of working material, individuals began to master skills that led to more effective tools and weapons. Communities with permanent dwellings emerged with facilities for storing food supplies. The result was a growing population where individuals had to develop areas of expertise in order to more efficiently cope with the increasing complexity of life. In becoming territorial, humans faced a new threat—other humans. The remnants of walls and towers in Jericho, dated 7000–6,000 B.C., are testimony to the threat of territorial dispute and marauding raiders.

The building of permanent dwellings, the growing of crops, and the domestication of animals represented a shift from a nomadic hunting culture to one that might be described as a tribal or village culture. One result of this shift in cultural life-style was the production of many ceramic utensils for daily use. Many of these clay vessels were decorated with various patterns that are abstract in nature. The fact that surface decoration was used carries great implications concerning the social development of the culture, for decoration is not necessary for the function of an object; its purpose is to enhance the appeal of the object to one's senses.

The Arts of Neolithic Peoples

Many of the arts of this period seem to reflect the development of new religious and burial rituals and customs. For example, archaeologists have found skulls in Jericho (7000–6000 B.C.) that are layered in tinted plaster. The plaster is molded as flesh to cover the skull, with seashells set into the eye sockets. Each plastered skull has different features, as if representing different individuals. Though we cannot know for certain what their purpose was, these "individualized" skulls are believed by some researchers to represent an aspect of that culture's practice of ancestor veneration. As an art form, they may very well be the earliest examples of portraiture.

Megaliths

In Neolithic Europe, a number of monumental stone structures can be found. The earliest of these appeared in Western Europe around 3000 B.C. These megalithic structures have been associated with the religions and rituals of the period. There are stone tombs, called *dolmens*, that typically consist of two or more upright stones supporting a horizontal stone slab; these can be found in Brittany. There are structures and circular arrangements of huge stone slabs called *cromlechs*; these sites most likely provided the setting for special rituals and religious events. Perhaps the most famous of these cromlechs is the one located at Stonehenge (c. 1800–1400 B.C.) in England. It consists of a great outer ring of large stone slabs that support horizontal slabs called *lintels*. Inside the ring is another circle of stone slabs that encircle a horseshoe-shaped grouping of large lintel-topped slabs; each of the vertical stone slabs weighs forty-five to fifty tons. A person standing in the center of this stone complex at the summer solstice would have been able to observe the sun rise exactly at the heel stone, an altarlike structure just east of the inner circle.

CHAPTER 5

Egyptian Art

Chronology

c. 2772 B.C.	Egypt introduces yearly calendar of 365 days
c. 2700 B.C.	Step pyramid tomb of King Zoser
c. 2680–2260 B.C.	**The Old Kingdom**, Third to Sixth Dynasties
c. 2650 B.C.	Pyramid Cheops
c. 2600 B.C.	Pyramid Chephren and the Great Sphinx
c. 2575 B.C.	Pyramid Mycerinus
c. 2130–1790 B.C.	**The Middle Kingdom**, Eleventh to Twelfth Dynasties

c. 1975 B.C.	Interior tomb of Amenemhet I, at Beni-Hasan
c. 1720–1570 B.C.	The Hyksos rule Egypt
c. 1570–1085 B.C.	**The New Kingdom**, Eighteenth to Twentieth Dynasties
c. 1530–330 B.C.	Pylon temple at Karnak
c. 1480 B.C.	Funerary temple of Queen Hatshepsut
c. 1450 B.C.	*Hunting Scene* from tomb of Amenemheb
c. 1390–1290 B.C.	Pylon temple at Luxor
c. 1370–1353 B.C.	Stone relief, *Akhenaton with Nefertiti and Their Children*
c. 1275 B.C.	Temple of Ramses II
1085 B.C.	The end of the line of Ramses
332 B.C.	Egypt conquered by Alexander the Great

Though the Egyptians did not strive to build structures for daily life that would outlast them, they went to extraordinary lengths to create monuments and tombs that would last for eternity. However, with the exception of the tomb of King Tutankhamen, most have fallen prey to tomb robbers.

A principal quality of Egyptian art is its consistency. Except for the brief period of innovation during the reign of Amenhotep IV (Akhenaton), Egyptian artists followed a distinct tradition that was passed down through the generations. The monumental structures served as much more than simply testimonials to the power and memory of the pharaohs. Their function was inexorably a part of the cultural and religious life of the time. The same may be said of the sculpture and painting found in the temples and tombs of the pharaohs and nobility, where the figures depicted, though possibly visually awkward to us, were posed specifically to present their most representative visage. Once one gains an understanding of the Egyptian method of depiction,

it is not difficult to "read" Egyptian images for the very reason that they
are consistent.

To a great extent, archaeology developed as a science because of
the interest in uncovering and making sense of Egyptian artifacts and
architecture. Unfortunately, because of the inability to decipher hiero-
glyphics, a clear understanding of Egyptian culture and history was
inaccessible until the discovery of the Rosetta stone in Egypt in the late
eighteenth century. The Rosetta stone is etched with an inscription in
three parts. The first part is written in Greek, the second in demotic
Egyptian, and the third in priestly hieroglyphics. Although it was
believed that the three parts, though in different characters, were of the
same inscription, it was not until twenty years after its discovery that
Jean Champollion realized that the hieroglyphic characters were not
merely pictographs but were the symbols of the language of the ancient
Egyptians. It was at this point that an understanding of Egyptian life
became possible, through the "reading" of Egyptian artifacts.

The Old Kingdom

The Old Kingdom period encompassed the Third to Sixth Dynasties
and lasted from 2680 to 2260 B.C.

The Pyramids

Probably the best-known architectural symbols of the Old King-
dom period are the great pyramids of Giza, which are located across the
Nile River from Cairo. The three monumental pyramids are the tombs
of pharaohs of the Fourth Dynasty: Cheops (Khufu), c. 2650 B.C.;
Chephren (Khafre), c. 2600 B.C.; and Mycerinus (Menkure), c. 2575 B.C.
Prior to the use of these pyramidal forms as structures for entombing
the pharaohs, Egyptian royalty and court officials were buried in under-
ground chambers covered by square or rectangular mounds with sloping
sides and a flat roof faced with brick or stone. These structures were
called *mastabas*. During the Third Dynasty, Imhotep, the first artist of
recorded history, and later deified in Egyptian tradition, designed for
the pharaoh King Zoser a *step-pyramid tomb* (c. 2700 B.C.). This
pyramidlike structure was essentially a series of mastabas constructed
one upon another, decreasing in size at each level nearing the top. The

pyramidal form of the pyramid tombs found at Giza most likely evolved during the time of the Third Dynasty, when the pharaohs came under the influence of the cult of Ra, the sun god, whose fetish was a pyramidal stone. By the Fourth Dynasty, the pharaohs were perceived as, and represented themselves as, sons of the god Ra. It is likely that the pharaohs believed that since the essence and energy of Ra was maintained within a pyramidal stone, then in the same fashion, the pharaoh's spirit, or *ka*, and physical being could also be preserved within pyramidal tombs.

Cheops (c. 2650 B.C.) is the oldest and largest of the pyramids at Giza. Though there are a burial chamber and some galleries within Cheops, it is otherwise a nearly solid mass of limestone. It is 450 feet tall and each side of its base is 750 feet in length. The pyramid is made up of over two million individual blocks of stone, with each stone weighing approximately two and one-half tons.

Chephren (c. 2600 B.C.) is the middle pyramid, and when it was originally built, there was a covered causeway that went down into the valley and led to the valley temple. The valley temple of Chephren was constructed on the *post-and-lintel system*, in which both the large upright supports and the horizontal beams (lintels) that rested on them were carved of red granite; the floor was covered with slabs of alabaster. The Great Sphinx, commemorating Pharaoh Chephren, was carved from a single rock that was adjacent to the causeway.

Sculpture-in-the-Round

It was not only the form of the pyramids that was affected by the Egyptian notion of the pharaoh's divinity. Egyptian religious beliefs to a great degree affected the nature of Egyptian art in other areas as well. The Egyptians did not distinguish between the body and the soul the way Western culture typically does. They believed, instead, that an individual possessed a spirit, the *ka*, which could continue to inhabit the body even after one died. For the *ka* to continue to inhabit the body, however, the body would have to be kept intact. This belief resulted in the development of very sophisticated embalming techniques. Immortality required that the embalmed individual be placed in a tomb with food and drink and other items needed for the afterlife. Additionally, it was essential to provide sculpted images of the deceased, so that if the mummified body was destroyed or if it disintegrated, the *ka* would have

a place to dwell. Stone was used for these sculptures-in-the-round because of its permanence.

The sculptor would begin by drawing front and side views of the subject upon a single block of stone and would then, using a subtractive method of sculpture, chip and carve away the material to achieve the desired form. The blocklike forms produced by this method are representative of Egyptian figure sculpture of this period. Because the permanence of the sculpture was critical to the patron, hard stones such as granite were frequently used; because of the difficulty in sculpting such material, these figure sculptures were very expensive to have made, and only the wealthiest individuals could afford them.

The majority of large-scale sculpture-in-the-round is of seated and standing figures. Toward the end of the Fourth Dynasty, a third sculptural pose, the scribe sitting cross-legged on the ground, became popular, as did the portrait bust during the latter years of the Old Kingdom period.

Tomb Paintings

The subject matter of paintings found in the tombs of Old Kingdom royalty and officials usually also had to do with providing for the *ka* in the hereafter. The images were typically of hunting and agricultural scenes and represented seasonal events. When the individual interred in the tomb was depicted in a painting, his or her figure would usually be the largest and most idealized of those individuals represented, according to that individual's rank. When the pharaoh (or others of importance and wealth) was represented in paintings or in sculpted low relief, it was frequently in a pose with the eye and shoulders in frontal view and the head and legs in profile. His or her image was presented in this manner so that he or she could be depicted in the most complete way possible, conveying the majesty of the divine king or queen. This style of representing royalty is to be found in Egyptian art for more than 2000 years.

When individuals were represented in sculpture and in paintings, proportions of the figures to be depicted were already determined by a preconceived notion of the ideal figure. The canons of figure representation in both painting and sculpture were firmly established and followed by all artists. Their distinct style evolved because the purpose of the images was to convey the most information possible. This "best

view" was often depicted, even though it might not be photographically true. Concern for a realistic representation of the human figure was not to come for quite some time.

The Middle Kingdom

Following the Sixth Dynasty of the Old Kingdom, Egypt fell into a period of civil unrest during which local and regional forces fought for power. A number of dynasties came and went, and it was over one hundred years before Egypt was again united under a single ruler. The Middle Kingdom (2130–1790 B.C.), encompassing dynasties Eleven and Twelve, followed this reunification.

The Rock-Cut Tomb

During the Middle Kingdom period, few pyramid tombs were built; their cost was prohibitive and it was nearly impossible to protect their contents from ambitious grave robbers. As a result, a new burial custom was initiated; that of the *rock-cut tomb*, which was literally hollowed out of rock in remote areas. These tombs consisted of elements basic to Egyptian architecture: entry, columned corridor, and sacred burial chamber, as seen in the interior tomb of Amenemhet I, at Beni-Hasan (c. 1975 B.C.) [see illustration 1]. As in the burial chambers of the Old Kingdom pyramids, murals were painted on the inner tomb walls depicting various scenes that would enrich the environment of the *ka*.

The New Kingdom

Following the Twelfth Dynasty of the Middle Kingdom, the country returned to a state of unrest and was soon invaded by the Hyksos, a Semitic group of uncertain origin who migrated from Mesopotamia. They introduced to Egypt the horse, as well as new weapons and notions of strategy in war that the Egyptians would later use against them, leading to their expulsion about 1570 B.C. Amhose I became the first king of the Eighteenth Dynasty, which represents the beginning of the New Kingdom (1570–1085 B.C.), considered by many historians to be the greatest epoch in Egypt's history.

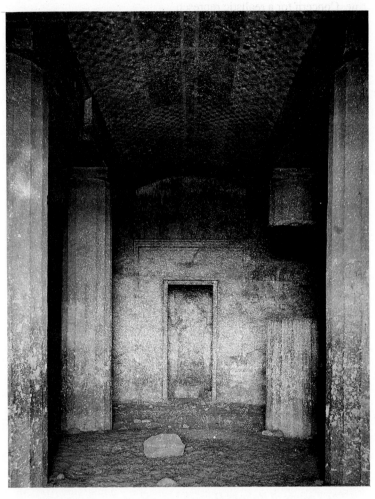

1. Interior Tomb of Amenemhet I, Beni-Hasan,
Egyptian, c. 1975 B.C.
The Metropolitan Museum of Art, photograph by Egyptian Expedition.

New Kingdom Architecture

During this period, Egypt extended its borders and culture through conquest, diplomacy, and trade with foreign lands. Thebes developed as the new capital, and along both banks of the Nile River were built new imposing temples, palaces, and burial tombs. Whereas the pyramids of Giza might be considered to be the monumental symbols of the Old Kingdom, representative of the New Kingdom were magnificent temples built to function during a king's or queen's life as a place to worship the gods, and after death, as a mortuary chapel. Rituals having to do with death and burial remained important facets of Egyptian religious practice. As during the time of the Middle Kingdom, the burial chambers of kings, queens, and royalty were carved out of rock, many with underground corridors hundreds of feet long, deep in the rocky hillsides. The entrances to these burial tombs were hidden in order to avoid desecration by grave robbers; the *mortuary temples*, typically built in another location, represented public monuments to the deceased.

The Funerary Temple of Queen Hatshepsut

In Deir el-Bahari is the majestic Funerary Temple of Queen Hatshepsut (c. 1480 B.C.). The temple complex is built on the floor of the valley, and in order to get to the sanctuary, which is deep in the rock face, one has to ascend three colonnaded courts that are connected by ramps. The design of the structure seems particularly suited to the immediate environment; the temple sits very naturally in its surroundings, with the colonnades seeming to repeat the silhouette of the cliffs above. Some of the colonnade pillars are simple rectangular forms, whereas others are beveled with sixteen sides. Additional decoration was provided in the form of nearly 200 sculptures-in-the-round integrated into the architecture, as well as by low relief wall murals depicting major events in the life of Queen Hatshepsut.

The Temple of Ramses II

Further up the Nile River, at Abu Simbel, was built the magnificent Rock-Cut Temple of Ramses II (c. 1275 B.C.). Sitting majestically in front of the temple face are four sixty-foot sculptures of King Ramses II. Inside the temple, facing both sides of the narrow corridor, are additional figures of the king fashioned from the living rock of the

corridor. Though they are symbolic and serve no structural purpose as support, they portend the Greeks' later architectural use of the caryatid, the sculpted female figure as supporting column. In 1968, in order to protect this monument from being submerged in the Aswan Dam reservoir, the entire temple was dismantled and rebuilt in another location.

Pylon Temples

In addition to mortuary temples, a number of monumental structures were built to exalt the various Egyptian gods. These temples were oftentimes begun by one king and then added onto by subsequent kings until they reached monumental proportions. Such temples may be found at Karnak, begun by Thutmose I in 1530 B.C. and added onto as late as the Ptolemaic period in 330 B.C.; and at Luxor, including the colonnade of Amenhotep III, c. 1390 B.C., and the court and pylon of Ramses II, c. 1260 B.C. These temples, sometimes referred to as *pylon temples* because of the shape of their massive facades, were all of a similar design. One approached the pylon temple by walking down an avenue that was bordered by sculpted figures, obelisks, and frequently, huge statues of the pharaoh flanking the entrance. The dominating feature of the approach was the *facade* of the pylon, a huge structure that was flat on the top with sloping walls on the sides, through which one entered. This entrance led to an open courtyard where the masses of people were allowed. Further in was the *hypostyle hall* (called hypostyle because its roof was supported by rows of columns), to which only a chosen few had access. The innermost area, the *sanctuary*, was only entered by the pharaoh and the priest.

New Kingdom Painting and Sculpture

Although the tradition of the *ka* figure was continued during this period, its physical form changed from the traditional sculpture-in-the-round format. The sculptor of the New Kingdom *ka* figure seemed to concentrate his attention and artistry on the portrait head, leaving the body literally a block covered with hieroglyphics. Subtle changes in style can also be seen in some tomb wall paintings of this period. For example, in the wall painting *Hunting Scene* found in the tomb of Amenemheb (c. 1450 B.C.) at Thebes, the figures are represented in the traditional Egyptian fashion, but the animal forms of a cat, fish, and

birds are represented in a much more realistic, naturalistic way. This easing of Egyptian convention in the treatment of certain forms can be found in a number of tomb murals created during the New Kingdom.

Probably the most radical changes in Egyptian art occurred during the Amarna period of the fourteenth century B.C. when Amenhotep IV (later known as Akhenaton) abolished worship of the cult of Amen. Having earlier absorbed the cult of Ra, the sun god, Amen was considered to be the native god sacred to the priests and people of Egypt. The cult of Amen was replaced by Amenhotep IV with the religion of Aton, whom Amenhotep IV declared to be the universal and only god of the sun. One effect of the introduction of this new religion was a discernable shifting of attention from matters having to do with the afterlife to those concerning life on earth.

In art, this change manifested itself in the manner in which the human figure was represented. Though for some time there had been a growing tendency to portray animals in a more realistic and naturalistic fashion, this trend now encompassed figure sculpture as well. Thus many of the sculptures created during Akhenaton's reign retained the classical frontal pose, but they also incorporated the curving contours of the body and represented the irregularities that differentiate one person from the next. Although there are still formal qualities to the work, these sculptures also exhibit a softness that belies the reality of the person represented. These characteristics are also to be found in many of the carved reliefs and wall paintings of this period. Stiff lines that once defined the figure are replaced by curves that represent individuals in more natural stances. Strikingly evident is the lack of idealized proportion in the portrayal of human figures in relation to one another. In the stone relief *Akhenaton with Nefertiti and Their Children* (c. 1370–1353 B.C.) it is significant to note that Queen Nefertiti is portrayed in the same scale as the pharaoh. Whereas in traditional Egyptian art, rank and status determined the scale of the human figure depicted, during this relatively short period of time, natural proportion guided practice.

Although this more naturalistic style continued to some degree during the reign of Akhenaton's successor, Tutankhamen, successive pharaohs, under pressure from the priests of Amen, restored the old cult and attempted to erase all traces of Akhenaton's religion by razing his temples and monuments and reinstituting the traditional styles of art.

The dynasties of the line of Ramses finally came to an end in 1085 B.C., after which time the grandeur and influence of Egypt continued to diminish until its subjugation by Alexander the Great in 332 B.C.

CHAPTER 6

Greek Art

Chronology

10th–8th cent. B.C.	**The Geometric Period**
8th cent. B.C.	Dipylon vase (amphora), with funeral scenes
c. 776 B.C.	First Olympic Games
c. 700–480 B.C.	**The Archaic Period**
7th cent. B.C.	Eleusis vase (amphora), *The Blinding of Polyphemos*
c. 600 B.C.	*Kouros from Attica*
c. 575 B.C.	François vase (krater vessel) by Ergotimos, painting of Peleus' wedding by Kleitias

c. 570 B.C.	*Kouros from Tenea*
c. 550 B.C.	Basilica at Paestum
c. 540 B.C.	Drinking cup (kylix), *Dionysus in a Sailboat* by Exekias
c. 530 B.C.	Development of red-figure technique by the Andokides Painter
c. 530 B.C.	*Peplos Kore*
c. 530 B.C.	Treasury of the Siphnians at Delphi
c. 525 B.C.	*Kouros from Anavysos*
late 6th cent. B.C.	Amphora, painting of *Revelers* by Euthymides
late 6th cent. B.C.	Krater vessel, *Herakles Strangling Antaios* by Euphronios
5th cent. B.C.	Kylix, *Revelers* by the Brygos Painter
c. 580–500 B.C.	Pythagoras, mathematician
c. 540–480 B.C.	Heraclitus, philosopher
495–429 B.C.	Pericles, of Athens
c. 490–338 B.C.	**The Classical Period**
480 B.C.	Athens and the Acropolis are ransacked by the Persians
c. 480 B.C.	*Kritios Boy*
470–399 B.C.	Socrates
460 B.C.	Aeschylus writes *Prometheus Bound*
c. 460 B.C.	Temple of Hera
460–429 B.C.	Pericles rules Athens
c. 450 B.C.	Argonaut krater by the Niobid Painter
450–440 B.C.	*Doryphorus* by Polyclitus

448–432 B.C.	The Parthenon
443 B.C.	Sophocles writes *Antigone*
438–432 B.C.	*Three Goddesses*
437–432 B.C.	The Propylaea, Acropolis
431–404 B.C.	Peloponnesian War
428–347 B.C.	Plato
427–424 B.C.	The Temple of Athena Nike, Acropolis
421–405 B.C.	The Erechtheum, Acropolis
415 B.C.	Euripides writes *The Trojan Women*
c. 400 B.C.	Grave stela of Hegeso
384–322 B.C.	Aristotle
323 B.C.	Death of Alexander the Great
323–30 B.C.	**The Hellenistic Period**
c. 230–220 B.C.	*Dying Gaul*
c. 200–190 B.C.	*Nike of Samothrace*
c. 150 B.C.	*Aphrodite of Melos*
2nd–1st cent. B.C.	*Laocoön Group*

For the Greeks, who called themselves Hellenes, the human being was the measure of all things. In Athens, the concept of democracy evolved, and with it, the phenomenon of philosophical discourse and debate and the love of intellectual endeavor. With the development of an ideal sense of intellectualism came a perception of the "ideal" in terms of physical form. The bases of Greek culture were the individual, reason, and nature, and it was upon these three domains that achievements in art, literature, science, and philosophy were made.

Unlike Egyptian artisans, Greek artists did not feel bound to any single artistic tradition, but felt free to experiment with the depiction of the human figure. Although the Greeks began with the Egyptian orien-

tation of portrayal based upon an intellectual knowledge of the way things looked, they soon moved toward an art that was grounded upon the artist's direct perception of his subject. Greek potters, painters, and sculptors were aware of what their contemporaries were doing and they freely borrowed ideas and techniques from one another. A significant event in this evolution of Greek art was the development of a visual technique called foreshortening, *which allowed the Greek painter and sculptor to create the illusion of an object or figure projecting or receding in space. This new visual technique coincided with, and was a useful tool in, the movement toward naturalism.*

Many changes occurred during the Greek epochal periods. Geometric designs on pottery gave way to the stylization of plant motifs, influenced by Asian art, and later adopted by the Romans. Greek art eventually moved away from foreign influences and developed its own styles and forms. The Archaic frontal pose evolved to contrapposto, *while figure sculpture became less majestic and more humanistic, reflecting attention to the notion of the ideal form. By the middle of the fourth century B.C., the Greek painter Pamphilus represented a movement that proposed that perfect art could not exist without geometry and mathematics.*

The Geometric Period

Examples of art representative of the Geometric period, the earliest distinctively Greek style, can be seen in the Greek vase painting of the tenth to the eighth centuries B.C. In these examples, tight horizontal bands with abstract geometric designs decorate the pottery. Toward the end of this period, the human figure became a design element in the decoration motif. The Dipylon vase, so-called because it was found in the Dipylon cemetery in Athens, may be considered representative of the eighth-century B.C. *amphora*, a vessel used to store such goods as wine and oil [see illustration 2]. Its decoration consists of rigid horizontal bands that are filled with geometric designs. Approximately two-thirds of the way up from the base, at the vessel's shoulder, the band incorporates human figures depicted abstractly in a geometric manner. The figures represented had a decorative function, as opposed to the narrative role they would soon begin to play.

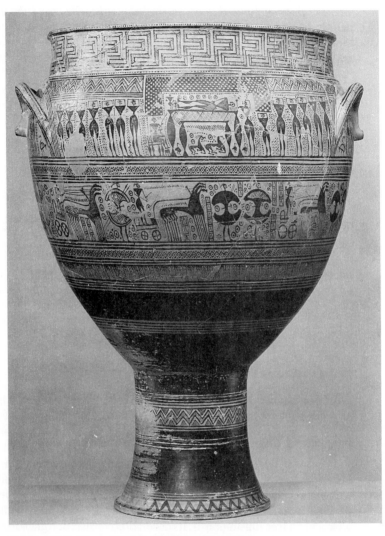

2. Vase, Dipylon: colossal, with funeral scenes.
Attic Geometric, 8th Century B.C. H. 40½" (72.3 cm.).
The Metropolitan Museum of Art, Rogers Fund, 1914. (14.130.14)

The use of figures in narrative scenes is illustrated in an eighth century B.C. *krater*, a wide-mouthed vessel used to mix wine and water, which was also found in the Dipylon cemetery. Though the human forms are still stylized, the imagery, instead of having a purely decorative function, also serves as a visual narrative of a funeral procession that includes warriors, horses, and chariots.

The Archaic Period

Following the Geometric period, the Archaic period (700–480 B.C.) represents a time during which the Greeks expanded their commercial interests as far east as Egypt and Mesopotamia. One effect of this contact with the cultures of the East can be seen in the way in which figures were represented on Greek vases. Up to this time, rigid horizontal bands of geometric designs dominated the pottery surface. In a seventh-century B.C. amphora vase from Eleusis, which portrays the story of the blinding of Polyphemos, the figures have evolved from geometric, rigid forms to more organic, active figures that dominate the surface area of the vessel, leaving the geometric design to play a secondary role. Typical of most examples of Archaic painting was what might be described as a drawing filled in with flat solid color.

Collaboration Between Potter and Painter

During the seventh century B.C. there appeared a number of vases signed by both potter and painter, which suggests the elevation of this art to a level equal to that of sculpture and other established arts. Such a vase is the François vase (c. 575 B.C.), a krater vessel signed by the potter Ergotimos and the painter Kleitias. The krater is decorated with six bands that depict over 200 figures. The narrative represents the wedding of Achilles' father, Peleus, as well as a boar hunt and the funeral games of Patroklos. Another type of vessel from this period is the *kylix*, a drinking cup. One kylix in particular worth mentioning, by the potter Exekias, is decorated with the image *Dionysus in a Sailboat* (c. 540 B.C.). Both Kleitias, the painter of the François vase, and Exekias used a popular decorative method called the *black-figure technique* in order to achieve an effect whereby figures were silhouetted in black against a red background, the natural color of the clay. Detail could be

added by using a needle to scratch through the layer of black pigment, which allowed the natural red color of the clay beneath to show through. Exekias, however, incorporated a new visual element in his depiction of Dionysus' ship; in his painting of the ship's sail, he does not follow the traditional form and manner of illustration, but rather attempts to represent the full-blown sail as it would actually appear, interacting with the force of the wind. It is this increased awareness and attention to detail based upon physical reality and observation that typifies Greek art from this point on.

Experimentation and Innovation in Painting

Experimentation with techniques of painting also ensued during this time. In 530 B.C. a painter referred to as the Andokides Painter (because he decorated a number of vases signed by the potter Andokides) developed a new painting style, called the *red-figure technique*, because it allowed him to create a black background with the foreground figures in red, the reverse of the black-figure technique. This new technique provided vessel painters with much more flexibility in depicting figures in more natural stances and with more detail.

Depiction of the Human Figure

With the technical ability to represent the human figure in a more natural fashion now available, a number of painters began to focus upon human anatomy. Euphronios, a red-figure painter, was one of this group, and during his time (late sixth century B.C.) he was quite popular for his skill. His observations and study of the human form are evident in his vessel painting *Herakles Strangling Antaios*, from a late sixth-century B.C. krater. Not only does he place the two combatants in an entangled position, he also attempts to depict the physical tension and strain that this type of wrestling match would entail. Although it is true that later artists would be more successful in their ability to render the human form accurately, Euphronios' legacy was his insight concerning the value of observation from life.

Along with the interest in the human's physical form was a growing curiosity concerning its depiction. Euthymides, a contemporary of Euphronios, in his painting *Revelers* on a late sixth-century B.C. amphora, experiments with the representation of figures from different

perspectives. Where Euphronios directed his attention to the anatomy of his figures, Euthymides was interested in portraying them in space as three-dimensional forms that were turning and twisting. Another example of the Revelers as subject matter can be seen in a fifth-century B.C. decorated *kylix* painted by the Brygos Painter. Here, for the first time, figures are represented in *contrapposto* position, twisted in such a manner so that the forward leg is placed in front of the figure and the torso is turned toward the viewer. This manner of depicting the human figure implies an understanding on the part of the artist as to the body's volume and mass. It also reflects the artist's attempt at creating the illusion of substance and depth upon a flat two-dimensional surface where the figure had traditionally been represented as flat and uni-dimensional.

Figure Sculpture

Early Greek sculpture was typically small, until the seventh century B.C. when contact with the East, specifically Egypt, led to the development of monumental, life-size figure sculpture. Besides the borrowed techniques for working with stone, Egyptian influence can be seen in the early Greek *Kouros* (youth) figures, which were represented with broad shoulders and evenly distributed weight with the left foot advanced in a frontal pose. Whereas the Egyptian figures usually relied upon a stone slab as a supporting feature, the Greek *Kouros* figures (ranging from five to eleven feet in height) were freestanding and stiff; they were nude, with head held high and arms hanging down with clenched fists, and their features were modeled in the round rather than incised in the stone. These features reflect the Greeks' attention to anatomy and realism, as well as the pride with which they regarded the athletic male body. The *Kouros from Attica* (c. 600 B.C.) [see illustration 3] and *Kouros from Tenea* (c. 570 B.C.) are representative of this type of sculpture. Whereas the form of the *Kouros from Tenea* shows attention to anatomical detail in the modeling of the body, the *Kouros from Anavysos* (c. 525 B.C.) is a funerary sculpture of a particular individual, Kroisos, who died in battle. Both figures reflect their creators' familiarity with human structure and proportion and their ability to carve stone, but the *Kouros from Tenea* is a more generalized figure, and the *Kouros from Anavysos* portrays a specific person in the form of a portrait sculpture.

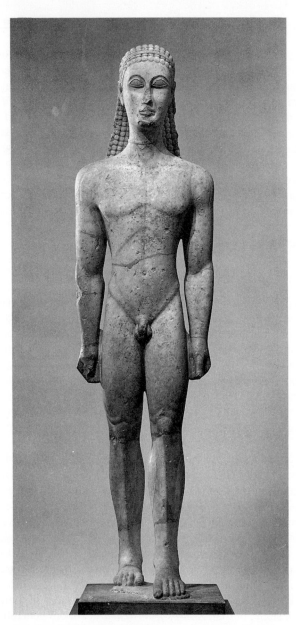

3. Statue of a Kouros (c. 600 B.C.).
Island marble, said to be from Attica. H. w/o plinth: 6' 4" (1.927 m.).
The Metropolitan Museum of Art, Fletcher Fund, 1932. (32.11.1)

Whereas the *Kouroi* (youths) represented the male figure, the *Korai* (maidens) portrayed that of the female. An example of a *Kore* (maiden) is the *Peplos Kore* (c. 530 B.C.), which was created during the same period in which the *Kroisos Kouros* was sculpted. The *Peplos Kore* is one of many such figures found on the Acropolis in Athens. The face of the *Peplos Kore* is expressive and, in contrast to Egyptian statues, which typically showed the figure's arms lowered, her left arm is extended. The sculptor's interest in anatomy is again apparent in the way the figure is modeled beneath its sculpted drapery. Originally the *Peplos Kore* was, like the majority of Greek stone statuary, painted. Color was utilized to highlight areas of the figure in order to make the figure appear more lifelike. The method of applying color, called *encaustic*, involved the combining of hot wax and pigment, and was painted onto the surface of the sculpture while hot. The fact that color is still evident on many sculptures attests to the permanence of this technique.

As noted above, the *Kroisos Kouros* (525 B.C.) represents a shift from the representation of a generalized figure to that of a specific individual. The *Kritios Boy* (c. 480 B.C.) of the later Classical period represents another major step in Greek figure sculpture. The *Kritios Boy* is significant because it lacks the stiffness and rigidity of earlier sculptures; it does not portray a figure posing at rest, but rather a figure at rest in a very natural manner. This effect could only be achieved if the artist grasped the principle of weight shift, in which the limbs of the body are seen in relation to the vertical but flexible axis of the spinal column. The understanding that the human figure possesses its own laws of movement was necessary before Greek sculptors would be able to represent the human form in all forms of motion.

The Greek Temple

The first Greek temples, structures that evolved from the sanctuaries built to protect statues dedicated to the gods, were made of wood. Eventually, these architectural forms were constructed of more permanent material such as stone. As with sculpture, early Archaic temples, which tended to be long and narrow, reflected the Greeks' concern for proportion and symmetry, based on their perception of order. In the case of temple design, proportions were based on mathematics.

The architects who devised the form of the Greek temple planned in terms of three basic components: the *platform*, the *column*, and the

entablature (the superstructure, i.e., everything that rested on the columns). The specific proportions for each of these units, as well as the accompanying detail, formed what is called an *order*. The earliest Greek architectural styles were the *Doric order* found in Greece and the *Ionic order* found in the Aegean Islands and Asia Minor. A third order, the *Corinthian*, developed during the fifth century B.C. and was popular during the Roman era.

The Greek Column

Columns, depending upon whether they were of the Doric, Ionic, or Corinthian order, generally consisted of two or three sections: the *shaft*, the *capital*, and, in the case of the Ionic and Corinthian orders, the *base*. The width of the shaft was not constant, but decreased towards the top of the column in order to achieve the effect of a slight curvature. In the Doric order, the top of the shaft had one or more incised horizontal lines that acted as a transitionary device between shaft and capital. The capital, which topped the shaft and upon which the entablature rested, consisted of two elements. The upper section of the capital in all orders was a square block that supported the entablature. In the Doric order, the lower section of the capital was convex; in the Ionic order, the sides were in the shape of a scroll; in the Corinthian order, the form was that of an inverted bell.

The *entablature* consisted of three sections: the *architrave*, supported directly by the columns and, in the case of the Ionic and Corinthian orders, made up of three horizontal bands; the *frieze*, in the Doric order made up of triglyphs and metopes and left open as a surface for reliefs in the Ionic order; and the *cornice*, which formed a triangle enclosing the pediment.

It is likely that the Doric use of triglyphs and metopes was a carryover from the time when temples were constructed of wood, where the *triglyphs* served as vertical beams supporting the cornice above the architrave, and the *metopes* were the equivalent of the open areas between the triglyphs.

The Doric order is heavy in appearance in contrast with the Ionic order, which appears to be much lighter and decorative. This contrast is especially evident in the way the capital is presented; the Doric being severe and plain, the Ionic and Corinthian being very ornamental. Another distinction that may be noted is that during ancient times, the

Doric order was considered to be masculine, and the Ionic, to be feminine in orientation.

Sculptural Relief Decoration

Decoration, in the form of sculptural relief, was generally limited to the frieze and pediment. As with figure sculpture, this ornamentation was highlighted with paint, usually reds and blues. In the Doric order, this ornamentation was usually restricted to the metopes of the pediment, whereas the Ionic order typically utilized the entire frieze.

The Archaic Doric Style of Construction

An example of the Archaic Doric style of construction is the c. 550 B.C. Basilica of Paestum, Italy. Though a *basilica* is actually a type of Roman building, early researchers found this Greek temple's form to be similar, and thus labeled it a basilica. The columns of the Basilica of Paestum seem heavy; their cumbersome capitals support a massive entablature that contributes to the squatlike feeling the columns project. The reason for this sense of mass in the columns may be attributed to the early Doric builders' concern for strength and stability in their construction. In later years, the Doric architects would adjust the proportions of their columns in order to achieve a more refined effect. A step in this direction can be seen in the Temple of Hera (c. 460 B.C.), also found at Paestum. Although the columns are still somewhat unwieldy and close to one another, some refinement in proportion has taken place, and when compared to the Basilica, the Temple of Hera conveys a sense of height and compactness. What is unusual about this temple is that the interior columns that support the roof are higher than the outer columns. According to Greek notions of proportion, because single roof-supporting inner columns (of the massive Doric type) would distort the scale of the temple, a solution was arrived at whereby smaller Doric columns were constructed supporting a stone course with a second set of Doric columns above, supporting the roof. Eventually, Greek architects would simply use Ionic or Corinthian order columns as interior roof supports, because they were taller in relation to their diameters than were the Doric ones.

The Early Ionic Style of Construction

The Treasury of the Siphnians at Delphi (c. 530 B.C.) is a building of the early Ionic order. Instead of Ionic columns, *caryatids*, sculpted

female figures, serve as supports for the entablature. What is typically Ionic about the Treasury of the Siphnians is the unbroken surface of the frieze, filled with ornamental relief sculpture.

The Classical Period

The Classical period of Greek civilization, classical in the sense of the art and literature representing models of excellence, is traditionally seen as beginning with the Persian invasion of Greece in 490 B.C. and ending in 338 B.C. with the reign of Philip II of Macedon. Though during the Persian War Athens and its Acropolis were captured and ransacked in 480 B.C., the final outcome was a Greek victory in which Athens and Sparta played major roles. Athens emerged as the dominant power, and was able to retain that power for a time under the leadership of Pericles. Eventually, however, Athens was defeated by Sparta in the Peloponnesian War, which lasted from 431 to 404 B.C.

Though much Greek literature of this period survives, the same cannot be said of the great art of this era. Written evidence documents visual masterpieces of the fifth century B.C., and while there are Roman copies (whose accuracy in replicating the Greek originals may be questioned), an unfortunate result of these years of unrest is the paucity of original Greek artwork that remains. What did survive, though in ruins, is a significant amount of Greek architecture that reflects the standards of this Classical period. None is a better representation of this time than the Parthenon, a Classical Doric temple, which sits upon the Acropolis overlooking the city of Athens.

Architecture

The Parthenon

To symbolize their power and victory over the Persians, Pericles, head of state between 460 and 429 B.C., and the Athenians exerted monumental efforts to completely rebuild the Acropolis, which had been severely damaged during the Persian War. The Parthenon, dedicated to Athena Parthenos, was designed by the architects Callicrates and Ictinus and followed the form of a *peripteral temple*, in which the structure is surrounded by a single colonnade. Inside, the *cella*, an enclosed alcove central to Classical temples, was separated into two

areas. In the larger area of the enclosure was a forty-foot-tall gold and ivory cult statue of Athena Parthenos, created by the sculptor Phidias. Roof support was provided by a double colonnade. The smaller portion of the cella was to serve as the Treasury of the Delian League and incorporated four single Ionic columns in its design. Egyptian attention in design and decoration had primarily been directed toward the interior of the temples constructed; in Greece the emphasis in embellishment was placed on the exterior. Whereas in Egyptian construction, columns were placed on the inside, the Greeks primarily utilized columns on the outside of their temples as roof supports.

Though our perception of the Doric order is one of severity in its rigid straight lines, a closer examination of the actual structure of the Parthenon reveals very sophisticated subtleties. For example, the *stylobate*, or upper level of the platform upon which the columns rest, though appearing to the naked eye to be perfectly horizontal, is slightly curved. The ends of the long side of the platform are approximately four inches lower than the center; the same holds true for the entablature. The columns, which lean inward slightly (approximately two inches), appear to be of the same diameter and equally spaced around the circumference of the Parthenon. In reality, the columns are closer to one another and thicker as they near the corners of the structure. Though researchers have no doubt that these deviations found in the Parthenon and other temples are intentional, they do dispute their intent. Reasons advanced to account for these deviations in the stated norm range from concerns with drainage and structural settling of the foundation to attempts to integrate the form of the structure more fully into the immediate environment to compensate for the subtle distortions that occur in visual processing. If one accepts the notion that the Greek architects utilized their engineering skills as a means to create a temple that would be seen as an impressive sculptural form, then the latter explanation seems to be the most likely one. Additionally, portions of the structure were painted in order to highlight or define elements that might otherwise be lost to the viewer against a brilliant sky or because they did not stand out on their own.

The Parthenon today is being restored. Although it was built as a Greek temple, it has, during the centuries, also served as a Christian church, a Turkish mosque, and an ammunition storage site. During the

Turkish-Venetian war of the seventeenth century, it was hit by a rocket and further damaged. Little original sculpture remains on the site; the majority of work that once embellished the Parthenon may be seen in London in the British Museum, where it has been since the early nineteenth century.

Phidias, the sculptor of the statue of Athena that was housed in the cella of the Parthenon, is also believed to have designed the pedimental groups and friezes of the temple. At one end of the Parthenon, in the east pediment, was a representation of the birth of Athena; the west end depicted Athena's struggle with Poseidon for the city of Athens. The Phidian style in which the sculptures were designed and executed reflects the attention paid to appearance and typifies the direction of Greek sculpture during this period. The *Three Goddesses*, also known as *The Fates*, from the east pediment illustrates this manner of treatment. The forms of the figures and their gowns seem real, and the effect is accented by the way in which the drapery that envelops them follows the contours of their bodies. Although sculpted from marble, there is the illusion of fabric being draped over and clinging to the human figure; the drapery reveals, rather than conceals, the bodies beneath.

The metopes, the regularly repeated square spaces between the triglyphs on the Doric frieze, were decorated with high-relief pairs of figures, such as Amazons and Greeks, and gods and giants, all engaged in struggle. Running the entire perimeter of the cella's external wall, and seen above eye level by reflected light, was an Ionic frieze of continuous sculpture. The background of the frieze was painted, and the sculpture consisted of figures in procession, possibly representing the Great Panathenaia, a religious festival that included a vast procession from the city to the Parthenon. For the viewer to benefit fully from the effect of the depicted procession, he or she would follow the more than 500-foot-long frieze around the temple. Beginning on the western side of the cella, the observer could view the members of the procession coming together and preparing to set out and then proceeding along, with intermittently spaced marshals guiding horsemen at the turn. On the long sides of the frieze, double lines of figures seemed to advance slowly towards the eastern side of the cella, where seated gods joined Athena in celebrating her festival. The sculpted figures, though not representing particular individuals, are individual in their nature by their stance and dress.

The Propylaea: Entranceway to the Acropolis

When the Parthenon was completed, another project was immediately begun, the Propylaea, or entranceway to the Acropolis. Designed by the architect Mnesicles, the Propylaea consisted of two buildings with Doric facades that were linked by an Ionic colonnade that served as a gate hall. Construction (437–432 B.C.) was interrupted by the Peloponnesian War, and the Propylaea was never completed.

The Temple of Athena Nike (Athena Victory)

The Temple of Athena Nike, also known as Athena Victory, was built between 427 and 424 B.C., and is the oldest existing example of a purely Ionic structure found on the Acropolis. It was through Athens' domination of several cities on the coast of Asia Minor and the islands of the Aegean that the Greeks were exposed to the Ionic style. Though there were several buildings on the Greek mainland that were wholly Ionic in style (such as the Treasuries in Olympia and Delphi), these had been built by Aegean architects, not by mainland Greeks.

The Erechtheum

The last of the buildings constructed on the Acropolis under the auspices of Pericles was the Erechtheum (421–405 B.C.). Like the Temple of Athena Nike, the Erechtheum was of a wholly Ionic design, though because of the Peloponnesian War, it was never completed as planned. Named after a mythic Athenian hero, Erechtheus, the Erechtheum is unusual in that it is asymmetrical and housed a number of shrines. Its south patio, dominated by caryatids, sculpted female figures that serve as supporting columns, is known as the Porch of the Maidens. Earlier caryatids, such as those carved over one hundred years earlier for the Treasury of the Siphnians, had to support the massive superstructure of the entablature, and this overloading was apparent in the stiffness and rigidity of the figures. The architect of the Erechtheum caryatids sought to overcome this problem so that he could create forms that were supportive, yet give the appearance of being real (like the *Three Goddesses* of the east pediment of the Parthenon). This was accomplished by posing the figures in more realistic stances and having them support only an architrave and cornice.

Grave Stelae

Other examples of this natural treatment of the human form can be seen in the *grave stelae* (carved stone grave markers) of the fifth century B.C. Whereas the Egyptian grave monuments celebrated the afterlife, Greek grave monuments and markers stressed life. The grave stela of Hegeso (c. 400 B.C.), found in the Dipylon cemetery and sculpted in low relief, portrays Hegeso, the deceased, gazing at a necklace (which was originally painted on the stela surface) that she has removed from a box held by a servant girl (or possibly a daughter). The contours of the stela are treated as an architectural form that frames the figures within. The chair upon which Hegeso sits is depicted with arching back and legs and acts as a transitionary device between the rigid outer boundary of the stela and the organic forms of the figures within.

Figure Sculpture

Most of the figure sculpture of this time was designed to be seen from a particular vantage point. Polyclitus, a sculptor from the city-state of Argos whose work spanned the period 452–417 B.C., focused his attention on achieving a sense of sculptural unity through the development of a theory, or canon, of bodily proportions, whereby a sculpture could be seen from multiple viewpoints with the same impact that was traditionally achieved from the single designated viewpoint. Polyclitus' works have been lost to us; during periods of war and invasion, bronze statues were melted down for weapons. Barbarians reduced marble works to lime for mortar. In the second century B.C., much of what was left was carried off to Rome. All that remains are written descriptions of some of the works of art and Roman copies, which probably provide little more than an indication of the poses that were popular among the fifth century B.C. Greek sculptors. Nevertheless, the Roman copy of Polyclitus' *Doryphorus*, or *Spear Bearer* (the original is from 450–440 B.C.), does to some degree reflect the original and the artist's success in depicting realistic movement through his canon of proportions. Polyclitus' struggle with proportion and depiction represented a philosophy of maintaining a balance between the traditions of idealism and naturalism. His aim was not to simply duplicate the human figure in stone or bronze, but rather to translate it into a medium while maintaining this synthesis. The figure

of Doryphorus, like the architecture of the Doric order, represents an attempt to balance form and function, and idealism and naturalism, through the use of a formal system, and thereby create visual unity and harmony.

Attention to Naturalism in Painting

Evidence suggests that the attention to naturalism through the modeling of form and the depiction of space and movement was not limited to the efforts of the Greek sculptors of the Classical period but included the painters as well. Unfortunately, we only know of these paintings through the writings of the period; no known originals exist today. Although it is likely that paintings from the Classical period were used as models for some of the wall murals found at Pompeii and were copied in Italy, it is doubtful that these facsimiles are very true to the originals. What does remain, reflecting the painting of the time and the techniques used, is painted Greek pottery, which was used as functional ware and in rituals.

Pottery Painting and Decoration

One of the most popular mural painters of the period was Polygnotos. None of his original works remain, but his style is likely reflected in the Argonaut krater (c. 450 B.C.), attributed to the Niobid Painter. For 200 years, up until the time of Polygnotos, the standard method for representing figures in both Greek vase painting and monumental painting was to arrange them in horizontal bands with their heads at the same level. The decorative painting on the Argonaut krater departs from this tradition radically, with the placement of figures on different planes of the surface. If this method of depiction was an attempt to represent space in terms of foreground and background, however, it was not completely successful because all the figures are still depicted the same size. Another example of a vase painting the style of which was likely influenced by the work of Polygnotos is by Meidias, *Hilaeiria Being Carried Off in a Chariot by Polydeuces.*

The styles of the painters Zeuxis and Parrhasius are thought to be reflected in the treatment of surface decoration on a number of late fifth-century B.C. *lekythoi*, the *lekythos* being a small jug with elongated neck that was used to hold oil and was frequently used in burial rituals.

Figures are defined by the use of minimal, bold brushstrokes to indicate volume and mass.

The Hellenistic Period

The Hellenistic period refers to a time span of some 300 years, beginning with the death of Alexander the Great in 323 B.C., when the empire that he had built through conquest was broken up into separate kingdoms and ruled by his Greek generals as separate states, and ending in the middle of the first century B.C. During this period, the capitals of the kingdoms that formed the Hellenistic world became centers of trade and culture. Among these were Alexandria in Egypt, Antioch in Syria, and Pergamum in Asia Minor. Though Alexander's successors set themselves up as monarchs, the various kingdoms were still united by a common culture and language; the day of the city-state was over.

Sculpture

In sculpture, the Hellenistic era reflects continued interest in naturalism through the refinement of technique and three-dimensional depiction. Considered to be a masterpiece of this age is the *Nike of Samothrace* (c. 200 B.C.), which commemorates a naval battle. Whereas earlier Greek sculpture personified gods and heroes, Hellenistic sculpture was more allegorical and symbolic. *Nike*, or *Victory*, with her wings outswept, seems to lightly touch down upon the prow of a war galleon. The exquisite craftsmanship of this work in marble is nowhere more apparent than in the treatment of the drapery, which billows around Nike's thighs and legs and at the same time is sensuously stretched across her stomach. The sculptor, in so adeptly working the stone to create a subtle range of highlights and shadows, achieves the effect of both strength and elegance.

The *Dying Gaul* (c. 230–220 B.C.) was one of a series of bronze sculptures to commemorate the victory of Attalus I over the Gauls c. 230 B.C. when they attempted to invade the Hellenistic kingdom of Pergamum in northwestern Asia Minor. Although we only know of the *Dying Gaul* from a later Roman copy in marble, its visual impact is still quite great. Here, there is little subtlety to the realism portrayed. The

figure, a Gaul injured in battle with a fatal chest wound, sits supporting himself with one arm, head bent. It is obvious through the gestural pose that the warrior's right arm cannot support his weight for long, just as it is obvious from his wound that he is not long for this life. Yet, even in defeat, the Gaul is instilled with a sense of dignity.

The *Nike of Samothrace*, with its realistic portrayal of flesh and fabric, and the *Dying Gaul*, with its sense of drama and suffering, illustrate two themes representative of the Hellenistic period. The *Aphrodite of Melos* (c. 150 B.C.), better known as the *Venus de Milo*, is another example of the former theme, where the medium, though marble, conveys the sensuous effect of supple, warm flesh.

Another well-known classical work from the Hellenistic period is the dramatic *Laocoön Group* (2nd–1st century B.C.), also referred to as *Laocoön and His Sons*, which makes reference to a celebrated incident in Greek mythology. During the last year of the war between the Greeks and the Trojans, the Greeks constructed a huge wooden horse in which Greek soldiers could be hidden, then presented it to the Trojans at the gates of the city of Troy as a gift to the goddess Athena. Laocoön, a citizen of Troy and a priest of Apollo, suspected the "Greeks bearing gifts" and counseled the citizens of Troy to keep the gates to the city closed to the great wooden horse. Poseidon, the Greek god of the sea, supported the Greeks in their efforts to destroy Troy and sent two great serpents from the sea to strangle Laocoön and his two sons. In the end, the Trojans accepted the gift of the wooden horse and with it the Greek soldiers inside who would burst out and lay waste to the city. The *Laocoön Group* sculpture, by the sculptors Agesander, Athenodorus, and Polydorus, portrays the struggle of Laocoön and his sons with the serpents of Poseidon. The intensity of effort and the expressions on the faces of the figures reflect the Hellenistic artist's interest in arousing reactions in the viewer. Although some researchers consider this work to have been brought to Rome, others suggest that it may have been sculpted in Rome by Greek sculptors.

CHAPTER 7

Roman Art

Chronology

c. 750 B.C.	Rome is founded
509–27 B.C.	**The Roman Republican Period**
c. 500 B.C.	The Roman Republic is established
2nd cent. B.C.	House of Pansa, Pompeii
2nd cent. B.C.	Mosaic, *The Battle of Alexander*, House of the Faun, Pompeii
148 B.C.	Rome annexes Greece
late 2nd cent. B.C.	Temple of Fortuna Virilis, Rome
1st cent. B.C.	Wall painting, a villa at Boscoreale, near Naples

1st cent. B.C.	Pont du Gard, near Nîmes
c. 80 B.C.	Portrait sculpture, *Head of a Roman*
c. 80 B.C.	Sanctuary of Fortuna Primigenia, Praeneste
70–19 B.C.	Virgil, poet
60 B.C.	First Triumvirate
c. 55 B.C.	Portrait sculpture, *Pompey the Great*
52 B.C.	Caesar and Pompey compete for control of Rome
50 B.C.	Villa of the Mysteries, near Pompeii
c. 50 B.C.	*Seated Boxer*
49–44 B.C.	Reign of Julius Caesar
48 B.C.	Caesar defeats Pompey at Pharsalus
48 B.C.	Pompey murdered in Egypt by order of Cleopatra
44 B.C.	Julius Caesar is assassinated
late 1st cent. B.C.	Maison Carree, Nîmes
31 B.C.–A.D. 192	**The Early Imperial Period**
27 B.C.–A.D.14	Augustus rules the Roman Empire
c. 20 B.C.	*Augustus of Primaporta*
c. 13–9 B.C.	Ara Pacis Augustae
A.D. 14	Tiberius succeeds Augustus as emperor
A.D. c. 20	Portrait bust, *Livia*
A.D. 37	Caligula succeeds Tiberius
A.D. 41	Claudius succeeds Caligula
A.D. 54	Nero succeeds Claudius

A.D. 63–79	The Ixion Room, House of the Vettii, Pompeii
A.D. c. 70	Wall painting, *Herakles and Telephos*, Herculaneum
A.D. 72–80	The Colosseum (Flavian Amphitheatre), Rome
A.D. c. 75	Portrait bust, *Vespasian*
A.D. 79	Mt. Vesuvius erupts; Pompeii and Herculaneum are buried
A.D. c. 81	Arch of Titus, Rome
A.D. c. 90	Portrait bust, *Portrait of a Lady*
A.D. 98–117	Trajan's reign
A.D. 106–113	Column of Trajan, Rome
A.D. 117–138	Hadrian's reign
A.D. 118–125	The Pantheon, Rome
A.D. c. 120	Portrait bust, *Hadrian*
A.D. 161–180	Marcus Aurelius' reign
A.D. 165	Bronze statue, *Marcus Aurelius*
A.D. c. 215	Baths of Caracalla, Rome
A.D. c. 215	Portrait sculpture, *Caracalla*
A.D. 248	Rome celebrates its 1000th anniversary
A.D. 284–527	**The Late Imperial Period**
A.D. 284	Diocletian comes to power
A.D. 298–305	The Baths of Diocletian
A.D. c. 305	Sculpture, *The Tetrarchs*
A.D. 306	Constantine comes to power

A.D. 310–320	Basilica of Constantine
A.D. 313	The Edict of Milan legalizes Christianity
A.D. 313–315	Arch of Constantine, Rome
A.D. 320	St. Peter's (original), Vatican Hill
A.D. 330	Constantine moves the capital from Rome to Byzantium

By the second century B.C., Rome was the center of the largest empire the world had yet seen. Through an efficient administrative system, Rome was able to rule economically, politically, and militarily all of Italy; the islands of Corsica, Sardinia, and Sicily; southern France; northern Africa; and Greece. Although the area had seen periods of unrest, the rule of Emperor Augustus (27 B.C.–A.D. 14) initiated a time of relative peace that was to last for over a century. His successors would increase the domain of the Roman Empire so that it encompassed an area that reached from the Euphrates to the Atlantic Ocean and from Scotland to northern Africa.

The awesome power of the Roman Empire was felt from the Mediterranean to the Near East and western Europe. In the visual arts, the Romans borrowed a great deal from the Greeks and other peoples with whom they came in contact and continually struggled to develop a character that could be called Roman. Though Classical forms were utilized and drawn upon, they were used to delineate Roman expressions of interest. The Romans made advances in the areas of architecture and engineering. By using concrete as a binding agent, the Romans were able to create arches and large vaulted spaces that did not rely on internal supports or columns. Though they did not invent either concrete or the arch and vault, by using them together, they revolutionized architectural design by expanding the possibilities.

While it is possible to think in terms of a Roman style of architecture, it is somewhat more difficult to identify a Roman style of art. Though one might simply denote any artwork produced in the Roman Empire as Roman art, this solution does not account for the stylistic differences among the culturally diverse populations that made up the empire, especially since strong Hellenistic traditions persisted in

*Greece and the eastern Mediterranean regions of the Roman Empire.
The Romans were very taken with Greek art and, as early as the third
century B.C., were avid collectors of Greek statuary. After Greece was
annexed into the Roman Empire during the second century B.C., there
was an almost continuous flow of Greek sculpture to the palaces and
public buildings of the Roman Empire. With the growing demand for
"Greek" sculpture and less of original Greek work available, sculptors
began fabricating new pieces to meet current market demands. Little
attention was paid to the originals in terms of material or scale. Many
Greek sculptures that were originally created in bronze were recreated
for the Romans in marble, and required visible armature support for
stability; also the scale of reproductions was altered without hesitation
in order to meet the needs of the buyers.*

The Roman Republican Period

Though the Roman Republic was established in the fifth century
B.C., it was not until after the assassination of Julius Caesar in 44 B.C.
and the collapse of the Republic that a Roman art characteristically
different from late Hellenistic art emerged.

The Greco-Roman Style of Sculpture

After 148 B.C., when Greece was annexed by Rome, a Greco-
Roman style of sculpture may be identified, representing a mixture of
Greek and Roman artistic styles. The *Seated Boxer* (c. 50 B.C.) reflects
this genre, the realism of the figure with his battered face and scars
appealing to the viewer's emotions. Although it is true that the Romans
did not incorporate the Greek sense of idealism into their art, it is also
true that they were attracted to it; much Greek sculpture in bronze and
marble was brought to Rome to decorate palaces and public and private
buildings. As original Greek pieces became more difficult to obtain,
Roman copies were made.

Portrait Sculpture

It was to become a characteristic of Roman art to leave behind the
descriptive sense of the late Hellenistic style and focus even more upon
portrait sculpture as a vehicle for realistically portraying the individual

as a personality. The *Head of a Roman* (c. 80 B.C.) is such a portrait. By dispensing with the notion of an "ideal" of what the individual should look like, the artist could concentrate instead on the particular traits of the person he was to depict. What appears, then, is a faithful recreation of the features of the person being represented. In the portrait sculpture *Pompey the Great* (c. 55 B.C.), the artist seems not only to have recreated the visage of the general, but also to have imbued it with personality and expression. In terms of Roman art, it is perhaps the portrait bust that most represents a Roman style of sculptural form.

Architecture

The Temple of Fortuna Virilis

The Temple of Fortuna Virilis (late second century B.C.) is an example of the *pseudoperipteral temple*, a design favored by Roman builders. Though it is similar in plan to the Greek Ionic peripteral temple, the Temple of Fortuna Virilis is built upon a podium, is of the Corinthian order, and has a cella that is the width of the structure. Though the columns on the porch are freestanding, those on the sides are connected with walls in order to enclose the cella, and are therefore decorative, serving no supportive function. Another example of the Roman pseudoperipteral temple can be found in Nîmes, in southern France. Like the Temple of Fortuna Virilis, Maison Carree, built in the first century B.C., sits upon a podium and has columns on the sides that are purely decorative.

The Sanctuary of Fortuna Primigenia

The Sanctuary of Fortuna Primigenia at Praeneste (c. 80 B.C.) illustrates even further the departure from the Greek style of architecture, as well as a consideration of the relationship between structure and setting. As if growing from the hill behind, the Sanctuary of Fortuna Primigenia has seven terraces that rise to a double-colonnaded terrace containing the temple sanctuary. The manner in which the terraces were designed reflects a plan of strict axial symmetry, with the major visual components of the complex laid out longitudinally.

Engineering Innovations

By using concrete as a binding agent, the Romans were able to create arches and large vaulted spaces that did not rely on internal

supports or columns. Though the Romans did not invent either concrete or the arch and vault, by utilizing them together, they revolutionized the possibilities of architectural design. An example of this engineering skill can be seen in the use of the arch in the construction of the Pont du Gard, near Nîmes in southern France. Built during the first century B.C., this aqueduct is nearly thirty miles long and reflects the Roman sense of proportion, the total height of the structure being six times the width of the upper arches, the eighty-foot central arches being four times the width, and the end arches being three times the width.

The Building of Rome

Though Julius Caesar planned during his reign (49–44 B.C.) to replace the mud-brick buildings of Rome with more imperial structures, it was not until the reign of his heir and great-nephew, Octavius, that this building plan was carried out. When Octavius repelled the armies of Antony and Cleopatra in 31 B.C., he ended a long period of civil war. Three years later, the Roman Senate conferred upon him the name Augustus and declared him the first emperor of Rome, a position he would hold until his death in A.D. 14. Augustus' rule initiated a period of peace that would last for nearly 150 years, during which time he and his successors not only poured resources into the expansion of the Roman Empire, but also created a Rome that would reflect their image of the imperial capital in art and architectural magnificence.

The Early Imperial Period

The cities of Pompeii and Herculaneum, which were covered with lava and ash as a result of the volcanic eruption of Mount Vesuvius in A.D. 79, provide some of the best-preserved extant examples of Roman art reflecting daily life during the early Imperial period, though much of the architecture of Pompeii dates from the Republican period. Both Herculaneum and Pompeii were provincial towns whose arts, with few exceptions, probably did not rival those produced in Rome. The two cities and their citizenry were preserved (literally) in a volcanic shroud for nearly 1600 years until they were discovered in the eighteenth century.

The House of Pansa

Commonfolk such as shopkeepers and artisans lived in simple dwellings, whereas the local upper class lived in elegant comfort, some in homes that rivaled the royal palaces. An example of a dwelling belonging to a patrician in Pompeii is the House of Pansa (second century B.C.). This atrium-style city house abutted the public walkway. Its narrow entrance opened into an atrium that was not entirely enclosed, so that rainwater could be collected in a shallow pool beneath. Small rooms led off the sides of the atrium, beyond which was the *tablinum*, a place where statues and family records were kept. Past the tablinum was a courtyard, to which the family's private rooms opened.

Wall Paintings to Create Illusions of Space

The paintings and mosaics found in the buildings in Pompeii were frequently utilized to create an illusion of increased space within the rooms where they were created. There seem to have been four primary styles of decoration that served to "affect" the spatial qualities of rooms. Though these styles did not originate in Pompeii, many of the finest and best-preserved examples of them are there.

Incrustation Style

The first of these decorative styles is the incrustation style, in which bright-colored panels were rendered upon the walls as a way of breaking up the wall surface.

Architectural Style

The second genre of decoration is the architectural style. Here, the images of architectural facades and structures were depicted so as to give the impression that the room extended beyond the actual plane of the wall. This style can be seen in a first-century B.C. wall painting from a villa at Boscoreale, which is near Naples [see illustration 4]. It illustrates how images of windowsills and columns were painted on the wall in a way that gives the viewer the impression that he is looking out upon a cityscape. Although this second method is convincing in its effect, technically it did not rely upon any formal system of perspective.

An exceptionally well-preserved wall painting is found outside of Pompeii in a country home known as the Villa of the Mysteries. The rite or ritual the painting (c. 50 B.C.) depicts is unknown. The illusion of

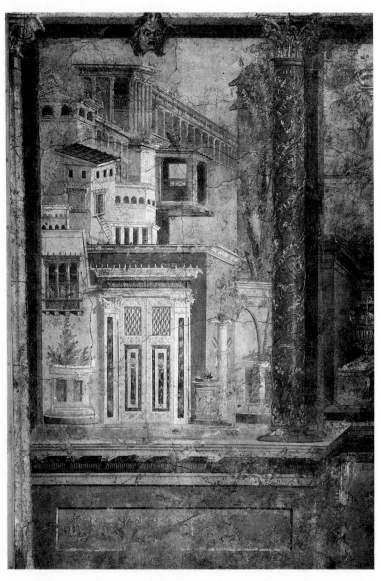

4. Wall painting from a Villa at Boscoreale. Roman, 1st Century B.C. The Metropolitan Museum of Art, Rogers Fund, 1903. (03.14.13)

architectural embellishment that creates a shallow extension of space consists of a ledge painted to provide a "walkway." Upon this walkway are figures engaged in some type of ceremony, possibly a rite of initiation into one of the many mystery cults that had made their way into the Roman Empire. Both mortals and immortals are portrayed, just short of life-size in scale, and it is likely that many of the figures were based upon Hellenistic sculpture. Another thing that is particularly striking about these wall paintings is that the figures gesture and gaze at one another not only within the picture planes of the individual walls, but also towards figures portrayed on other walls within the room.

Ornate Style

The ornate style is the third of the four styles. Although the architectural style strived to create an illusion of looking "through" a wall to some cityscape or scene of nature, the ornate style involved a more fantastic imagery in which architectural elements lost some of their realism and appeared surreal. Many of the scenes depicted were presented almost like pictures hung on the wall.

Intricate Style

The fourth and last style is the intricate style, which was probably influenced by the artisans who were responsible for the theatrical scenery of the time and who had developed their own system of perspective. Here again we see the use of architectural elements to frame scenes that exist "beyond" the literal confines of the room. Rather than relying on the linear perspective of other styles, the intricate style incorporated a perspective that was aerial in nature and made extensive use of light and the dramatic effect that results from such use. The wall painting from the Ixion Room in the House of Vettii (A.D. 63–79) in Pompeii illustrates the application of this style. Here, numerous panels of various sizes depict a wide range of subject matter, ranging from the mythical to landscape to still life.

The Use of Greek Themes and Imagery in Wall Painting

The wall painting *Herakles and Telephos*, from Herculaneum (A.D. 70), illustrates the Roman tendency to borrow Greek themes and imagery. The treatment and portrayal of the figures in the painting, which shows Herakles finding the child Telephos in Arcadia, suggest that the

models for the various figures were copied from one or more earlier sources. This can be seen in the way that the allegorical form of Arcadia is depicted in relation to Herakles; though he is in the foreground and she is in the middle ground, she is represented as larger. The manner in which these two figures are painted also differs greatly; Arcadia bears the characteristics of a piece of sculpture, whereas Herakles reflects the mode of pictorial illusionism. The work comes just short of appearing like a collage, in which the different elements of the composition have been cut out of or lifted from various paintings and pasted together to form a new image.

Floor Mosaics

In addition to decorating the walls of their buildings, the Romans often adorned their floors, generally with mosaics. What is significant about these mosaics is the painterly fashion in which the mosaicists created their images; that is, by incorporating aspects of shading, modeling, and texture. To achieve these effects, very small *tesserae* were used. One of the best-known examples of this mosaic method is *The Battle of Alexander* (second century B.C.), from the House of the Faun in Pompeii. Although it is probably more Greek than Roman, its quality of realism is uniquely Roman. Through the use of light and shading, the figures not only appear as solid beings but also seem to move through the space depicted.

Architecture

The Colosseum of Rome

In Rome, one of the most imposing structures built during the early Imperial period was the Colosseum (A.D. 72–80), also known as the Flavian Amphitheatre. Its construction was begun during the reign of Vespasian, the first of the Flavian emperors, and was completed by his successor, Titus. Although the structure and form of the "theatre" itself was not new, the construction of an oval arena enclosed between two facing theatres was uniquely Roman.

The Colosseum is 615 feet long and 510 feet wide; the outer walls are 100 feet tall, with metal clamps holding the blocks of stone together. The structure, more than three stories high, consists of arches enframed by engaged columns and entablatures. The design of each story reflects

a different order; the first Doric, the second Ionic, and the third Corinthian. Although the use of the various orders had little to do with actual structural support, they do have an aesthetic function in the way that they integrate the components of the surface by rhythmic horizontal and vertical repetition. This vertical sequencing of Doric–Ionic–Corinthian orders reflects the Roman model for buildings that were more than one story high and is based upon the visual proportions of the various orders. Because the Doric order was the heaviest in appearance, and therefore would be able to bear the greatest load, it was used on the ground level; the Corinthian order, visually the lightest, was placed on the upper level.

Given the Colosseum's seating capacity of over 45,000, the architects were faced with the problem of how to facilitate the efficient entrance and exit of so many people. The solution, similar in design to today's football stadiums, was the creation of multiple corridors and stairways leading from the steep rows of seats on the various levels to ground level, with its many arched openings. Below ground was another world, with quarters for gladiators, rooms of props and equipment for spectacles, and holding pens for animals and men and women who were to be part of the "entertainment" for which the Colosseum is infamous.

The Pantheon

Another symbol of Roman architecture found in Rome was the Pantheon (A.D. 118–125), built by Emperor Hadrian. Whereas the interior space is sublime, the exterior is decidedly simple and plain in comparison. The Pantheon consists of two major sections: a rectangular temple-front portico with huge granite columns and an imposing domed rotunda. Although the visual effect of the juxtaposition of these two diverse elements may seem awkward to us today, it would not have seemed so to people approaching the Pantheon in A.D. 125, who would have come to the building by way of a colonnaded court that would have hidden all but the portico. When the Pantheon was built, an older basilica partially concealed its back and sides from the approaching viewer. Additionally, because the ground was at a lower level at that time, a visitor had to climb five steps to enter the portico. Inside, the domed rotunda was over 140 feet in diameter, and at its highest point, the distance from the floor to the ceiling equaled that diameter. In the center of the dome was the oculus, a round opening thirty feet wide, through which light entered the interior of the rotunda. The inner surface of the dome was coffered in five circular bands in order to create an

illusion of rectangular recessed panels. This treatment was not only decorative, it also reduced the weight and mass of the dome structure.

The Baths of Caracalla

As mentioned earlier, the Roman innovative use of the arch, the vault, and the dome revolutionized architectural design. With these elements, it was possible to enclose vast areas of space without the internal supports that had been necessary up until this time. The design of the Baths of Caracalla in Rome (A.D. c. 215), probably the largest of the Roman *thermae* at the time, reflected this method of vaulting as a means for enclosing immense spaces. The central structure, which housed the baths, had ceilinged vaults 90 feet high that canopied a space approximately 720 feet long and 360 feet wide. The baths, with temperatures ranging from hot to cold, could accommodate more than 1500 individuals. The fifty-acre compound provided for both physical and intellectual endeavor, for along with the baths and lounges, there were libraries, shops, restaurants, and gymnasia.

Commemorative Monuments

The Ara Pacis Augustae

The Ara Pacis Augustae (c. 13–9 B.C.), the Altar of Augustan Peace, was built to celebrate the return of Augustus to Rome in 13 B.C. and the end of the civil wars that had plagued the Republic. The form of the monument itself is Greek; the enclosed altar sits upon a podium, its interior and exterior surfaces adorned with relief sculpture. One, the *Tellus Relief*, which celebrates the Augustan peace, portrays Tellus, the Roman earth mother, in the center of the panel surrounded by figures representing the various elements. Other panels, most likely recording the actual dedication of the monument, depict a procession of senators and Augustus and his family. The figures represented are both real and ideal, yet they are recognizable as individuals. A sense of space, shallow though it is in relief sculpture, is achieved by portraying figures that are closer to the viewer in higher relief than figures that are farther away. Though the manner in which the figures are represented is Hellenistic and the style in which the drapery is depicted is Classical, the subject itself is clearly Roman. It is the purpose—the recording and celebrating of a specific event in history—that reflects the Roman attention to fact and reality.

The Imperial Triumphant Arch

The Arch of Titus (A.D. c. 81) is an excellent example of a popular type of commemorative monument, the imperial triumphant arch. These freestanding, decorative structures, originally based on the design of a monumental city gate, served no function other than to laud the accomplishments of the empire or a particular emperor. They were erected as early as the second century B.C. The triumphant arch provided a focus for the triumphal procession entering the forum. The Arch of Titus is located on the Via Sacra at the entrance to the Roman Forum. The arch is flanked by imposing support piers with Corinthian columns, which are decorative and serve no supportive function. Above the arch, on the superstructure, is a commemorative inscription that reads: "The Roman Senate and People to Deified Titus, Vespasian Augustus, Son of Deified Vespasian." The lettering, though simple in form, followed the same laws of proportion that governed Roman architectural design.

In the *spandrils*, the spaces between the exterior curve of the arch and the enclosing right angles of the piers, are relief figures of *Winged Victory*. The inner passageway of the arch consists of panels sculpted in relief, depicting Titus' victorious return to Rome with the spoils of war taken from the Temple in Jerusalem, following the Roman conquest of Jerusalem, which ended the Jewish wars of A.D. 66–71. Though damaged, the sculptural reliefs still convey a strong sense of movement in space. Whereas the sculptor of the Ara Pacis panels achieved some degree of spacial depth, the creator of the panels of the Arch of Titus went much further through the use of overlapping forms and the way in which animals and men are represented. The range of sculpted relief, from low to very high, produces a real sense of depth that is accented by the shadows cast by the high-relief figures. The manner in which the events portrayed in the panels are depicted does not attempt to mythologize the incident but rather to record the events as factually as possible.

The Commemorative Column

Commemorative columns were another means by which historical events and persons were monumentally honored in public. The Column of Trajan (A.D. 106–113) was perhaps the first of these commemorative columns. Designed by Trajan's architect, Apollodorus of Damascus, it was built in front of the Temple of the Trajanic Gods in Rome. The

column itself is over 120 feet tall and rests upon a square base that served as a mausoleum for Trajan's ashes. Originally, the column was topped with a statue of Trajan, but sometime during the Middle Ages the portrait sculpture of Trajan was removed, and in the sixteenth century, a statue of St. Peter was put in its place. The column is covered with a 600-foot-long band of marble sculpted relief that winds around the column depicting, in 150 episodes, Trajan's military campaigns in Dacia. There is a great amount of imagery, in which over 2500 figures are incorporated into the narrative. Because the guiding principle behind this work was the portrayal of how and when specific events occurred rather than how things would have to be depicted in order for them to *appear* real, much of the illusion of space and proportion achieved in the archway reliefs of the Arch of Titus was sacrificed here. Additionally, the degree of depth of the relief is rather shallow so as to avoid creating shadows that would make it more difficult for the viewer below to make out the forms. Whereas the reliefs of the Arch of Titus represent an attempt to depict an event as it occurred in a fashion (equally realistic) that made it look real, the reliefs of the Column of Trajan reflect an approach that places more emphasis upon the account being portrayed than upon a "true" manner of depiction.

The Portrait Bust

Much of the Roman portrait sculpture of the early Imperial period was created by simply affixing a portrait head to a fully sculpted body, a reproduction of a Greek original picked out from a sculptor's "showroom" that housed ready-to-go headless figures of all shapes and sizes in a wide variety of poses. These "ready-mades" were utilized to commemorate individuals not only from the common citizenry, but from the ruling class as well. The *Augustus of Primaporta* (c. 20 B.C.) is an example of such a portrait sculpture, though its visual impact rivals that of an original work. Polyclitus' *Doryphorus,* a sculpture that represented the Greek ideal of male proportion, was the likely model for the figure of *Augustus of Primaporta*. Though slight changes were made in the pose—the left arm was lowered somewhat, the right arm was raised as if addressing an audience, and a general's uniform was added—the proportion and handling of the figure still reflect Polyclitus' canon of proportion as manifested in *Doryphorus*.

However, it was in the realm of portrait busts that Roman art excelled. During the various periods of the Roman Empire, common citizens were generally depicted realistically, whereas portrait busts of the ruling class reflected the style of the period, fluctuating between realism and idealism. The sculptures of *Augustus* (c. 20 B.C.), *Augustus of Primaporta* (c. 20 B.C.), and *Livia* (A.D. c. 20) illustrate the subtle Roman mixture of realism and Classical idealism. In the case of *Augustus*, the hair, though idealized in the way it is sculpted, does not take away from his likeness. *Livia*, who was Augustus' second wife and the mother of Tiberias, is represented elegantly, yet realistically.

The portrait bust of *Vespasian* (A.D. c. 75), who followed Nero as emperor of Rome, does not seem to represent the quality of subtlety found in the portrait busts of *Augustus* and *Livia*. Vespasian the military veteran is portrayed with all the directness of a general who was known for his military prowess and straightforward manner.

One of the finest examples of a portrait bust is the *Portrait Bust of a Lady* (A.D. c. 90). We do not know who the sculpture is supposed to represent, but from the manner in which her hair is styled and the elegance of her pose, we can probably safely assume that she was a member of the upper class. The elaborate texture of her hair, styled as it is, contrasts greatly with the softness of her skin. Her expression is vague, and it is left to the viewer to interpret its meaning.

Like the *Portrait Bust of a Lady*, the portrait *Hadrian* (A.D. c. 120) presents a visage with an expression that is nebulous. What is striking about the bust is the Greek styling of the hair and the Greek beard; emperors in earlier portraits were clean-shaven. This affectation of the beard will be seen on many of the emperors who followed Hadrian.

One of the last emperors of a stable Roman Empire was Marcus Aurelius. The magnificent bronze statue *Marcus Aurelius* (A.D. 165) showing him sitting upon a war horse can be found on the Capitoline Hill in Rome. The expression on the face of his mount is one of excitement at being restrained for what was likely a parade before the legions or the people of Rome. The expression on the face of Marcus Aurelius is one of meditative calm.

In contrast to the benign image of Marcus Aurelius is the portrait sculpture of Caracalla (A.D. c. 215), son of Septimus Severus. Caracalla, a brutal and violent man, reigned for a short time early in the second century A.D., and his portrait shows his cruel personality. Soon after the

reign of Caracalla, during a period of some fifty years or so, at least twenty-one emperors came and went. These rulers have come to be known as the "barracks emperors" because, rather than being elected to office by the Senate, they were put on the throne by various legions of the army and then were deposed (usually through assassination) by other legions of the army. Suffice to say, during the brief reigns of these emperors (averaging three years or less), their attention and energies were spent more on survival than on encouraging artistic expression.

The Late Imperial Period

Conditions of instability continued until A.D. 284, when Diocletian came to power. At this time, there was unrest within the empire, and its borders were being challenged from without. To achieve some sense of control and stability, Diocletian instituted a new form of rule that involved the co-ruling of the empire by two emperors, himself and Maximian, each with the rank of augustus, where one would govern the east, the other the west. Additionally, each augustus would have an assistant, or caesar, to help rule. Though this system of government, called the *tetrarchy* (government by four persons ruling jointly), did restore some order to the empire, Diocletian's solution of ruling the empire through a shared emperorship established a new precedent that would have serious ramifications in the years to come.

The Baths of Diocletian

One manner in which Diocletian demonstrated his imperial power was in the building of the Baths of Diocletian (A.D. 298–305). An example of its monumental scale may be seen in the tepidarium (warm bath room), which was almost twice as large as the one found in the Baths of Caracalla. Here, the vault spanned a space of 200 feet by 80 feet. Another notable project of Diocletian was his ten-acre fortified palace at Spalato on the Dalmatian coast (now Yugoslavia) in A.D. 300.

The Tetrarchs

The Tetrarchs (A.D. c. 305), a sculpture from the eastern provinces, depicts the four co-rulers of the Roman Empire. They are portrayed

standing close to one another, embracing each other as they symbolically hope to embrace the empire. What is striking about the work is its style. The advances that had been made up to this point in proportion and figure depiction seem to have been ignored. The figures are not realistic, nor idealistic. The faces are like masks, bearing no resemblance to the individuals being portrayed, and the treatment of the drapery is minimal and unconvincing. In terms of technical skill and presentation, the sculpture's style seems less Roman and closer to that of the earlier Greek period.

Constantine and Constantinople

In A.D. 306, Constantine came to power, revoked the governmental changes instituted by Diocletian, and asserted himself as the sole imperial ruler. Additionally, whereas Rome had for hundreds of years been the center of power in the Roman Empire, Constantine decided to create a new city to be named after him—Constantinople—which resulted in a shift of the power base from Rome east to Constantinople (now Istanbul, Turkey). This eastern domain of the Roman Empire would later be known as Byzantium.

The Arch of Constantine

The Arch of Constantine (A.D. 313–315) in Rome commemorated Constantine's assumption of sole power of the empire. Though the design of the arch itself is traditionally Roman, the embellishment is borrowed from the decoration of monuments of such earlier emperors as Trajan, Hadrian, and Marcus Aurelius. For example, on each side of the arch are two circular panels depicting, among other things, a boar hunt and a sacrifice to the god Apollo. The style of relief of these circular panels, or *roundels*, called the *Hadrianic Medallions*, is distinctly Hellenistic in the naturalistic treatment of the figures represented. Beneath the roundels is a frieze with a relief that portrays Constantine making a speech. The pose of the relief is frontal, with ill-proportioned figures in rigid stances, little sense of space and depth, and no sense of movement. The artistic quality of the frieze relief seems crude and lacking in technical skill, especially in comparison with the *Hadrianic Medallions*.

The Basilica of Constantine

Though Constantine was to move the power center of the Roman Empire east, he still left his mark on Rome by constructing some notable structures. Among them was the Basilica of Constantine (A.D. 310–320), considered to be the last great Roman building built in Rome. When completed, it was 300 feet long and 215 feet wide, with a ceiling vault over 100 feet high. The vaults were coffered, and the interior was decorated with marble, stucco, and mosaics. In the western *apse*, a semicircular recess in the wall, was a thirty-foot-tall sculpture of Emperor Constantine, in a seated position. All that remains of this sculpture today is the head, which itself weighs more than eight tons and is over eight feet high. Whereas it was a characteristic of earlier portrait busts to be sculpted in a style that could be described as realistic or idealistic (or somewhere in between), the bust of Constantine reflects little of the personality of Constantine himself. Like the earlier sculpture of the Greek Archaic period, the pose is frontal, and the effect is one of rank rather than person.

CHAPTER 8

Early Christian and Byzantine Art

Chronology

1st–6th cent. A.D.	**Early Christian Art**
2nd cent. A.D.	Catacomb arch painting, *The Breaking of Bread*, Rome
4th cent. A.D.	Catacomb ceiling painting, *Dome of Heaven*, Rome
A.D. 313	Christianity is legalized in Rome (Edict of Milan)
A.D. 320	St. Peter's (original), Vatican Hill
mid-4th cent. A.D.	Church of Santa Costanza, Rome

A.D. c. 359	Sarcophagus of Junius Bassus, Rome
late 4th cent. A.D.	The Good Shepherd sarcophagus of Praetextus
A.D. c. 430	Mosaic, *The Parting of Lot and Abraham*, Santa Maria Maggiore, Rome
early 6th cent. A.D.	Ivory leaf, *The Archangel Michael*
A.D. 526–547	Church of San Vitale, Ravenna
A.D. 527–565	**The First Golden Age of Byzantium, Reign of Justinian**
A.D. 532–537	Hagia Sophia, Constantinople
A.D. 610	Sergius becomes patriarch of Constantinople
A.D. 630	Muhammed captures Mecca
A.D. 700	Greek, rather than Latin, becomes the official language of the Eastern Roman Empire
A.D. 730	The Byzantine emperor is excommunicated by Pope Gregory II
10th and 11th cent.	**The Second Golden Age of Byzantium**
early 10th cent.	Illuminated page, *David Composing the Psalms*, from the *Paris Psalter*
11th cent.	Wall mosaic, *The Crucifixion*, Daphnē, Greece
1020	Church of the Katholikon, Greece
1040	Church of Theotokos, Greece
begun 1063	St. Mark's, Venice
1204	Constantinople is sacked by Fourth Crusade

1453	Constantinople is conquered by Ottoman Turks
1482–1490	Cathedral of the Annunciation, Moscow
1554–1560	Cathedral of St. Basil, Moscow

In A.D. 330, the seat of power of the Roman Empire was formally transferred from Rome to the site of the ancient Greek settlement of Byzantium, which was renamed Constantinople, after the emperor who initiated the move. This relocation was to have a profound effect on the course of history—politically, religiously, and artistically. Political separation of the Roman Empire into eastern and western segments was complete before the end of the fourth century.

Though it was during the rule of Constantine that Christianity was legalized and then declared the state religion (A.D. 313), disputes over supremacy and doctrine between the bishop of Rome and the patriarch of Constantinople led to the splitting of the Christian church into two factions: the Catholic church in the Western Empire and the Orthodox church in the Eastern Empire. While the Roman Catholic church held to its independence from secular control, the Orthodox church retained its connection with the state through the person of the emperor, who represented both the secular and religious domains and had the power to appoint the patriarch of Constantinople.

Eventually, the artistic expressions of the West and the East diverged into what is now referred to as Early Christian and Byzantine art. However, only the latter may be discussed in terms of a particular style. The term Early Christian art *is used more aptly to describe specific objects with regard to their function (or at times, subject) than to indicate their style; it refers to those works created by or for Christians prior to the separation of the Catholic and Orthodox churches from one another. Stylistically, much Early Christian artwork was indistinguishable from the secular artwork of the same period, except in terms of the nature of the subject matter portrayed. As church rituals evolved, religious objects were developed by artisans to meet the increasingly complex needs of Christian ritual in both the East and the West. Many of the images and symbols that have come to be associated with*

Christianity were derived from pagan themes seen in the artwork of the cultures that surrounded and coexisted with the early Christians.

After Christianity became the official state religion of the Empire and adherents could gather publicly in prayer, churches were built as public sites for worship. Though the rectangular basilica design became the preferred configuration for churches in the Catholic western realm, in the Byzantine East, the circular-domed church, probably inspired by the Pantheon, was the popular style.

Early Christian Art

Early Christian art created between the first and sixth centuries A.D. is not easily distinguishable from the contemporary secular art of the period in a particular stylistic sense as much as in terms of subject matter. In fact, much of the artwork identified as Early Christian was derived from themes represented in the pagan artwork of the surrounding culture. The use of the shepherd and the lamb as symbols of Christ is an example of Early Christian work that borrowed imagery from the Classical period. Other works were symbolic as well, such as those that incorporated into their design the letters *Chi-Rho*, the first two Greek letters of *Christos*.

Catacomb Paintings

The earliest examples of Early Christian art that exist today are found in the catacombs of Rome. This underground cemetery, with as many as five levels of galleries, was the final resting place for several million Christian dead between the second and fifth centuries. Individuals were buried in shelflike openings called *loculi*, which were cut into the walls of the galleries. However, it is within the small chapel rooms (*cubicula*) cut out of the walls, on the ceilings and arches, that a number of Early Christian paintings are found. Much of the subject matter depicted is based upon the Old Testament, although there are also examples with events from the Gospels. *The Breaking of Bread*, a second-century painting on the arch of the Catacomb of Priscilla, portrays men and women sitting at a table set with wine and bread. A fourth-century ceiling painting in the Catacomb of Saint Pietro and Saint Marcellino is done within a circle motif, symbolizing the Dome

of Heaven, with the image of the Good Shepherd as Jesus in the middle. The symbol of the Christian faith, a cross, radiates from the center as well and leads the viewer's eye to scenes from the Old Testament story of Jonah.

It is likely that the catacomb paintings were done quickly. The conditions under which the catacomb painter worked probably included poor lighting, decaying bodies, and cramped, awkward spaces. The better paintings were probably the work of professional artists who may or may not have been Christians.

St. Peter's

Until Christianity was legalized in the Roman Empire, it is likely that worship took place in private homes. When Christianity became the official state religion, buildings based upon the Roman basilica were built as places of worship. Under the auspices of Constantine, the original St. Peter's was built during the second decade of the fourth century on Vatican Hill in Rome on the traditional site of St. Peter's tomb. Conjecture concerning the design of the old St. Peter's is based upon old drawings as well as on excavations beneath the present-day St. Peter's, which sits on the same site.

St. Peter's overall form was rectangular, and it rested upon a stepped podium, typical of earlier Roman temples. Though the entrance to the traditional Roman basilica was on the long side of the building, in the Christian church it was moved to the short side. Additionally, unlike the large Roman structures with concrete vaulted arches and ceilings, St. Peter's was built with a wooden-timbered roof. One entered the church by proceeding through an open colonnaded *atrium*, or patio, to the *narthex*, a vestibule through which one passed to enter the nave of the church. When standing at the entrance to the *nave*, the long central hall of the church, one could view the aisles, the large wall paintings of biblical scenes, and the columns topped with a horizontal *entablature* that flanked the nave for its entire length. At the far end of the nave, directly opposite the entrance, was a central *apse*. Researchers have found evidence to suggest that, at some point, the rear wall and the apse were moved back in order to create a *transept*, an area that crosses at right angles to the nave between the nave and the apse, which could accommodate a larger congregation of worshippers.

The Church of Santa Costanza

Though the rectangular basilica design was to become the preferred configuration for churches in the Catholic western realm, it was not the only one used by the Early Christians. Another popular style, probably inspired by the Pantheon, was the *circular-domed church*, which became very popular in the Byzantine East. The Church of Santa Costanza in Rome is an example of such a structure. Built around the middle of the fourth century, its original purpose was to serve as the tomb for Constantia, Constantine's daughter. Later, it was converted to a Christian church, the Church of Santa Costanza. The domed ceiling was supported by a circle of twelve pairs of freestanding granite columns that were topped with Corinthian capitals. These columns, away from the outer walls, allowed sufficient space for a walkway, or *ambulatory*, which had a vaulted ceiling decorated with geometric designs and naturalistically depicted greenery.

Painted Murals and Wall Mosaics

The great wall surfaces of the Christian churches were covered with painted murals and mosaics. The use of mosaics predated the time of the Early Christians—the Greeks and the Romans used small squares of marble called *tesserae* that reflected the light. Early Christian masters made extensive use of the media in the form of tesserae of colored glass. Whereas the Roman mural painters developed techniques of visual illusion to create a sense of space upon a flat surface, the Early Christian mosaic artists sought to create the illusion of an ethereal world upon the wall surface.

The mosaic *The Parting of Lot and Abraham* (A.D. c. 430) found in Santa Maria Maggiore in Rome not only illustrates the combining of the traditional Roman naturalistic style with the new symbolism of Christianity, but also incorporates a particular visual device that later would be associated with Christian art, that of gesture and head clustering. The image depicted in this mosaic represents clearly the Old Testament story of Lot's decision to take his family to the city of Sodom. The figures, which are placed in the foreground, are modeled to give them some sense of mass, but there is little depiction of actual space within the picture plane other than through the overlapping of figures.

Illuminated Manuscripts

Another medium that is worthy of note is the illuminated manuscript, by no means as available to the masses of the period as mechanically reproduced books are to us in the twentieth century. These hand-copied editions consisted of *vellum* (veal skin) and *parchment* (lamb skin), were bound along one side, and were somewhat more durable than the traditional *papyrus* scrolls of earlier times. Images on papyrus scrolls were usually line drawings, since the act of rolling and unrolling them over time would have caused layers of pigment to crack and peel. With the advent of flat-bound codices of vellum and parchment, it was possible to incorporate colors into the imagery portrayed. As a means of communication and a teaching tool, the pictorial images were nearly as valuable as the text upon which they were based.

Relief Sculpture Decoration on Sarcophagi

Other examples of the development of Early Christian art can be seen in the relief sculpture found on sarcophagi. The Early Christian theologians interpreted the biblical prohibition concerning the creation of graven images to refer to the life-size or larger than life-size sculptures found in pagan temples. To avoid any association with idol worship, early sculptural work did not include large-scale statuary or relief that involved much spatial depth.

The carvings on the Sarcophagus of Junius Bassus (A.D. c. 359) from the Grotto of St. Peter's in Rome, though Classical in style and in depiction, are similar to those found beneath the *Hadrianic Medallions* on the Arch of Constantine in their frontal positioning, nonclassical proportions, and stiffness. There are two levels of bands containing a series of scenes from the Old and New Testaments; the scenes are separated by columns. In the center of each band is a scene depicting Christ. In the upper band, he is portrayed upon a throne with St. Peter on one side and St. Paul on the other, with his feet resting on a canopy over the figure of the Roman god of the sky. In the lower band, Christ is seen entering Jerusalem on Palm Sunday. It is interesting to note that Christ is represented without a beard, wearing drapery in the Greek, not the Roman, fashion.

A slightly later example from the end of the fourth century is the Good Shepherd Sarcophagus of Praetextus, which illustrates the con-

tinued development of this style as well as the manner in which pagan themes were redefined in Christian terms. Here again, the figures represented are posed frontally, lack classical proportion, and are carved in low relief so that they appear more as a pattern of decoration than as individuals in a narrative. In this case, the Good Shepherd, representing Jesus, is bearded, and cupid figures, which in later imagery will develop into cherubs, work a wine press, producing wine that originally was symbolic of Bacchus, but now connotes the blood of Christ.

An Ivory Leaf in the Classical Style

An ivory leaf from an early sixth-century diptych from the Eastern Empire, *The Archangel Michael*, reflects the Christian use of certain aspects of the Classical style. St. Michael, as portrayed here, suggests the Greco-Roman *Victories* in the manner in which his face, wings, and drapery are depicted. What the work does not incorporate from earlier times is the naturalistic treatment that typifies Roman sculpture. This can be seen, for example, in the way the architecture behind the figure has been flattened out, functioning ornamentally and symbolically rather than spatially.

Byzantine Art

The First Golden Age

It is difficult to speak of a Byzantine art distinctly different from Early Christian art until the period of Justinian's reign, known as the First Golden Age, in the sixth century (527–565). During this time, Constantinople not only regained its position as the political center of the empire, but established itself as the artistic center as well.

Some of the finest extant examples of Byzantine architecture and art are found in Ravenna, Italy, where, in 539, Emperor Justinian's general, Belsarius, successfully recaptured the area and thus provided a base of power for the Eastern Empire in Italy. Ravenna served as the seat of power for its Byzantine governors for two centuries, and its art and architecture exemplify the Byzantine style as accurately as that of Constantinople.

The Church of San Vitale

The Church of San Vitale (526–547), in Ravenna, is of a style that was popular in Constantinople. Though vaguely similar in plan to the mid-fourth-century Santa Constanza in Rome, from which it likely evolved, it is larger and more spacious and has a domed center built into its octagonal design. On the eastern side of the building, possibly as a carryover from the rectangular basilica design, there is an apse and a cross-vaulted area that open up to a central space defined by eight large supporting pillars with concave niches in between. These columned "hollows" allow access to the outer aisle (ambulatory), which has a second story that was reserved for women. Toward the west, there is a narthex that tends to create a sense of imbalance in the schematic design of San Vitale; the reasons for its asymmetrical placement are not fully understood.

The Mosaic Murals of San Vitale

In addition to its layout, its mosaics strongly associate San Vitale with the Byzantine Empire. In the center of the apse is a depiction of a beardless Christ wearing the purple robes of an emperor, seated upon the orb of the world, flanked by two angels. The furthermost figure on the right is Bishop Ecclesius, who founded the church, and he holds in his hands a model of San Vitale. On the far left is the figure of St. Vitalis, accepting a crown or wreath from Christ. The only type of communication between the figures is gestural, for they face the viewer frontally.

On one wall of the apse is a mosaic of the Byzantine emperor Justinian with his attendants bringing forth the sacraments of the Eucharist. In the middle is Justinian, wearing a robe of imperial purple, carrying a container that holds the bread. On the other wall of the apse, his empress Theodora is portrayed carrying a golden cup that holds the wine. Along with Justinian are court and church officials, including to his left, Bishop Maximianus, his name labeled above him, and to his right, soldiers, one of whom bears a war shield upon which is emblazened the *Chi-Rho* monogram of Christ. The images of Justinian and Theodora have both political and religious overtones. Justinian, emperor of the Byzantine Empire, is depicted with a halo, implying his authority in the realm of the spiritual as well as the political. The empress's robe is decorated with an image of the three Wise Men bringing offerings to the newborn Jesus and Mary. The emperor is

accompanied by twelve associates, possibly representing the apostles in number. Some researchers suggest that here a visual analogy is being presented between Jesus and Mary, and Justinian and Theodora.

These intricate mosaics seem particularly suited to the ambiance created within San Vitale. The colors of the tesserae—gold, green, blue, and white, with highlights of violet and crimson—are vivid. The figures depicted are tall and slender. The tall, slender figures face forward, staring out at the viewer with prominent eyes. Only the most important members of the two groups bear a trace of portraiture. Here, in these mosaics, there is no sense of movement or time, and little sense of earthly space. Small visual contradictions invalidate the viewer's initial perception that these are figures standing in temporal space. For example, though Justinian's cloak and the vessel he carries are in front of Bishop Maximianus, leading one to believe that he is positioned closer to the viewer than the bishop, his feet are behind the bishop's feet, a visual contradiction. Additionally, though the scene portrayed is of a procession being led by the acolyte carrying the censer, any sense of implied movement to the right is lost because of the way in which the figures are positioned and staring straight out from the picture plane.

Hagia Sophia, the Church of Holy Wisdom

Today, in Constantinople, there are few remnants of the buildings erected during the reigns of Constantine and Justinian. A notable exception is Hagia Sophia, the Church of Holy Wisdom (A.D. 532–537), which was built under the auspices of Emperor Justinian as a symbol of his power and of a revitalized Byzantine Empire. After the Ottoman conquest of the mid-fifteenth century, it was converted to function as an Islamic mosque. Considered to be a masterpiece during Justinian's age, it remains an impressive structure even by today's standards, and now serves as a museum.

The architects of Hagia Sophia, Isodorus of Miletus and Anthemius of Tralles, were mathematicians and in designing the church they applied their craft to the creation of a structure 240 feet by 270 feet, with a crown 180 feet above ground level and a dome over 100 feet in diameter. From the outside, the focal point of the building is the massive dome, though today there are architectural elements such as buttresses and Turkish minarets that were not original to the structure, but were added in later years. Inside, the nave is dominated by a central square

space that is canopied by the dome. At both ends of the nave there are half-domes with arcaded niches.

Like earlier churches discussed, Hagia Sophia's exterior is decidedly plain and unadorned. Its basic design incorporates the longitudinal axis of the Early Christian basilica of the Western Empire and the central plan of the domed churches of the Eastern Empire.

Around the base of the dome are windows—forty in all—which create an illusion of weightlessness and allow light to pour into the nave. Numerous openings in the nave walls seem to reduce the mass of the structure even more. One is struck by the contrast between the unconcealed weight of the unadorned outer structure of the building and its inner monumental space, which seems to lack an equivalent mass. Unlike the dome of the Roman Pantheon, which sits upon a drum supported by weight-bearing walls and columns, the dome of Hagia Sophia rests upon four *pendentives*, archlike in appearance, which spring from four massive piers. This method of *pendentive fabrication*, developed in the Near East and perfected by Byzantine architects to allow for the covering of vast areas of space, was probably Byzantium's most important contribution to architectural engineering. Up until this time, it was assumed that domes had to be supported by circular bases. It was the architects of Hagia Sophia who were able to develop a means for placing a circular dome above a square space.

Unlike the Romans who used concrete extensively in their constructions, the Byzantine builders of Hagia Sophia utilized squared stone to erect the supporting piers. Since the walls did not have to bear the weight of the dome, they could be built of brick set in mortar. The decision to brick the roof was not an entirely successful one, as it collapsed in 558 and took five years to replace. The buttresses, added later, were an attempt to further stabilize the structure.

The Trullan Council

Though much Early Christian art was symbolic and allegorical, there were those who felt that the biblical prohibition against graven images should not apply to representations of Jesus, Mary, and the Apostles. However, in 692 the Trullan Council of the Church ruled that the "good shepherd" metaphor for Jesus need not be the only means of representing him. This ruling brought about a revitalization of the naturalistic style of depiction, as seen in a panel painting *The Virgin and Child Enthroned Between St. Theodore and St. George*. Here, especially

in the treatment of the heads of Mary, the child Jesus, and the two saints, can be seen the style of modeling that typified earlier periods when the depiction of space and mass on a two-dimensional surface was valued. Whereas earlier artworks were utilized to teach or inform or to provide a means for focusing one's prayer or meditation, this piece represents a new genre of religious artwork, the *icon*, which in time would be considered a holy object in its own right.

The Iconoclasts

An imperial edict of the early eighth century, though rejected by the pope in Rome, disallowed the representation of Jesus and Mary, or their retinue, in human form. All such images were to be obliterated, and offenders were to be severely punished. Those who were willing to accept only symbolic, abstract representations and who supported the destruction of religious images and opposed their veneration were called *Iconoclasts*. The dispute over these images and their representation was to last for over one hundred years, until the middle of the ninth century, when Iconoclasm was officially renounced. It is interesting to note, however, that sculptural representation continued to be considered inappropriate by the Eastern church. The renunciation of Iconoclasm, which occurred on the first Sunday of Lent, is celebrated as the Triumph of Orthodoxy. Though the formal splitting of the Catholic church and the Orthodox church did not occur until the eleventh century, it was during the ninth century that Orthodoxy became the central force behind Byzantine art.

The Second Golden Age

Churches

The tenth and eleventh centuries represent a period considered to be the Second Golden Age of Byzantium. Churches built during this age did not possess the same imperial aura that was conveyed by Hagia Sophia. Many were built in the form of the Greek cross, with vaulted arms of the same length within a square. The central feature was a square space with windows and a dome above. The apse was placed at one end and the narthex at the other. These elements were, for example, incorporated into the plans of the Church of the Katholikon (1020) and the Church of Theotokos (1040) at the monastery of Hosios Loukas in

Phocis, Greece. These two churches also reflected a change in attitude toward exterior ornamentation typical of the Second Golden Age.

A monumental church from this period is St. Mark's, in Venice (begun in 1063). The design of St. Mark's was also based upon the form of the Greek cross within a square, but here, each arm of the cross is accentuated with its own dome.

Classical Motifs in Religious Art

The prohibition against religious art from the eighth to the mid-ninth century did not apply to art of a secular nature. When the ban was lifted, advances that had been made in secular art, especially the reemergence of the Classical style due to a renewed interest in Greek culture, were applied to religious art as well. An illuminated page from the early tenth-century *Paris Psalter, David Composing the Psalms*, incorporates a number of Classical motifs, with the figures depicted likely derived from Classical images. Orpheus, who nearly rescued his wife from Hades by charming Pluto and Persephone with his lyre, may have been the model for David, portrayed here charming the beasts. The other characters in the picture have nothing to do with biblical tradition, but are allegories.

The Crucifixion, an eleventh-century wall mosaic from the Monastery Church at Daphnē, Greece, portrays Christ on the cross, with the Virgin Mary on his right and St. John on his left. The style of figural portrayal reflects a synthesis of Greek Classical elements and the Byzantine style of symbolic representation. The effect of the work is not so much to inform or instruct as an historical narrative but rather to serve as an image for contemplation. Although the figures here are similar to the elongated linear figures found in the apse mosaic of *Justinian and Attendants* from San Vitale, they differ in that they are modeled three dimensionally and possess an organic quality not seen in the earlier work. Like the earlier artwork of the Greek Classical period during the fifth century B.C., gesture and expression are emphasized. This style of elongating the human form in order to de-emphasize the corporal and emphasize the ethereal became a characteristic of much Byzantine art at this time.

Russian Churches in the Byzantine Style

The religion and architecture of Byzantium were far-reaching. In 988, Orthodox Christianity was declared the state religion of Russia, where it continued to exert a major influence until the Russian Revolution of 1917. From the Byzantine Empire came envoys of clergy, and architects and artisans, the former to teach and baptize, the latter to design and decorate churches.

Though from the fifteenth century, the Cathedral of the Annunciation (1482–1490), in Moscow, reflects the adaptation of the Byzantine style in Russian architecture during the Middle Ages. Whereas the domed cross remains the basic formula for the cathedral, the domes here are *onion shaped*, a design characteristic associated with the Russian Orthodox church. Additionally, the numerous domes, all covered with a highly reflective metal and topped with crosses, are built at different levels, with the central dome being the tallest. Seeming less Byzantine and even more Russian in style is the Cathedral of St. Basil (1554–1560), in Moscow. Here again, the many onion-shaped domes are placed at different levels, except in this case, they are vibrantly and colorfully patterned with ornamentation.

Recommended Reading for Part II

The Ancient World

Adred, C. (1980). *Egyptian Art in the Days of the Pharaohs, 3100–320* B.C. New York: Oxford University Press.

Amiet, P. (1980). *The Ancient Art of the Near East.* New York: Abrams.

Boardman, J. (1985). *Greek Art.* London: Thames & Hudson.

Brilliant, R. (1973). *Arts of the Ancient Greeks.* New York: McGraw-Hill.

Grand, P. (1967). *Prehistoric Art: Paleolithic Painting and Sculpture.* Greenwich, Conn.: New York Graphic Society.

Groenewegen-Frankfurt, H., & Ashmole, B. (1972). *Art of the Ancient World.* Englewood Cliffs, N.J.: Prentice Hall.

Krautheimer, R. (1986). *Early Christian and Byzantine Architecture.* Harmondsworth: Penguin.

Macdonald, W. (1982). *The Architecture of the Roman Empire.* New Haven, Conn.: Yale University Press.

Mango, C. (1972). *The Art of the Byzantine Empire, 312–1453.* Englewood Cliffs, N.J.: Prentice Hall.

Mendelssohn, K. (1967). *The Riddle of the Pyramids.* New York: Praeger.

Pericot-Garcia, L., et al. (1967). *Prehistoric and Primitive Art.* New York: Harry Abrams.

Pfeffer, J. (1982). *An Inquiry into the Origins of Art and Religion.* New York: Harper & Row.

Wingert, P. (1965). *Primitive Art: Its Traditions and Styles.* New York: New American Library.

Part III

The Middle Ages

The Middle Ages, the years between the fifth and fifteenth centuries, encompasses a period of time during which the focal point of European culture and civilization shifted from Italy to the region that had been the northern frontier of the Roman Empire. The historical event that was to lead to this shift was the decision of Emperor Constantine to move his imperial capital from Rome to Constantinople. Soon after, Christianity, the "glue" that had helped to maintain a sense of unity between the eastern and western domains of the empire, began to weaken as friction increased between the Orthodox church of the East and the Catholic church of the West.

With the center of power located in the East, the western domain became vulnerable to attack and incursion by the various Germanic tribes, the Lombards and Ostrogoths in Italy, the Visigoths in Spain, and the Franks in Gaul. What prevented the Byzantine Empire from reasserting itself in these areas were the Arab forces, which, during the mid-eighth century, not only overtook the Byzantine provinces of Spain and North Africa, but threatened the Eastern realm.

Part III

The Middle Ages

CHAPTER 9

Early Medieval Art

Chronology

4th cent.	Western Europe invaded by Germanic tribes
7th cent.	Gold-enameled purse cover from ship-burial site, Sutton Hoo
600–800	Christian art flourishes in Ireland
late 7th cent.	Illuminated manuscript, *Lindisfarne Gospels*
early 8th cent.	*Codex Amiantinus*
790–799	Monastery Church of St.-Requier, France
792–805	Palatine Chapel, Aachen

793	The English monastery of Lindisfarne is burned by Vikings
800	Charlemagne crowned emperor
c. 800–810	*Gospel Book of Charlemagne*
9th cent.	Wooden animal head from ship-burial site, Oseberg
early 9th cent.	*Book of Kells*
814	Charlemagne dies
816–835	*Gospel Book of Archbishop Ebbo of Reims*
c. 870	Front cover of the *Lindau Gospels*
879	The pope in Rome and the patriarch of Constantinople excommunicate each other
910	The Benedictine Abbey of Cluny is founded
919–936	The rule of German King Henry
936–973	Otto I rules
962	Otto I is crowned "Emperor of the Romans"
980	Church of St. Pantaleon, Cologne
993	First canonization of saints
997–1000	*Gospel Book of Otto III*
c. 1000	Oldest manuscript of *Beowulf*
1001–1031	Church of St. Michael, Hildesheim
1066–1087	William the Conqueror reigns as king of England

Since the first century B.C., barbarians had attempted to invade the northern borders of the Roman empire, but had been withstood. During the fourth century A.D., however, the weakened Western Empire was no longer able to repel these invasions. For the next few centuries, oftentimes referred to as the migration period, Western Europe was inundated with Germanic tribes who formed their own kingdoms. Over time, these tribes, many of them already Christian, adopted various aspects of the late Roman Christian culture that they found in their new colonies. What is typically referred to as early medieval art was produced over a period of 600 years, between the fifth and eleventh centuries.

Germanic Art

The art characteristic of the Germanic tribes was usually geometric and decorative in nature. Since these tribes were nomadic, they found it impractical to produce large-scale artworks that would be cumbersome to move. What Germanic artisans concentrated on were weapons and smaller objects, such as belt buckles, jewelry, and ornaments.

The Animal Style of Design

The Germanic tribes that came to western Europe tended to be superstitious and possessed a folklore rich with monsters and beings that in the coming years would evolve into the creatures that inhabited the medieval conception of hell. The *animal style* of design, likely dating back to prehistoric times, was incorporated into the geometric designwork of the Goths by the third century A.D. and was later assimilated into the artwork of many other tribes. The animal motifs used were so designed as to fit harmoniously within the object's overall geometric pattern, such that they are frequently difficult to identify as separate from the pattern. This style was to be an important element in the Celtic and Germanic art of this period.

Metalcraft

Metalcraft was the preferred medium of the Germanic artisans, who frequently utilized a decorative technique called *cloisonné*, which involved setting semiprecious stones or fired enamel in small niches

created by soldering thin metal strips edge up on a metal surface. *Fibulae*, ornamental pins used for clasping the fabric of clothing, seem to have been a popular item among many of the tribes. Typically cast of gold, silver, or bronze and decorated in the cloisonné technique, they were embellished with patterns that accented the form of the pin and oftentimes were set with semiprecious stones as well.

A number of pieces from this period have been found in a seventh-century ship-burial site at Sutton Hoo, on the eastern coast of Great Britain. Among the objects (including a buried Viking ship) found at this grave of an East Anglian king is a gold-enameled purse. The decoration includes groupings of men and animals, stylized nearly beyond recognition; the geometric designs consist of both linear and interlacing patterns.

Though earlier examples of interlacing patterns being used as a decoration can be found in some Roman and Early Christian art, the integration of the interlacing ornamentation with the animal style seems to be unique to the early medieval art of the Germanic tribes. The artistry of this metalcraft was the representative art of the Early Middle Ages in western Europe. Its effect was so impressive that the style was imitated in other media such as stone and wood, and in illuminated manuscripts. A ninth-century wooden animal head, from a ship-burial site near Oseberg, Norway, reflects this adaptation. Though certain aspects of the form of the head are realistic, the surface decoration consists of interlacing and geometric designs.

Christian Art in Ireland

In the years between 600 and 800, which are usually considered part of the Dark Ages, Christian art flourished in Ireland. During the fifth century, Christianity swept Ireland, which had not been part of the Roman Empire. The Church of Rome as an urban institution was not well suited to the rural Celtic population of Ireland, however. Rather than adopting the monastic style of the Western Empire, Irish adherents tended to follow that of the Eastern Empire, as developed in the Near East, and thus built their monasteries in the countryside, where, among other activities, they produced large numbers of copies of the Bible and other Christian texts. Irish monasteries were eventually founded in northern England, as well as in Scotland, Germany, and France.

At the same time, England, which had earlier been exposed to Christianity, was constantly under siege from outside forces. When the Roman presence in England was withdrawn, the growth of Christianity there was halted and the Church of Rome began to lose its foothold. This condition lasted until the end of the sixth century, when Rome reassigned missionaries to England to revive the faith and to counter the proselytizing of the Irish missionaries. Soon, friction developed between the Irish missionaries and those sent from Rome. This situation was eventually resolved in the middle of the seventh century at the Synod of Whitby, which determined that matters of Christianity in England would fall under the dictum of Rome.

The Hiberno-Saxon Style of Design

The books created by the Irish monks were exquisite. The design motifs utilized elements of both Germanic and Celtic origin in what has come to be known as the Hiberno-Saxon style. The ornamental carpet pages that precede each of the Gospels in the manuscript of the late seventh-century *Lindisfarne Gospels* reflect this style; each page portrays a cross with intricate, interlaced knots and interwoven serpentine forms of fantastic birds and animals, some of whom are devouring one another, while twisting and turning in a pulsating fashion. For those working in the Hiberno-Saxon style there were strict prescriptions concerning symmetry, use of color, and the repetition of specific shapes through evenly stressed line. Close observation indicates that geometric and organic forms were kept apart, and that animal forms were to consist of a single strand though they might weave over and under many other strands.

Another example of the interlacing technique can be seen in its application of decorating capital letters, such as is found in the early ninth-century *Book of Kells*. Each passage of the Gospels begins with a capital letter that has been ornamented differently in terms of color, form, movement, and interweaving. Considering that this involved over 2000 intricate illustrations, it was certainly a major undertaking.

Attention was also paid to the binding and cover of special books. The front cover of the *Lindau Gospels* (c. 870), for example, reflects intricate metalwork and the incorporation of gemstones. A cross forms the central focus of the cover, with the figure of Jesus portrayed with outstretched arms.

The Depiction of Saints in Illuminated Manuscripts

The imagery of the *Lindisfarne Gospels* also included depictions of various saints. Many of these were based upon earlier works. The illustration of St. Matthew is likely based upon an earlier image from the Italian *Codex Grandior*. The monk who painted the Lindisfarne *St. Matthew* utilized even line and was either unaware of or uninterested in using techniques that would create a realistic illusion of space in the picture plane or a sense of mass to the form of St. Matthew's body through the use of light and shadow. Though the pose of St. Matthew in the *Lindisfarne Gospels* is similar to that of the earlier Italian work, the treatment of the figure and drapery is flattened and linear, and the artist has translated an image of tones into one of pattern.

In contrast is an illustration, *The Scribe Ezra Rewriting the Sacred Records*, from the early eighth-century *Codex Amiantinus*, which was created in the monastery at Jarrow, founded by St. Benedict Biscopo of the Church of Rome. This illustration, in the Classical style of Rome, is based upon the same image as the Lindisfarne *St. Matthew* but, through the blending of color, utilizes many of the pictorial devices of late antiquity in which light and shadow were incorporated to create the illusion of space and mass.

Copying

The mode of copying earlier-accepted archetypal images was typical of medieval artists. In the depiction of sacred images, prior illustrations were thought to possess an authority that nature did not. However, as errors were made in the reproducing of these pictures, new styles developed and different styles were combined.

Carolingian Art and Architecture

The Carolingian dynasty began with the Frankish king, Pepin the Short, who in the eighth century forced the Lombards out of Ravenna, once the western foothold of Byzantium, and then placed Ravenna under the authority of the pope. In 800, his son, Charlemagne, was crowned Emperor of the Romans by Pope Leo III. The empire he was to rule, later to be known as the Holy Roman Empire, encompassed much of France, Switzerland, Belgium, the Netherlands, and Germany,

to which he would eventually add Italy as far south as Rome. Charlemagne admired Emperor Constantine greatly, and his desire was to restore not only a unified Christendom but also a sense of Roman civilization. He was an advocate of learning and the arts, and though his mother tongue was German, he learned to speak Latin fluently, recognizing its religious, historical, and official significance. It was under his auspices that the corruptions of Latin usage and spelling were examined and revised, along with the development of a lettering script that has evolved into the lowercase letters we use today. As to why our letters are called Roman rather than Carolingian (when the Roman alphabet consisted only of capital letters), it is because many of the Roman manuscripts that Charlemagne had copied in lowercase style were, in later times, misidentified as being of Roman origin.

In his attempt to restore the imperial past of Roman civilization, Charlemagne turned to the literature, architecture, and arts of Constantine's era. Through his many trips to Italy, he became especially familiar with Rome and Ravenna and the treasures they held. He wanted his own capital of Aachen to reflect the same imperial style through the use of Roman techniques of design and construction. The Germanic tribes of northern Europe had traditionally made use of the great forests for their building materials; thus, their architecture was based upon the use of timber. Although timber would continue to be a primary building material for a number of years, Charlemagne's use of Mediterranean methods of construction, in which stone was the building material, would have long-lasting effects on architecture in this region.

The Palatine Chapel

The design of Charlemagne's Palatine Chapel (792–805) at Aachen may have been loosely based upon that of San Vitale in Ravenna. Though planned by the Frankish architect Odo of Metz, many of the design elements and materials of this central-plan church, such as the marble and granite columns with Corinthian capitals and bronze gratings, were imported directly from Italy. In contrast with San Vitale, the Palatine Chapel seems stiffer and more massive, with an emphasis on its vertical orientation rather than the horizontal. The columns on the upper galleries are more decorative than structural, and while the piers of San Vitale are faced with light brick, the piers of the Palatine Chapel are faced with marble. A major difference in the design of the Palatine

Chapel, and a uniquely Carolingian contribution to church architecture, was the construction of a *westwork* at the western entrance to the chapel. At San Vitale, one entered through the narthex, which was semiattached and set at an odd angle to the main axis of the church. At Aachen, the westwork was attached to the chapel and was in line with the church's central axis. A component of this entranceway was two towers with staircases that led to the galleries within. This is significant because Charlemagne's throne was set in the first-level gallery above the door to the chapel, which is probably why such a monumental entrance was seen as necessary to begin with.

The Monastery Church of St.-Riquier

While the Palatine Chapel is one of the few extant examples of great Carolingian architecture, other advances in architectural design were made as well. In fact, it would be the basilica-design church, not the central-plan church of the Carolingian period, that would have the greatest impact upon the soon-to-evolve Romanesque architecture. None of the basilica churches of Charlemagne's time exist today; however, there is evidence that though many of them were similar to those of the Early Christian period, others incorporated new elements. One of the greatest basilican churches of this time was the Monastery Church of St.-Riquier (790–799) in northeastern France. Though destroyed, drawings and descriptions have indicated that its westwork was even more elaborate than that of the Palatine Chapel. Additionally, St.-Riquier had six large cylindrical towers, three at each end of the basilican nave. The placement of three towers at the west end, the two outer ones being stair towers of the westwork entrance structure, became a feature of the Carolingian basilica church.

Monasteries and the Benedictine Rule

Because monasteries were seen as a major vehicle for the revitalization of learning in the empire, strict guidelines were established concerning their organization. The Benedictine Rule, which had earlier been recognized as the definitive approach for monasteries in western Europe to follow rather than the Irish monastic way, dealt with issues of obedience, chastity, and vows of poverty, among others. Saint Benedict's Rule also indicated the manner in which the monastery

should be laid out. A document from the ninth century portrays a schematic drawing of the "ideal" layout for the rebuilding of a monastery at St. Gall, Switzerland. Though the monastery was never built, the blueprints show that at the center of and dominating the 500-foot by 700-foot complex was the monastery church with a cloister at its side. Arranged around the cloister were buildings that were to house meeting rooms, the kitchen, refectory, sleeping rooms, and storage facilities. Because the monastery was to be self-sufficient, provisions were made for barns, mills, artisan workrooms, and a garden. Space was also allocated for a cemetery, the abbot's house, a school, and guest housing.

Though the proposed church was similar to Early Christian churches in its overall design as a basilica with three aisles, it included some innovations, such as the addition of an apse at the western end of the church. The reasons for this second apse are unknown; however, it is significant because it becomes a feature of German churches for the next 200 years. The planners of this church also incorporated other elements that were to affect the evolution of church architecture in the north. Whereas Early Christian churches did not reflect a concern for the *proportional relationship* between the components that, together, comprised the church, the plan of the church at St. Gall does reflect such interest. This can be seen in the manner in which, for example, the nave and the transept are the same width, forming a square where they intersect. The use of the *crossing square* as the unit of measurement for the design of the rest of the church pulls the components of the church together so that they relate geometrically. This attention to proportion serves as an important step in the development of Romanesque architecture design.

The *Gospel Book of Charlemagne*

As mentioned earlier, Charlemagne was very interested in the knowledge and the arts of the Roman Empire during its Late Antique period. He brought to Aachen scholars and artisans from the Byzantine East and western Europe, as well as whole libraries of Italian and Byzantine works, which were studied and from which copies were made. A favorite text of Charlemagne's was the *Gospel Book of Charlemagne* (c. 800–810), later known as the *Coronation Gospels* because, from the eleventh century on, it was used as part of the coronation ceremonies of the Holy Roman Emperors. The parchment of the text

was dyed purple, a color reserved in the East for only the Crown, and the lettering was done in silver and gold. Four pictorial representations of saints are included in the text, depicted in the Classical fashion. Though the large golden halos that accompany the figures are not typically Roman, the illusionistic brushwork is. The portrait of St. John, probably based upon an earlier fifth- or sixth-century work, illustrates this technique in the way the fabric of his drapery is painted to appear to wrap around his body. The artist even further emphasizes his ability to depict space by stationing the stool upon which St. John rests his feet in front of the painted frame that encircles the page. The image of St. Matthew, portrayed seated while calmly writing his gospel, is also likely based upon earlier Classical images of the seated philosopher writing and reflects a similar treatment of form.

The *Gospel Book of Archbishop Ebbo of Reims*

The *Gospel Book of Archbishop Ebbo of Reims* (816–835) also includes portraits of the saints, but the method of depiction is very different from that found in the *Coronation Gospels*, which probably represents the height of Carolingian Classicism. The stylistic differences are easily seen by comparing the *St. Matthew* of the Ebbo text with the *St. Matthew* of the *Coronation Gospels*. The poses are similar, implying the use of similar models, but there the similarity ends. The Ebbo *St. Matthew* seems agitated as he sits, composing his gospel; his hair is ruffled, and his robe seems to vibrate with his frenzied writing. Attention is primarily focused upon the book, pen, hands, and head, emphasizing the act St. Matthew is performing. St. Matthew is represented in another plate of the *Ebbo Gospels*. This figure is also portrayed composing his gospel but at a moment of contemplation, with pen in inkwell while he gazes in ecstasy at his "symbol," a winged lion with a scroll. Like the *St. Matthew* of the same text, it is a very expressionistic image; his robe swirls about him as if the line is alive.

The sense of expression that is in these portraits is characteristic of the Carolingian interpretation of Classical models and represents the shift in the perception of humans that occurs during the Middle Ages. The Classical mode seen in the *Coronation Gospels* is forsaken for a style that reflects a shift in attention to gesture and pose as vehicles for conveying the inner emotions and spirituality in a way that was more decorative.

Ottonian Art and Architecture

Charlemagne died in 814, and the century following his death was to be one of the most chaotic in European history. The empire he had ruled began to crumble from within as well as from without. Internally, none of his heirs were strong enough to hold the empire together, let alone maintain their various domains. Externally, there were constant attacks from the Moslems in the south, from the Vikings in the north and west, and from the Magyars in the east.

The Norsemen in France

The Norsemen from the north were able to get a foothold in northwestern France in an area that today is still called Normandy. Once settled, these Norsemen adopted the Christian faith as well as the Carolingian culture. In 911, the Viking leader was given the title of duke by the Frankish king. By the middle of the eleventh century, the Norman duke William, also known as William the Conqueror, had become king of England, and yet other Normans were responsible for forcing the Moslems out of southern Italy.

The Consolidation of Power in Germany

Meanwhile, during the tenth century, order was restored in the eastern part of the empire through the efforts of the German king Henry (919–936), whose authority was further consolidated under the rule of his son, Otto I (936–973). Otto I was later crowned Holy Roman Emperor by the pope in 962, and it is after Otto I and his heirs, who would cause Germany to serve as the European center of government and artistic achievement, that the Ottonian style is named.

Revival of the Carolingian Style

Ottonian planners of churches essentially continued the traditions of the Carolingian builders. The Benedictine Abbey Church of St. Pantaleon (980) in Cologne, built by Archbishop Bruno, the brother of Otto I, reflects this revival of Carolingian style in the form of the massive westwork with its tower above the western transept and tall stair-enclosing towers on either side of the portico.

The Church of St. Michael

Innovations were also made in church architecture during this period. The Benedictine Abbey Church of St. Michael (1001–1031) in Hildesheim, built by Bernward, bishop of Hildesheim, who had earlier served as a tutor of Otto III, bears similarity to the Church of St.-Riquier in its placement of towers and westwork and in the solid upper nave walls, but it also includes some new elements. With the addition of a second apse and transept (with stair turrets and crossing towers), the nave, instead of being the central focus of the church, becomes a hall that connects the east and west apses. The spatial proportions of the parts of the church were based upon the cross square, with, for example, the nave being the equivalent of three squares in length and one in width. This use of the cross square was accentuated by placing piers at the corners of the squares and pairs of columns in between. This method of bracing, called the *alternate support system*, is characteristic of many later Romanesque churches. Although this method does provide support to the structure of the church, its original intent was aesthetic, to demonstrate the geometric proportions of the church design. Additionally, a change was made by placing entrances on both the north and south sides of the church, resulting in a further distancing from the traditional basilican orientation to the east.

St. Michael's contained a number of large bronze works, which is not entirely surprising, considering that Bishop Bernward was also a patron of the arts, as well as experienced in the art of casting bronze. While in Rome as a tutor of Otto III, he most certainly saw the Column of Trajan, which may have inspired his commissioning a twelve-foot-high bronze candlestick in the form of a column, embellished with a spiraling band of relief depicting events from the life of Christ. Also created for the church were a pair of bronze doors, each fifteen feet high, which were cast in a single piece, an achievement probably not attained since the time of Rome. Though most of the sculpture of the period preceding the creation of these doors was small in scale, here we find the reintroduction of monumental sculpture that will become characteristic of Romanesque art. On each door were scenes from the Old Testament, which were meant to be read horizontally. The relief work was fairly high, and the figures were natural and expressive, lacking the ideal proportions characteristic of the Classical era but not the gestural qualities to convey significant meaning.

The *Gospel Book of Otto III*

The painting of this time also reflects expressiveness through gesture. Illustrations from the *Gospel Book of Otto III* (997–1000) exemplify the Ottonian genre of depiction, which combines Carolingian and Byzantine styles. The illumination *The Annunciation to the Shepherds* portrays an angel proclaiming the birth of Jesus to some very startled shepherds. The oversized figure of the angel stands upon a hill, with the lines of his gown accented through the use of severe line. *Christ Washing the Apostles' Feet* appears on another page from the Gospel. As in Early Christian art, Christ is portrayed beardless, his stance here likely based upon a Roman relief of a physician attending to a patient. As with the angel in *The Annunciation to the Shepherds*, gesture is emphasized by the lengthening of the figures' arms. The architectural elements of the picture, probably based upon Roman stage designs, do not incorporate elements that might lend to a sense of perspective and depth, but are flattened out.

Not all the images in the *Gospel Book of Otto III* have to do with events in the life of Christ. In the illumination *Otto III Enthroned Receiving the Homage of Four Parts of the Empire*, the emperor himself is pictured holding an orb inscribed with a cross and a scepter and is accompanied by members of the clergy (representing the church) and barons (representing the state). This image of the emperor flanked on the one side by the church and on the other by the state portends the struggle and conflict between church and state that will characterize Europe during the coming centuries.

CHAPTER 10

Romanesque Art

Chronology

1067–1087	Church of St.-Etienne, Normandy
c. 1080–1120	Church of St.-Sernin, Toulouse
c. 1090	Stone panel, *Apostle*, Church of St.-Sernin
1093–1130	Cathedral of Durham
1095–1099	First Crusade
late 11th cent.	Relief, *Christ in Majesty*, Church of St.-Sernin
late 11th–early 12th cent.	Church of Sant' Ambrogio, Milan
early 12th cent.	Illumination, *Morilia in Job*
1115–1135	Church of St.-Pierre, Moissac
1120–1132	Church of Ste.- Madeleine, Vézelay
c. 1130–1135	Church of St.-Lazare, Autun
1147–1149	Second Crusade
mid-12th cent.	Illumination, *Bury Bible*
mid-12th cent.	Illumination, *Eadwine Psalter*
1152	Baptistery of Pisa Cathedral
1173	Campanile of Pisa Cathedral (Leaning Tower)
late 12th cent.	Church of St.-Trophime, Arles

Many changes took place during the Romanesque period. The religious fervor that spread through western Europe manifested itself in a number of ways, including a noticeable increase in the number of churches being built and a growing number of individuals making religious pilgrimages to sites such as Santiago de Compostela in Spain. The first of the Crusades, in 1095, occurred during this period as well, and the Mediterranean trade routes were reopened to meet the need for transport to the Holy Land and the ensuing movement of trade goods. A surge

in commercial activity also occurred, with the growth of urban centers and new towns and the emergence of a new middle class of merchants and craftsmen. Though no unifying imperial court bound the various political powers together, there were two elements that were common among them: Christianity and the feudal system.

Monasticism, with its roots in the Early Middle Ages, continued to gain momentum as an influential force as well. The Cluniac Order, with its main abbey at Cluny, France, had developed in the early tenth century. As a reform movement, its precepts were based upon St. Benedict's Rule, and it encouraged intellectual and artistic endeavors. As the Cluniac Order became wealthy from the gifts of patrons seeking redemption, a second major Romanesque order, the Cistercian Order, evolved. This order called for reforms that manifested themselves in the form of manual labor and self-denial.

The term Romanesque art *was utilized by early nineteenth-century art historians who saw the Gothic style of the Late Middle Ages as the zenith of the period's achievements in art and architecture. Their use of the term Romanesque to describe the architecture of the period that preceded the Gothic style reflected their perception of a similarity between the style of Romanesque architecture (with its columns, rounded arches, and solid mass) and that of early Roman architecture. Unlike the art and architecture of the Carolingian and Ottonian periods, which was bound to and sponsored by the imperial court, Romanesque art (1050–1200), encompassing many regional variations, seemed to develop around the same time all over western Europe, which by this time was largely Christian.*

Architecture

Though the 200 years that encompassed the Romanesque style of architecture reflected a range of regional styles with different methods of vaulting and lighting, their common features allow us to speak of a Romanesque style of building, whose design was influenced by a number of factors. The growth of urban centers and the increasingly large number of individuals making pilgrimages led to the development of *pilgrimage-type churches*, with large transepts and naves that could accommodate greater numbers of worshippers.

During earlier invasions by Norsemen and Magyars, many churches had been destroyed by fire. These churches were rebuilt, using contemporary designs that substituted vaulted ceilings for timbered roofs, surfaced the exterior with stone, and increased buttressing to add to the overall strength of the structures.

The Cluniac Romanesque Style

The Church of St.-Sernin (c. 1080–1120), built in the Cluniac style at Toulouse in southern France, was one of many pilgrimage-type churches along the route that led to the pilgrimage center of Santiago de Compostela in northwestern Spain. The crossing square of the nave and the transept at the eastern end served as the measure by which the rest of the components of the church were designed. On both sides of the central nave are two aisles that originate at the two towers of the western facade. These two towers were never finished, however. The inner aisle continues unbroken as it flows around the transept and the apse. To the apse have been added small chambers that are part of the pilgrimage choir; this arrangement allowed more than one priest at a time to conduct mass. Based upon the modular unity of the crossing square, the aisles consist of square bays, which lend a sense of regularity to the design and reflect the articulation of the outer walls. These features are emphasized on the exterior by the placement of the various roofs at different levels, corresponding to the nave, the transept, the inner and outer aisles, and the apse and radiating chapels. A tall tower rises from the crossing square.

Whereas the interiors of the Early Christian basilican churches had consisted of flat, unbroken wall and ceiling surfaces, St.-Sernin had a barrel-vaulted nave with supporting diaphragm arches and groin-vaulted arches as an alternate solution to the traditional wooden roof (an inherent fire hazard) that was typical of earlier churches. Above the inner aisles were galleries that accommodated larger groups of worshippers. They also allowed light to filter into the central nave, for the incorporation of the barrel-vaulted ceiling in the nave made it impossible to include a clerestory. Here the nave vaults rest on arcades, with the weight and pressure carried to the outer church walls by the vaults that were over the aisles, whereas exterior buttresses between the windows help to counteract the outward pressure of the inner vaults. The problem of designing a vault system that would at the same time

allow light to enter the church was probably the major issue facing architects of the Romanesque period.

The German Romanesque Style

In the Rhineland region of Germany, Speyer Cathedral was built in 1030 with a timber roof. Between 1082 and 1106 it was rebuilt by Emperor Henry IV, and the timber roof was replaced with groin-vaulted ceilings. Though the groin vault system had been popular among Roman architects, the use of concrete, which had allowed them to create great vaulted areas, was unknown during the Middle Ages.

In a groin vault, the weight is not borne by the entire wall, but by four corner points, which makes the construction and distribution of weight and pressure difficult. Though groin vaulting on a small scale can be seen throughout the Early Middle Ages, it was not until Romanesque masons were able to develop the technique of joining cut stone with mortar in conjunction with buttressed walls that they were able to create large vaulted spaces, as in Speyer Cathedral, where the vaults are over one hundred feet tall and forty-five feet wide. Unlike St.-Sernin, Speyer Cathedral utilizes the alternate-support system of columns and piers, probably because Speyer Cathedral was originally built with a timber roof with articulated shafts that rose between the clerestory windows. When the timber roof was replaced with a vaulted ceiling, the alternate-support system provided a means for strengthening the piers at the corners of the vaults, which correspond to every other support. The end result was a system whereby a single vault unit in the nave was flanked by two smaller vault units in the aisles, a configuration seen frequently in Romanesque design in the north.

Above the crossing square is an octagonal dome. Here again, the crossing square provides the unity of measure for the components of the cathedral; the nave is approximately four times its length, the aisles are one-half the width of the nave, and the length of three wall supports equals the size of the crossing. Though not as precisely executed as St.-Sernin, Speyer Cathedral represents another example of the use of *square schematicism* to regulate the proportions of the church structure.

Though the exterior of Speyer Cathedral maintains the Ottonian convention of towers at both the east and west ends, the Ottonian western apse and side entrances have been deleted, and the entrance has been returned to the western end. A number of decorative elements,

probably of Lombard origin, have been added to the exterior wall surfaces; these include molding that accents the levels of the towers, and arcades beneath the eaves.

The Lombard Romanesque Style

The Church of Sant' Ambrogio, in Milan, is an example of the Lombard style of architecture. Built during the late eleventh to early twelfth centuries, it was one of the last church structures that incorporated an atrium as part of its design. Its narthex, consisting of two stories, has open arches on both levels, and though there is no transept above the nave on the eastern end, it has an octagonal tower reminiscent of the type found on German churches. Its two facade towers were built at different times, the shorter one in the tenth century, the taller one (typical of Lombard towers with its decorative horizontal projections and open arches on the uppermost level) during the twelfth century.

Inside, square schematicism has again been used to determine the proportions of other components of the church. Each bay is the equivalent of a full square in the nave and is in turn flanked by the equivalent of two small squares in the aisle, with groin vaults above both. Sant' Ambrogio does not have a clerestory; light is filtered in through the octagonal dome that sits above the easternmost bay of the nave. The transverse arches that separate the four bays of the nave are slightly lower than the vaults. Here again, the alternate-support system is used with the partial supports stopping at the gallery level and the full supports rising to support the main vaults.

The Norman Romanesque Style

Of all the Romanesque styles of architecture, the Norman style was probably to have the greatest effect upon the development of Gothic architecture.

The Church of St.-Etienne

The Church of St.-Etienne, in Caen, Normandy (northwestern France), is an exemplar of the Norman Romanesque style. Its construction was begun in 1067 under the auspices of William the Conqueror and was completed sometime before 1087 when he was buried there. The placement of four massive buttresses on the fairly unembellished

exterior of the western facade creates three bays that correspond to the aisles and nave in the interior. The spires on the two towers that seem to spring from the facade were an addition to the original structure and are Gothic in style. The original towers were divided horizontally into three levels, with a greater degree of incising of arches proceeding toward the upper levels.

Saint-Etienne, like Speyer Cathedral, was originally constructed with a timbered roof, but unlike Speyer Cathedral, it incorporated from the beginning an interior alternating-support system of columns and half-columns, though probably for aesthetic rather than structural purposes in order to emphasize the square schematicism of the church's overall design. When the timber roof was replaced with the vaulted ceiling, it was possible, because the nave bays were square, to install ribs that divided the vault areas into six sections (i.e., a single X-pattern with a transverse rib) creating a sexpartite vault that was separated by ribs rather than heavy transverse arches. These vaults are also considered to be early examples of the ribbed vault style, because the transverse and diagonal ribs create a structural framework that helps to support the paneling between the ribs. The Norman design of the ribbed vault is considered to be one of the major engineering accomplishments of the Middle Ages, and its use characterizes Gothic architecture.

The Cathedral of Durham

In northern England, the Cathedral of Durham (1093–1130) was designed with vaulting in mind from the beginning. Being 400 feet long, in scale and mass it is similar to Speyer Cathedral, but with perhaps more attention paid to the relationship between the vault spaces and the vertical components of the supporting structure. The design of the cathedral, with its long nave and transverse transept, does not rely on the use of square schematicism to the same degree as St.-Etienne. In the nave, between the compound piers that support the transverse arches of the vaults in this alternate-support system, are large austere pillars decorated with nonrepresentational designs, whose origins probably go back to the ornamental design of the migration period. It is worth noting that the rib vaults of the choir, built around 1104, were probably the first of their type in Europe. Moreover, in having rib vaults that are a component of the same structure as the pointed arches found in the western end of the nave, the Cathedral of Durham is the first building to contain two of the major design elements of Gothic architecture.

The Tuscan Romanesque Style

Of all the Romanesque styles, the architecture produced in Tuscany, in southern Italy, most retained the basic qualities of the Early Christian basilica.

Pisa Cathedral

Pisa Cathedral, Baptistery and Campanile, located in the Piazza del Duomo, or Cathedral Square, of Pisa, reflect this conservative style and also represent a reinterpretation of classical Christian elements. Pisa Cathedral (1063–1162), which is similar to the Early Christian basilican structures in form, is distinctly Romanesque with its dome over the crossing square, projecting transept, exterior embellishment, and the arcade galleries on its facade. The interior of the cathedral, with regularly spaced columns lining both sides of the nave, arcades, and a timbered roof, is also reminiscent of the earlier basilica design. However, the galleries above the columns are of Byzantine influence. Other nonclassical features that reflect the Romanesque period include the pointed arches at the crossing square and the vertical orientation of the interior. A characteristic of the Tuscan Romanesque style can also be seen in the arch supports of the galleries, where alternating cut-stone blocks of green- and cream-colored marble have been used to create a striped effect.

Construction of the round campanile, popularly called the Leaning Tower of Pisa, was begun in 1173 and, due to settling, tilted from the vertical even during its construction. Today it is some sixteen feet out of vertical alignment. Its exterior is elaborately embellished with arcades, similar to those of the facade of the cathedral, that accent its different vertical levels. The circular domed baptistery, begun in 1152, is, like the campanile and cathedral, covered with white marble inlaid with ornamental patterns and horizontal stripes of green marble.

The Church of San Miniato al Monte

Another church that reflects the Tuscan Romanesque style of architecture is the Church of San Miniato al Monte (1018–1062) in Florence. Its exterior is rich with the geometric ornamentation of green and white marble. The lower level of the facade utilizes Corinthian columns to frame its five doorways, three of which are real, two of which are false and purely decorative. The upper level, probably com-

pleted a century later, is in the form of a Classical temple facade. Inside, like the early basilica, it has a tall nave flanked by aisles, but here the nave is divided into three equal areas by diaphragm arches that rest upon compound piers. Like Pisa Cathedral and many of the other Tuscan Romanesque churches, San Miniato al Monte has a timbered roof.

The Baptistery of San Giovanni, Florence

The same type of exterior decorative motif was adopted for use on the Baptistery of Florence (1060–1150). Dedicated to the city's patron, St. John the Baptist, the octagonal building's blind arcades are so classical in their detail and symmetry that many have thought it to be of much earlier origin.

Sculpture

The eleventh century is a significant point of the Romanesque period as it marks the revival of monumental figurative stone sculpture in western Europe. Between the sixth century and the mid-eleventh century, little stone sculpture was created. Figurative work was typically small in scale; the stone sculpture of the period served as architectural embellishment and decoration and was carved in low-relief. However, as religious fervor spread, more and more stone churches were built and the number of pilgrims increased. With this increase in pilgrimages came renewed interest in the decoration and embellishment of the exterior of these new churches through the use of the technique of relief carving. Just as the Romanesque style of architecture encompassed a number of variations, so did Romanesque sculpture.

Sculptural Work Within the Church

Though the subjects depicted were dictated by the theologians of the time, they were interpreted by the Romanesque artisans in their own style and manner. The Romanesque artisans turned to available models of earlier figural depiction, which included Roman sculpture, relief work, and illuminated manuscripts. The *Apostle* (c. 1090) is a stone panel now in the ambulatory of the Church of St.-Sernin; its original location in the church is unknown. The figure, more than half life-size in scale, is solid in appearance and possesses a classical quality, such

that it is likely that the sculptor referred to extant late Roman sculpture as his prototype. At the same time, its position within the architectural frame and the frontal pose it has assumed are Byzantine elements.

Another work in the ambulatory of the Church of St.-Sernin is a relief sculpture, *Christ in Majesty* (late eleventh century). Though of stone, *Christ in Majesty* is believed to have been modeled after an earlier work that had been created in metal, possibly a book cover, because of the manner in which the figure has been handled, as if hammered from behind. Like earlier book covers, the sculpture incorporates the symbols of the Evangelists at its four corners. Its particular placement within the ambulatory seems random, as if the space were available and accessible and therefore was "filled" with the object. What is missing is a sense of relationship between the sculpture and its location.

Sculptural Work Within the Church Portal

The next step in the evolution of the relationship between sculpture and architecture (culminating in the Gothic period with the integration of statuary within the church facade) was the Romanesque placement of sculpture within the boundary of the church portal. Not only was this a logical next step because of the natural demarcation of space created by the portals, it also afforded great visibility of the works. On the western facade of the Church of St.-Trophime (late twelfth century) in Arles, France, is a portal whose *tympanum*, the area within the arch of the portal, is filled with sculptural relief that depicts the Last Judgment. Following convention, Christ, as King and Judge, sits upon a throne in the center, with symbols of the Evangelists on either side, and the twelve apostles below. Other figures, such as angels and elders, accompany the central group.

At the abbey at Moissac, France, another important center of Romanesque sculpture, the tympanum of the south portal of the Church of St.-Pierre (1115 –1135) also portrays the Last Judgment. This version reflects both a Spanish and an Islamic influence in the decorative treatment of the portal. Other qualities that were developing as uniquely Romanesque had their roots in the styles of the Carolingian and Ottonian eras. The emerging style can be seen in the elongated figures, their stances, the zigzag accenting of drapery, the positioning of the hands, and the wide cheekbone structure. Carved in the *trumeau*, the column beneath the portal that supports the lintel, is the elongated figure

of Jeremiah the Prophet. Entwined with crossed lions, an animal motif seen in manuscript illumination, he is sculpted in a crossed-leg position but with little indication that any movement is taking place. Jeremiah's hair and beard are incised with very fine line, and what his posture lacks in expressive qualities is made up for in the treatment of his face, as he gazes with unfocused eyes, as if in a trance. The folds of his drapery, in a style most probably derived from the pictorial illustrations found in illuminated manuscripts, are lightly etched and seem to flow across his form.

On the east side of the porch that precedes the portal are the relief sculptures the *Adoration of the Magi*, the *Visitation*, and the *Annunciation*. The elongated figures and limbs are similar in treatment to *Jeremiah*, and where there is variation in the size of the forms, it is due to the architectural space within which they are placed.

The tympanum of the west portal of the Church of St.-Lazare (c. 1130–1135) in Autun, Burgundy, presents us with yet another version of Christ as the Divine Judge. Here, souls are being weighed, while below, the dead are depicted rising. The demons of hell are portrayed as well, while angels and devils vie for the souls of man and woman.

At the Church of Ste.-Madeleine (1120–1132) at Vézelay, Burgundy, the tympanum of the center portal of the narthex portrays *The Mission of the Apostles*. Rays of light emanate from Christ's hands as the Apostles, holding the books of the Gospels, receive instructions for their spiritual duties. The decorative border of the portal represents the works of the months, the seasons, and the signs of the zodiac. The familiar faces of demons are in attendance; humanity, with all its weaknesses and deformities equally represented, waits for Christ and Redemption. The subject of the "mission" was especially appropriate for this time because it coincided with the Crusades.

Painting and Illumination

Though mural paintings were produced during the Carolingian and Ottonian eras, the Romanesque period reflects a resurgence of this medium. Like the variations in style that developed in architecture and sculpture, regional variations occurred in painting, though there were few abrupt changes to differentiate it from the earlier styles. In fact, of the Romanesque styles in architecture, sculpture, and painting, it was

illuminated manuscripts that maintained the greatest degree of continuity with the preceding periods.

Illumination of *St. Mark*

Changes in style may be seen in the illumination of *St. Mark* from a mid-eleventh-century Gospel Book, which was probably produced at the monastery of Corbie, in northern France. Though the linear qualities of the work resemble those of earlier examples from the Carolingian period, what is apparent is the lack of any sense of Classical illusionism. Firm outlines and solid color create flat overlapping planes, resulting in an image that, while symbolic, is also representational and decorative.

Byzantine Qualities of Romanesque Painting

A fresco painting in the apse of the Church of Santa Maria (eleventh century) in Catalonia, Spain, is the *Adoration of the Magi*. Like many Romanesque paintings, it possesses distinctly Byzantine qualities. The figures seem formal, an impression reinforced by the decorative qualities of the drapery, which appear to flatten and stiffen the forms. The roots of this style can clearly be seen in some of the illuminated manuscripts of the Ottonian period, as in the *Gospel Book of Otto III*. The firm partitioning of areas of color gives the effect of an assembled puzzle. The linear patterning of the forms in conjunction with the bright coloring makes for a very eye-catching image.

The Life and Miracles of St. Audomarus

Another example of a variation of this Romanesque style of painting is the eleventh-century illuminated manuscript *The Life and Miracles of St. Audomarus*. In one panel, which depicts St. Audomarus (St. Omer) tied and being abused by two captors, the figures are created by thick lines filled in with patterns. Though movement is implied, it is stiff and unconvincing. The page, though framed with a border, does not hold the figures within, for they are portrayed overlapping it in areas.

St. George and the Dragon

From the *Morilia in Job* (early twelfth century), created in the Cistercian abbey of Citeaux, is an initial page with the depiction *St. George and the Dragon*, which incorporates the figures of St. George, his servant, and the dragon into the ornamented letter *R*. Saint George is portrayed with his sword in his lifted right hand, holding his shield in his left to keep the dragon at bay, while beneath, his servant drives a spear through the dragon, which is superimposed upon the arc and diagonal of the letter. The Romanesque manner of depicting figures in segments and dovetailing the folds of the drapery lends to the vertical orientation of St. George and the action of the servant. Though the same visual vocabulary of other works of this genre is used, the artist of *St. George and the Dragon* has avoided the stiffness and flatness that is conveyed in these other works.

The Frontispiece to the *Bury Bible* Book of Deuteronomy

Another illumination that reflects the refinement of the Romanesque style is the mid-twelfth-century *Bury Bible* frontispiece to the Book of Deuteronomy, from the abbey of Bury St. Edmunds, in England. The illuminated page is bordered by a leaf motif that also horizontally divides the surface into two sections, allowing two scenes from the Book of Deuteronomy to be portrayed. In the upper space, Moses and Aaron are shown presenting the Law to the Israelites, who are seated and attentive. In the lower scene, Moses is illustrated addressing the Israelites as to which animals are clean and which are unclean. The images rely on the use of figurative gesture, which is portrayed here much more successfully than in earlier Romanesque works. The figures of Moses and Aaron seem somewhat more relaxed and natural, without the abrupt jerkiness seen in *The Life and Miracles of St. Audomarus*. Though the treatment of the figures and their drapery still consists of hard line filled with color, the patterning is a little more subtle, and the scenes portrayed are contained within the decorated borders of the page.

The Scribe Eadwine

The mid-twelfth-century work *The Scribe Eadwine*, from the *Eadwine Psalter*, illustrates a change in the Romanesque style from what

we have seen thus far. Created around the same time as the *Bury Bible*, and similar in some respects in its use of pattern, there is a noticeable change in the way the fabric drapes around the body, following its contours more naturally. Though the surface of the drapery is still treated decoratively, its effect begins to take a more subservient role to its function, implying a differentiation between fabric and figure not seen in earlier works of this style. Here, the lines begin to again describe three-dimensional shape, with their ornamental quality used to describe mass. This attention to naturalism, lacking up until now, becomes more apparent as time goes on.

Another point worth noting is the fact that the *Eadwine Psalter* contains a portrait of the volume's scribe, Eadwine. Though it is true that earlier illuminated manuscripts had included the images of living individuals, these individuals were emperors, with the "right" to be represented in manuscripts. Eadwine's including a portrait of himself in the manuscript indicates a change in the status and role of the artist.

CHAPTER 11

Gothic Art

Chronology

1145, 1194–1220	Chartres Cathedral
consecrated 1208	Abbey Church of Fossonova
1215	Magna Carta
1220–1230	*St. Martin and St. Jerome*, Chartres Cathedral
1220–1270	Salisbury Cathedral
1220–1270	Amiens Cathedral
1225–1299	Reims Cathedral
1228–1239	Church of San Francesco, Assisi
1233–1283	Church of St. Elizabeth, Marburg
1240–1250	*Ekkehard and Uta* from choir of Naumburg Cathedral
1240–1250	*The Kiss of Judas* on choir screen of Naumburg Cathedral
1243–1248	Cathedral of Ste.-Chapelle
1248–19th cent.	Cologne Cathedral
1258	The House of Commons is established
1261–1275	Church of St.-Urbain, Troyes
1271–1295	Marco Polo travels to China
1288–1309	Palazzo Pubblico, Siena
1296–1436	Cathedral of Florence
begun 1298	Palazzo Vecchio, Florence
1337–1453	Hundred Years' War
1345–1438	The Doge's Palace, Venice
1347–1350	Europe is devastated by the Black Death (bubonic plague)

| begun 1386 | Milan Cathedral |
| 1434–1514 | Church of St.-Maclou, Rouen |

The term Gothic *was originally used to refer to a particular architectural style that existed between 1150 and 1550 in Europe. Scholars from the Renaissance period, disdaining the style and its lack of conformity with the canons of Classical Greek and Roman architecture, called it "Gothic," implying that it originated with the barbarian Goths. Later, the term was also applied to the sculpture and painting of the period. Using a term like this to differentiate the "new" styles of architecture, sculpture, and painting from older styles suggests change. The greatest changes in Gothic architecture occurred between 1150 and 1250; in sculpture, between 1220 and 1420; and in painting, between 1300 and 1350.*

The geographic center of Gothic art, beginning around 1150, consisted of Paris and its surrounding area, known as the province of Île-de-France. By the middle of the thirteenth century, one hundred years later, the Gothic style had permeated much of Europe, and through the Crusades, its influence was felt in parts of the Near East as well. By the mid-1400s, the Gothic style began to fade in some areas, such as Italy; a century later, little or no Gothic art was being produced.

Early Gothic Architecture

Two individuals who are considered to have had a great impact upon the development of the Gothic style of architecture were Bernard of Clairvaux and Abbot Suger. Bernard, who was appointed head of the Cistercian Order in 1134, represented a philosophy that upheld qualities of intuition and mysticism rather than rationalism as the foundation of faith. The church architecture of the Cistercian Order reflected his ideology. Shunning the ornate architecture of the Cluniac Order, the Cistercian Order produced structures with austere lines, simplicity, and diffused lighting, qualities that were especially conducive to the meditative atmosphere that Bernard believed the church should possess. The Abbey Church of Fontenay (1139–1147) was such a church, repre-

senting the Cistercian precepts in a Gothic style of the order's own that renounced ornamentation in lieu of attention to form. Its style, with a flat choir, no apses, high vaults, and thin windows, became a required design for all their churches by 1200.

Abbot Suger and the Abbey Church of St.-Denis

Abbot Suger served as chief advisor to King Louis VI and was instrumental in the monarchy's efforts to extend its authority beyond the Île-de-France. By negotiating a union between the Church and the Crown, Suger gained for Louis VI the support of the bishops of France. In turn, the Church gained the king's support in its challenge of the authority of the German emperors. In 1122, Suger was made abbot of the monastery of St.-Denis, whose eighth-century church was the shrine of the Apostle of France, the setting for the coronations of both Pepin and his son, Charlemagne, and the burial site of kings since the ninth century.

While Suger was using his religious and political influence to garner support for the king, he began working toward a second goal, the rebuilding of the Church of St.-Denis, such that it would become the greatest of the pilgrimage churches as well as the spiritual center of France. Abbot Suger's plans for the Abbey Church of St.-Denis, although based upon the design and geometric proportions of earlier churches, called for a refinement of line, chapels, and windows in a manner that heretofore had not been seen. As noted in his account of the time, the central nave of the new church was to be the same width as the nave of those built during the Carolingian period; the same was to be true of the aisles. It was with the Abbey Church of St.-Denis (begun in 1140), and the attention paid to *natural lighting* and *geometric proportion*, that the Gothic style of architecture began.

Today, only the ambulatory of the east end, completed in 1144, remains as Abbot Suger intended; the choir that it encompassed was replaced a century later. What made the design of the Church of St.-Denis so distinctive was the way in which it utilized existing architectural elements. Its arcaded apse surrounded by an ambulatory and radiating chapels, for example, is basically similar to that of the Romanesque Church of St.-Sernin in Toulouse. However, the seven chapels radiating off the apse were designed without walls, forming a wavelike second ambulatory. Ribbed vaults had been used with pointed

arches in the past, but not with such regularity as in the St.-Denis church, in which they are part of its unified design. Whereas prior ribbed vaults consisted of diagonal arches beneath the groins of a vault, the *Gothic ribbed vault* incorporated the pointed arch as part of its structure, allowing the crowns of the arches to be of the same height. The advantage of using the pointed arch with the ribbed vault was that the pointed arch could be elevated to any height, no matter what the width of its base. The Gothic ribbed vault was lighter than the irregularly shaped domical vaults used by Romanesque builders and also allowed for the incorporation of large clerestory windows.

The Church of St.-Denis and Gothic architecture, in general, convey a sense of interior weightlessness and lightness. Though the Gothic ribbed vaults created a great amount of outward stress, this pressure was borne by the massive exterior buttresses that were constructed between the chapels. In this way, the lightest elements of the structure were visible within the church, whereas the bulkiest elements were on the outside, reversing the arrangement of structural elements in the Romanesque interior. The Gothic ribbed vault structure also allowed Suger to achieve luminosity, a quality he associated with spirituality. In earlier churches, natural light filtered in through small openings cut in the walls. In the Church of St.-Denis, an abundance of natural light flowed in through the large, tall windows that the technique made it possible for him to incorporate into the design.

The Cathedral of Laon

The Cathedral of Laon (1160–1205), also in the Île-de-France, is another example of an Early Gothic church that integrated the Gothic ribbed vault and pointed arch with Romanesque features, such as the crossing square and a nave made up of sexpartite ribbed vaults. The result is an alternate-support system with a nave interior consisting of a series of bays, each flanked by two smaller bays in the aisles. A new component characteristic of Early Gothic architecture and reflecting the developing interest in breaking up continuous wall surfaces was the *triforium*, a gallery forming an upper story to the aisle, typically an arcaded story between the nave arches and clerestory. With its addition, the nave-wall elevation had four components: the nave arcade, the gallery, the triforium, and the clerestory.

Externally, the Cathedral of Laon also reflects a number of Early Gothic characteristics, as in the treatment of the windows and porches, which are deeply recessed in such a way as to integrate them more fully into the overall mass of the structure. Another factor that influenced the design of the western facade was the desire to delineate the levels of the facade horizontally to reflect the interior stories of the church. As in the German Romanesque tradition, the Cathedral of Laon was to have two western towers, a tower over the crossing square, and a pair of towers flanking each arm of the transept. Because of the great expense of construction, only two of the towers that were to flank the transept were completed, along with the tower above the crossing square and the two western facade towers.

The Cathedral of Notre-Dame

The Cathedral of Notre-Dame, in Paris, was begun in 1163. Its transept and choir were finished by 1182, the nave by 1225. For twenty-five years, construction continued. Chapels were built between the buttresses, the arms of the transept (which were originally no wider than the breadth of the building) were elongated, and the facade was completed. A Romanesque feature that persists is the nave, with its square bays and sexpartite vaults. The vertical orientation of the interior, the slender structural forms, and the large clerestory windows are all Gothic elements. Like Abbot Suger's Church of St.-Denis, the Cathedral of Notre-Dame relies upon buttresses to support the outward thrust of the inner vaults. It is above the aisles that the piers turn into flying buttresses that arch above to the outer walls, where, between the clerestory windows, they provide the thrust necessary to counterbalance the outward pressure of the nave vaults.

The western facade is similar in layout to that of earlier churches, such as the Church of St.-Etienne and the Church of St.-Denis, in its three-story scale and the placement of its portals. However, the large portals, windows, and lacelike stonework effectively break up the wall surface, reducing the effect of the mass and its solidity. This is evident when comparing the west facade and its central rose window, which is recessed and covered by stone lacework yet clearly distinct from the surrounding wall, with the later south facade of the transept. In the latter case, the rose window, covered with stone lacework that is flush with the surrounding wall, is indistinguishable from its frame.

High Gothic Architecture

During the middle of the twelfth century, the bishop of Chartres reconstructed his cathedral in the new style. In 1194, a fire destroyed nearly everything but the western facade of Chartres Cathedral. Rebuilding began almost immediately and continued to 1220. The new Chartres Cathedral, planned from the beginning with flying buttresses, represents the debut of the High Gothic style of architecture.

Chartres Cathedral

Flying buttresses had been utilized effectively at the Cathedral of Notre-Dame as well as at the Cathedral of Laon. Romanesque architects had used similar methods of buttressing but had concealed their efforts beneath the roofs of tribune galleries that were constructed above the aisles for that purpose as well as to provide support for the nave. Gothic architects, in an effort to allow more light to enter, dispensed with the tribune galleries, exposed the buttresses, and trimmed them in such a manner that they were both functional and aesthetic. At Chartres Cathedral they are particularly evident around the east end of the structure. The use of buttresses in this fashion did away with the need for Romanesque wall-construction techniques, including the alternate-support system, and allowed for the building of skeletal structures that were self-supporting.

Design

The design of Chartres Cathedral reflects a shift from square schematism as the operational proportion to one that is based upon the rectangular bays of the nave. This *rectangular-bay scheme* became standardized during the High Gothic period. Because the rectangular bay encompassed a lesser area of space, the architects of Chartres Cathedral were able to install vaults that utilized only four panels instead of the six (sexpartite) seen in the cathedrals of Laon and Notre-Dame. Instead of being perceived as a series of bays, the nave was transformed into a large, vast, open space. The interior was enhanced further by the large clerestory windows, made possible by a change in the nave-wall elevation. With the refinement of the flying buttress method of abutment, the support provided by the tribune gallery above the aisle was no longer necessary. This resulted in a new High

Gothic nave-wall elevation consisting of arcade, triforium, and clerestory. The clerestory stained-glass windows, the majority of which are original to the church, admit less light than might be expected, owing to the light-filtering effect of the colored glass. What they lack in the amount of light they allow in, however, they more than make up for in terms of the quality of light that is admitted, for their function was to be one of illumination, both spiritual and physical. The light, filtered as it is through the windows, creates an atmosphere within that is very different from the one without.

Figure Sculpture

Though Chartres Cathedral was built in the High Gothic style, the portals of the western facade, which were not destroyed in the fire of 1194, represent examples of Early Gothic sculpture. On the *embrasures*, the flaring outward walls flanking the doorways, are carved statues of kings and queens of the Old Testament, similar to those that must have flanked the portals of the Church of St.-Denis. Though figures had been represented on the embrasures of Romanesque churches, they were typically carved in relief; those at Chartres are nearly free-standing, and represent a return to sculpture in the round. The portal on the left portrays the Ascension; the one in the middle, the Second Coming and the Last Judgment, presented in a manner that indicates salvation rather than damnation. The portal on the right illustrates the birth of Jesus, the Presentation at the Temple, and the infant Jesus on Mary's lap. On the capitals, scenes from Jesus' life are depicted.

Though the sculptural poses assumed during this and the previous period had been determined to a great degree by the location of the works in relation to the architectural structure, a renewed interest in naturalistic depiction led to a more realistic human sculptural representation. This change is reflected in *St. Martin and St. Jerome* (1220–1230), two figures from the *Porch of Confessors*, located in the south transept of Chartres Cathedral. The increased sense of realism can be seen in the way that the figures, though placed within an architectural setting, are not posed by it. Unlike the rigidly fixed figures represented in the portals of the west facade, St. Martin and St. Jerome face one another ever so slightly, their robes draped over their forms rather than etched upon them. Their faces are also less masklike and more individualistic.

Amiens Cathedral

Amiens Cathedral was begun in 1220. Its nave, designed by Robert de Luzarches, was completed in 1236; its radiating chapels, in 1247; its choir, in 1270. The facade, also begun in 1220, is topped with two towers; the shorter one was constructed during the fourteenth century and the taller one during the fifteenth. Inside, Amiens Cathedral is representative of the High Gothic style in its use of the rectangular-bay system; its four-paneled ribbed vaulting, which is 140 feet tall and gives the illusion of membrane stretched over skeletal structure; and its buttressing, which allowed for the use of structural forms that were much lighter than the heavy weight-bearing walls of the Romanesque period. The vertical orientation and lightness of the mass are accented by the colonnetes and compound piers as well as by the natural light that enters through the clerestory windows.

The facade also reflects a refinement of the High Gothic style. Although the portals, in form, are similar to those of Laon Cathedral, they differ in that their placement is in relation to the aisles and nave, and they originate within the facade wall, rather than projecting from it. The upper level of the facade, with its rose window, is reminiscent of the Cathedral of Notre-Dame. What is striking, though, is the manner in which the facade was etched with a variety of surface decoration, which effectively broke up any perception of a continuous wall surface, yet was still integrated with the overall form of the structure, and accented the verticality of the structure.

Reims Cathedral

Design

The refinement of the vertical orientation of the High Gothic facade can also be seen in the treatment of the west facade of Reims Cathedral (1225–1299). Though some of the elements are similar to those found in the Cathedral of Notre-Dame, there are significant differences as well. The portals at Reims project from the structure, and the tympanums of the portals have been replaced with windows. Pinnacles have been added to emphasize the vertical nature of the facade. Except for the rose window, the other elements on the face of the church are thinner and taller and are juxtaposed with a greater amount of sculptural embellishment than we have thus far seen.

Figure Sculpture

The sculptural figures represented in the portals of the western facade (1225–1245) of Reims Cathedral also reflect qualities of the High Gothic style of sculpture. This is especially evident in the embrasures, with figures that seem to be free-standing, in contrast to those of Chartres Cathedral, which approximate the same mass as the columns that support them. What maintains the figures' integration with the facade is the use of canopies above and pedestals below.

Stylistic differences among the figures indicate that a number of sculptors were involved in their creation. For example, on the central portal's right embrasure there are four sculpted figures. The two figures on the right represent the Visitation; the two figures on the left, the Annunciation. The sculptor of *The Visitation* based his figures upon the Classicism of late antiquity, as seen in the naturalistic interpretation of the figures' robes and faces. The physical mass of the figures is emphasized, for example, by the horizontal folds of the drapery appearing to be pulled across the abdomen. It is likely that the *Annunciation* figures were sculpted by two different craftsmen, because of the differing treatment of the Virgin and the angel. The Virgin is portrayed in a way that emphasizes her vertical orientation, the folds of her robe being elongated and angular. Her stance is rigid; her expression is solemn. The angel is crafted in an elegant fashion, her robe gently draped, her body slightly turned, a smile on her face.

The figures of Abraham and Melchizedek, carved during the middle of the thirteenth century and set in the interior western wall of the cathedral, exhibit the continued evolution of the elegant style seen in the angel of the *Annunciation*. Abraham, dressed in the garb of a knight, is portrayed rather severely; his pose is stiff and the angles of the folds of his drapery are sharp. Melchizedek, on the other hand, is depicted in a fashion that is reminiscent of the angel in the *Annunciation* in the way that the folds of his robe envelop him, and in the attention to detail in his beard and hair.

The Rayonnant Style

During the latter part of the thirteenth century there was a shift in emphasis from the vertical elements of the church to the refinement of

surface decoration. This refinement of design characterizes the Rayonnant style, which was centered in Paris at the Court of King Louis IX.

The Cathedral of Ste.-Chapelle

The Cathedral of Ste.-Chapelle (1243–1248) is considered by some to be an early representative of the Rayonnant style. Its designers attained a notable sense of weightlessness by reducing the structural supports to a minimum and increasing the amount of stained glass to the point that nearly three-quarters of the church consists of stained-glass windows. These windows, approximately fifty feet tall and fifteen feet wide, were probably the largest of their type created at the time and resulted in an interior that literally seemed to consist of walls of glass.

The Church of St.-Urbain

The Church of St.-Urbain (1261–1275), in Troyes, well illustrates Rayonnant style. The exterior is embellished with stone lacework and tracery that will become a characteristic of the late Gothic or Flamboyant style. Inside, the triforium has been deleted and the flying buttresses have been reduced to very slender arches. These subtle changes allow, as in the Cathedral of Ste.-Chapelle, for a greater mass of glass to be incorporated into the structure. The stained-glass windows of the chapel, for example, are set only some ten feet above the floor, giving one the illusion that the mass of the church is defined by the windows rather than by the stone walls and supports.

Late Gothic Architecture

The Late Gothic style of architecture is sometimes called the Flamboyant style because of its flamelike curve and countercurve decorative form. During the fourteenth and fifteenth centuries, when the style was particularly popular, France was at war with England, and few court-supported projects occurred. The new style, then, took place outside of the province of Île-de-France. The Church of St.-Maclou (1434–1514), in Rouen, Normandy, represents the Late Gothic style. Though smaller than many of the great cathedrals (75 feet tall, 180 feet long), it has a new facade design. Its five gabled portals form an arc,

with the gables filled with pierced flamboyant tracery. Behind the gables, arcades, also pierced and wiry, run diagonally along the roof line. Because the pierced gables are, in a sense, transparent, it is difficult initially to identify the various planes that define the facade.

English Gothic Architecture

Salisbury Cathedral

Representative of the English Gothic style of architecture is Salisbury Cathedral (1220–1270). Its overall plan is long, low, and rectangular, with a flat eastern end (characteristic of churches of the Cistercian Order) and two strongly projecting transepts. The interior is Gothic in its compound piers, its three-story elevation, and its use of ribbed vaulting with pointed arches, and there is a sense of segmentation found in Romanesque structures. However, there are differences that are typically English. The ribbed vaults, instead of connecting directly with the colonnettes, rise from corbels in the triforium, creating a horizontal orientation. It is with the English Gothic style that such elements as the vault, the wall, and the pier become increasingly complex in their decoration and detail.

The facade of Salisbury Cathedral is very different from those found on cathedrals in the Île-de-France, and as a screen wall, it extends beyond and does not correspond to the interior walls of the church. Its portals are small in relation to the overall scale of the facade, which consists of horizontal bands of niches filled with sculpture and ornamentation and incorporates two dwarf towers. The focal point of the cathedral is the tower that rises above the crossing square. Though flying buttresses are utilized, the height of the vault is modest.

German Gothic Architecture

Until the middle of the thirteenth century, most German churches retained a Romanesque orientation in their design, although some did incorporate the rib-vault, buttressed against the stone walls of the structures.

The *Hallenkirche*

When the influence of the French Gothic style was felt in Germany, it was interpreted and developed into the *Hallenkirche* (hall church), in which the aisles were constructed at the same height as the nave. The Church of St. Elizabeth (1233–1283), in Marburg, is such a church. This new design did away with the need for flying buttresses, because the aisles were able to provide the needed support. The effect upon the interior was such that the nave was more spacious, a quality enhanced by tall, double rows of windows.

The hall choir of the Church of St. Sebald, in Nuremberg, added between 1361 and 1372, is another example of the *Hallenkirche*. The openness of the space is similar to that beneath a canopy.

Cologne Cathedral

Another example of the German High Gothic style of architecture is Cologne Cathedral, which, though begun in 1248, remained unfinished until the nineteenth century. For 500 years the cathedral consisted solely of the lower sections of the facade towers, the transept, and the eastern end. Completed, the cathedral, with its 150-foot-high choir, seems to reach toward the sky, its vertical thrust emphasized by the structure's vertical lines and the tracery of the facade towers' spires.

Sculpture in German Gothic Churches

The sculpture of Germany, as well as its architecture, was influenced by the French Gothic style, as seen in the figures *Ekkehard and Uta* (1240–1250) from the choir of Naumburg Cathedral. Although carved quite some time after the deaths of these personages, the figures have the quality of portrait statues. The hints of naturalism and realism seen in *The Annunciation* and *The Visitation* at Chartres Cathedral are more evident here, in the manner in which the body and robes have been treated as separate elements. The drapery fits and flows about their forms as it would in real life. Additionally, the figures *Ekkehard and Uta* are significant because they reflect a change in attitude that allowed secular individuals to be represented in the cathedral.

These qualities of naturalism and personality are seen again in *The Kiss of Judas* (1240–1250), which is found on the choir screen of

Naumburg Cathedral. They are most evident in the differing stances of the passive Christ and the violent, sword-bearing figure of St. Peter.

Italian Gothic Architecture

Many of the Italian churches of the late twelfth and early thirteenth centuries followed the Gothic style as introduced by the Cistercian Order. The Abbey Church of Fossonova, consecrated in 1208, is such a church. Following the Cistercian canon of austerity, it has no facade towers, and only a lantern tower above the crossing square. The vaults, though including the pointed arch, do not have diagonal ribs.

The Church of San Francesco

Eventually, the Italian cathedrals developed their own stylistic orientation, as seen in the Church of San Francesco (1228–1239), at Assisi. Its plan is fairly simple and consists of a Latin cross with a five-sided apse. Inside, there is an equal balance of vertical and horizontal elements. There are no aisles, allowing for a wider nave, and the articulation of this space is defined by bays that are delineated by the placement of slender columns against the walls, forming piers. Except for some carving on some capitals, there is no relief sculpture inside. The fresco murals that cover the smooth walls of the nave are understated and reflect in a nonallegorical manner the life of Christ as well as that of St. Francis. The only elements of the High Gothic style seen here are the pointed traceried windows and the use of ribbed vaults.

The Cathedral of Florence

Art historians disagree as to whether or not the Cathedral of Florence (1296–1436) should be considered a Gothic structure. Though the nave consists of ribbed vaulting, its windows are small, there are no clerestory windows, and it lacks flying buttresses. The ribbed vaulting rests directly upon the nave arcade; this creates a horizontal orientation, emphasizing width rather than height. Inside, the focal point is the area beneath the dome. The exterior of the cathedral is decorated in the Tuscan manner of the Church of San Miniato, in Florence, with geometric designs in marble, and matches the nearby baptistery. The fact

that its facade was not completed until the nineteenth century reflects the attitude that the exterior was not as important as the interior. The orientation of the structure is horizontal, even with its massive octagonal dome. Next to the cathedral is a campanile that was designed in lieu of facade towers by the painter Giotto.

Milan Cathedral

In northern Italy, in the Lombardy region, northern European influences had greater impact than they did in central Italy. The design for Milan Cathedral (begun in 1386), the largest Gothic cathedral in Italy, was developed by architects from England, France, and Germany, as well as from Italy, and combines Gothic and Italian elements. The interior reflects the Italian influence in its ratio of height and width, whereas the exterior is Late Gothic in style.

The Town Hall

The church of this period was the religious center and the wealth and pride of a city; the town hall served as the secular center. The Palazzo Pubblico (1288–1309) of Siena was likely such a structure. Though more uniformly shaped than many of its contemporary structures, it possessed a bell tower from which one could see for miles around. Like the Palazzo Pubblico, the Palazzo Vecchio (1298), the town hall of Florence, has a fortresslike quality. The political situation of the time, the constant threat of civil war from within as well as attack from the outside, required that these town hall structures be fortified. Their massive walls and battlemented towers bear witness to the city governors' need to defend themselves. The defensive posture of the Palazzo Pubblico and the Palazzo Vecchio is seen in much of the secular architecture of the Italian mainland as well; this is a prime example of how nonarchitectural considerations can affect the design of a building.

The Doge's Palace

Whereas Milan and the rest of the Italian mainland had to deal with the problems arising from civil unrest, Venice, surrounded by water, protected by a navy, and governed by a stable system of ruling families for centuries, was able to develop a different style of secular architec-

ture. At ground level of the Doge's Palace, stubby columns support pointed arches that sustain the weight of the structure above. At the second level, the number of columns has been doubled, while their mass has been reduced, resulting in slender columns carrying *ogival*, or diagonal, arches with pierced medallions. The scale of the building has been determined geometrically; each story is taller than the one below, with the uppermost story equaling the height of the two lower stories. The face of the upper story is covered with cream- and rose-colored marble, creating a geometric pattern that alleviates the sense of mass that would otherwise occur.

Recommended Reading for Part III

The Middle Ages

Conant, K. (1978). *Carolingian and Romanesque Architecture*. Harmondsworth: Penguin.

Davis-Weyer, C. (1971). *Early Medieval Art, 300–1150*. Englewood Cliffs, N.J.: Prentice Hall.

Frisch, T. (1987). *Gothic Art, 1140–ca.1450*. Toronto: University of Toronto Press.

Grodecki, L. (1977). *Gothic Architecture*. New York: Abrams.

Hearn, M. (1981). *Romanesque Sculpture*. Ithaca, N.Y.: Cornell University Press.

Snyder, J. (1989). *Medieval Art: Painting, Sculpture, Architecture, 4th–14th Century*. New York: Abrams.

Stokstad, M. (1986). *Medieval Art*. New York: Harper & Row.

Swann, W. (1969). *The Gothic Cathedral*. Garden City, N.Y.: Doubleday.

Part IV

The Renaissance; The Baroque

Until a century ago, the Renaissance, encompassing the fourteenth through the sixteenth centuries, was seen as the "rebirth" of Classical culture following the Middle Ages, which were perceived as a period of cultural and artistic darkness. Since then, historians have come to realize two important things: one, that during the years between the fall of the Roman Empire and the fifteenth century, Classicism in fact continued to figure in medieval culture, and two, that much that was considered to be medieval carried over into the Renaissance.

To identify a particular moment or event as representing the end of the Middle Ages and the beginning of the Renaissance is difficult, if not impossible, and there are researchers today who question whether there actually was a "renaissance." They hold instead that the notion of a renaissance of Classical art and culture was put forth by Italian humanists of the late fourteenth and fifteenth centuries who believed that the Middle Ages represented a period of artistic degeneration and who saw the "sudden" revival of accomplished artists during their own age.

Though the degree to which there was an actual resurgence in the arts may be in question, there is no doubt that the Renaissance was an era of change in many domains. It was a period of experimentation,

during which time artists discovered the mathematical formulas neces-
sary for visually representing perspective and space accurately on a
two-dimensional surface. It was during this time that the power of the
popes declined and the influence of local clergy grew, as the division
between church and state became less and less distinct. Advancements
in science and technology allowed for exploration of the world beyond
Europe, and with these advances came new economic rewards. Also
significant were the changes that occurred in humankind's perception
of people and the world within which they lived.

As noted earlier, the art of Gothic France had primarily been
supported by the royal family. In Italy, the art of the Renaissance period
was supported by the merchant class, which also governed the cities.
Though people of the Middle Ages were concerned with saving their
immortal souls, the people of the Renaissance looked inward toward
achieving greatness through their own efforts and held in high esteem
the notions of humanism and individualism. These beliefs were postu-
lated by the fourteenth-century poet Petrarch, who believed that only
the gifted were revered by society, and therefore, if one's work was
upheld by the public, then one must be worthy. This philosophy of
humanism led many to return to the works of the Classical period, from
which they concluded that one's attention should be focused upon life
in this world with humankind at the center of the universe, being guided
by reason rather than doctrine. Where the medieval theologian had
utilized Classical sources to support Church doctrine, the Renaissance
humanist, though retaining faith, referred to the classics in order to seek
guidance concerning humankind's ability to "know" through ex-
perience.

CHAPTER 12

The Early Renaissance

Chronology

c. 1220–1278	Nicola Pisano
c. 1250–after 1314	Giovanni Pisano
c. 1255–c. 1319	Duccio di Buoninsegna
1259–1260	Nicola Pisano: Marble pulpit, Baptistery of Pisa Cathedral
c. 1267–c. 1337	Giotto di Bondone
14th–16th cent.	The Renaissance
1302–1310	Giovanni Pisano: The *Nativity*, panel in marble pulpit of Pisa Cathedral

147

1305–1306	Giotto: Fresco, *The Lamentation*, Arena Chapel, Padua
1308–1311	Duccio: Panel, The *Maestà Altar*
c. 1351	Boccaccio writes *Decameron*
c. 1374–1438	Jacopo della Quercia
1377–1446	Filippo Brunelleschi
1380–1406	Claus Sluter
c. 1381–1455	Lorenzo Ghiberti
c. 1384–1421	Nanni di Banco
1386–1400	Chaucer writes *Canterbury Tales*
1386–1466	Donatello
1395–1406	Sluter: *The Moses Well*
1397–1475	Paolo Uccello
1401	Competition, design for north doors of Baptistery of Florence
1401–1428	Tommaso Guido Masaccio
1404–1472	Leone Battista Alberti
1410–1414	Di Banco: *Quattro Santi Coronati*, Church of Or San Michele, Florence
c. 1410–1461	Domenico Veneziano
1411–1413	Donatello: *St. Mark*, Church of Or San Michele
1412	Filippo Brunelleschi writes *The Rules of Perspective*
c. 1415–1417	Donatello: *St. George*, Church of Or San Michele
1420–1436	Brunelleschi: Dome, Cathedral of Florence

c. 1420–1492	Piero della Francesca
1423–1425	Donatello: *Zuccone* (*Prophet*), Cathedral of Florence
1423–1457	Andrea del Castagno
1425–1452	Ghiberti: *Gates of Paradise*, east doors of Baptistery of Florence
c. 1425–1430	Donatello: *David*
c. 1427	Masaccio: *The Tribute Money*
1430	Jacopo: *The Expulsion from the Garden of Eden*
1431	Joan of Arc burned at stake
1431–1498	Antonio del Pollaiuolo
1434	Rise to power of the Medici in Florence
1435–1488	Andrea del Verrocchio
c. 1444–1510	Sandro Botticelli
1445	Domenico: *St. Lucy Altarpiece*
1445–1450	Donatello: *Erasmo da Narni* (*Equestrian Monument of Gattamelata*), Padua
c. 1445–1450	Castagno: *The Last Supper*
1446–1451	Alberti: Palazzo Rucellai, Florence
1450	Alberti: Renovation of exterior of Church of San Francesco, Rimini
1454–1456	Gutenberg Bible is published
c. 1455	Uccello: *Battle of San Romano*
c. 1460	Piero: *The Resurrection*
1465	Verrocchio: *David*
c. 1465–1470	Pollaiuolo: *Battle of Ten Naked Men*

1468	Rossellino: *Matteo Palmieri*
1470	Alberti: Church of San Andrea, Mantua
c. 1475	Pollaiuolo: *Herakles and Antaios*
1478	Botticelli: *Primavera*
c. 1480	Botticelli: *The Birth of Venus*
c. 1483–1488	Verrocchio: *Equestrian Monument of Colleoni*, Venice

Though for much of Europe the Gothic style continued into the sixteenth century, the beginnings of the Renaissance style can be seen rising in Italy during the late thirteenth century. Among the artists whose works represent the transition between the medieval and Renaissance styles are Nicola Pisano, Duccio di Buoninsegna, Giotto di Bondone, and Claus Sluter. Stylistically their work possessed qualities that would be seen in the Renaissance period. However, they are still frequently associated with the Middle Ages because, though the Renaissance artist typically looked to Greece and Rome for inspiration, these artists still primarily relied upon earlier works from Byzantium and the Gothic style.

The Early Renaissance was a time of experimentation; it was during this time that artists discovered the mathematical formulas necessary for representing perspective and space accurately on a two-dimensional surface. There was innovation not only in architecture and painting, but also in sculpture, where the movement toward an art of realism based upon observation was at the same time interpreted in a Classical mode.

Transitionary Artists

Nicola Pisano

The marble pulpit of the baptistery of Pisa Cathedral (1259–1260), by the sculptor Nicola Pisano (c. 1220–1278), incorporates elements of both medieval and Classical design. Though the lions at the base of the columns supporting the pulpit are typically medieval, the round arches, Corinthianlike capitals, and rectangular reliefs that enclose the pulpit all have a Classical quality. Pisano's use of the Classical prototype is clearly seen in the organization and treatment of the figures in the relief panels of the pulpit, which are similar to some relief panels found on Roman sarcophagi. One of Pisano's panels in particular, the *Nativity*, represents figures that are obviously classically inspired in their heavy forms, proportion, posture, and costuming.

Giovanni Pisano

Nicola Pisano's son, Giovanni Pisano (c. 1250–after 1314), was also a sculptor. His marble panel relief of the *Nativity* from the pulpit of Pisa Cathedral (Santa Andrea of Pistoia) (1302–1310), created some forty years after his father's classicized work, is very different in treatment. The elder Pisano's figures seem somewhat heavy and stiff when compared to the animated and "plastic" forms created by his son.

Duccio

The work of the Sienese painter Duccio di Buoninsegna (c. 1255–1319) may also be considered transitionary, as seen in his altarpiece, the *Maestà Altar* (1308–1311), which portrays, on one side, the Madonna as the Queen of Heaven and, on the other side, various scenes from the life of Christ. Here Duccio's contribution to later artists is seen in his treatment of space within the composition as well as in the manner in which he has modeled his figures (in contrast to the traditionally flat Byzantine style of depiction). These qualities are especially evident in the section *Christ Entering Jerusalem*. Here the architecture is not flattened out and used merely as background for the action taking place in the foreground, but is staggered within the picture plane and is used to create a sense of "real" space with depth and mass. It is also

significant to note the way in which Duccio utilizes light and dark to define the figures and the drapery that envelops them. His treatment also effectively guides the viewer through the composition.

Giotto

The Florentine painter Giotto di Bondone (c. 1267–1337) went to even further extremes than Duccio in his treatment of space. As seen in the Arena Chapel in Padua, Giotto's fresco painting *The Lamentation* (1305–1306) represents a very different manner of depicting space within a painting. Instead of flattening out the forms as areas of decorative space, Giotto treats the composition as if it were a theatrical scene upon a stage, with the viewer as audience. In effect, the space of the picture plane begins with the viewer and then seems to recede continuously into the picture, drawing the viewer along. Though the illusion of looking "through a window" into a scene is a common one for us today, during the fourteenth century it was considered to be quite revolutionary. This effect, combined with Giotto's treatment of his figures within the painting as emotional, feeling beings, produced an image with a powerful impact.

Claus Sluter

Claus Sluter (1380–1406), a Dutch sculptor who practiced his craft in France during the last decade or so of the fourteenth century, is perhaps best known for his high-relief sculpture known as *The Moses Well* (1395–1406). The sculptural pedestal has six sides, and emerging from each panel is a life-size prophet from the Old Testament. What is striking about these figures is the individuality of personality that is portrayed in each. Though the figures themselves lack the rigidity typical of the style of the Middle Ages, this quality is still seen in the heavy treatment of the drapery and fabric that envelop them.

The Artist's Knowledge of the Visual World

Whereas artists during the Middle Ages had relied upon established archetypal images as sources for their depiction of the human figure, the Renaissance artist, living in an era that allowed for humankind to

examine itself and its surroundings, slowly began to shift this visual attention to the natural world. By the fifteenth century, it was an accepted practice to utilize nature as a source for one's artistic production; by the sixteenth century, concise theories encompassing the naturalistic representation of the human figure and the visual world were established.

These changes in the core values concerning the manner in which art was produced paralleled changes in thought concerning how humankind was to know its world. Instead of the traditional modes of thought typical of the Middle Ages, in which people were to come to know God and the world through philosophy and reason, the people of the Renaissance came to rely on direct human experience for their knowledge. This approach supported the notion of experimentation that emerged with the scientific method of investigating natural phenomena.

The Fifteenth Century in Florence

Many historians consider Florence to have been the source of the Renaissance, which commenced at the beginning of the fifteenth century. Florence was then governed by wealthy families from the merchant class, including the Albizzi, Capponi, Medici, Pazzi, and Strozzi. By the 1430s, however, it was the Medici family that ruled the city, though not by title. The Medici were also great patrons of the arts and literature.

Relief Sculpture: The Baptistery Doors Competition

Representative of the new artistic era of Florence was a competition held in 1401 for the design of the north doors of the Baptistery of Florence, which was built in the eleventh century. The south doors of the Baptistery, cast in bronze, had been designed by Andrea Pisano and were Gothic in style. Six artists were selected from those who entered the competition, and they were given one year to design and produce a panel cast in bronze depicting the Old Testament story of the sacrifice of Isaac. At the end of the year, the works of the artists were judged, and the field was narrowed down to the work of two young artists: Filippo Brunelleschi (1377–1446) and Lorenzo Ghiberti (c. 1381–

1455). As it happened, their entries to the competition also were the least conservative and traditional of the works submitted.

Brunelleschi's Entry

Brunelleschi's entry depicted the exact instant Abraham's thrust of the knife toward his son Isaac's throat was stopped by an angel of the Lord. Brunelleschi's placement of the figures within the panel seemed to be in response to the four-lobed (quatrefoil) form of the panel itself, with the angel on the left, Abraham on the right, and Isaac in the middle—a fairly symmetrical composition. The stances of the figures as well as the sweeping drapery that enveloped them appeared to reflect the shape of the panel.

Ghiberti's Entry

The panel that Ghiberti submitted—and for which he won the prize—portrayed Abraham and Isaac at a moment in time when Abraham was about to thrust the knife into his son's throat. His placement of the figures within the panel was asymmetrical, with the focus of attention upon Abraham in the middle and Isaac on the right. Ghiberti's treatment of the figure of Isaac reveals, in part, the direction the Renaissance was to flow. His Isaac was obviously based upon earlier Classical works, as reflected in the figure's musculature and well-proportioned form; the panel reflects both a sense of realism and the quality of idealized beauty. Ghiberti's design for the doors followed the format established by Pisano on the south doors, with the space divided up into twenty-eight quatrefoils, each representing a figure or a biblical scene. As in his prize-winning panel, Ghiberti's style as seen in his treatment of the figures and his use of space represented a shift from Gothic idealism to naturalism.

Ghiberti's Gates of Paradise

Soon after Ghiberti's doors were completed and installed, he was offered the opportunity to create yet another set of doors, this time for the eastern side of the baptistery facing the cathedral. These doors took twenty-five years to complete and were finally set in place in 1452. His design for these doors changed somewhat from the earlier ones, as seen, for example, in the manner in which he reduced the number of panels from twenty-eight to ten and used the same figural proportion throughout, so that the foreground figures were all the same size. His treatment

of space, perspective, and the figure suggests his continued study of nature. These doors so impressed the artist Michelangelo that he referred to them as the *Gates of Paradise*, a title still in use today.

Jacopo della Quercia

Another artist who submitted a panel for consideration in the baptistery competition of 1401 was Jacopo della Quercia (c. 1374–1438). His relief panel, *The Expulsion from the Garden of Eden* (1430), part of a series he created for the Church of San Petronio in Bologna, consisted of well-muscled figures that reflected the Classical period. Though sculpted in relief, the forms seem nearly powerful enough to stand on their own.

Nanni di Banco

The *Quattro Santi Coronati* (1410–1414), found in an outside niche of the Church of Or San Michele in Florence, do stand on their own. The life-size figures commemorate the martyrdom of four Christian sculptors who refused the Roman emperor Diocletian his request for pagan images. Sculpted by Nanni di Banco (c. 1384–1421), they reflect a partial resolution to the problem of integrating sculpture and architecture. Though the niche is part of the architecture, the treatment of its space conveys a sense of separation. The figures relate to one another, not only because they are installed in a semicircular pattern, but also because they are gesturing toward and looking at each other; while one "speaks," the others "listen."

Sculpture

Donatello

The movement toward an art of realism based upon observation of the world, yet at the same time interpreted in a Classical mode, comes together with the work of the sculptor Donato di Niccolo di Betto Bardi (1386–1466). Better known as Donatello, he is considered to be the progenitor of modern sculpture. As a youth, Donatello was one of a number of assistants who worked with Ghiberti on the first set of the bronze doors for the Baptistery of Florence.

An early work, *St. Mark* (1411–1413), commissioned for the Or San Michele in Florence, reflects Donatello's awareness of Classical Greek and Roman sculpture, his familiarity with the Bible, and his

desire to imbue his works with a sense of animation. The pose of *St. Mark* and the manner in which the figure's weight is distributed are distinctly Greek, and it is here that we first see the use of *contrapposto* since the Classical period. At the same time, Donatello has imbued the figure with a personality, perhaps the result of his readings of the Gospel. Though the figure was placed within a niche, in a sense removing it from the immediate environment of the viewer, it is free-standing and self-sustaining, and its impact upon the viewer owes little to the environment within which it exists. The figure of *St. Mark* is very lifelike, and the enveloping drapery is not independent of the body beneath, but seems to move with it.

In 1415, Donatello was commissioned by the armorers' guild to do a sculpture of St. George (1415–1417) for the Or San Michele in Florence. This work is considered by many to be of special significance because, they feel, more than appealing to the viewer schematically on a purely symbolic level, it also reaches out psychologically. Donatello achieved this psychological effect by imbuing the figure with personality. The character and inner strength of St. George are apparent; the niche within which he stands is shallow, and he appears to share the space of the viewer more than that of the architecture. Here we see another change occurring in the Renaissance, the shift from saint as symbol to man as hero.

During the next twenty years, among other works, Donatello sculpted five statues for the campanile of the Cathedral of Florence. One of the most interesting, reflecting Donatello's attention to personality and the inner psyche, is the figure of a prophet (1423–1425) that has come to be known as *Zuccone*, or "pumpkin head." Zuccone is bald, and his features, figure, and costume are realistically sculpted in the manner of portrait sculpture from Roman times. The somewhat disheveled appearance of the drapery that envelops Zuccone belies the power and intensity of his stare. Close scrutiny is required to grasp the subtlety of the craftsmanship.

Donatello's *David* (c. 1425–1430) is honored as being the first free-standing nude statue to be presented in the round since antiquity. Classical in nature, the nude David is portrayed as neither an athlete nor a god but as a self-conscious, introspective figure, albeit a sensuous one, reflecting Donatello's ability to combine naturalism and idealization and to infuse a figure with a sense of both action and inaction. As a

milestone in Renaissance art, *David* represents the achievement of high-quality bronze casting, the acceptance of free-standing sculpture, and the use of the nude as a subject, which had been considered generally inappropriate during the Middle Ages.

From between 1445 to 1450, Donatello worked on a commission in Padua. The work was an equestrian statue of Erasmo da Narni, also known as Gattamelata, who was a captain-general of the Venetian army. Like the equestrian statues of Rome, Donatello's equestrian statue of Erasmo da Narni conveyed a sense of restrained power of both beast and man. Though dressed in Roman armor, da Narni's costume reflects the style of the period. Also interesting to note is the manner in which Donatello modeled the features of the figure's face so that it would most effectively be perceived from ground level rather than at eye level.

The Portrait Bust

Throughout the latter half of the fifteenth century, Donatello's successors continued to develop his innovations in sculpture. During this age of humanism, the portrait bust again became popular. Antonio Rossellino's portrait bust of Matteo Palmieri (1468) is realistic and lifelike in its sense of individuality but does not possess the death mask quality that is typical of many of the earlier Roman portrait busts.

Andrea del Verrocchio

Probably the most significant sculptor of the latter half of the fifteenth century was Andrea del Verrocchio (1435–1488), whose students included, among others, Leonardo da Vinci. Like Donatello, Verrocchio also made a bronze *David* (1465). Verrocchio's *David* possesses the physicality, stance, and attitude of a young man who has just achieved a great victory. Whereas Donatello's *David* was relaxed, Verrocchio's possesses the tension of the fight.

Another comparison may be made between the work of the two master sculptors by way of Donatello's equestrian statue of Erasmo da Narni (1445–1450) and Verrocchio's equestrian statue of Bartolommeo Colleoni (c. 1483–1488). Given the challenge of representing the condottiere, Verrocchio created a work of great power and energy. Bartolommeo Colleoni's horse does not walk, it prances; its powerful neck twists to one side, muscles rippling with excitement as it is reined in by its rider. The condottiere himself is portrayed as a powerful figure, with

the stirrups bearing his weight as he seems to lift himself from the saddle while turning to address his troops.

Antonio del Pollaiuolo

Though much of the figure sculpture made during this time portrayed individuals at rest or at intervals of motion, the bronze sculpture *Herakles and Antaios* (c. 1475) by Antonio del Pollaiuolo (1431–1498) is worthy of notice because it depicts two individuals in motion as combatants and because it represents a return to Classicism for subject matter as well as style.

Painting

At the same time that Donatello was struggling with naturalism and animation in his sculpture, the early Renaissance painters were grappling with these same concepts as they applied to the flat, two-dimensional surfaces upon which they worked.

Tommaso Guidi Masaccio

One painter whose work was highly influential was Tommaso Guidi Masaccio (1401–1428). Masaccio combined contemporary advances in perspective and the naturalistic style with the style of Giotto to arrive at a new way of representing space on a flat surface. His best-known work, *The Tribute Money* (c. 1427), reflects his mastery of composition in the manner in which he depicts three episodes of the story in the same painting. The focal point of the painting is the group of Apostles with Christ in the middle, placed just off-center in the composition. Here, Christ is telling Peter to pay the tax collector with a coin he will find in a fish's mouth. To the left Peter is depicted at the water's edge removing the coin from the fish's mouth. This episode is not apparently that significant to Masaccio, for it is placed at the very edge of the composition. Attention is then called to the conclusion of the story, where, on the right, Peter pays the tax collector. Masaccio's use of architecture as background effectively separates the two figures from the rest of the composition.

Like Donatello, Masaccio's use of *contrapposto* imbues his figures with substance and weight. The drapery that envelops them reflects the structure of the forms and the flesh underneath and allows the viewer to believe that the figures are capable of movement. Masaccio's use of

light and shadow imparts a dramatic sense of modeling to the figures and the illusion of depth within the picture plane. A sense of real space is created by arranging the group of Apostles in a circle around Jesus; as the space within the painting recedes, forms and colors become less distinct as they do in the visual world we live in.

Perspective and Representation of the Human Figure

Other Renaissance painters would continue to focus their efforts toward perfecting the application of perspective and the representation of the human form structurally. The painting *Battle of San Romano* (c. 1455), by Paolo Uccello (1397–1475), reflects the artist's passion for depicting perspective and his lesser interest in convincingly representing the human form. Andrea del Castagno (1423–1457), in his *Last Supper* (c. 1445–1450), employs perspective in so rigid a manner that it limits the perceived potential for movement on the part of the characters he portrays.

A contemporary of Castagno, Domenico Veneziano (1410–1461) also strove to master the phenomena of perspective and naturalistic figure depiction. His *St. Lucy Altarpiece* (1445), an early genre example of the *sacra conversazione*, in which figures appear to be in conversation with the viewer or one another, reflects his level of craftsmanship.

The work of Piero della Francesca (c. 1420–1492), a student of Domenico and a great admirer of Masaccio, incorporated the rules of geometry and mathematics as a basis for pictorial composition. In his fresco painting *The Resurrection* (c. 1460), Piero has arranged his figures in such a way as to form a triangle, with the sleeping soldiers at the base and Christ's head at the apex, his body forming the vertical axis of the painting. By arranging Christ in a pose that has his left leg raised and bent and his right arm lifted while holding a staff and banner, Piero has softened the symmetrical arrangement of the composition. Though there is a definite structure that contributes to the strength of the composition, the figures themselves are fluid and natural in their poses.

The Depiction of Realism in the Human Figure

Antonio del Pollaiuolo, mentioned earlier as a sculptor, was also an engraver and a painter. His engraving *Battle of Ten Naked Men* (c. 1465–1470) reflects his interest in pursuing the depiction of realism in the human figure [see illustration 5]. By creating a scene of battle, he has provided himself with the opportunity to portray the human figure

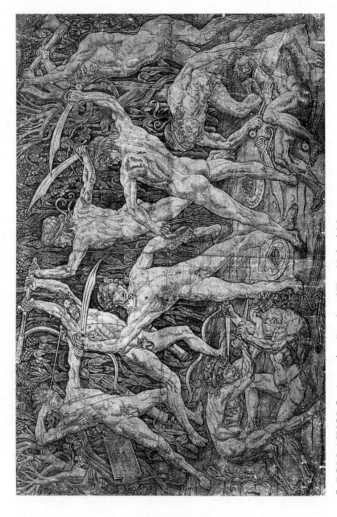

5. POLLAIUOLO, Antonio. *Battle of Ten Naked Men.*
Engraving.
The Metropolitan Museum of Art, Purchase, 1917, Joseph Pulitzer Bequest. (17.50.99)

in action in a variety of poses and from many different angles. Though Pollaiuolo was familiar with human anatomy, his figures appear to be somewhat stiff due to the fact that he has depicted his combatants with all their muscles contracted, not realizing that in reality, while some muscles are contracting others are relaxed. The power of this image reflects Pollaiuolo's use of outline rather than modeling to indicate action. His treatment of the figures' faces reflects the strain portrayed in their poses, linking physical action and emotional level.

Sandro Botticelli

A major painter of this era was Sandro Botticelli (c. 1444–1510) who, like Raphael and Michelangelo, had the good fortune to receive the patronage of the Medici family. Botticelli's paintings *Primavera* (1478) and *The Birth of Venus* (c. 1480) are two large works that the Medici family commissioned for their villa. Both works reflect the artist's interest in Greek and Roman myths as sources for his paintings, as well as his interest in the portrayal of the feminine form. His women are sensuously modeled and seem nearly weightless; it is obvious that his attention is focused upon them rather than upon the space of the composition, which is rather flat and shallow. In both paintings, Venus is the main subject, reflecting a shift away from the traditional female subjects of Eve and Mary. Botticelli's *Birth of Venus* is especially significant because his nude Venus is the first portrayal of a large female nude since the Classical period.

Architecture

Filippo Brunelleschi as Architect

Though Filippo Brunelleschi's entry to the competition for the bronze doors of the Baptistery of Florence was not selected for the commission in 1401, he continued to work as a sculptor and goldsmith for several years before turning toward architecture as an avocation. In his travels to Rome, he became familiar with Roman architecture and building techniques and, through his drawings of various buildings and monuments, contributed much to the growing body of knowledge having to do with linear perspective.

In 1420 an architectural competition was held, the prize being the honor of designing the dome (1420–1436) of the Cathedral of Florence. Again, as in the competition of 1401, both Brunelleschi and Ghiberti

entered. This time, Brunelleschi received the commission. Though construction of the cathedral had begun in 1297, the dome was never finished because the technology had not then existed to cover a space that was 140 feet in width. The traditional system of buttressing would not work in this case, given the octagonal drum already in place. Brunelleschi's solution was to construct the dome out of three shells around a framework of ribs, with the two innermost shells connected by ribs and bearing most of the weight. Brunelleschi was responsible for the design of many buildings in Florence, including the Ospedale degli Innocenti, the Church of San Lorenzo, the Church of Santo Spirito, and the Pazzi Chapel.

Leone Battista Alberti

Like Brunelleschi, the architect Leone Battista Alberti (1404–1472) began his career as an artist. His Palazzo Rucellai (1446–1451) in Florence consists of three stories with a somewhat classical facade. The design of the facade was likely based upon that of the Roman Colosseum, but the columns are nearly flush with the exterior wall, reflecting Alberti's desire to integrate Classical motif with non-Classical architecture.

In 1450, Alberti received a commission to renovate the exterior of the Gothic Church of San Francesco in Rimini. His solution was to literally build an outer structure around the older building. The facade of the building consists of three large arched niches, the middle one encasing the entrance being the largest. On either side of the niches are columns sitting on blocks, similar to those found on the Arch of Constantine in Rome. Whereas the columns of the Palazzo Rucellai are nearly flush with the exterior wall, allowing for a horizontal orientation to the structure, the columns of the Church of San Francesco contribute to the facade's strong vertical orientation, as they do in earlier basilica.

Alberti resolved the problem of integrating the Classical motif with non-Classical architecture in his design for the Church of San Andrea in Mantua in 1470. His solution can be seen in its façade. Here, in the center, Alberti placed a deep, arched niche. He again used flat columns, so as to not draw attention away from the surface of the facade, but these columns are not as flush as those of the Palazzo Rucellai and thus serve as an accent. The two outer pairs of columns stand the full three stories of the structure, while the columns that support the arch are only two stories tall and are etched with vertical lines.

CHAPTER 13

The High Renaissance

Chronology

1489–1492	Michelangelo apprentices at sculpture studio of Lorenzo de' Medici
1490–1576	Titian (Tiziano Vecelli)
1492	Columbus lands in America
1494–1557	Jacopo Pontormo
1495–1520	The High Renaissance
1495–1540	Rosso Fiorentino
c. 1495–1498	Leonardo: *The Last Supper*, refectory of the Church of Santa Maria delle Grazie, Milan
1499–1546	Giulio Romano
1500–1571	Benvenuto Cellini
1501–1504	Michelangelo: *David*
c. 1503–1505	Leonardo: *Mona Lisa*
1503–1540	Parmigianino (Girolamo Grancesco Mairia Massuoli)
1503–1572	Agnolo Bronzino
1505–1506	Raphael: *Madonna del Cardellino*
1508–1512	Michelangelo: Ceiling fresco of the Sistine Chapel, the Vatican
1509	Henry, Prince of Wales, crowned King Henry VIII of England
1510–1511	Raphael: *The School of Athens*, Stanza della Segnatura, the Vatican
c. 1513–1515	Michelangelo: *Moses*
1517	Martin Luther posts his ninety-five theses
1518–1594	Jacobo Robusti Tintoretto

1519	Magellan begins his voyage around the world
1519–1526	Titian: *Madonna with Members of the Pesaro Family*, Church of San Maria dei Frari, Venice
c. 1520	Titian: *Man with the Glove*
1520–1600	Mannerism
1521	Rosso: *The Descent from the Cross*
begun 1524	Michelangelo: Laurentian Library, San Lorenzo
1525–1528	Pontormo: *The Descent from the Cross*
1525–1535	Romano: Palazzo del Te', Mantua
1529–1608	Giovanni da Bologna
1534–1541	Michelangelo: *The Last Judgment*, altar wall of the Sistine Chapel, the Vatican
c. 1535	Parmigianino: *The Madonna with the Long Neck*
1537	Michelangelo: Capitoline Hill, Rome
1538	Titian: *Venus of Urbino*
1541–1614	El Greco (Domenikos Theotocopoulos)
1543–1544	Cellini: *Diana of Fontainebleau*
1546–1564	Michelangelo: St. Peter's Cathedral
1548	Titian: *Charles V at Muhlberg*
1550	Bronzino: *Venus, Cupid, Folly, and Time*
1550	Bronzino: *Portrait of a Young Man*
c. 1550	Bronzino: *Eleanora of Toledo and Her Son Giovanni de' Medici*

1564	William Shakespeare born
1566–1567	Tintoretto: *Christ before Pilate*
1583	Da Bologna: *The Rape of the Sabine Woman*
1586	El Greco: *The Burial of Count Orgaz*
1592–1594	Tintoretto: *The Last Supper*
1594	Shakespeare writes *The Two Gentlemen of Verona*
1605	El Greco: *Fray Felix Hortensio Paravicino*
1605–1615	Cervantes writes *Don Quixote*
1610	El Greco: *The Vision of St. John*
1610	El Greco: *Christ on the Cross with Landscape*

It was during the sixteenth century that the perception of the artist as genius rather than artisan developed. Though the High Renaissance lasted only from 1495 to 1520, many well-known personalities, including Leonardo da Vinci, Michelangelo, Raphael, Titian, Tintoretto, and El Greco, lived during this time. The concept of the Renaissance man emerged, representing an individual with diverse interests who has proven expertise and mastery in different areas.

Florence, which up to this point had been the artistic center of the Renaissance, was in political upheaval; as a result, Venice, Rome, and Milan began to share artistic leadership. There was continued growth in the monumentality of the arts, including architecture, and the developing perception of the arts as intellectual endeavor. The various artistic centers began to represent different schools of thought, with Rome and Florence being the centers of the Mannerist style. During the period between the late fifteenth century and the mid-sixteenth century, Rome became the center of political and artistic power owing to the efforts of a succession of powerful popes. The technical aspects of the arts were not the only issue of attention; the creative dimensions of artistic work were valued as well.

Leonardo da Vinci

Leonardo da Vinci (1452–1519) epitomizes the concept of the Renaissance man. Sculptor, painter, and architect, his range of interests and achievements spanned and exceeded the dimensions of art, extending into science, engineering, anatomy, mathematics, and music.

From age fifteen to twenty-five, Leonardo served as an apprentice to the painter and sculptor Andrea del Verrocchio in Florence. In 1482, he moved to Milan. There he served as the official artist of the duke of Milan until 1499, when he returned to Florence. During his latter years, Leonardo was court painter to Louis XII, king of France, and to his successor, Francis I. Though many of his notebooks and drawings have survived, only a dozen paintings can be absolutely attributed to him; of his sculpture, none are known to exist today, yet his influence was monumental.

The Adoration of the Magi

One of Leonardo's early commissions, an altarpiece for the monks of San Donato a Scopeto, is an unfinished work entitled *The Adoration of the Magi* (1481–1482). His preliminary sketches for the painting reflect the process he went through to achieve his final image. Leonardo's sense of precise order and his use of perspective are evident in the composition of the work, which depicts over sixty individuals whose facial expressions and gestures serve as the focus of attention for the viewer. His figures are not defined by line but rather by light and shadow (chiaroscuro). Whereas other painters had applied shadow to their figures in order to model them and create a sense of mass, Leonardo's figures appear to emerge from the darkness, challenging traditional conceptions of light and dark and how shape is defined.

The Virgin of the Rocks

In 1485, while in Milan, Leonardo painted *The Virgin of the Rocks*, utilizing a strong triangular orientation (similar to that seen in Francesca's *The Resurrection*), as well as chiaroscuro to model the figures. Light and shadow are used to both reveal and conceal the figures, who form a group, unified by their gestures toward one another. Hazy and dreamlike, the atmosphere of the painting contributes to the

work's being perceived as a poetic image rather than as a real-world representation.

The Last Supper

When Leonardo was commissioned by the friars of the Church of Santa Maria delle Grazie in Milan to do a painting in their refectory, the subject to be depicted was a traditional one: the Last Supper. This theme had been painted many times and, typically, was composed with the Apostles lined up next to Christ on one side of a table and Judas standing on the opposite side. Leonardo's approach to the composition, as seen in his version of *The Last Supper* (c. 1495–1498), would be considered the first great work of the High Renaissance. His figures are expressive, the Apostles appearing startled at Christ's declaration that one of them would betray him. Christ, in the center, is framed by a window with an arch that acts as a halo, and the reaction of the Apostles to his words is linked to the way they are posed in groups of three. Leonardo's space is created out of a mathematical precision that makes the room seem to be impossibly perfect in its dimensions. Though close scrutiny might lead the viewer to the conclusion that the scale of the figures does not match that of the room, the illusion is necessary to create a powerful image, one that portrays tragedy. Drama is added to the scene in the artist's use of atmosphere and chiaroscuro and through the emotions he has imbedded in the facial features and gestures of the figures.

What is unfortunate about the work is its lack of physical durability. In order to avoid the restrictions of the fresco technique, which required that the artist work quickly in applying paint to still-wet plaster that would adhere it to the wall surface, Leonardo experimented with a pigment that he felt would not only allow him to obtain the subtleties of light and shadow he sought but would also allow him to work on the entire composition at the same time on a dry wall. Unfortunately, his pigment did not take well to the wall, and even during Leonardo's lifetime there were signs of deterioration. Restoration of *The Last Supper* has been continuous; as early as the eighteenth century it had been repainted twice.

Mona Lisa

Leonardo was also responsible for what has probably become the world's best-known portrait: *Mona Lisa* (c. 1503–1505). The portrait is of La Gioconda, the wife of Zanobi del Gioconda, a banker in Florence. As in Leonardo's earlier works, his use of *sfumato* is instrumental in creating a hazy atmosphere. The subtle modeling of the figure's features, which obscures the expression on her face, contributes to what has been referred to as her enigmatic smile.

Michelangelo

Michelangelo Buonarroti (1475–1564), though a master of painting and architecture, saw himself foremost as a sculptor. At age thirteen he was apprenticed to the painter Domenic Ghirlandaio, and at fourteen he entered the sculpture studio of Lorenzo de' Medici, where he studied with Bertoldo. By the time he was seventeen, he felt ready to set out on his own. His manner was one of independence of thought. He dispensed with the mathematical proportions established by others for portraying idealized beauty, trusting instead his own senses, his own eye.

David

By the time Michelangelo was twenty-five, his reputation as a sculptor was already such that he received a commission in Rome. The sculpture was of the biblical character David (1501–1504), and its impact upon the viewer is likely no less today than it was more than four centuries ago. The figure, eighteen feet tall, does not represent David after his battle with Goliath, as do earlier versions, but shows him before the confrontation. David appears to stand waiting, preparing himself while looking to the left. His is not a figure at rest, but one with muscles tense, readying himself for action. The expression on his face is one of concentration and determination, contributing to the overall feeling of tension and energy that the sculpture conveys.

Though there is reference to earlier Classical sculpture in *David*, Michelangelo's figure reflects the artist's knowledge of human anatomy (he dissected cadavers) and his reliance upon his own sense of proportion in the way in which he emphasizes the figure's face, hands, and

feet. His figure of David, though carved of marble, gives the impression of having a framework of muscle and bone covered with flesh.

Moses

Michelangelo's *Moses* (c. 1513–1515), originally intended as one of a number of sculptures for the tomb of Pope Julius II, has many of the same qualities as *David*. Though sitting, *Moses*, too, turns his head to the left, but with an angry expression beginning to form on his face. A sense of restraint is implied, though the contraction of the muscles of the arms and the position of the legs lead one to believe that he is about to rise.

The Ceiling of the Sistine Chapel at the Vatican

Between 1508 and 1512 Michelangelo worked on what was to be one of his greatest achievements: the ceiling of the Sistine Chapel at the Vatican. Though he had already begun working on sculptures for the tomb of Pope Julius II, the pope decided that he wanted Michelangelo to stop what he was doing and decorate the ceiling of the Sistine Chapel in fresco. This challenge would entail applying paint to still-damp plaster, which allowed no mistakes, while lying on his back on a scaffolding nearly seventy feet above the floor. Only a small area could be worked on at any given time because the conditions for fresco painting were very restrictive. Given the dimensions of the ceiling, 128 feet by 44 feet, it was quite a task, compositionally as well as technically. Michelangelo's solution was then and remains today a masterpiece. He organized the space into a framework of painted triangles, squares, and rectangles filled with the portrayal of numerous biblical stories including the Creation, Adam and Eve, the Fall of Man, and his Redemption. Like his sculptures, Michelangelo's painted figures, over 300 in all, contain the energy and physical substance that typify his style.

Michelangelo as Architect

Following the death of Pope Julius II, Michelangelo continued to serve the succeeding popes, who relied upon the sculptor's talents as an architect. Much of his work was done in San Lorenzo, including the

Laurentian Library (begun in 1524), which was to house the collection of the Medici. As in his depiction of the human form, Michelangelo ignored the traditional standards and proportions of architecture, and like his figures, the interior of the building has a sense of energy and tension.

Among his architectural accomplishments was the reorganization of the Capitoline Hill in Rome in 1537. Given that the Palazzo dei Conservatori, built a century before, and the Medieval Palazzo dei Senatori were two structures that Michelangelo would have to incorporate into his design, he applied to the problem his theorem of units revolving symmetrically around a central axis and proposed, among other modifications, the construction of a new structure—the Museo Capitolino—that would give a trapezoidal orientation to the piazza. After Michelangelo completed his design for the Capitoline Hill, Pope Paul III requested that he direct the construction of St. Peter's Cathedral (1546–1564). Earlier plans for the cathedral drawn up by the architect Donato d'Agnolo Bramante (1444–1514) called for a series of interlocking crosses. Michelangelo adjusted the plan to form a cross in a square with a dome above, so as to reduce the fragmentation of the structure. His design for both the interior and the exterior of the church reflected his ongoing desire to achieve a sense of balance and harmony in his work.

The Last Judgment

Twenty years after completing the ceiling of the Sistine Chapel, Michelangelo returned to the Vatican to paint *The Last Judgment* (1534–1541) on the altar wall of the Sistine Chapel. Here, instead of portraying Christ as the redeemer, as he had earlier on the ceiling, Michelangelo chose to depict him as a judge. His portrayals of the dead rising and the damned in hell are powerful and graphic.

Raphael

Raphael Sanzio (1483–1520), though influenced by and a contemporary of Leonardo da Vinci and Michelangelo, developed his own manner of painting that also reflected the thought of the High Renaissance. At age seventeen, Raphael was apprenticed to the Umbrian

painter Pietro Vannucci Perugino (1446–1523), who had studied in the studio of Verrocchio at the same time as Leonardo da Vinci. While in Florence in the early 1500s, Raphael had access to the work of both da Vinci and Michelangelo, and his ability to learn from other masters became evident in his work,

Madonna del Cardellino

The composition of Raphael's *Madonna del Cardellino* (1505–1506), for example, is based upon the triangular organization of Leonardo's *Virgin of the Rocks* (1485), and he used chiaroscuro to subtly define the figures. From Perugino, he borrowed the style of the background, and he used highlights to accent the figures.

The School of Athens

In 1509, Raphael received a commission from Pope Julius II to decorate, in fresco, three of the pope's private rooms at the Vatican. The most famous of these is found in the Stanza della Segnatura, and consists of four frescoes, one on each wall, that depict the areas of knowledge upon which the power of the pope rested: philosophy, poetry, law, and theology. One of the frescoes, *The School of Athens* (1510–1511), has come to symbolize the High Renaissance in terms of its artistic achievement and thought. Its physical achievements are represented by the architecture depicted, which is probably based upon Donato d'Agnolo Bramante's design for St. Peter's Cathedral in Rome.

At the center of the composition stand Aristotle and Plato, framed by arches. The figure of Aristotle points downward; to his right stand individuals who were renowned for their investigation of the physical world as the means for finding truth. Plato, meanwhile, arm raised, points upward; to his left stand philosophers who looked for answers and explanations in the realm of ideas. The work also includes the personas of such individuals as Euclid, Pythagoras, and Heraclitus. (The latter form, it is said, was based upon the features of Michelangelo himself; certainly the figure's pose is based upon the work found in the Sistine Chapel.) There is a distinct sense of visual balance and harmony to the composition in the way the architectural elements and the individuals are presented. However, the grouping of the figures also represents the intellectual differences between the different schools of

thought. Though recognizing and honoring human achievements, of humankind, Raphael also subtly acknowledges that humankind lives with limitations as well.

Titian

Better known as Titian, Tiziano Vecelli (1490–1576) was probably the most famous of the Venetian painters during the High Renaissance. It was during his era that the shift from painting on wood to painting on canvas occurred, and it is Titian who is frequently credited with establishing the acceptability of using oil paint on canvas.

Madonna with Members of the Pesaro Family

Titian's reputation was established with his *Madonna with Members of the Pesaro Family* (1519–1526) for the Church of San Maria dei Frari, in Venice. Though the interactions of monumental architecture and figures were traditional to High Renaissance art, Titian's compositional organization of these elements was unique. In this painting, instead of composing the image symmetrically with a horizontal orientation, he arranged the figures in a manner that creates a strong diagonal thrust to the work, so that the viewer is looking into the picture from an angle rather than frontally, and attention is directed to the Madonna. A strong sense of movement is achieved through his use of rich color, light and shadow, and the gestures of his characters.

Titian as Portrait Painter

Titian was also a portrait painter, and many of his portraits exist today. Among them is the *Man with the Glove* (c. 1520). Attention is divided between the subject's hands and face, and the slightly turned head is very expressive and meditative, reflecting the attitude of this period. As the court painter and close friend of Emperor Charles V, Titian painted many portraits of Charles, including *Charles V at Muhlberg* (1548). Here, Titian utilizes visual subtleties to present the emperor as heroic and honorable. The beautiful armor and costume and the strutting steed contribute to the overall effect.

The *Venus of Urbino*

In 1538 Titian painted the *Venus of Urbino* for the duke of Urbino. This painting, of a nude woman lying upon a bed, would become the model for the reclining nude for many years to come.

Mannerism

Mannerism is a term used to describe a certain genre of literature, art, and architecture that was produced during the period from Raphael's death in 1520 to the beginning of the seventeenth century, that is, between the end of the High Renaissance and the beginning of the Baroque period. Although the mannerists looked to the artists of the High Renaissance, such as Michelangelo and Raphael, as sources of inspiration, they did not concern themselves with the relationship between nature and appearance as these masters did. To the Mannerists, the art was in the abstracting and idealizing of the subject. Whereas artists such as Michelangelo had sought balance and harmony, the Mannerists sought instability, choosing to explore the possibilities for manipulation in their art. Characteristics of their style include the distortion of space and the elongation of the human figure.

Mannerist Painting

Rosso

An example of the early Mannerist style in painting is Rosso Fiorentino's (1495–1540) *Descent from the Cross* (1521). Startling for its clambering forms, sharp edges, and harsh colors, this work, in effect, is a rejection of the Classical traditions established for painting during the High Renaissance.

Jacopo Pontormo

Jacopo Pontormo (1494–1557), a friend of Fiorentino, painted his own version of the subject shortly thereafter. In Pontormo's *The Descent from the Cross* (1525–1528), the figures are not in the center of the composition as tradition would dictate, but have been pushed away. Christ is posed in a somewhat contorted manner, and the space created is vague without cues to indicate its limits. Pontormo's colors, his distortion of the figures, and his composition contribute to the overall

tension of this image, which, like Rosso's, represents an anti-Classical approach to painting.

Parmigianino

Girolamo Francesco Maria Mazzuoli, better known as Parmigianino (1503–1540), created a work that reflects the manner of Raphael and of Leonardo as well. His painting *The Madonna with the Long Neck* (c. 1535) is much more elegant than Pontormo's *The Descent from the Cross* and exemplifies the direction that Mannerism would take. The elongated torso, hands, and neck of the Madonna add dramatic distortion to the composition and illustrate the Mannerists' focus upon those elements as vehicles of expression of idealized beauty. To the left of the Madonna, a cluster of figures gazes adoringly at her, while behind her, at some unidentified distance, stands an erect figure with a scroll.

Agnolo Bronzino

At its most elegant level, the style of the Mannerists appealed to the taste of the aristocracy, especially in the form of portraits. The painting *Portrait of a Young Man* (1550) [see illustration 6], and the portrait *Eleanora of Toledo and Her Son Giovanni de' Medici* (c. 1550), by Agnolo Bronzino (1503–1572), the court painter of Cosimo I de' Medici, possess many of these desired qualities. These two paintings by Bronzino, though of real persons, do not seem to represent the individuals as much as their position in society.

The Mannerists particularly enjoyed portraying allegorical images, as seen in Bronzino's *Venus, Cupid, Folly, and Time* (1550). Here again, special attention has been paid to the heads and the hands to accentuate their expressive qualities. The figures are sensuously modeled and so fill the composition that little of the space surrounding them is revealed.

Tintoretto

It was not until the middle of the sixteenth century that the Mannerist style was seen in Venice, where Jacobo Robusti Tintoretto (1518–1594) was respected as a Mannerist painter. Although his painting *Christ Before Pilate* (1566–1567) has qualities that recall Raphael's use of light and shadow and color, the figures and the atmosphere are distinctly Mannerist.

If Leonardo da Vinci's *Last Supper* is considered to be the classical version of that subject, then Tintoretto's version of *The Last Supper*

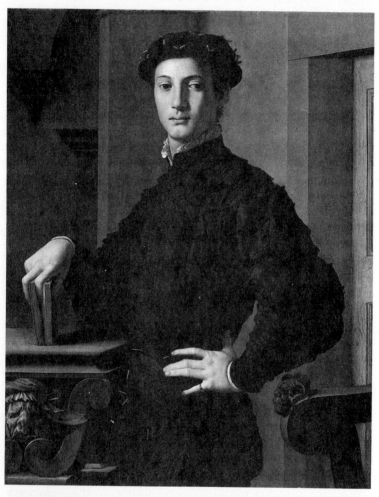

6. BRONZINO (Agnolo di Cosimo di Mariano). *Portrait of a Young Man,* possibly Guidobaldo II, Duke of Urbino.
Oil on wood. H. 37⅜", W. 29½".
The Metropolitan Museum of Art, Bequest of Mrs. H. O. Havemeyer, 1929. The H. O. Havemeyer Collection. (29.100.16)

(1592–1594) is its antithesis. Tintoretto has placed the table on a strong diagonal axis. Christ is at the center, but because of the perspective his figure is small and would not stand out were it not for the halo that envelops him. Earthly qualities are introduced in the form of servants milling about while the Apostles converse with one another. As Christ conducts the Passover ceremony, smoke from an oil lamp overhead is transformed into heavenly beings who gravitate toward him. Although Tintoretto has chosen to focus upon the ritual of Passover rather than Christ's announcement that he will be betrayed, the overall effect of the composition is one of extreme drama.

El Greco

One of the last, and probably the most famous, of the Mannerist painters who studied in the Venetian School was Domenikos Theotocopoulos (1541–1614), better known as El Greco. One of his best-known works is *The Burial of Count Orgaz* (1586). Though this huge painting, sixteen feet tall and nearly twelve feet wide, recounts an event that took place more than two centuries earlier, El Greco took the liberty of depicting, among those present, individuals from the Church and aristocracy who were his contemporaries. The painting is set into the wall of the chapel of the Church of Santo Tomé in Toledo, Spain, directly above a stone plaque that represents the sarcophagus of Count Orgaz. The effect is powerful, for one is faced with an image of the count being lowered into his resting place, while above, his soul is carried up to heaven and Christ.

Besides his religious painting, El Greco was renowned as a portrait painter, as evidenced in his portrait of Fray Felix Hortensio Paravicino (c. 1605). Though the painting is similar in some ways to Titian's *Man with the Glove* (1520), the subject's intense expression is made even stronger by El Greco's sensitive treatment of his hands and face. However, it was the elongated manner in which El Greco depicted the human figure for which he is probably best known, and his paintings *The Vision of St. John* (1610) and *Christ on the Cross with Landscape* (1610) well illustrate this style. In the former painting, the elongated features of the figures reaching upward accent their movement and the tension they possess. The image does not pretend to represent an actual event but rather a vision, and the unearthly quality of the work is apparent. In the latter work, the elongation of Christ's torso and limbs

conveys a sense of weightlessness; he seems to float upon, rather than hang from, the cross.

Mannerist Sculpture

Benvenuto Cellini

The work of Benvenuto Cellini (1500–1571) is representative of the Mannerist style of sculpture. His *Diana of Fontainebleau* (1543–1544), cast in bronze, is larger than life-size. In proportion to the rest of her body, her head seems small, whereas her arms and legs are elongated, accenting her reclining *contrapposto* position.

Giovanni da Bologna

Giovanni da Bologna (1529–1608) is considered by some historians to be the greatest Italian sculptor after Michelangelo. His work *The Rape of the Sabine Woman*, so named after it was completed in 1583, reflects the artist's compliance with and rejection of Mannerist principles. The three figures that make up the sculpture are intertwined; an old man cowers below with his left arm raised defensively, while a young man stands above him holding a woman who has flung her left arm out. Bologna was very conscious of his use of both positive and negative space. As one views the sculpture from different angles, one becomes aware of the spaces between the figures as well as of their mass. The sculpture is self-contained in that it carries its own space with it, rather than extending out and sharing that space with the viewer. Like Michelangelo, Bologna is able to depict a moment of movement involving figures that appear to be capable of action.

Mannerist Architecture

Giulio Romano

Closely associated with the Mannerist style of architecture is the painter and architect Giulio Romano (1499–1546), who served as Raphael's assistant while he was working on the Vatican stanza for Pope Julius II. In 1524, several years after Raphael's death, Romano moved to Mantua, where he received a commission to build the Palazzo del Te' (1525–1535) for Duke Federigo Conzaga. What Conzaga desired was a palazzo that would serve not only as a summer palace but also as a stud farm for his stable of horses.

Dispensing with the High Renaissance tradition of using a central portal to emphasize the main axis of a building, Romano designed a structure that had its entrance on the west, with a large garden bordered by the stables facing the east. His treatment of the structure itself overtly ignored and at the same time parodied the Classical traditions concerning construction and symmetry.

CHAPTER 14

The Renaissance in Northern Europe

Chronology

1430–1435	Lochner: *Madonna in the Rose Garden*
1432	Hubert and Jan van Eyck: The *Ghent Altarpiece*
1434	Jan van Eyck: *Giovanni Arnolfini and His Bride*
1435	Van der Weyden: *Escorial Deposition*
1436	Jan van Eyck: *Virgin with the Canon van der Paele*
1444	Witz: *The Miraculous Draught of Fish*
1449	Christus: *The Legend of Saints Eligus and Godeberta*
1450	Fouquet: *Etienne Chevalier and St. Stephen*
c. 1450–1516	Hieronymus Bosch
1464–1468	Bouts: *The Last Supper, Altarpiece of the Holy Sacrament*
1471–1528	Albrecht Dürer
c. 1480–1528	Matthias Grünewald
1480–1538	Albrecht Altodorfer
c. 1496	Dürer: *The Riders on the Four Horses from the Apocalypse*
1497–1543	Hans Holbein the Younger
1500	Dürer: *Self-Portrait*
1503	Dürer: *The Great Piece of Turf*
1504	Dürer: *The Fall of Man*
1510–1515	Bosch: *The Garden of Earthly Delights*
c. 1510–1515	Grünewald: *Isenheim Altarpiece*
1513	Dürer: *Knight, Death, and Devil*

1525–1569	Pieter Bruegel the Elder
1526	Dürer: *The Four Apostles*
1529	Altodorfer: *The Battle of Issus*
1533	Holbein the Younger: *The French Ambassadors*
1540	Holbein the Younger: *Henry VIII*
1565	Bruegel the Elder: *Hunters in the Snow*
1565	Bruegel the Elder: *Peasant Wedding*
1568	Bruegel the Elder: *Peasant Dance*

The Gothic style that Italy would follow for only a brief time remained dominant in the north until the fifteenth century in painting and sculpture and into the sixteenth century in architecture. This was in part due to the Classical heritage that the northern Europeans lacked, but that the Italians possessed and returned to in their development of later styles. Though Titian may have been instrumental in the mastery and adoption of the medium of oil paint in Italy, it was the Flemish painter Jan van Eyck who is credited with developing the medium one hundred years earlier. Whereas the colorists of the south painted with contrasting values of light and dark, brash color, and a nonglazed surface to realize the structure of their subjects, the painters of the north worked with saturated colors and glazed surface while focusing their attention upon the way light affected the appearance of things.

The innovations of the Italian Renaissance had far-reaching effects on the artistic development and evolution of the arts in the rest of Europe. In the north, the guild system exerted an even greater influence than it had in the south. The various crafts were maintained and regulated by the guilds. To gain entrance to the guilds, a requirement for practicing one's craft, one began, while still a youth, by working as an apprentice to a master. After mastering the various techniques of the craft and the style of the master, one was eligible to become a journeyman, which provided the opportunity to work in a variety of settings with different masters. Finally, one could apply for membership within

the guild, which would also act as agent in terms of the commissions one received.

The Fifteenth Century

Flanders

Flanders, the region between western Belgium and northern France, was the home of many significant artists during this period.

The van Eyck Brothers

Among the Flanders artists was Jan van Eyck (c. 1390–1441), who with his brother Hubert van Eyck (c. 1370–1426) was responsible for one of the greatest works of the fifteenth century, the *Ghent Altarpiece* (1432). Trained in the art of miniature painting, the van Eycks applied all their talent in detail work and the craft of color use to their larger compositions. Though the arrangement of the panels has been changed since the time it was painted, the work remains a masterpiece. The altarpiece, which opens and closes, reflects the medieval attitude toward layers of truth and meaning that are hidden and must be sought after. When its doors are closed, the Annunciation is portrayed. Above the figures of the angel and Mary are those of Micah and the Cumaean sibyl and Zachariah and the Erythaean sibyl. Below, flanking statues of St. John the Baptist and St. John the Evangelist, are figures representing the donors of the altarpiece, Jodoc Vyt and his wife. The architecture that serves as a backdrop to the angel and Mary possesses both Romanesque and Gothic qualities; the two figures, however, are out of proportion to their surroundings, reflecting the painters' lack of interest in relating the figures to their space.

When the doors of the altarpiece are opened, the Redemption is depicted as a medieval image. On the lower level, the central panel shows a gathering of the saints, the Apostles, the minor prophets, and the Evangelists, as they move towards the altar of the Lamb. To either side, other groups representing the four cardinal virtues also converge. Above, on the upper level, God, portrayed in all his splendor, is flanked by Mary and St. John the Baptist; the far panels portray choirs of angels and Adam and Eve. The detail in these panels is exquisite, the saturation of color, captivating. Though the subject depicted is spiritual in nature,

its portrayal and representation are realistic and natural, a contradiction that cannot but hold the attention of the viewer and inspire awe.

Another painting that illustrates Jan van Eyck's skill in applying the art of the miniature to larger works is his *Virgin with the Canon van der Paele* (1436). Here again, van Eyck has differentiated the various surfaces through his use of exquisite color to create textures and contrasts. Though the color is brilliant, he is careful to keep it from overpowering the composition in terms of subject. The work also illustrates the artist's use of multiple perspective as a way to focus the viewer's attention upon the major subjects of the painting. His intent was not, like that of Italian painters, to create a sense of unified three-dimensional space but rather to arrange his figures upon a two-dimensional surface through the use of color and shape. His subjects are rigidly poised, with little suggestion of movement or action.

In 1434 Jan van Eyck did a portrait, *Giovanni Arnolfini and His Bride*, which is secular in subject matter but possesses the spiritual atmosphere of his other works. Additionally, as with his religious paintings, it is laden with symbolism, though here that symbolism is related to the institution of marriage. The two figures stand while holding hands, reliving their marriage vows. Their shoes, which they have taken off because their ceremony has made the room a holy place, lie on the floor; a small dog in the foreground represents the fidelity of marriage. Other symbolic images abound; the drawn curtains of the marriage bed, the bedpost where sits a statuette of the patron saint of childbirth, St. Margaret, and more.

Rogier van der Weyden

Rogier van der Weyden (1400–1464), known for his paintings of religious themes, did not focus upon the image as symbol, as did van Eyck, but rather upon the image as portrayer of emotion, often sorrow and anguish. His *Escorial Deposition* (1435) is such a painting. Here he limits the space within which the event takes place, thus concentrating the attention of the viewer on the characters.

Petrus Christus

It is not known whether Petrus Christus (1410–1472) actually spent time in Italy, but his depiction of space and treatment of the figure reflect the style popular in Italy during this period. Although critics have commented that he was influenced by both Jan van Eyck and Rogier

van der Weyden, his work shows his interest in the underlying structure of his subjects rather than in their surface appearance. The three figures in Christus' painting *The Legend of Saints Eligus and Godeberta* (1449) illustrate this attention to form.

Dirk Bouts and One-Point Perspective

The first painting of this period in the north known to utilize one-point perspective in the depiction of interior space is *The Last Supper* (1464–1468), the middle panel of the *Altarpiece of the Holy Sacrament*, by Dirk Bouts (1415–1475). Here the projecting lines of the composition come together just above the head of Christ, the centrally placed figure in the painting, and the room within which the event takes place conveys a real sense of depth and volume. Unlike his predecessors, Bouts also seems to have made some effort to adjust the proportions of his figures to be more appropriate for the space within which he has placed them. There is little evidence to suggest that his depiction of space was based upon the Italian use of perspective; it seems likely that he developed the application on his own. The tone of Bouts' painting is rather static, which might also lead one to conclude that his intent was more to depict space in a particular fashion than to create an image that would overwhelm the viewer with its drama and emotion.

Hieronymus Bosch

Hieronymus Bosch (c. 1450–1516) is probably best known for his triptych *The Garden of Earthly Delights* (1510–1515), a work whose symbolism and meaning are still debated, though it is likely that during the artist's time his visual allusions and metaphors were understood within the context of the culture. His imagery is both erotic and frightening. The panels depict a number of Old Testament and New Testament themes but in what many consider to be a rather bizarre fashion. In the left panel, Eve is portrayed as a temptress rather than as the mother of the human race. The central image depicts the foibles of humankind taking place within a surreal landscape; and the horrors of hell are graphically illustrated in the right panel.

France

Jean Fouquet

In France, the work of the most prominent French painter of the fifteenth century, Jean Fouquet (1420–1481), was influenced by both Flemish and Italian painting, as seen in his painting *Etienne Chevalier and St. Stephen* (1450). Though the format of the composition is fairly standard fare for Flemish painting (the three-quarter view of the figures; the standing saint and the kneeling figure making an offering), the artist's attention to the underlying structure of the figures rather than the overt surfaces is distinctly Italian in style, as is his depiction of space through the use of architectural perspective. Another difference worth noting is the manner in which Fouquet has presented the two subjects of his painting. The distinction between saint and man is not so obvious in their manner of dress or appearance, narrowing the gap between this world and the next.

Germany

German painting of the fifteenth century was also influenced by the work of the Flemish painters. The integration of the Flemish style in Germany varied from the soft, ornate style of Stephan Lochner (1400–1435), as seen in his *Madonna in the Rose Garden* (1430–1435), to the harsher manner of Conrad Witz's (1400–1447) *The Miraculous Draught of Fish* (1444).

The Sixteenth Century

Flanders

During the sixteenth century the Italian manner continued to influence the direction of northern art, though in many different ways. It was also during this period that the influence of the German painters grew, while that of the Flemish painters waned.

Pieter Bruegel the Elder

That is not to say that there were no Flemish painters worth noting, for there were, especially Pieter Bruegel the Elder (1525–1569). Bruegel created landscapes that were more than simply places of human

activity; they were subjects worthy of attention in their own right. This orientation may be seen in his *Hunters in the Snow* (1565), one of the paintings among a series he did portraying the months of the year. Here, though the attention of the viewer is upon the men returning from the hunt, their wives tending the fire, and the townspeople skating on frozen ponds, it is impossible to ignore the vast landscape.

For his human subjects, Bruegel did not limit himself to one particular social stratum; in fact, he did many paintings of peasant life. The characters depicted in his *Peasant Wedding* (1565) may seem somewhat flat and unidimensional, but this plainness of treatment conveys a sense of simplicity and what life is like in the country. Though the subject is peasant life, the wedding is nonetheless treated in a solemn fashion. Similarly, his painting *The Peasant Dance* (1568) is alive with the energy of a country festival, while at the same time it serves as a social commentary in the way he has placed his characters (facing away from the town church), and in his placement of a picture of the Madonna (attached to a tree on the right).

Germany

Though some German artists, such as Albrecht Dürer (1471–1528), went to Italy to study the art of the south, others were content to remain in Germany and learn of the Italian manner secondhand, incorporating into their own style those elements that appealed to them. Among the regional styles that developed in Germany was the *Donaustil*, or *Danube*, style, in which artists such as Albrecht Altodorfer (1480–1538) painted. The Donaustil represented a genre of landscape painting that emphasized feeling and emotion. Although the detail of Altodorfer's work tends to be similar to that of the miniaturists, his *The Battle of Issus* (1529) presents the viewer with an immense vista in which humans are portrayed as minute figures in the cosmos.

Matthias Grünewald

Mathis Niethardt, better known as Matthias Grünewald (c. 1480–1528), represented the German equivalent of the Italian Renaissance man. During his life, he served as architect, engineer, and painter. Between 1510 and 1515 he painted the panels for the *Isenheim Altarpiece* for the Monastery Church of the Order of St. Anthony at Isenheim. When the altarpiece is closed, the exposed panels depict the Cruci-

fixion, but not in a manner that had been seen before. Grünewald's version represents one of the most unsettling versions of that subject ever created. The crucified Christ is portrayed in a dark landscape in all his agony, his body showing the effects of the abuse he has suffered. He seems to convulse in spasm, and his hands are taut, with fingers extended in torment. To the right of Christ, the Virgin Mary, St. John, and Mary Magdalen despair at the death of Christ the man, while to Christ's left, St. John the Baptist serenely points to Christ the savior.

In contrast to the dark suffering and tragedy of *The Crucifixion* are the uplifting panels within the altarpiece: *Annunciation*, *Angel Concert for the Madonna and Child*, and *The Resurrection*. *The Resurrection* is especially luminous in its portrayal of Christ floating up toward heaven. Where Grünewald used color in *The Crucifixion* to create a dark sense of tragedy and earthly pain, he masterfully used color to create an unearthly sense of light and hope in *The Resurrection*.

Albrecht Dürer

It is likely that when German artists began to travel to Italy to study the Renaissance style of the south, Albrecht Dürer (1471–1528) was among the first to go. He was so impressed with what he found in Italy that upon returning to the north, he made it his cause to expose his contemporaries to the style of the Italian Renaissance. Though trained as a goldsmith, it is for his prints that he is especially known, and his fame as a craftsman in the art of the woodcut and engraving is as great today as it was during the sixteenth century.

Dürer's unique handling of the woodcut may be seen in his *The Riders on the Four Horses from the Apocalypse* (c. 1496) [see illustration 7] which was part of a series of woodcuts he did to illustrate The Revelations of Saint John, from the New Testament. His portrayal of Death trampling a church official, Famine swinging his scales, War with raised sword, and Pestilence with bow and arrow drawn was of a type very different from the traditional woodblock print, which was typically a black and white image with limited contrast. Using the woodcut, Dürer was able to incorporate a range of lights and darks (chiaroscuro) that had never been achieved with this medium. By using subtle techniques adopted from the art of engraving, Dürer was able to convey a visual sense of mass to his figures that otherwise would have been impossible to accomplish with woodcuts.

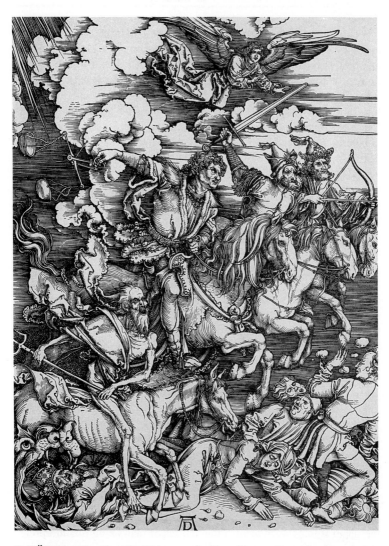

7. DÜRER, Albrecht. *The Riders on the Four Horses From the Apocalypse.*
(c. 1496)
Wood Cut.
The Metropolitan Museum of Art,
Gift of Junius S. Morgan, 1919. (19.73. 209)

Dürer was also fascinated with the self-portrait and during his lifetime he did many of them. His *Self-Portrait* of 1500 is notable for its serious, intent expression and frontal pose. Dürer's interest in the Italian Renaissance also led him to investigate systematically the depiction of idealized proportions for the human figure. His engraving *The Fall of Man* (1504), also known as *Adam and Eve*, portrays Adam and Eve as idealized, not real-life figures. Though they do not quite seem to belong there, they are placed against the backdrop of a forest whose detail implies great attention to nature on the part of the artist. Whereas the figure of Adam is similar to the Italian conception of the perfect male form, that of Eve retains more of the German proportions. Dürer has also followed the northern tradition of incorporating a number of visual symbols into his composition. For example, the cat and mouse in the foreground symbolize the tension between Adam and Eve as she offers him the fruit from the Tree of Knowledge of Good and Evil.

Dürer valued and cultivated his skill of observation, through which he felt he could gain a special kind of knowledge. His respect for nature is reflected in his watercolor *The Great Piece of Turf* (1503), which is as realistic as it is "true." This particular work is significant in that it is what it appears to be—a still-life—and does not incorporate elements of symbolism in order to legitimize its existence.

Though there may have been some sense of disparity between the influences of naturalism and idealism in Dürer's *The Fall of Man* (1504), he seems to have at least somewhat resolved the conflict by 1513, when he did the engraving *Knight, Death, and Devil*. Here, the horse and rider, though idealized, work together within the context of the composition.

Dürer's paintings of religious themes oftentimes carried political overtones as well. In *The Four Apostles* (1526), presented by Dürer to the city of Nuremburg as a gift, the Apostles John and Peter are pictured in one panel, Mark and Paul in the second. Though the overt message is a religious one, the passages from the New Testament inscribed upon the panel frames warn against the actions of man being misinterpreted as the will of God, probably in reference to the friction between the Catholic church and the Protestant movement at the time.

Hans Holbein the Younger

Another German artist who integrated the northern manner of realism with the Italian dimension of monumentality was Hans Holbein

the Younger (1497–1543). Holbein's skills are especially evident in his portraits. *The French Ambassadors* (1533) illustrates his attention to detail, as seen in the pattern of the floor tiles and the drapery. His sense of organization lends stability and strength to the work, and his use of color adds richness.

One of Holbein's most famous portraits is of Henry VIII (1540). The pose is rigid, and it is obvious that the artist spent much time attending to the minute detail of his subject's costume. It is the king's mass, however, that has the most impact upon the viewer; it gives the impression that this is not an individual to be trifled with.

CHAPTER 15

Baroque Art

Chronology

1598–1680	Gianlorenzo Bernini
c. 1599–1602	Caravaggio: *The Calling of St. Matthew*
1599–1660	Diego Velázquez
1600–1750	Baroque art
1601	Caravaggio: *The Conversion of St. Paul*
1603	Shakespeare's *Hamlet* is published
1603	Death of Queen Elizabeth I
1604	Caravaggio: *The Deposition*
1606–1669	Rembrandt
1607	Jamestown, Virginia, is founded
1609–1610	Rubens: *The Raising of the Cross*
1611	The King James version of the Bible is published
1614	Domenichino: *The Last Communion of St. Jerome*
1617	Rubens: *The Rape of the Daughters of Leucippus*
1617–1618	Rubens: *The Lion Hunt*
1618–1648	Thirty Years' War
1619	Velázquez: *The Water Carrier of Seville*
1620	*Mayflower* arrives at Plymouth
1620	Van Honthorst: *The Supper Party*
1621	Terbrugghen: *The Calling of St. Matthew*
1623	Bernini: *David*
1624–1633	Bernini: Bronze altar canopy, St. Peter's Cathedral, the Vatican

1626	Rembrandt: *Tobit and Anna with the Kid*
1628	Velázquez: *Los Borrachos*
c. 1628	Hals: *The Jolly Toper*
1628–1630	Rembrandt: *Supper at Emmaus*
1630	De La Tour: *The Lamentation Over St. Sebastian*
1630	Poussin: *The Shepherds of Arcadia* (first version)
1633–1666	Bernini: Scala Regia, the Vatican
1634	Rembrandt: *Self-Portrait with Saskia*
1636	Rembrandt: *The Blinding of Samson*
1636	Rubens: *Landscape with the Chateau of Steen*
c. 1636–1637	Poussin: *The Rape of the Sabine Women*
c. 1638	Rubens: *The Garden of Love*
1639	De Ribera: *The Martyrdom of St. Bartholomew*
1640	Poussin: *The Shepherds of Arcadia* (second version)
1642	Rembrandt: *The Company of Captain Frans Banning Cocq*
1643–1715	Reign of King Louis XIV
1645	Hals: *Balthasar Coymans*
1645	De La Tour: *Joseph the Carpenter*
1645–1652	Bernini: *St. Teresa in Ecstasy*, Cornaro Chapel
1646–1708	Jules Hardouin-Mansart

1648	Poussin: *Landscape with the Burial of Phocion*
1650	Hals: *Malle Babbe*
1652	Rembrandt: *Self-Portrait*
1656	Velázquez: *Las Meninas*
1658	Rembrandt: *Self-Portrait*
1662	Rembrandt: *The Syndics of the Cloth Guild*
1664	Hals: *The Women Regents of the Old Men's Home at Haarlem*
1667	John Milton publishes *Paradise Lost*
1668	Isaac Newton develops the reflecting telescope
1669–1685	Versailles
1680	Stradivari makes his earliest known cello
1682	Peter the Great becomes czar of Russia
1684–1721	Jean-Antoine Watteau
1687	Newton sets forth law of universal gravitation
1697–1764	William Hogarth
1699–1779	Jean-Baptiste-Siméon Chardin
1700–1775	Rococo style
1703–1770	François Boucher
1715–1774	Reign of King Louis XV
1717	Watteau: *A Pilgrimage to Cythera*
1720–1721	Watteau: *L'Indifferent*
1720–1721	Watteau: *Gersaint's Signboard*

1723–1792	Joshua Reynolds
1727–1788	Thomas Gainsborough
1740	Chardin: *Grace at Table*
1741	Chardin: *The House of Cards*
1742	Handel's *Messiah* is first performed
1745	Hogarth: *Breakfast Scene*
1754	Boucher: *Cupid a Captive*
1759	Boucher: *Marquise de Pompadour*
1775	Gainsborough: *The Honourable Mrs. Graham*
1776	Declaration of Independence
1785	Gainsborough: *Mrs. Richard Brinsley Sheridan*
1786	Mozart's *Marriage of Figaro* is first performed
1787	Reynolds: *Lord Heathfield*

The term Baroque art *encompasses the period between 1600 and 1750 and represents the era when subjects such as the everyday activities of people, the landscape, and still life became acceptable themes for artists to depict. This diversity in subject matter and style may be seen in the work of the Dutch artists, who performed a style of art that might be characterized as Realist art, focusing on the atmospheric effects of dramatic shadow and lighting. It was a time when the idealism of the High Renaissance gave way to Baroque realism and an art that is often described as dynamic, with greater color saturation and more contrast between light and shadow.*

The Counter-Reformation also had an effect upon the art of this period, for the Catholic church encouraged artists to produce works that inspired faith. The realism which developed was instrumental in stressing the human-feeling dimension of religion. It was also during

the Baroque period that an academic tradition of art developed that looked to antiquity and the masters of the Renaissance as sources of inspiration.

The Seventeenth Century

Italy

Gianlorenzo Bernini

The artist who is probably most frequently associated with the Baroque period is Gianlorenzo Bernini (1598–1680). His reputation and expertise extended into the areas of painting, sculpture, and architecture, and he made contributions as a composer and playwright as well. As an architect, he spent much of his career working on a number of projects at the Vatican, including the monumental bronze baldachino (1624–1633), or canopy, for the major altar of St. Peter's Cathedral. He is also responsible for the Scala Regia (1633–1666), a majestic staircase that leads to the private papal rooms, and the colonnade and piazza in front of St. Peter's Cathedral.

The sense of energy and movement typical of Baroque sculpture may be seen in Bernini's *David* (1623). Earlier versions of David portrayed him at rest or preparing for action; Bernini captured him in motion, as he twists around to sling his stone. In this way, Bernini describes rather than interprets the event. The figure's movement is so strong in its implied relationship to the unseen Goliath that it breaks out from what might be perceived of as its own space and enters that of the viewer. It is, in fact, this relationship with the surrounding space that differentiates Baroque sculpture from the sculpture that preceded it.

One of Bernini's greatest achievements is his design for the Cornaro Chapel in the Church of Santa Maria della Vittoria, in Rome. It is an excellent example of Bernini's ability to integrate architecture, painting, and sculpture, while controlling the lighting to achieve the maximum dramatic effect. Here, a drama unfolds, and as it does, sculpted figures representing the chapel's donors, the Cornaro family, sit in opera boxes on both sides of the chapel and "watch," sharing space with the viewer. The painted ceiling presents a luminous picture of heaven, while below is the focus of attention, *St. Teresa in Ecstasy* (1645–1652), a dramatically lit sculptural work of white marble and gilt

bronze. Saint Teresa, a Carmelite nun, was a significant figure in the Counter-Reformation; she had visions that she felt were brought on by an angel who plunged an arrow into her heart. The moment that Bernini has chosen to depict in his sculpture is the one in which the angel is about to plunge his arrow into St. Teresa's heart. As depicted by Bernini, St. Teresa's ecstasy is both physical and spiritual.

Caravaggio

Michelangelo de Merisi (1571–1610), better known as Caravaggio, though a highly respected painter, was criticized for his apparent disdain of the masters of the Renaissance. Though many of his contemporaries whose training took place in the academies looked to antiquity and the Renaissance for modes of interpreting nature, Caravaggio felt that his powers of observation would provide him with the cues he needed to paint his subjects.

The manner in which Caravaggio depicted some of his subjects in paintings that were of religious themes also met with disapproval. In works such as *The Calling of St. Matthew* (c. 1599–1602), Caravaggio took a religious theme and translated it into visual imagery that is common in portrayal and naturalistic in depiction. Matthew, sitting at a table in a tavern with other men, is approached by two figures from the right. Though one of the approaching figures is Christ, it is not the slightly visible halo that signifies his identity so much as his gesture, which is highly illuminated. Caravaggio's use of light provides cues as to how the painting is to be read as well as to its meaning.

Caravaggio's "common" depiction of religious themes is seen also in his painting *The Conversion of St. Paul* (1601). There is little in the image itself to indicate that an event of religious significance has occurred. Having been thrown from his horse, St. Paul lies on his back, arms raised, while a stableman guides the horse away so that the fallen figure will not be trod upon. What is striking about the painting is, again, Caravaggio's use of light, which is harsh, but which selectively accents the figures portrayed in a way that heightens the drama and realism of the image. His manner of using light so effectively to contrast with shadow is referred to as *tenebrism*, "the dark manner."

Another example of Caravaggio's use of tenebrism to heighten the reality of an image can be seen in his painting *The Deposition* (1604), which portrays the lowering of Christ's body from the cross. Here again, the viewer is struck by the drama of the event portrayed through the use

of contrasting light and shadow. The composition is constructed on a diagonal axis, and the artist's placement of light upon the characters guides the viewer through the painting.

While there may have been disagreement between Caravaggio and the academic painters of his time, it is still safe to assume that the academic painters were influenced to some degree by Caravaggio's work. His influence, for example, can be seen in *The Last Communion of St. Jerome* (1614), a painting by Domenico Zampieri (1581–1641), who is better known as Domenichino. Though the work is traditional in mood and theme, Domenichino has successfully integrated elements of Caravaggio's tenebrism, high-contrast light and shadow, to accentuate St. Jerome's features and other elements of the composition.

Spain

José de Ribera

There were a number of Spanish artists who focused their attentions upon the realistic portrayal of religious themes. Among them was José de Ribera (1588–1652), who received the nickname "Lo Spagnoletto," the "Little Spaniard," after he moved to Italy. His painting *The Martyrdom of St. Bartholomew* (1639) reflects the severe attitude that characterized the period of the Counter-Reformation. The painting portrays St. Bartholomew as he is being readied to be flayed; torture was a popular method of the time for encouraging people to embrace the "true" faith. St. Bartholomew is treated in the same fashion as the other figures in the painting; the overall effect is similar to that of a photograph that documents an event.

Diego Velázquez

Another popular Spanish painter was Diego Velázquez (1599–1660), whose mastery of realism in painting is still recognized today. His naturalistic tendencies and his ability to depict an individual's character were apparent even in his early works, such as *The Water Carrier of Seville* (1619) and *Los Borrachos* (1628). *In Los Borrachos*, which portrays a group of men drinking, he includes the character of Bacchus, the Greek god of wine, crowning one of the participants who rests on his knees before him. Though Velázquez presents the drinkers as common folk, each is depicted individually with his own gestural and facial expression.

Velázquez is perhaps best known for his painting *Las Meninas* (1656), (*The Maids of Honor*), which reflects his mastery of the use of light to model surfaces. He was able to achieve a sense of daylight in his work through his careful study of the gradual changes in visual tonality that occur when light reflects off of the surface of an object. These subtle changes he replicated in light and dark, with occasional accents of highlights and deep shadow. The setting for the painting is the artist's studio. There, Velázquez has portrayed himself on the left before a large canvas, while in the foreground stands Princess Margarita, the daughter of the king and queen whose reflections can be seen in the mirror on the rear wall of the studio. Margarita is accompanied by her attendants (*las meninas*), a dog, and a dwarf. In the background, the open door to the studio frames the figure of a man, while on the wall above hang paintings by Pietro da Cortona and Peter Paul Rubens. Velázquez's painting may be seen as functioning on at least two levels. On one level, it is a portrait of the individuals inhabiting his studio space at a point in time, portrayed in the manner of Realism. On another level, however, the painting is a statement by Velázquez concerning different dimensions of "visual reality," as in the reality of a viewer's imaging, the reality of an image upon a canvas, the reality of the reflected image from a mirror, and the reality of a painting of a painting.

Flanders

Peter Paul Rubens

One of the most influential painters of this period, one who had little competition from other painters in Flanders, was Peter Paul Rubens (1577–1640). Before beginning his studies in art in Antwerp, the artistic center of Flanders, Rubens served for a time as a page in the home of a wealthy aristocrat, where he was exposed to the formal norms and traditions that would serve him later when he was a court painter. In 1599 he traveled to Italy, where he studied the Italian masters and produced works for the duke of Mantua as court painter. After eight years he returned to Antwerp.

The effects of his exposure to the Italian masters can be seen in *The Raising of the Cross* (1609–1610), a painting he did for the Cathedral of Antwerp soon after he returned from Italy. The image is a powerful one, in which Italianesque brawny figures are depicted with muscles

straining under their task, creating a sense of action that seems to extend beyond the borders of the painting, a characteristic of the Baroque style. Rubens has used foreshortening as a device to create the illusion of receding space. The dramatic lighting and strong diagonal thrust of the composition are reminiscent of Caravaggio's *The Deposition* (1604), and the naturalistic, strongly defined musculature of the figures may have been based upon Michelangelo's paintings on the ceiling of the Sistine Chapel (1508–1512).

Consistent in Rubens' work is his interest in depicting the human body in action. His painting *The Rape of the Daughters of Leucippus* (1617) portrays the gods Castor and Pollux carrying off the daughters of Leucippus without seeming to exert any effort. Rubens' treatment of the figures here represents his use of color, accented with light and dark, to define his subjects, rather than relying upon contrasting highlights and shadows alone. Rubens' ability to depict the human form in action is also apparent in his painting *The Lion Hunt* (1617–1618). Here he has interwoven the figures of men, horses, and lions in a deadly struggle, and the viewer cannot help but be drawn into, and possibly repulsed by, the ferocity of the confrontation.

Though both northern and southern influences would remain in his work, Rubens' style softened somewhat during the latter part of his career, when he created genre paintings such as *The Garden of Love* (c. 1638) and landscape paintings such as *Landscape with the Chateau of Steen* (1636). Though the Garden of Eden theme can be traced back to the northern Gothic period, Rubens' depiction portrays individuals from his time in a contemporary portrayal of the traditional scene.

Holland

The Dutch painters of the seventeenth century were sensitive to the tastes of their public and thus tended to specialize in terms of the subject matter they depicted. A variety of masters and styles representing different "schools" could be found not only in Amsterdam, but also in such cities as Delft and Haarlem. The manner of realism seen in the work of Jan van Eyck during the fifteenth century was combined with the Italian high-contrast style of Caravaggio. The Dutch painters of this period who were taken with the atmospheric effects of dramatic shadow were referred to as *night painters*. Gerrit van Honthorst (1590–1656) was of this school, and his interest in dramatic lighting is seen in *The*

Supper Party (1620). Like Honthorst, Hendrik Terbrugghen (1588–1629) was a student of the Utrecht School, and his painting *The Calling of St. Matthew* (1621) has a similar sense of high-contrast lighting and detail. Although neither Honthorst nor Terbrugghen, nor for that matter the Utrecht School, would become widely known for their artwork, their efforts were invaluable in exposing other Dutch artists to the style of Caravaggio.

Frans Hals

Frans Hals (1580–1666), of Haarlem, utilized Caravaggio's dramatic lighting effects in his portraits as well as the energetic style of Rubens but in a manner that did not formalize the relationship between viewer and portrait as much as relax the space between the two. In *The Jolly Toper* (c. 1628), Hals portrays his subject in midmotion and, as in his portrait *Balthasar Coymans* (1645), in a relaxed state with an expression that invites interaction and communication, an effect that is reinforced by the visible brush strokes. What is significant here is the informality of the portrait. The traditional formal pose and distancing between portrait and viewer that have typified the art of portraiture are lacking here.

Hals' ability to render the public image of individuals as approachable portraits extended to his depiction of idiosyncratic personalities such as Malle Babbe (1650), who sits chuckling, a tankard in her hand and an owl on her shoulder. Here again, the seemingly spontaneous brushwork contributes to the immediacy and approachability of the portrait.

Hals' expertise in portraiture was his remarkable ability to depict character and personality. One of his later works, *The Women Regents of the Old Men's Home at Haarlem* (1664), reflects this ability in the way that the facial expressions of the women he has depicted seem to convey the effects of years of exposure to death and dying. Hals was familiar with the subject of this painting, for it was at the Old Men's Home at Haarlem that he spent his last years as a resident.

Rembrandt van Rijn

Rembrandt van Rijn (1606–1669) is considered by many art historians to be one of the greatest artists of all time, though during his lifetime that opinion was not necessarily shared by all of his contemporaries. A master of painting, drawing, and etching, his subject matter

included portraits, landscapes, religious themes, and over one hundred self-portraits. Rembrandt was able to manipulate light and dark in his work in such a subtle manner as to be able to nearly replicate the psychological effects of the actual nuances that exist in the real world. His technique reflected his ability to portray the concept of light and dark, as opposed to the physics of light and dark, as a means of expressing mood and emotion.

Rembrandt's early works, such as *Tobit and Anna with the Kid* (1626) and *Supper at Emmaus* (1628–1630), tended to be realistic, with high contrasts in light and dark, reflecting the probable influence of Caravaggio through the work of artists with whom Rembrandt was familiar, such as Gerrit van Honthorst. In *Supper at Emmaus*, for example, the light source is placed behind the foreground figure, Christ, creating a dramatic silhouette effect. In a later version of the subject, *Supper at Emmaus* (1648), Rembrandt's style has changed; he has replaced the dramatic lighting of the earlier composition with a subtle range of values that creates a sense of drama through the expression of the subjects.

As his style matured, Rembrandt continued to use dramatic light in a theatrical manner, as seen in his painting *The Blinding of Samson* (1636) and a group portrait, *The Company of Captain Frans Banning Cocq* (1642), also known as *The Night Watch*. In both compositions, figures fade in and out of the shadows and light.

Rembrandt's group portrait *The Syndics of the Cloth Guild* (1662) reflects his mastery of and sensitivity toward the elements of light and shadow, color, and implied movement as vehicles for portraying the personality of the subject. The viewer of the painting is apt to feel that he or she has just interrupted the meeting of this group of individuals, for they seem to turn to meet the viewer's gaze.

Rembrandt's interest in time and change as dimensions of his paintings is especially evident in his self-portraits. His *Self-Portrait with Saskia*, painted in 1634, portrays himself with his first wife, Saskia, during a period of time when he was very successful and still imbued with the optimism of youth. A later self-portrait (1652) pictures him as a confident, mature artist, standing alone and independently. This image of Rembrandt is very different from the one in a later self-portrait painted in 1658, in which he depicts himself as aged and wearied.

France

In France, the direction the Baroque style took was directly influenced by the taste of King Louis XIV, who preferred a more dignified Classicism to the stirring Baroque style of Italy. As a result, the French Baroque style tended to be more dignified in its imagery and technique.

Georges de La Tour

French painters such as Georges de La Tour (1593–1652) were influenced in their use of light by the work of Caravaggio and Honthorst, as may be seen in de La Tour's painting *The Lamentation Over St. Sebastian* (1630). A night scene is the setting for his composition; the drama of the painting does not arise from the expressions or gestures of its figures, but from the use of light and the inclusion of the light source itself, the torch. The forms of his figures are simplified, and the surfaces of skin and drapery are smooth, allowing the light to bathe those areas in line with its source. De La Tour was fond of including the light source in his compositions as a dramatic device, as seen again in his painting *Joseph the Carpenter* (1645).

Nicolas Poussin

More representative of the French manner of Classicism during this period is the work of Nicolas Poussin (1594–1665). Though Poussin spent much of his active career in Rome, he is considered to have been the greatest French painter of his century. Two versions of the painting *The Shepherds of Arcadia*, painted ten years apart, reflect Poussin's modeling of the style of two masters of painting. In the first version, painted in 1630, Poussin's handling of the figures, his use of light and shadow, and the treatment of landscape are akin to Titian's style. In the latter version, painted in 1640, his composition more closely reflects Rubens' approach.

To Poussin, there were specific subjects and themes that were appropriate for depiction, such as those having to do with religion, heroes, and war. He felt that in the actual depiction, too, it was the responsibility of the artist to portray these noble themes in an idealized fashion that would appeal to the intellect rather than to the sensual nature of the viewer. Genre painting being not worthy of his attention, he focused primarily on Classical themes. His painting *The Rape of the Sabine Women* (c. 1636–1637) portrays Romulus, the first king of

Rome, signaling the men of Rome that it is time to carry off the Sabine women who have come with the townsfolk of Sabina to attend a celebration [see illustration 8]. The modeling and stances of the figures portrayed are based upon Poussin's study of Greek and Roman statues, and the entire scene seems somewhat artificially posed. Here the artist has relied upon the formal organization of his composition rather than on passion and drama to convey his message to the viewer.

One of Poussin's later works, *Landscape with the Burial of Phocion* (1648), reflects the level of intellectual sophistication that he was able to achieve in his painting, in this case, another narrative. His landscape does not represent a particular place as much as the idea of place that is appropriate for the subject he is portraying. Though the beauty of his landscape is unreal in its calculated, idealized depiction, it nonetheless invites the viewer to enter.

Versailles

Probably the greatest architectural undertaking of the century was the transformation of King Louis XIV's hunting lodge at Versailles into a palace (1669–1685) that is more than one-quarter of a mile wide and is part of a complex that covers approximately 200 acres of land. Louis Le Vau, court architect to King Louis XIV, designed the original garden front of Versailles, but died soon after. Jules Hardouin-Mansart (1646–1708) was accorded the honor of directing the design and construction of the complex. The magnificent park that extends from the garden front was designed by Andre Le Notre. In its ornamentation and dynamism the decor of the palace reflects the French Baroque style. The most impressive of the hundreds of rooms in the palace is the Hall of Mirrors, which is over 200 feet long and is lined with mirrors.

The Eighteenth Century

Rococo

Rococo, an extension of the Baroque, was a style of the first three-quarters of the eighteenth century. Characteristically ornate and intricate in design, it is seen mainly in furniture, architecture, and some artwork. The term *Rococo* is probably a derivation of the word *barocco*, itself derived from two French words, *rocaille* (rock) and *coquille*

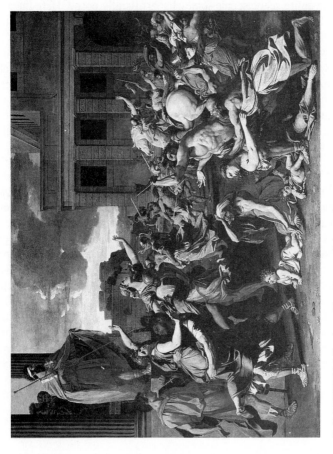

8. POUSSIN, Nicolas. *The Rape of the Sabine Women.*
Oil on canvas, 60⅞ × 82⅜" (154.6 × 209.9 cm.).
The Metropolitan Museum of Art, Harris Brisbane Dick Fund, 1946. (46.160)

(shell), which were frequent motifs in the decorative arts of this period. In contrast to the Baroque style, which was frequently employed to express religious themes on a grand scale, in bright colors, the Rococo tended to be used in a secular context on a smaller scale, expressed in subtle pastel colors.

Jean-Antoine Watteau

The work of the French painter Jean-Antoine Watteau (1684–1721) illustrates the decorative and sometimes lighthearted treatment of the Rococo. In his heritage, Watteau was Flemish, and the influence of Rubens can be seen in his work. (Watteau's French nationality came about because of a treaty signed a few years before he was born according to which the part of Flanders in which he lived became French territory.) His mastery of gesture and light and color are apparent in his paintings *L'Indifferent* (1720–1721) and *Gersaint's Signboard* (1720–1721). In *L'Indifferent*, Watteau portrays a dancer, possibly performing the minuet, a popular couples dance of the period. In *Gersaint's Signboard*, the characters do not interact with the viewer but with one another. In a rather lighthearted fashion, Watteau presents a picture of an everyday scene in the life of high-society France, as the elegant members of that class shop for paintings with which to decorate their homes. Perhaps Watteau's best-known painting is *A Pilgrimage to Cythera* (1717). As is characteristic of much of his work, the figures are in small groups, their scale small in the landscape, which, although somewhat idealized through the artist's brush, retains a naturalistic ambience.

François Boucher

Watteau's successor was François Boucher (1703–1770), who had as a patron Madame de Pompadour. His favorite theme and subject was the female nude, which he depicted in a Classical manner, as seen in *Cupid a Captive* (1754). Here he has modeled his figures three dimensionally, and they form a triangle in the center of the painting. The ornamentation and intricate style of the Rococo era are seen in combination with the traditional Baroque manner of composition, with the landscape receding through slanting planes and strong diagonals. Whether nude or clothed, his female figures were typically depicted in subtle shades of pink, accenting the form rather than the substance of the character. Boucher's portrait of *Marquise de Pompadour* (1759),

mistress and advisor to King Louis XV, reflects his ability to manipulate color and to portray the intricate details of a costume that is layers thick, as well as to capture the ambience of a time that many have considered superficial and frivolous.

Jean-Baptiste-Siméon Chardin

The style and themes expressed by artists such as Boucher that appealed to the interests and tastes of the aristocrats were considered by much of the middle class to be frivolous, and the work of artists such as Jean-Baptiste-Siméon Chardin (1699–1779) was found to be more appealing. Chardin tended to focus his skills on the depiction of still lifes and everyday scenes from the lives of the middle class, as seen in *Grace at Table* (1740). His paintings are calm and serene compared to those of Boucher.

Chardin also enjoyed portraying children, as in his painting *The House of Cards* (1741). The sense of intensity between the standing cards and the boy's concentration as he builds his "house" is reinforced by the artist's use of light to highlight the boy's face, the cards, and an open drawer, forming a triangle. Chardin's attention to the relationship between form and value lends a sense of strength and dignity to his paintings.

England

William Hogarth

During the seventeenth century, there were few notable English painters, and until the time of William Hogarth (1697–1764), the English aristocracy typically engaged such artists as Holbein and Rubens to produce works of art. Though Hogarth's work was likely influenced by the art of the French Rococo, his painting was characteristically English in reflecting the age of satire in which he lived. He was fond of doing series, such as his *Marriage à la Mode*, which portrayed the marital travails of a young viscount. *The Breakfast Scene* (1745) from that series portrays the disheveled young couple on the morning after a late night out, and it is apparent that all is not well. A servant exits the room, for example, carrying unpaid invoices, while the young nobleman sits slumped in a chair, pockets empty from gambling. The decor of the room itself is a parody of the style of the time, and

there are numerous details in the image that challenged the standards of eighteenth-century English society.

Thomas Gainsborough

Though Hogarth's genre paintings were quite popular, it was the portrait at which English painters excelled. Thomas Gainsborough (1727–1788), known for his landscapes as well as his portraits, treats the portrait differently in his paintings *The Honourable Mrs. Graham* (1775) and *Mrs. Richard Brinsley Sheridan* (1785). In the former portrait, Gainsborough has portrayed Mrs. Graham next to a solid column, her dress and expression indicating her social status. Mrs. Sheridan, however, is placed in a rural landscape setting, enveloped by an airy atmosphere.

Joshua Reynolds

A contemporary of Gainsborough, Joshua Reynolds (1723–1792), also known as a portraitist, was skilled in conveying the character of his subjects, as in his portrait of Lord Heathfield (1787).

Recommended Reading for Part IV

The Renaissance; The Baroque

Blunt, A. (1973). *Art and Architecture in France, 1500–1700*. Harmondworth: Penguin.

Cole, B. (1983). *The Renaissance Artist at Work*. New York: Harper & Row.

Chambers, D. (1971). *Patrons and Artists in the Italian Renaissance*. Columbia: University of South Carolina Press.

Crow, T. (1985). *Painters and Public Life in Eighteenth-Century Paris*. New Haven, Conn.: Yale University Press.

Enggass, R., & Brown, J. (1970). *Italy and Spain, 1600–1750*. Englewood Cliffs, N.J.: Prentice Hall.

Hartt, F. (1987). *History of Italian Renaissance Art*. New York: Abrams.

Haskell, F. (1980). *Patrons and Painters: A Study in the Relations Between Italian Art and Society in the Age of the Baroque*. New Haven, Conn.: Yale University Press.

Held, J., & Posner, D. (1971). *Seventeenth and Eighteenth Century Art: Baroque Painting, Sculpture, and Architecture*. New York: Abrams.

Levey, M. (1966). *Rococo to Revolution*. New York: Praeger.

Rosenberg, J., Slive, S., & Kuile, E. (1977). *Dutch Art and Architecture, 1600–1800*. Harmondworth: Penguin.

Snyder, J. (1985). *Northern Renaissance Art*. New York: Abrams.

Stechow, W. (1966). *Northern Renaissance Art, 1400–1600*. Englewood Cliffs, N.J.: Prentice Hall.

Varriano, J. (1986). *Italian Baroque and Rococo Architecture*. New York: Oxford University Press.

Vasari, G. (1966). *Lives of the Artists*, transl. G. Bull. New York: Penguin.

Part V

The Modern World

The term *modern* is a relative one, typically defined as relating to or characteristic of the present or the recent past. Here it is used to refer to the art of the nineteenth and twentieth centuries. Though what we refer to as "modern" will at some time be renamed by generations to come, for us, the term encompasses the last two centuries during which great advances were made in industry, paralleling great advances in science and technology. At the same time, there have been major changes in society and culture, religion, economics, and the value systems under which we live.

During these two centuries, an unprecedented number of styles of art have emerged. These movements in art—Neoclassicism, Romanticism, Realism, Impressionism, and Post-Impressionism, to name a few—are described here in terms of their subject matter, style of depiction, and aim.

CHAPTER 16

Neoclassicism and Romanticism

Chronology

1738–1820	Benjamin West
1746–1828	Francisco Goya
1748–1825	Jacques-Louis David
1749–1777	Walpole: Strawberry Hill
1752	Great Britain adopts Gregorian calendar
1755–1792	Soufflot: Portico of the Panthéon, Paris
1756–1763	Seven Years' War
1757–1827	William Blake
1758	Stuart: Doric portico, Hagley Park
1759	Voltaire writes *Candide*
1762	Stuart and Revett: *Antiquities of Athens*
1767–1824	Anne-Louis Girodet
1770	West: *The Death of General Wolfe*
1770–1784	Jefferson: Monticello, Charlottesville, Virginia
1771–1835	Antoine-Jean Gros
1773	Boston Tea Party
1775–1851	Joseph Mallord William Turner
1775–1783	American Revolution
1776–1837	John Constable
1777	Goya: *The Parasol*
1778	Copley: *Watson and the Shark*
1780–1867	Jean-Auguste-Dominique Ingres
1781	Kant publishes the *Critique of Pure Reason*
1784	David: *Oath of the Horatti*

1785–1789	Jefferson: State capitol building, Richmond, Virginia
1787	David: *The Death of Socrates*
1789	French Revolution begins
1790–1831	Goethe's *Faust* is published
1791–1824	Théodore Géricault
1793	David: *The Death of Marat*
1794	Blake: *The Ancient of Days*, from *Europe, a Prophecy*
1794–1799	Goya: *Los Caprichos*
1796	Gros: *Napoleon at Arcole*
1796–1875	Jean-Baptiste-Camille Corot
1798–1863	Eugène Delacroix
1800	Goya: *The Family of Charles IV*
1803	Louisiana Purchase
1804	Napoleon becomes emperor
1804	Gros: *Pest House at Jaffa*
1807	Ingres: *François Marius Granet*
1808	Girodet: *Burial of Atala*
1808	Ingres: *Oedipus and the Sphinx*
1812	Géricault: *Mounted Officer of the Imperial Guard*
1814	Goya: *The Third of May, 1808*
1814	Ingres: *Grand Odalisque*
1814–1875	Jean Millet
1815	Napoleon is defeated at Waterloo

1815–1879	Thomas Couture
c. 1818	Goya: *Bobabilicon*, from *Los Proverbios*
1818–1819	Géricault: *The Raft of the "Medusa"*
1819–1823	Goya: *Saturn Devouring His Children*
1821	Constable: *Hampstead Heath*
1821–1824	Géricault: *The Madman*
1822–1823	Géricault: *The Madwoman*
1822–1824	Delacroix: *Scenes of the Massacre at Chios: Greek Families Awaiting Death or Slavery*
1824–1904	Jean-Léon Gérôme
1825–1905	Guillaume-Adolphe Bouguereau
1826	Constable: *Salisbury Cathedral from the Bishop's Garden*
1826	Delacroix: *Death of Sardanapalus*
1826	Corot: *Papigno*
1827	Delacroix: *Greece Expiring on the Ruins of Missolonghi*
1830	Delacroix: *Liberty Leading the People*
1832	Ingres: *Louis Bertin*
1836	Constable: *Stoke-by-Nayland*
1837–1901	Reign of Queen Victoria
1838–1839	Turner: *Fighting Temeraire*
1840	Turner: *The Slave Ship*
1847	Couture: *Romans of the Decadence*
1848	Communist Manifesto

1850	Millet: *The Sower*
1851	Corot: *Harbor of La Rochelle*
1857	Millet: *The Gleaners*
1859	Gérôme: *Thumbs Down*
1879	Bouguereau: *Birth of Venus*

The lighthearted subjects portrayed in pastel that were characteristic of the Rococo style lost much of their popularity toward the end of the eighteenth century, due in part, some historians say, to the French Revolution. In France, the revival of Classicism, referred to as Neoclassicism, greatly influenced the work of such artists as Jacques-Louis David and Jean-Auguste-Dominique Ingres, who followed a tradition that noble themes were the only appropriate subject matter. Eugène Delacroix, though accepting the Romantic tradition of imagination as a basis for an art whose purpose is to "move" the public, was also very conscious of the role played by technique. It is, in fact, in his work that we truly see the drama and theater that earlier artists had strived to achieve. Delacroix's observations concerning color are particularly worthy of note, for they may be seen as precursors to Impressionist thought about color.

In England, the Romantic style may be considered a response to the perceived artificiality of the Baroque manner. Some English landscape artists turned their attention to refining the elements of color and light as vehicles for producing works that internalized and emotionalized their subject matter. Others were more analytical about their painting and valued direct observation as the basis for their work.

The period of time encompassing the movements Neoclassicism and Romanticism began in the mid-eighteenth century and ended in the mid-nineteenth century. Neoclassicism refers to the revival of Classicism; Romanticism was a philosophical movement that emphasized the imagination and emotions and, according to some scholars, may have developed as a reaction against Neoclassicism.

Architecture

The roots of Romanticism may be seen as originating as early as the late 1600s in England as a reaction to the Classical architecture of the period. While it is not surprising that trade with the Far East would lead to interest in Chinese art, an unanticipated result was the impact of traditional Chinese gardens upon the English, leading to a reevaluation of the more formal gardens with which the English were familiar. The result was the development and popularity, during the 1700s, of English gardens that resembled more the gardens of the Orient than those found at such sites as Versailles. The change in taste from "ordered" to "natural" would affect the domain of architectural design as well, as seen in a return to the use of the Gothic style, which may have seemed more natural and certainly more romantic than the Baroque/Rococo manner of the day.

Naturalism in Architecture

Though there was no one agreed-upon definition of what "natural" meant architecturally, various architects designed structures in response to the trend. The architect John Vanbrugh (1664–1726), though known for his Baroque architectural designs such as Blenheim Castle (1705–1722), which he built for the duke of Marlborough, later built for himself a country home that looked like a Gothic castle. Richard Boyle, the earl of Burlington, wanted a natural, yet formal villa set in an informal garden. Chiswick House (1725), designed in collaboration with William Kent (1684–1748), was such a dwelling. Based upon the design of the Villa Rotunda (1567–1570) in Vicenza, Chiswick House represents a simplified geometric ordering of elements. Taking another direction, Horace Walpole (1717–1797) remodeled Strawberry Hill (1749–1777), his estate at Twickenham, to resemble a Gothic castle. However, Strawberry Hill and other structures representing a Gothic revival were closer in design to fairy-tale castles than to actual Gothic buildings.

"Natural" gardens were also created that incorporated Classical structures such as the fabricated Gothic ruins (1747) and Doric portico (1758) found in the gardens at Hagley Park. In 1762, James Stuart (1713–1788), who designed the Doric portico in Hagley Park, published, with Nicholas Revett, the first of a series of volumes entitled

Antiquities of Athens, which lauded the achievements of Greek art. The text provided a focal point for those who were dissatisfied with the Baroque, Rococo, Gothic, and Chinese styles; it heralded a return to Greek art and architecture as sources of inspiration and launched the Neoclassical movement.

Renewed Interest in the Civilizations of Greece and Rome

Greek art and architecture became the standards by which art and architecture were judged. Along with the Neoclassical enthusiasm for Greek art came renewed popular interest in Roman art and architecture. This interest coincided with a major archaeological discovery: the two ancient Roman cities of Pompeii and Herculaneum. Europeans were fascinated with the fact and fiction of Greece and Rome. The perception of Rome as a city of majestic ruins was partially shaped by the work of Giovanni Battista Piranesi (1720–1778), who produced in 1750 a portfolio of over one hundred prints entitled *Views of Rome*.

Neoclassicism as Reaction to Baroque and Rococo Styles

The contemporary architecture of the mid-eighteenth century also reflected the strong influence of Neoclassicism as a rebellion against the Baroque and Rococo styles, as seen in Jacques-Germain Soufflot's (1713–1780) Neoclassical design of the portico of the Panthéon (1755–1792) in Paris. Though Soufflot utilized Gothic engineering methods to build and support the structure, its colonnade design was likely based upon Roman ruins found at Baalbek. The design of the structure is that of the Greek cross, with a Neoclassical colonnaded dome said to have been inspired by that of St. Paul's Cathedral in London.

The influence of Neoclassicism was felt as far away as America, as seen in Thomas Jefferson's design for the state capitol building (1785–1789) in Richmond, Virginia, based upon a Roman temple, as well as in his design for Monticello, his home in Charlottesville, Virginia, (1770–1784). This is not to suggest, however, that the Gothic style immediately became obsolete. During the early nineteenth century, the Gothic style was preferred over the Classical. When the Parliament building of England was lost to a fire in 1834, it was the decision of the Parliamentary Commission that the new Houses of Parliament (1835–1863) should be built in the Gothic style.

Painting

Benjamin West

The origins of the Romantic style in England may be considered a response to the perceived artificiality of the Baroque manner. The American painter Benjamin West (1738–1820) ended up in London by way of Rome, where he became one of the original members of the Royal Academy of Art. In his painting *The Death of General Wolfe* (1770), he captures the heroic spirit of the death of General Wolfe during the French and Indian War but depicts it in a contemporary fashion. Lacking the formal, Classical orientation to painting of many of his European contemporaries, West felt comfortable portraying the death of a contemporary figure in Classical terms.

John Singleton Copley

Another American who made his home in London and was a contemporary of West was the Bostonian John Singleton Copley (1738–1815). One of Copley's best-known works is *Watson and the Shark*, (1778) which dramatically portrays Watson being attacked by a shark while swimming in Havana Harbor. Given the romantic attraction of the public to themes of a frightening nature, Copley's graphic composition possessed all the elements necessary for a successful painting.

William Blake

The attraction to the romanticism of the Gothic period and the Middle Ages was also interpreted by William Blake (1757–1827) in much of his work. Influenced by the illuminated manuscripts of the past, Blake produced modern versions using hand-colored engravings, as seen in his book *Europe, a Prophecy*, published in the late eighteenth century. His images from the text, such as *The Ancient of Days* (1794), were based upon earlier medieval works.

Joseph Mallord Turner

Meanwhile, the landscape artists of the Romantic period, such as Joseph Mallord William Turner (1775–1851), turned their attention to

refining the elements of color and light as vehicles for producing works that were based upon the internalizing and emotionalizing of their subject matter. Like many landscape artists of this time, Turner did studies working directly from nature in order to gain a sense of the immediacy of the colored light he was portraying, although he did not hesitate to rearrange elements within his paintings to suit his sense of balance and composition. Though Turner's early works, such as his *Fighting Temeraire* (1838–1839), reflect his use of color to create romantic images, his later works indicate his interest in exploring the close relationship between color and light to a degree such that his work approaches a manner that may be called Impressionistic.

Turner's powerful image of *The Slave Ship* (1840) portrays the powers of both humankind and nature. The painting, based upon an actual event in which the captain of a slave ship threw slaves overboard who were ill because his insurance would cover the loss of human "cargo" at sea but not loss through illness, raises the moral issue of the power one person has over another. At the same time, an approaching storm places the ship in danger, a predicament perhaps to be interpreted as the working of justice, or merely as a whim of fate. Turner chooses not to graphically present the event itself, but to convey his emotive impression of the incident.

John Constable

Another well-known English painter, one who is known to have influenced the work of Eugène Delacroix, was John Constable (1776–1837). Constable approached painting analytically. In his landscapes, he experimented with broken brush strokes and the depiction of light through color as reflected upon surfaces, frequently doing his studies of nature directly from nature, for he valued observation over imagination. His interest in capturing a sense of light and atmosphere is apparent in *Hampstead Heath* (1821), in which his depiction of the earth is subservient to, and simply sets the context for, his portrayal of the sky.

Though Constable may have painted Romantic subjects, such as *Salisbury Cathedral from the Bishop's Garden* (1826), his manner of depiction was not in the Romantic tradition of portraying the "actual." Rather, his intent was to capture the Romantic ambience of light and atmosphere, taking into account the optical qualities of color as reflected light in nature. In his later works, Constable was able to

capture this sense of atmosphere in his depiction of both the land and the sky, as seen in his painting *Stoke-by-Nayland* (1836).

Francisco Goya

The well-known Spanish painter Francisco Goya (1746–1828) is difficult to place in a particular school or style but is appreciated as a transitional figure of nineteenth century art. His range of depiction and technique was wide, and though a number of his early works, such as *The Parasol* (1777), were Romantic genre paintings from which a tapestry was to be designed, many others were graphic portrayals of humankind's darker side. Goya's work was inspired by nature and by the work of Velázquez, the latter's influence being evident in Goya's *The Family of Charles IV* (1800). Like Velázquez in his painting *Las Meninas* (1656), Goya included his own image on the left side of the painting, which portrays the royal family. Though Goya's realism, technique, and treatment of color are similar to those of Velázquez, Goya reduced the depth of the space that his characters occupied and portrayed the group in an unflattering manner, it is felt, in order to reflect the corruption and crassness that typified the reign of Charles IV.

Goya's social consciousness and artistic response to critical social issues manifested themselves not only in the subtle form of the painting *The Family of Charles IV*, but also in graphic etchings and paintings. From 1794 to 1799, he produced a series of works, *Los Caprichos (The Caprices)*, which reflected his attitude toward and perception of the folly of humankind. When the forces of France, under the command of Napoleon Bonaparte, clashed with those of Spain in the early 1800s, Goya's response to the horrors of war was to produce etchings and paintings that graphically portrayed people's inhumanity to people under the guise of war. One of the most famous of these works is his painting *The Third of May, 1808* (1814), which portrays a French firing squad brutally executing civilians of Madrid. Unlike the stiffly posed members of the royal family, his figures here are highly agitated, and the work has the emotional impact of the religious art of earlier times. Goya's use of coarse, grating color made all the more jarring the harsh image of French soldiers intent upon their task and townsfolk with arms outstretched or huddling in horror and defiance. Goya's aquatint etchings entitled *The Disasters of War*, though not published for some three

decades after his death, were equally graphic in their depiction of war's low regard for human life.

In the latter part of Goya's life, it is likely that illness and the horrors of war that he had observed contributed toward what has been called his dark style. Many of the images he produced during this later period are of grotesque figures and monsters, as seen in his etching *Bobabilicon* (1818) [see illustration 9] from the series *Los Proverbios*, as well as in a work entitled *Saturn Devouring His Children* (1819–1823).

Jacques-Louis David

The French painter Jacques-Louis David (1748–1825) is typically identified as a Neoclassicist. Influenced greatly by the work of Poussin and actively involved in the French Revolution, David held Greek art in high esteem and, along with it, the tradition that dictated that noble themes were the only appropriate subject matter. His *Oath of the Horatti* (1784) is such a painting and, though it is based upon a folktale from Republican Rome, it shows an academic approach to the Neoclassical style. It was painted prior to the Revolution. However, because of its implied message—that patriotism and loyalty are of a higher order than the personal emotions of love and grief—it was perceived as a political artwork, and the Neoclassical style came to be associated with the revolution.

The influence of Poussin is apparent in David's *The Death of Socrates* (1787). Like Poussin in *The Rape of the Sabine Women* (c. 1636–1637), David "constructs" his figures in a very rigid, sculptural manner. What is striking about his painting is the degree of realism and his use of direct light, probably borrowed from Caravaggio, which creates sharp shadows, more fully defining the figures.

David's painting *The Death of Marat* (1793), on the other hand, represents the artist's dramatic classicizing of an actual current event: the murder of the revolutionary Marat in his bath by Charlotte Corday. In this case, David relied more upon the tradition of religious art than Classical art. His manner of classicizing the contemporary led some of his contemporaries to reject his style, for the basis of Classicism rested upon the concept that there were timeless and heroic qualities to an act or event whose "truth" could be realized only over time. Therefore, by

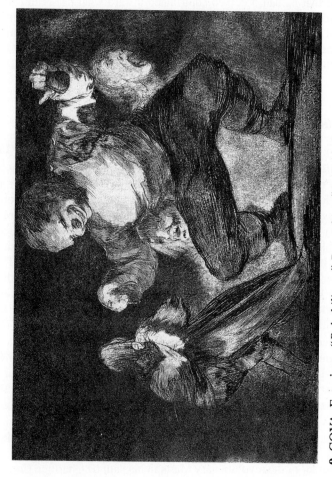

9. GOYA, Francisco. *"Bobabilicon." Proverbios #4.* (c. 1818)
Etching and aquatint.
The Metropolitan Museum of Art, Harris Brisbane Dick Fund, 1924. (24.30.5)

definition, contemporary events were considered inappropriate for depiction.

Anne-Louis Girodet and Antoine-Jean Gros

Among David's well-known students were Anne-Louis Girodet (1767–1824) and Antoine-Jean Gros (1771–1835), both of whom developed styles somewhat different from their master's. Girodet's *Burial of Atala* (1808), though it makes use of the Classical manner of figure modeling, also incorporates elements of the Baroque and Rococo and appeals to the viewers' imagination and feeling rather than to their interest in the political. Gros deviates even further, as seen in his Romantic portrayal portrait *Napoleon at Arcole* (1796). In *Pest House at Jaffa* (1804), Gros again uses Baroque mechanisms to focus attention upon the central character of the painting, Napoleon Bonaparte, who is pictured here as a Christ figure healing the sick. Gros's placement of the scene within such an exotic environment contributes greatly to the Romantic atmosphere of the work.

Théodore Géricault

The thread of realism that ran through the work of Jacques-Louis David and those who followed him is seen in a more fully developed state in *The Raft of the "Medusa"* (1818–1819), by the Romantic artist Théodore Géricault (1791–1824). He too utilized Baroque devices to dramatize his image, with strong highlights and shadows emphasizing the terror of the individuals on the raft as they attempt to call attention to their plight. To authentically paint this contemporary event, Géricault met with survivors of the tragedy, studied records, and examined cadavers. The sense of energy that he was able to capture in this painting may be seen in an earlier work, *Mounted Officer of the Imperial Guard* (1812), in the manner in which he glorifies the Romantic image of the military hero. The popular interest in the depiction of character is evident in both the soldier and the horse, who become one in their intensity. The realism of this Romantic image is later manifested in terms of the inner workings of humankind to include the insane, as seen in Géricault's paintings *The Madman* (1821–1824) and *The Madwoman* (1822–1823), and reflects the period's infatuation with nature and man's role in nature.

Eugène Delacroix

Eugène Delacroix (1798–1863), though accepting of the Romantic tradition of imagination as a basis for art whose purpose was to "move" the public, was very conscious of the role played by technique. It is in his work that we truly see the drama and theater that earlier artists had strived to achieve. The painting that established his reputation, though it was met with mixed reviews at the Salon of 1824, was his exotic *Scenes of the Massacre at Chios: Greek Families Awaiting Death or Slavery* (1822–1824). Though based upon the Greek rebellion against Turkish rule, the painting does not attempt to graphically represent a historical event, but rather Delacroix's view of the war in general. In a later work, *Greece Expiring on the Ruins of Missolonghi* (1827), he has created less of a narrative recording an event of modern history and more of a symbolic image of his support for the Greek cause. His use of color is reminiscent of Rubens and shows his mastery as a colorist.

In another of his dramatic works, *Death of Sardanapalus* (1826), Delacroix puts to use a broad range of highlights and shadow, his mastery of color, and a diversity of Rubenesque figural poses to convey the dramatically horrifying image of King Sardanapalus calmly watching his personal treasures, including his wives and slaves, being obliterated by his command rather than allowing a conquering army to possess them.

The period from the late eighteenth century into the early nineteenth century was a time of revolution, and Delacroix's *Liberty Leading the People* (1830) represents an allegorical Romantic image of revolution, with Liberty represented as a partially clad woman leading the citizenry over the bodies of those who have died in their quest for freedom.

Delacroix's observations concerning color are particularly worthy of note, for they may be seen as precursors to Impressionist thought pertaining to color. He noted that although artists typically utilized pure color tones blended together in their compositions, color did not, in fact, occur in nature as pure tones. His solution for coming closer to the manner in which color exists in nature was to not blend his brush strokes upon the canvas, for he believed that this blending would occur naturally for the viewer when viewing the painting.

Jean-Auguste-Dominique Ingres

During this period, there was continued debate between two factions as to which was the most important dimension of painting, color or drawing. Delacroix opted for color; Jean-Auguste-Dominique Ingres (1780–1867) argued that drawing was superior. Ingres studied for a short time with Jacques-Louis David and is considered by many to have carried on the tradition of David. As a Neoclassicist, he held in high esteem the art of Greece and Rome. The work of Delacroix, which was even further from the Classical style than David's, polarized the issue of "acceptable" style such that Ingres' work, in keeping closer to Classical norms, was heralded by those who were of the traditional academic tradition.

Though Ingres's approach to painting involved more than simply filling in drawings with colored pigments, he focused upon the linear qualities of his figures. His painting *Oedipus and the Sphinx* (1808) reflects his sculpturesque manner of depicting the figure, with Oedipus in the center foreground of the composition, firmly posed. Representative of his style and typical of the Romantic intrigue with the exotic is his *Grand Odalisque* (1814). The concubine's nude body, like his figure of Oedipus, is almost outlined and is modeled so that it reflects light like polished stone.

The same generalization of form is found in Ingres' portraits, such as his painting of *François Marius Granet* (1807), which is more a representation of the character of the subject than a photographic likeness. His later portraits, however, have more of the solidity and photographic realism of David, as seen in Ingres' portrait of *Louis Bertin* (1832), which, though realistic in portrayal, still conveys a sense of the subject's character.

Thomas Couture

The schism between the academic art of Ingres and the unofficial or "progressive" manner of Delacroix continued to have a great effect upon the art being produced during this period. Academic art was the accepted norm, and as such, artists who belonged to this school tended to receive more public support for their work than those who rebelled against it. Representative of the academic tradition was the work of Thomas Couture (1815–1879). The manner of Romanticism led to the

continued staging of pageantry as seen in his *Romans of the Decadence* (1847), which appealed to the public not only because of its subject matter, but also because of its social implications and commentary concerning a current issue, decadence. For the audience of the nineteenth century, the painting had all the elements that made for a popular work of art: a dramatic, somewhat idealized environment from the past setting the stage for idealized nude and partially clad figures engaged in activity. Couture's painting is a good example of the artist's keying in on what is popular and developing a "formula" for delivering what the public wants to see.

Guillaume-Adolphe Bouguereau

The academic manner of figure depiction was interpreted in different ways and contexts by various artists of the time. In his *Birth of Venus* (1879), Guillaume-Adolphe Bouguereau (1825–1905) incorporates a dimension of realism in his figures such that they are less idealized forms and seem to anticipate photographic realism.

Jean-Léon Gérôme

The photographlike quality of a dramatic scene is also evident in the painting *Thumbs Down* (1859), by Jean-Léon Gérôme (1824–1904). Though it deals with a subject of Classical history, there is little that is heroic in this image of gladiators battling to the death.

Jean-Baptiste-Camille Corot

In France, perhaps the best-known landscape painter of this period was Jean-Baptiste-Camille Corot (1796–1875). During his career, he painted in a manner that was directed toward the popular taste of the public as well as in a fashion that was oriented toward explorations in the depiction of light. Many of his early landscapes, such as *Papigno* (1826), were painted directly from nature and possess the same energy as sketches. An example of a later painting is his *Harbor of La Rochelle* (1851), which reveals a full range of subtle color and a mastery of light.

Jean Millet

Contemporary with Corot were a group of artists who, because of their proximity to the hamlet of Barbizon, became known as the Barbizon school of painters. One of the major painters of this group was Jean Millet (1814–1875), who is especially known for his paintings that portray the dignity of French rural life, as seen in *The Sower* (1850) and *The Gleaners* (1857).

CHAPTER 17

Realism, Impressionism, and Post-Impressionism

Chronology

1808–1879	Honoré Daumier
1819–1877	Gustave Courbet
1830–1903	Camille Pissarro
1832–1883	Édouard Manet
1834	Daumier: *Rue Transononain*
1834–1903	James Abbott McNeill Whistler
1834–1917	Edgar Degas
1836	Morse invents the telegraph

1838	Dickens publishes *Oliver Twist*
1839–1906	Paul Cézanne
1840–1917	Auguste Rodin
1840–1926	Claude Monet
1841–1919	Auguste Renoir
1844–1910	Henri Rousseau
1845–1926	Mary Cassatt
1848–1903	Paul Gauguin
1849	Courbet: *The Stone Breakers*
1849	Courbet: *Burial at Ornans*
1853–1890	Vincent van Gogh
1854–1855	Courbet: *Interior of My Studio: A Real Allegory Summing Up Seven Years of My Life as an Artist*
1859	Darwin's *Origin of Species* is published
1859–1891	Georges Seurat
1860	Daumier: *The Uprising*
1860–1949	James Ensor
1861–1865	The American Civil War
1862	Daumier: *The Third-Class Carriage*
1863	Manet: *Déjeuner sur l'Herbe*
1863–1944	Edvard Munch
1864–1901	Henri de Toulouse-Lautrec
1866	Manet: *The Fifer*
1868	Monet: *The River*
1868–1870	Cézanne: *Christ in Limbo*

1869	Monet: *La Grenouillère*
1869	Renoir: *La Grenouillère*
1871	Whistler: *Arrangement in Black and Gray: The Artist's Mother*
1874	Impressionists hold first exhibition in Paris
1874	Monet: *Impression: Sunrise*
c. 1874	Whistler: *Nocturne in Black and Gold: The Falling Rocket*
1876	Bell invents the telephone
1876	Degas: *Ballet Rehearsal (Adagio)*
1876	Degas: *The Glass of Absinthe*
1876	Degas: *Prima Ballerina*
1876	Renoir: *Le Moulin de la Galette*
1877	Edison invents the phonograph
1879–1882	Cézanne: *Fruit Bowl, Glass, and Apples*
1879–1889	Rodin: *The Thinker (Le Penseur)*
1880–1966	Hans Hofmann
1882	Manet: *A Bar at the Folies-Bergères*
1883–1884	Seurat: *The Bathers*
1884–1886	Seurat: *A Sunday Afternoon on the Island of La Grande Jatte*
1885	Van Gogh: *The Potato Eaters*
1886	Degas: *The Tub*
1886	Rodin: *The Burghers of Calais*
1886–1887	Cézanne: *La Montagne Sainte-Victoire*

1886–1898	Rodin: *The Kiss*
1887–1888	Seurat: *Invitation to the Side Show*
1888	Van Gogh: *The Night Cafe*
1888	Gauguin: *The Vision after the Sermon (Jacob Wrestling with the Angel)*
1888	Ensor: *The Entry of Christ into Brussels*
1888–1889	Van Gogh: *The Artist's Room at Arles*
1889	Van Gogh: *Wheat Field and Cypress Trees*
1889	Van Gogh: *Self-Portrait*
1889	Van Gogh: *The Starry Night*
1890	Ensor: *Intrigue*
1890	Degas: *Morning Bath*
1890	Cézanne: *Still Life*
1891	Cassatt: *In the Omnibus*
1891–1892	Cassatt: *The Bath*
1892	Gauguin: *The Spirit of the Dead Watching*
1892	Gauguin: *Nefea Faaipoipo (When Are You to Be Married?)*
1892	Toulouse-Lautrec: *At the Moulin Rouge*
1893	Munch: *The Scream*
1893–1895	Cézanne: *Boy in a Red Vest*
1894	Monet: *Rouen Cathedral*
1895	Pissarro: *Place du Theatre Français*
1897	Rousseau: *The Sleeping Gypsy*
1897–1898	Rodin: *Monument to Balzac*
1900	Monet: *Pool of Water Lilies*

| 1907 | Monet: *Water Lilies, Giverny* |
| 1910 | Rousseau: *The Dream* |

During the latter half of the nineteenth century, many artists and writers strove to achieve a sense of fidelity in their art toward nature and real life, preferring accurate representation, that is, realism, above idealization. This accurate representation and attention to detail is well represented by the work of Courbet. If his Burial at Ornans *(1849) had been painted in the Classical or Romantic manner, it would likely have been a small work portraying an idealized vision of the life of the common laborer. However, Courbet chose to paint his scene in a Realist manner, based upon his own observations. He depicted his common laborers and the hardships they endured in a larger-than-life format on a canvas eleven feet high and twenty-three feet wide, a scale traditionally reserved for "appropriate" subjects, which did not include the mundane and the ordinary.*

The Impressionists, however, set as their goal the depiction of scene, emotion, and character by evoking subjective and sensory impressions in the viewer rather than by recreating visually an objective reality. In style, this was achieved through the use of individual brush strokes of unmixed pigments to simulate the effects of actual reflected light. The attitudes represented in Impressionist thought are considered by many to represent the beginning of the modern art movement. The subjects the Impressionists chose allowed them the flexibility to paint in a manner such that they were not copying nature or following traditional canons of art, but using nature as their point of departure. For the Impressionists, it was not the subject they painted that was important, but their impression of the subject, frequently in terms of the light falling on that subject.

Post-Impressionism, as the term implies, grew out of the Impressionist movement. Because the major Post-Impressionists worked during the same period of time, they are conveniently referred to collectively as a movement. However, by and large, they worked independently of one another, and each has been the source of a different movement that followed: Cubism has its roots in the work of Cézanne; Fauvism can be traced back to Gauguin, Expressionism, to Van Gogh, and Pure Abstraction, to Seurat.

Realism

Honoré Daumier

The notion of artists utilizing their art to comment on social issues continued to be manifested in the work of Honoré Daumier (1808–1879), whose social satires and visual commentaries did not make him popular with the French government. His lithograph *Rue Transononain* (1834) has the same graphic impact as Goya's work and serves as a record of a stark and brutal event: a squad of French soldiers killing the inhabitants of a building after a sniper apparently fired on them.

Whereas much of the work of Millet portrayed life in the French countryside, the work of Daumier, who was of the city of Paris, centered around the effects of industrialization upon the population of that city. In *The Uprising* (1860), a painting that portrays a citizen attempting to incite those around him to action, Daumier conveys the political tension of the time. His efforts to call attention to the plight of the masses is seen in his painting *The Third-Class Carriage* (1862). Unlike Millet, he does not glorify the plight of his subjects, the impoverished, but portrays them as a displaced population that has not benefited from the rapid changes occurring in the urban environment. His style of depiction is loose and relaxed. Because Daumier seemed to be more concerned with the emotional representation of his subject than with a pictorial representation, some historians have questioned whether he should, in fact, be classified as a realist at all.

Gustave Courbet

The academic tradition of depicting heroic and idealized subjects was challenged by such artists as Gustave Courbet (1819–1877), who felt that the artist should rely primarily upon his own experience of nature. The socialist orientation of much of his work was considered by many of his contemporaries to be inappropriate.

His paintings typically portrayed "common" themes and subjects. Such a painting is *The Stone Breakers* (1849), whose limited range of color seems fitting for the subject. When Courbet's entries to the 1855 Paris International Exhibition, *The Stone Breakers* and *Burial at Ornans* (1849), were rejected because they were not in the academic tradition, he presented them himself, along with other works, in a site adjacent to

the International Exhibition that he called his "Pavilion of Realism," thus giving birth to the term *Realist style*. One of the paintings he exhibited in his Pavilion of Realism was a large work, *Interior of My Studio: A Real Allegory Summing Up Seven Years of My Life as an Artist* (1854–1855). Though this painting was of the same genre as *The Maids of Honor* (1656) by Diego Velázquez, Courbet placed an image of himself, the artist, at the center of the composition. On the left are individuals who represent the subjects he portrayed in his work: on the right are individuals representing the public of patrons and critics, some of them identifiable.

Édouard Manet

Another Realist painter of this period was Édouard Manet (1832–1883), whose work, however, is directly associated with the Impressionist style in his attention to the depiction of the effects of light rather than to the portrayal of the subject matter itself. For Manet, as for the Impressionists who would follow, the portrayal of themes and subjects was largely a means to an end, that end being the representation of surfaces reflecting light. The public did not always perceive Manet's intent, however, as seen in the negative reaction to his painting *Déjeuner sur l'Herbe (Luncheon on the Grass)* (1863). In the painting, two fully clothed men dressed in the fashion of the time and a nude woman are sitting in the woods having a picnic, while behind them another woman immerses herself in a pond. As an image, it was considered inappropriate and scandalous because of the realistic, though formal, portrayal of the figures, especially the nude woman; she is not a symbolic figure, thus denying any Classical orientation to the composition. That the "image" got in the way of the truly significant aspect of the painting is unfortunate. What was truly of import was Manet's innovative method of portraying the figures through the use of direct light, thus reducing and flattening them. As an intellectual exercise, Manet's placement of the nude figure alongside the clothed figures provided him with the opportunity to "describe" how the different surfaces would reflect light. Here the artist exercises his self-proclaimed right to manipulate whatever variables he saw fit in order to achieve his goal.

Manet's use of planes and fields of color tended to flatten his forms. This effect is quite apparent in his painting *The Fifer* (1866), which has little dimension to it and calls the viewer's attention to the fact that it is

an image made of pigment on canvas. This was Manet's goal—to cause the viewer to recognize that he or she is looking at the *surface* of the canvas.

Manet's mastery of depicting reflected light can also be seen in *A Bar at the Folies-Bergères* (1882), where he contends with the representation of artificial light. Unlike earlier painters who focused upon the portrayal of narratives, Manet was one of a new class of painters who were more interested in the optical qualities of the pigment upon the surface of the canvas than they were in conveying a message or providing information about their subject. This shift in attention from subject to medium challenged the traditional mode of looking "into" a painting and redirected the viewer's attention to its surface. By attending to contemporary themes and subjects, Manet helped to establish a tradition that would be followed by the Impressionists in their manner of working directly from nature as well as portraying scenes of daily life.

Impressionism

The Impressionistic goal of simulating actual reflected light was aided by scientific advances that dealt with the physics of light as well as technical advances that were made in the production of pigments for painting. The Impressionists studied the optical qualities of light, the effects of positioning colors adjacent to one another, and how light reflected off one object affected the perception of color of another object. Unlike earlier painters, they realized that shadows and highlights in nature were not, in reality, black and white, but rather were variations of hue and tone. They also realized that, though when viewed closely, their brush strokes might appear choppy, when viewed from a distance, they would merge in such a way as to better capture the true, vibrant nature of light.

Claude Monet

Impressionists like Claude Monet (1840–1926) experimented with these ideas as a means of recording perceptions of color and how things "looked" rather than recording actual events or images. It was, in fact, a painting by Monet entitled *Impression: Sunrise* (1874) that gave the

movement its name, by way of an art critic's negative response. The scientific approach to Impressionist painting can be seen in Monet's paintings of Rouen Cathedral, of which there were some twenty-six, all painted from the same view, but at different times of day; *Rouen Cathedral* (1894) is a classical example of this series [see illustration 10]. The attention to the painted surface of the canvas rather than the depiction of actual space is also evident in Monet's painting *The River* (1868). Here there is little difference in the artist's treatment of the forms along the bank of the river and of their reflection in the water. His painting *Pool of Water Lilies* (1900) shows his mastery of depicting glimmering light reflected off both water and flora. Four decades after painting *The River*, Monet, in his *Water Lilies, Giverny* (1907), still shows his attraction to the depiction of light and reflection, except here, the entire painting is filled with the surface of the water and its reflections.

Camille Pissarro

Attention to visual sensation in painting is also seen in the work of Camille Pissarro (1830–1903). *Place du Theatre Français* (1895) presents a view of the city square on a busy day as if one were looking down from an upper-story window. The sensation from which Monet worked was light; for Pissarro, as seen in this painting, the sensation was motion. In both cases, however, it was through color that the artist represented his sense of the visual.

Edgar Degas

Edgar Degas (1834–1917), too, was interested in movement and motion and is especially known for his paintings of dancers rehearsing for and performing ballet. In his *Ballet Rehearsal (Adagio)* (1876), he draws the viewer into the rehearsal hall of the painting through the use of a diagonal orientation and the placement of an open space in the composition that gives the illusion of sharing pictorial space with the viewer. Degas liked to create unusual angles of vision in his compositions. His use of diagonals in *The Glass of Absinthe* (1876) pushes the viewer away from the couple portrayed, conveying a sense of isolation. His manner of depicting space, at least partially derived from the

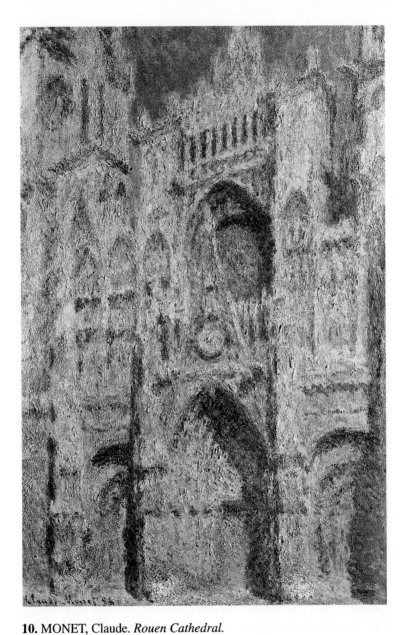

10. MONET, Claude. *Rouen Cathedral.*
39¼ × 25⅞" (99.7 × 65.7 cm.).
The Metropolitan Museum of Art, Bequest of Theodore M. Davis, 1915.
Theodore M. Davis Collection. (30.95.250)

Japanese prints that were popular in his day, contributed to his ability to momentarily stop the action of the subject he was portraying.

Besides painting in oils, Degas was a master of pastels, which are made of ground pigment and are used dry. His pastel drawings such as *The Tub* (1886) and *Morning Bath* (1890) reveal the versatility of the medium and Degas' ability to capture a moment in time. These works are compelling, too, because of Degas' selection of an unusual perspective.

Mary Cassatt

Mary Cassatt (1845–1926), an American, had as a child spent some years in France; she returned to Europe in the late 1860s to pursue a career in art. As a woman of her time, not only did she have to struggle with the displeasure of her family at her choice of occupation, she also had to make her way in an artworld that was male dominated. However, she persevered. Soon after the paintings that she had submitted to the Salons of 1875 and 1877 were rejected, she met Degas, who introduced her to the Impressionist circle.

Cassatt embraced the Impressionist doctrine of focusing upon the effects of light on the scene portrayed. Like Degas, she portrayed scenes from unusual angles and perspectives. Her use of points of view above normal sight lines is effective in creating a psychological space between the image and the viewer, such that any natural emotional response to the image is diminished. This effect is seen in such works as *In the Omnibus* (1891) and *The Bath* (1891–1892). Though the scenes depicted are somewhat intimate and private, Cassatt's angle of portrayal removes and separates the viewer from what is occurring.

Auguste Renoir

Auguste Renoir (1841–1919) often selected subjects that lent themselves to the depiction of flickering light, as in his painting *Le Moulin de la Galette* (1876). Here the scene of a crowded dance hall is the perfect environment for the artist who wants to play with the effects of light and shadow. He and Claude Monet were close friends and worked alongside one another during the late 1860s, both striving to capture the effects of light on water. In fact, their manner of painting during this time was very similar, as seen in a comparison of Monet's

La Grenouillère (1869) and Renoir's *La Grenouillère* (1869). Though they both tended to limit their palettes to the three primary colors (red, yellow, and blue) and their complements (green, violet, and orange), Renoir's brush strokes tended to be gentler than Monet's. Again, what was critical about their work during this time was the realization that shadows consist of color that is affected by the light in which it is seen.

James Abbott McNeill Whistler

Though born and raised in America, James Abbott McNeill Whistler (1834–1903) moved to Europe in the mid-1850s. He studied in Paris for several years before settling in London. During his trips to France in the 1860s, he was exposed to and was impressed by the Impressionist painters. He considered his most famous work, *Arrangement in Black and Gray: The Artist's Mother* (1871), to be an exercise in formal composition and the use of dark and light. A lesser known work, but one that was unusual for the time, was his painting *Nocturne in Black and Gold: The Falling Rocket* (c. 1874), which as a non-representational image reflected his interest in dealing purely with the aesthetic qualities of the canvas surface.

Auguste Rodin

As the Impressionists brought back an expressive quality to the medium of painting, Auguste Rodin (1840–1917) helped return expressiveness to the domain of sculpture. Though he maintained a Romantic orientation in his themes, he left behind the photographic realism found in the Realist sculpture that preceded him. Like the Impressionists, he was interested in the effects of reflected light upon surfaces, in his case, the three-dimensional surface of sculpture.

His mastery of the figure is evident in his bronze sculpture *The Burghers of Calais* (1886), which commemorated the martyrdom of seven citizens of Calais during the Hundred Years' War. He was able to convey the same level of expressive qualities in his work in marble, as seen in *The Thinker (Le Penseur)* (1879–1889) [see illustration 11] and *The Kiss* (1886–1898). In the latter work, two figures, embracing and kissing, seem to grow out of the marble base upon which they sit. Rodin's ability to convey the inner states of mind of his subjects is

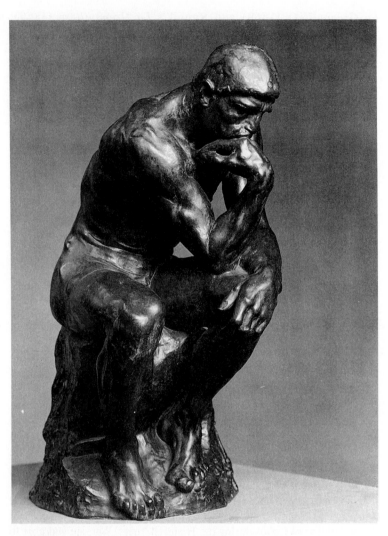

11. RODIN, Auguste. *The Thinker (Le Penseur).*
Bronze. (First modeled probably in 1880, executed about 1910).
The Metropolitan Museum of Art, Gift of Thomas F. Ryan, 1910.
(11.173.9)

evident in his *Monument to Balzac* (1897–1898), which, though not realistic in depiction, is a potent expression of the famous author's powerful presence.

Post-Impressionism

By the late 1800s, Impressionism was no longer considered an avante-garde movement. The Impressionist style was, by and large, being taken seriously by a public that was becoming more accepting of the bright canvases that represented the artists' sensations of light and color. A group of painters, though having their roots in Impressionism, developed their own styles of painting with the high-intensity colors of Impressionism. These artists have come to be known as the *Post-Impressionists*.

Paul Cézanne

Paul Cézanne (1839–1906), not content with what he perceived to be a lack of form in Impressionism, returned to nature in order to investigate the relationship between color and structure. His use of color as a means of portraying the structure, mass, and volume of forms is seen in his painting *La Montagne Sainte-Victoire* (1886–1887). Here, he has reduced the forms of nature and humans to faceted planes of color, a technique and manner that the later Cubists would take to a greater extreme. He does the same in an even earlier work, *Christ in Limbo* (1868–1870); here he has reduced even the shadows to planes of color.

Cézanne's reduction of form and his attention to form's geometric basis may also be seen in *Fruit Bowl, Glass, and Apples* (1879–1882) and *Still Life* (1890), in which the objects represented seem more like geometric shapes than the actual objects. This manner of geometric ordering is seen, too, in his figure depiction, as in *Boy in a Red Vest* (1893–1895). Not only have the figure and drapery been reduced to geometric planes, but the actual scale of elements has been altered in order to create a more balanced two-dimensional image. Like the Impressionists, Cézanne detached himself emotionally from his subject. In doing so, he felt free to distort and reorganize his subject in composing his painting.

Georges Seurat

Georges Seurat (1859–1891) worked very analytically and systematically, painting small dots in color fields, a method he referred to as *divisionism*, also called *pointillism*. In theory, the dots would "blend together" when viewed from a distance. Though that does not occur to the extent Seurat may have wished, the shimmering effect is, nonetheless, striking. The theme of his painting *The Bathers* (1883–1884) was not an uncommon one among the Impressionists, but his manner of working with minute brush strokes belies the immediacy of the image. One of the most famous of his works, *A Sunday Afternoon on the Island of La Grande Jatte* (1884–1886), reflects his efforts to organize and systematize the application of pigments through an intellectual approach. *Invitation to the Side Show (La Parade)* (1887–1888) was also painted in this manner, though Seurat, in this case, reduced the minute brush strokes to even smaller dots of color, with the result that his figures seem even more ethereal than those in his earlier works [see illustration 12].

Vincent van Gogh

While Seurat and Cézanne approached their art analytically, Vincent van Gogh (1853–1890) pursued art as a means of expressing his deepest thoughts and feelings. Even before Van Gogh saw the work of the Impressionists and their palette of bright color, his work possessed expressive power, as seen in *The Potato Eaters* (1885). After his exposure to the Impressionist painters in Paris, his canvases vibrated with color. His perception of the expressive qualities of color extended to the heavy manner in which he applied the pigment to canvas, and he felt that the surface textures he created through his brushwork were important to the overall effect of his compositions. His expressive use of color, which sometimes led critics to refer to his work as *Expressionistic*, can be seen in his painting *The Night Cafe* (1888), in which the harsh hues he uses convey a feeling about the place, albeit a negative one, rather than depict a true image of it.

Van Gogh's painting of his room in Arles, *The Artist's Room at Arles* (1888–1889), conveys a sense of loneliness. Containing little more than a bed, two chairs, and a small table with the artist's personal articles, the room seems bare and small, with everything pushed to the far wall,

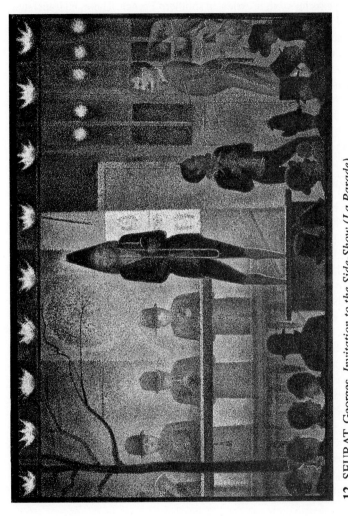

12. SEURAT, Georges. *Invitation to the Side-Show (La Parade).*
Oil on canvas, H. 39 ⅓", W. 59".
The Metropolitan Museum of Art, Bequest of Stephen C. Clark, 1960. (61.101.17)

leaving what seems to be an excessive amount of floor space in the foreground. Van Gogh produced many of his landscape paintings during the two years he spent in Arles, in southern France. There, he translated the staid environment around him into vistas of motion and movement. In his painting *Wheat Field and Cypress Trees* (1889), Van Gogh sees movement in both the land and the sky, and he represents them with an equal amount of energy. His self-portraits have the same vitality of color, as seen in his *Self-Portrait* of 1889. Van Gogh's expressive approach to painting is also reflected in *The Starry Night* (1889), which is not a portrayal of the night sky as it is familiarly seen, but the artist's very subjective perception of it, transformed into brush strokes on the two-dimensional surface of the canvas [see illustration 13].

Paul Gauguin

Like Van Gogh, Paul Gauguin (1848–1903) is known for his nontraditional use of color and his desire to achieve a greater sense of solidity than could be achieved through light alone. Gauguin is known especially for his exotic images of life in Tahiti, and his use of intense color planes in this work is the result of his interest in expressing imagery in a personal manner. His respect for and infatuation with the "primitive" life-style he found first in Brittany, then in the South Pacific, and the integral role that religion played in these cultures are apparent in his selection of themes, his use of bright colors, and the decorative quality of his paintings.

As a "modern" man living in a "primitive" culture, Gauguin produced images that reflected his interpretation of his surroundings, as seen in his paintings *The Vision after the Sermon (Jacob Wrestling with the Angel)* (1888) painted in Brittany, and *The Spirit of the Dead Watching* (1892) painted in Tahiti. *Nefea Faaipoipo (When Are You to Be Married?)* (1892), also painted in Tahiti, represents a particular characteristic of his style. Here, the images of the two women who are the subjects of the painting, as well as the elements that make up the landscape, are flattened out as broad areas of color.

Henri Rousseau

Another artist known for his primitive style is Henri Rousseau (1844–1910). Though considered naive by many of his contemporaries,

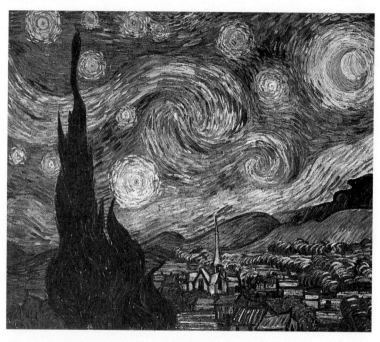

13. van GOGH, Vincent. *The Starry Night.* (1889)
Oil on canvas, 29 × 36¼" (73.3 × 92.1 cm.).
Collection, The Museum of Modern Art, New York.
Acquired through the Lillie P. Bliss Bequest.

Rousseau's dreamlike images are quite captivating. His painting *The Sleeping Gypsy* (1897) reflects this quality in the manner in which he has depicted the lion and the sleeping figure; the image created is almost disturbing in its portrayal of a person's vulnerability when asleep. A later work, *The Dream* (1910), possesses these same qualities [see illustration 14]. In this painting, however, Rousseau has created a color-saturated jungle, an exotic environment for the main subject of the painting—a female nude who gestures to a native playing a horn while under the watchful gaze of two lions, one of whom stares straight at the viewer.

Henri de Toulouse-Lautrec

Henri de Toulouse-Lautrec (1864–1901) also recorded his impressions of his environment. Though of the upper class, he was self-conscious of his dwarflike appearance (he had injured his legs in childhood) and chose to associate with the denizens of the gaudy nightlife of Paris. Like Degas, Toulouse-Lautrec's use of space in his compositions was influenced by Japanese prints, as seen in his use of diagonals in his painting *At the Moulin Rouge* (1892). He exaggerates the forms of his composition through the use of harsh colors in juxtaposition. Though not as extreme in his simplification of forms as Cézanne, Toulouse-Lautrec does reduce the distinctness of drapery and the features of his subjects in order to work in broader fields and planes of color.

James Ensor

Other artists, such as the Belgian painter James Ensor (1860–1949), continued to produce works that challenged societal norms. One of Ensor's most famous works, which was considered offensive when it was first exhibited, is *The Entry of Christ into Brussels* (1888). Here, Christ is portrayed with an entourage of bizarre masked figures. Ensor's perception of humankind as possessing little substance and humaneness is conveyed through his use of harsh color and the dark, festive nature of the scene. Another dark carnival-like image is found in Ensor's *Intrigue* (1890). At first glance the celebrants seem to be wearing masks, but upon closer examination it becomes evident that these are in fact their faces.

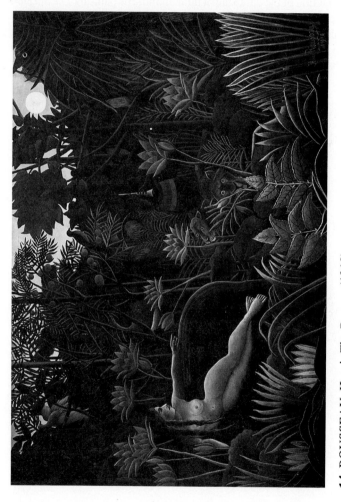

14. ROUSSEAU, Henri. *The Dream.* (1910)
Oil on canvas, 6'8½" × 9' 9½" (204.5 × 298.5 cm.).
Collection, The Museum of Modern Art, New York. Gift of Nelson A. Rockefeller.

Edvard Munch

Like Ensor, the Norwegian Edvard Munch (1863–1944) is known for his depiction of the dark side of humankind. His painting *The Scream* (1893) depicts in a powerful manner the inner torment of the individual as an isolated being. The scream emanating from the foreground figure seems to radiate throughout the painting by way of the brush strokes Munch has laid on the canvas.

CHAPTER 18

Twentieth-Century Painting and Sculpture

Chronology

1868–1928	Charles Rennie Mackintosh
1869–1954	Henri Matisse
1871–1958	Georges Rouault
1872–1944	Piet Mondrian
1879	Redon: *In a Dream*
1879–1940	Paul Klee
1880–1938	Ernst Kirchner
1880–1966	Hans Hofmann
1881–1955	Fernand Léger
1881–1973	Pablo Picasso
1882–1916	Umberto Boccioni
1882–1963	Georges Braque
1882–1967	Edward Hopper
1884–1950	Max Beckmann
1886–1980	Oskar Kokoschka
1887–1927	Juan Gris
1887–1948	Kurt Schwitters
1887–1964	Alexander Archipenko
1887–1966	Hans (Jean) Arp
1887–1968	Marcel Duchamp
1887–1985	Marc Chagall
1887–1986	Georgia O'Keeffe
1888–1978	Giorgio de Chirico
1890–1910	Art Nouveau style
1891–1973	Jacques Lipchitz

1891–1976	Max Ernst
1893–1959	George Grosz
1893–1983	Joan Miró
1895	Horta: Ornamental iron staircase, Hotel van Eetvelde, Brussels
1896–1910	Mackintosh: North facade, Glasgow School of Art, Glasgow
1896–1966	André Breton
1898–1967	René Magritte
1898–1976	Alexander Calder
1900	Freud's *Interpretation of Dreams* is published
1900–1955	Yves Tanguy
1901–1904	Picasso's Blue Period
1901–1985	Jean Dubuffet
1903	Picasso: *Poor People at the Seashore*
1903	The Wright brothers' first successful flight
1903–1970	Mark Rothko
1904	Picasso: *The Two Sisters*
1904	Picasso: *Acrobat with a Ball*
b. 1904	Willem de Kooning
1904–1906, 1910–1912	Wagner: Postal Savings Bank, Vienna
1904–1989	Salvador Dali
1905–1906	Picasso's Rose Period
1905	Picasso: *The Family of Harlequins*

1905	Picasso: *Acrobat with a Dog*
1905	Picasso: *The Juggler*
1905	Einstein proposes theory of relativity
1905–1907	Gaudí: Casa Milá
1906	Picasso: *Portrait of Gertrude Stein*
1907	Picasso: *Les Demoiselles d'Avignon*
1907–1908	Matisse: *Le Luxe*
1907–1909	Cézanne phase of Cubism
1907–1914	Cubism
1908	Hopper: *The El Station*
1908	Redon: *Anemones*
b. 1908	Victor Vasarely
1908–1909	Matisse: *The Red Room*
1908, 1911	Klimt: *Death and Life*
1908–1984	Lee Krasner
1909–1992	Francis Bacon
1910	Rousseau: *The Dream*
1910	*Manifesto of Futurist Painters*
1910	Kandinsky: *Abstract Water Color*
1910	De Chirico: *Enigma of the Oracle*
1910	De Chirico: *Enigma of an Autumn Evening*
1910	Braque: *Violin and Jug*
1910–1912	Analytic phase of Cubism
1910–1962	Franz Kline
1911	Braque: *The Portuguese*

1911	Picasso: *The Accordionist*
1911	Chagall: *I and the Village*
1911–1912	Picasso: *Still Life with Chair Caning*
1912–1921	Synthetic phase of Cubism
1912	Picasso: *The Aficionado*
1912	Braque: *Fruit Bowl*
1912	Nolde: *Warrior and His Wife*
1912	Duchamp: *Nude Descending a Staircase #2*
1912	De Chirico: *Enigma of Arrival*
1912–1913	Chagall: *Pregnant Woman*
1912, 1913	Kandinsky: *Improvisations 28 and 30*
1912–1956	Jackson Pollock
1913	New York Armory Show
1913	Boccioni: *Unique Forms of Continuity in Space*
1913	Braque: *Woman with Guitar*
1914	Van de Velde: Werkbund Exhibition Theatre, Cologne
1914	Picasso: *The Card Players*
1914	Kokoschka: *Bride of the Wind*
1914	Léger: *July 14th*
1914	De Chirico: *Mystery and Melancholy of a Street*
1914–1918	World War I
1915	Chagall: *The Anniversary*
1915	Picasso: *The Harlequin*

1915	Archipenko: *Woman Combing Her Hair*
b. 1915	Robert Motherwell
1915–1922	Dada movement
1915–1923	Duchamp: *The Bride Stripped Bare by Her Bachelors*
1916	Duchamp: *Bottle-Drier*
1916	Duchamp: *Bicycle Wheel*
1916	Duchamp: *Porcelain Urinal*
1916	Nolde: *Marsh Landscape*
1916–1937	Rouault: *The Old King*
1917	The Communist Revolution in Russia
1917	Miró: *Portrait of Ricart*
1917	Lipchitz: *Man with Mandolin*
1917	Braque: *The Guitarist*
1918	Duchamp: *To Be Looked At (From the Other Side of the Glass) With One Eye, Close To, For Almost an Hour*
1919	Duchamp: *L.H.O.O.Q.*
1919	Léger: *The City*
1919	Kollwitz: *Memorial to Karl Liebknecht*
1919	O'Keeffe: *From the Plains*
1919	The Bauhaus is established in Weimar Germany
1920	Arp: *Birds in an Aquarium*
1920	Schwitters: *Merz Picture 19*
1921	Ernst: *The Massacre of the Innocents*

1921	Léger: *Woman with Bouquet*
1922	Ernst: *Rendez-vous of Friends*
1922	Klee: *Twittering Machine*
1923	Klee: *Landscape with Yellow Birds*
1923	Klee: *Cosmic Flora*
1923	De Chirico: *Delights of a Poet*
b. 1923	Roy Lichtenstein
1924	Ernst: *Two Children are Threatened by a Nightingale*
1924	Breton: *Manifesto of Surrealism*
1924	Miró: *Turned Soil*
1924	Hitler's *Mein Kampf* is published
1925	First Surrealist exhibition, at Galerie Pierre
b. 1925	Robert Rauschenberg
1926	Calder: *Animal Sketchbook*
1926	Ernst: *Paired Diamonds*, in *Histoire Naturelle*
1926	Schwitters: *Collage in Blue and White*
1926–1931	Calder: *Circus*
1928	Braque: *The Table*
b. 1928	Donald Judd
1928–1929	Magritte: *The Treason of Images*
1928–1987	Andy Warhol
1929	Grosz: *The Entree*
1929	Kandinsky: *Unbiegsam*
1929	O'Keeffe: *Black Cross, New Mexico*

1929	O'Keeffe: *Black Hollyhock, Blue Larkspur*
b. 1929	Claes Oldenburg
1929–1941	The Great Depression
1930	Dali: *La Femme Visible*
1930	Hopper: *Early Sunday Morning*
b. 1930	Jasper Johns
b. 1930	Richard Anuszkiewicz
1931	Calder: *Fables of Aesop/According to Sir Roger L'Estrange*
1931	Calder: *Tumbling Family*
1931	Dali: *The Persistence of Memory*
1931	O'Keeffe: *Cow's Skull: Red, White, and Blue*
1931	O'Keeffe: *Cow's Skull with Calico Roses*
b. 1931	Audrey Flack
b. 1931	Robert Morris
b. 1931	Bridget Riley
1932	Calder: *The Circus*
1932	Picasso: *The Dream*
1932	Picasso: *Young Woman with a Mirror*
b. 1932	Carl Andre
1932–1933	Beckmann: *Departure*
1933	Miró: *Painting*
1934	Magritte: *The Human Condition*
1934	Grosz: *Punishment*
b. 1935	Christo Javacheff

1936	Mondrian: *Composition in Blue, Yellow, and Black*
b. 1936	Richard Estes
1936–1939	Spanish Civil War
1937	Picasso: *Guernica*
1938	Klee: *Animals in the Underbush*
1938–1973	Robert Smithson
1939	Calder: *Lobster Trap and Fish Tail*
1939–1945	World War II
1940	Klee: *Death and Fire*
b. 1940	Chuck Close
1942	Hopper: *Nighthawks*
1942	Miró: *Person Looking at the Sun*
1942–1943	Mondrian: *Broadway Boogie Woogie*
1943	Chagall: *Crucifixion*
1944	Calder: *Sartre*
1944	Miró: *Snob Evening at the Princess's*
1944	Hofmann: *Effervescence*
1944	Bacon: *Three Studies for Figures at the Base of a Crucifixion*
1945	Atomic bombs dropped on Japan
1946	Bacon: *Painting 1946*
1947	Pollock: *Lucifer*
1949	NATO (North Atlantic Treaty Organization) is formed
1950	Calder: *Red Gongs*

1950	Pollock: *Number 27*
1950	Kline: *High Street*
1950	Kline: *Chief*
1950	Dubuffet: *Corps de Dame, Sanguine et Grenat*
1950–1952	De Kooning: *Woman I*
1950–1953	Korean War
1951	Calder: *Bird on Wheels*
1952	Pollock: *Blue Poles*
1952–1953	De Kooning: *Woman and Bicycle*
1953	Bacon: *Number VII from Eight Studies for a Portrait*
1953	Bacon: *Study After Velázquez's Portrait of Pope Innocent X*
1955	De Kooning: *Composition*
1955	Johns: *Target with Four Faces*
1955	Johns: *White Flag*
1955–1958	Rauschenberg: *Odalisk*
1955–1959	Rauschenberg: *Monogram*
1956	Kline: *Mahoning*
1956	Rothko: *Orange and Yellow*
1957	Sputnik launched
1958	Rothko: *Four Darks on Red*
1958	Krasner: *The Bull*
1958	Johns: *Three Flags*
1959–1960	Krasner: *The Gate*

1960	Johns: *Painted Bronze*
1962	Oldenburg: *Two Cheeseburgers with Everything*
1962	Riley: *Blaze I*
1962	Vasarely: *Jong ("Births")*
1962	Warhol: *Marilyn Monroe*
1962	Warhol: *200 Campbell's Soup Cans*
1962	Warhol: *Green Coca-Cola Bottles*
1963	President John F. Kennedy is assassinated
1964	Warhol: *Brillo Boxes*
1964	Riley: *Current*
1964	Lichtenstein: *As I Opened Fire*
1965	Lichtenstein: *Little Big Painting*
1965	Judd: *Untitled*
1965	Morris: *Untitled (L-Beams)*
1965	Anuszkiewicz: *Splendor of Red*
1965–1973	Vietnam War
1966	Oldenburg: *Soft Toilet*
1968	Robert Kennedy is assassinated
1968	Martin Luther King is assassinated
1969	Calder: *Flying Saucers*
1969	Close: *Phil*
1969	First walk on the moon
1970	Smithson: *Spiral Jetty*
1971	Close: *Susan*

1971–1977	De Maria: *Lightning Field*
1972	Cottingham: *Roxy*
1973	Watergate
1973	Judd: *Untitled*
1973–1975	Vasarely: *V.P. Stri*
1974	President Richard Nixon resigns from office
1975	Calder: *Yellow Equestrienne*
1976	Christo: *Running Fence*
1977	Vasarely: *Sinfel*
1977	Estes: *Ansonia*
1978	Andre: *Equivalent VIII*
1979	Estes: *The Solomon R. Guggenheim Museum*
1979	Flack: *Golden Girl*
1980–1983	Christo: *Surrounded Islands*

The twentieth century is a period in which great changes and advances have taken place in the sciences, technology, the arts, and society. Inevitable with shifts in these domains are adjustments in the way individuals perceive themselves and the world around them. Answers from earlier times concerning truth, reality, and human existence have been reexamined by many Western thinkers during this century. Some have come to feel that the human senses are not the reliable indicators of reality they had previously been thought to be.

The art of the twentieth century has been characterized as being experimental and at the same time reactionary. With roots in the latter nineteenth century, the art of the twentieth century has evolved into a number of styles, but with a continued movement toward, and realization of, an art that does not depict any "thing" in the traditional sense.

Many artists choose not to base their work upon their visual perception of the world around them but rather to explore ways of presenting their perceptions of subjects and themes in terms of a variety of realities. Though there are artists who continue to produce art in a popular manner, there are many others who are not driven by public preference, and yet others who strive to challenge commonly held, contemporary societal norms and tastes, oftentimes being publicly condemned for their efforts.

Symbolism

The work of the Post-Impressionists represented an effort to explore new modes of expression. Their rejection of the Realist and Impressionist styles during the late nineteenth century for an art that emphasized their personal expression of a subject or theme allied them with the Symbolist movement found in art and literature, which revered the depiction of truth rather than empirical reality. While those artists who relied upon direct perception as their mode of artistic experience focused their attention upon images, others, like the Symbolists, pursued the ideal interpretation of symbols. The Symbolists believed that facts in themselves are meaningless and that art that simply portrays facts is equally insignificant. For art to have value, they held, the artist must make it his or her mission to see beyond the apparent. The Symbolist perception of the artist as visionary was a very subjective view whose goal was to remove from art any functional connotation.

As might be expected, the Symbolists' desire to see beyond mere appearance led them to create images that were typically mysterious, strange, and dreamlike. For sources of inspiration they looked to the Far East and other exotic places and times rather than to the traditional reservoir of Western culture. In method and composition, many Symbolists rejected the established manner of treating the picture plane as a window or stage that the viewer would look "into" and chose instead to work in a flat, two-dimensional way.

Gustav Klimt

The Viennese painter Gustav Klimt (1862–1918), though associated by some critics with the Art Nouveau style, is described by many

others as being a Symbolist. His painting *Death and Life* (1908, 1911), these latter critics feel, is representative of the Symbolist manner in its theme and execution. Influenced by his interest in and exposure to Byzantine art, Klimt's painting consists of flat areas of ornamentation with emerging contrasting organic forms that possess mass and volume.

Odilon Redon

Perhaps most often associated with the Symbolist movement is the work of Odilon Redon (1840–1916). Though a contemporary of the Impressionists, Redon felt that the Impressionist manner was too confining and directed his attention toward the role of the imagination in art. His paintings, such as *Anemones* (1908), reflect his efforts at integrating reality as he saw it with reality as he felt it. Though he spent much time observing nature, his paintings and lithographs, such as *In a Dream* (1879), reflect his imagination and inner dream world. As Symbolism became popular in the 1880s, Redon's work was acknowledged by many of the Symbolists as representing their philosophy, and he was admired by such artists as Gauguin and Matisse.

Art Nouveau

The Art Nouveau style was an international phenomenon (known as *Secessionstil* in Austria, *Jugendstil* in Germany, and the *Liberty Style* in England) that was popular between 1890 and 1910. A decorative art, it was characterized by sinuous, serpentine line and organic, foliate forms that were a reaction to the encroaching industrialization of the Western world. As a contemporary movement that responded to the growing mechanization of industry and the resulting mass production of products, the Art Nouveau style represented a concern for craftsmanship and the handmade object. Though it was primarily a decorative art, it was also used effectively, though with some difficulty, in the domain of architecture.

The Art Nouveau Style in Architecture

Some of the finest examples of the Art Nouveau style may be seen in Vienna, Austria. The Secession Building, designed by Joseph

Olbrich, was based upon a drawing by Gustav Klimt. It is similar in form to the ancient Egyptian mastaba, but capped with a metal dome that is decorated in a leaflike pattern. Another example of the Art Nouveau style in architecture is Otto Wagner's Postal Savings Bank (1904–1906, 1910–1912), whose structure is covered with thin slabs of marble, revealing a sense of the underlying framework of the building. Wagner, too, made use of a laurel-leaf motif. Through the use of strong horizontal elements, such as the pair of protruding overhangs above the public entrance to the building, he stressed the horizontal axis of the structure rather than the vertical.

Internationally, the Art Nouveau style was interpreted in different ways. An example of the Art Nouveau style used in the interior of a building is the ornamental iron staircase (1895) in the Hotel van Eet-velde in Brussels, which was designed by Victor Horta (1861–1947). The design of Charles Rennie Mackintosh (1868–1928) for the north facade of the Glasgow School of Art (1896–1910) substituted sunken windows for the outer walls and included an open two-story library whose visible wooden supports also visually reinforced its vertical orientation. The shape of the Werkbund Exhibition Theatre (1914) in Cologne, designed by the Belgian Henry van de Velde (1863–1957), reflected the outer contours of the modules that made up the structure.

One of the most remarkable structures, created in the most radical interpretation of the Art Nouveau style, was the Casa Milá (1905–1907), an apartment building in Barcelona, Spain. Designed by Antoní Gaudí (1852–1926) who, in his architecture, attempted to recreate the organic movement of forms in nature, it represents an extreme application of the paradigm of natural form. There are few linear qualities or level surfaces to this building, whose asymmetrical surface seems to oscillate like rock that has been eroded for centuries.

Fauvism

Fauvism was not so much a school of art reflecting a particular theory as it was a fairly brief movement that celebrated the intensity of pure color. At the 1905 Salon d'Automne, Henri Matisse and twelve other colorists exhibited their work, which was so startling that it created a scandal. The following year, they again exhibited their work together at the Salon des Independants, where the art critic Louis

Vauxcelles referred to their work as *Les Fauves*, the "wild beasts," a term that caught on.

Henri Matisse

The central figure of Fauvism was Henri Matisse (1869–1954), who studied under Gustave Moreau (1826–1989) at the École Nationale des Beaux-Arts. Under Moreau's guidance, Matisse studied the masters as well as nature. His early work was fairly traditional until he was exposed to the Impressionists in the 1890s and he began to experiment with brighter color.

Nothing in Matisse's work was accidental. Though he was considered uninhibited by some critics, his paintings were the result of painstaking planning. His use of flat fields of color and his manner of simplifying the form of the human figure are seen in his painting *Le Luxe* (1907–1908). Through the use of overlapping forms and shapes, he was still able to maintain a sense of space and depth in his composition. Though his treatment of the human figure may seem contrived and unsophisticated, to the contrary, it reflects his intimate knowledge of the human figure such that he was able to reduce it to a form that served his visual purpose. His approach reflected the degree to which he emphasized and valued his expression of a subject or theme above the actual depiction of that subject or theme.

The Red Room (1908–1909) further illustrates Matisse's use of the color of the Post-Impressionists. In this work, he contrasts warm colors with cool colors and curving lines with straight lines, creating a decorative composition that, while conveying a sense of ambiguous space, maintains the viewer's attention toward the surface of the canvas.

Georges Rouault

A colleague of Matisse's at the École Nationale des Beaux-Arts was Georges Rouault (1871–1958). Rouault's early training had been as an apprentice to a stained-glass painter, and his teacher at the École Nationale des Beaux-Arts, Gustave Moreau, recognized early on that Rouault would likely have a difficult time resolving his attraction to powerful images with his desire to achieve linear detail. The themes and subjects that Rouault chose to depict centered upon the religious and the social, and his treatment of peasants, prostitutes, clowns, and

other individuals raised his subjects to allegorical proportions. His manner of depiction is seen in his painting *The Old King* (1916–1937). This work reflects his familiarity with the art of stained glass in the way the powerful black lines of the figure recall the leaded divisions of stained-glass windows.

Expressionism

Unlike some of the art movements that have been discussed, such as Impressionism and Fauvism, Expressionism was not so much a particular art movement as it was a trend or tendency that has surfaced from time to time. The individuals who represented the initial Expressionist movement, which developed as a response to Impressionism and the formal approach of painters such as Paul Cézanne and Georges Seurat, included Vincent van Gogh and Edvard Munch. Their subjective approach to their art was manifested in both their use of vivid color and their depiction of dramatic themes.

Emil Nolde; Ernst Kirchner

For the German painters, especially the members of the groups *Die Brücke* (The Bridge) and *Der Blaue Reiter* (The Blue Horseman), who would become the German Expressionists, it was Fauvism that was the prime influence, prompting them to develop an art that reflected their personal sensations toward both life and their imaginations. Among these German painters were Emil Nolde (1867–1956) and Ernst Kirchner (1880–1938). Kirchner, one of the founders of the *Brücke* style in 1905, was influenced by Edvard Munch. In his paintings, Kirchner strove to simplify form and color, and he was attracted to the sensuous nature of the female nude and to the intensity of athletics. Though Nolde briefly belonged to the *Brücke* group between 1906 and 1907, he preferred to work alone. Paintings such as his *Warrior and His Wife* (1912) and *Marsh Landscape* (1916) illustrate his use of brilliant color and his belief that color did not represent reality, it *was* reality.

George Grosz; Käthe Kollwitz

The role of art as a commentator upon social conditions and situations also found fertile ground in Germany during the early decades of the twentieth century. Although George Grosz (1893–1959) trained as a painter and is known for such works as *Punishment* (1934), he is probably best known for his satirical drawings, such as *The Entree* (1929), which challenged the absurdities of World War I, the postwar years, and, in general, the materialistic tendencies of the middle class. Käthe Kollwitz (1867–1945) found the woodcut to be a very effective medium to convey somber subjects and themes, as seen in her *Memorial to Karl Liebknecht* (1919).

Oskar Kokoschka

The use of powerful brush strokes and intense color as a means of conveying impassioned, powerful sentiment can also be seen in the work of the Viennese painter Oskar Kokoschka (1886–1980), who was greatly influenced by Klimt. During his lifetime, much of Kokoschka's work was rejected by a public that found his paintings to be offensive. Living in Vienna at the same time that Sigmund Freud was investigating the possibilities of psychoanalysis, Kokoschka was creating paintings that might be characterized as visionary, depicting the physical transformation of his subjects and exploring the subconscious, as seen in his *Bride of the Wind* (1914). Here, the vigorous strokes of Kokoschka's brushwork are used to depict both landscape and lovers as tattered forms. As in many Expressionist works, there is a sense of violence to the handling of the pigment in a very textural way and in the manner in which colors are placed adjacent to one another.

Max Beckmann

Max Beckmann (1884–1950) is considered by some historians to be a German Impressionist and by others to be a German Expressionist. His paintings focused upon the power of the human figure, in degradation as well as in honor. A first-hand experience of war between 1914 and 1918 and the political persecution that caused him to flee Frankfurt in 1933 led Beckmann to create haunting images of disfigured individuals, cripples, and bizarre figures, conveying his feelings toward

the sufferings of humanity. During the latter part of his career, he painted seven large, symbolically complex triptychs. Probably the most famous of these is *Departure* (1932–1933). The two outer panels of the triptych portray dark, somber scenes of bondage and torture. The middle panel, in contrast, is a daylight scene, what appears to be a royal family in a boat [see illustration 15]. His simplified figures, delineated with heavy black lines, contribute toward an overall effect that is intense and powerful.

Wassily Kandinsky

In the work of Wassily Kandinsky (1866–1944), the concept of color serving as the content of paintings came to fruition. Whereas earlier painters had retained some elements of the objective world in their work, Kandinsky focused his attention exclusively upon the affective and psychological aspects of color and form, such that his paintings were nonfigurative in depiction. His first nonfigurative work, *Abstract Water Color* (1910), is evidence of his ability to separate the realm of art from the realm of nature and thus to create paintings that were devoid of representation.

It was from the *Blaue Reiter Year Book*, which Kandinsky and the German painter Franz Marc (1880–1916) produced, that the *Blaue Reiter* group of German Expressionists took its name. By the second decade of the twentieth century, Kandinsky had developed two types of paintings. His compositions, such as *Unbiegsam* (1929), consisted of purposefully ordered geometric forms, while his improvisations, such as *Improvisation 28* (1912) and *Improvisation 30* (1913), were more spontaneous.

Cubism

The Cubist style (1907–1914) was an innovation of Georges Braque and Pablo Picasso, who were later joined by Juan Gris and Fernand Léger. As with works that emerged under Fauvism and other perceived radical art movements, Cubist works were initially met with animosity. The term Cubism itself originated in 1908 with the art critic Louis Vauxcelles, who, in commenting upon Georges Braque's work, used the word "cubes." Though the Cubist painters eventually adopted

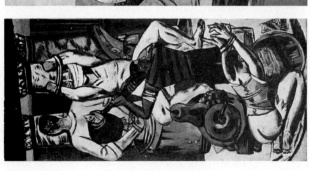

15. BECKMANN, Max. *Departure.* (1932–1933)
Oil on canvas; triptych, center panel, 7'3¾" × 45⅜"; side panels each 7'3¾" × 39¼".
Collection, The Museum of Modern Art, New York.
Given anonymously (by exchange).

the term to describe their work, it was not without their denying that they were representing a particular canon of art; rather, they claimed, they were producing works that reflected their own personal expression. The movement's evolution began with what is called the *Cézanne phase* (1907–1909), followed by the *Analytic phase* (1910–1912), and ending with the *Synthetic phase* (1912–1921).

Pablo Picasso

Picasso's Blue Period

Even as a child, Pablo Picasso (1881–1973) was a gifted artist. When he moved to Paris in 1900, he was attracted to the work of Vincent van Gogh and Henri de Toulouse-Lautrec, whose influence can be seen in his depiction of the isolated and the outcast. Picasso's work during this period, sometimes referred to as his Blue Period, was characterized by his manner of elongating the figure and working primarily in hues of blue, as seen in *Poor People at the Seashore* (1903), *The Two Sisters* (1904), and *Acrobat with a Ball* (1904).

Picasso's Rose Period

Picasso's Rose Period (1905–1906) represents the stage in his artistic development when he tempered the severity of forms and color seen during his Blue Period. Typical subjects during his Rose Period are circus scenes, harlequins, and the nude. Examples of this genre of painting include *The Family of Harlequins* (1905), *Acrobat with a Dog* (1905), and *The Juggler* (1905).

The Cézanne Phase of Cubism

It was during this time that Picasso became interested in the work of Cézanne and the raw, abstract qualities of the art produced by the peoples of Africa and Iberia. The influence of Cézanne can be seen in Picasso's *Portrait of Gertrude Stein* (1906), where, like Cézanne, he reduced the figure and drapery to basic planes, while depicting the subject from different points of view simultaneously [see illustration 16]. This reduction of form to simple planes, combined with the abstracting quality of primitivist art, was carried to an even further extreme in his startling work *Les Demoiselles d'Avignon* (1907) [see illustration 17]. It is, in fact, *Les Demoiselles d'Avignon* that is considered by many historians to be the milestone that immediately

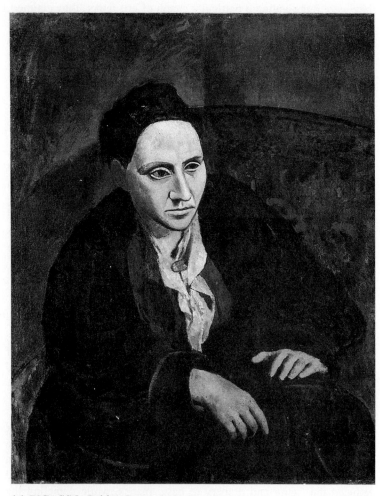

16. PICASSO, Pablo. *Gertrude Stein.*
Oil on canvas. Painted in 1906. 39⅜" × 32".
The Metropolitan Museum of Art, Bequest of Gertrude Stein, 1946. (47.106)

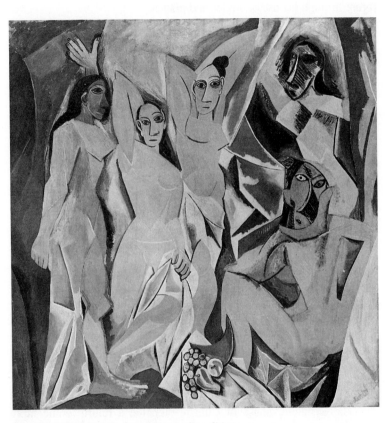

17. PICASSO, Pablo. *Les Demoiselles d'Avignon.*
Paris (begun May, reworked July 1907).
Oil on canvas, 8' × 7' 8" (243.9 × 233.7 cm.).
Collection, The Museum of Modern Art, New York.
Acquired through the Lillie P. Bliss Bequest.

preceded the Cubist epoch. A new trend in modern painting was repre-
sented in this composition in Picasso's further reduction of the human
figure through his use of angles and planes.

The Analytic Phase of Cubism

For the Cubists, the investigation of objects involved discerning
form and structure from multiple viewpoints; the depiction of an object,
then, involved a redefinition of space in portraying the object from these
different perspectives simultaneously. The Cubists quite logically
reasoned that because a given object does not exist from one point of
view alone, but from multiple points of view, in order to actually portray
the reality of that object, they must represent the various perceptions of
the object at the same time. This view of reality and visual images
represents the Analytic phase of Cubism, as seen in Picasso's painting
The Accordionist (1911), which though conveying a sense of volume,
does so without using the traditional techniques of modeling or linear
perspective.

Picasso's Collage Cubism

Besides challenging traditional notions concerning the depiction of
subject matter in the medium of painting, Picasso challenged the con-
cept of what a painting is by integrating and affixing other materials to
the canvas surface itself. In *Still Life with Chair Caning* (1911–1912),
to the pigment on the canvas the artist added materials such as rope and
paper, which simulated chair caning. By integrating the collage tech-
nique into the work, he brought it to a sculptural level.

The Synthetic Phase of Cubism

The Synthetic phase of Cubism signaled a return to the more
concentrated use of color, and many of Picasso's works during this
period seem to be more decorative than his earlier works. Typical of this
phase are *The Aficionado* (1912), *The Card Players* (1914), and *The
Harlequin* (1915). It was also during this time that Picasso produced a
large number of still-life works in the Cubist style that incorporated the
forms of the violin and the guitar. Soon after, Picasso saw himself
limited by his use of geometric abstraction and, for a time, turned his
attention to the study of the masters and Greco-Roman art. The result
was a series of works that portrayed distorted figures modeled in the
Classical manner.

Picasso's Work in the 1920s and 1930s

During the 1920s and 1930s, Picasso produced portraits of his son, scenes of the bullfight, and works that reflected flights of the unconscious. He also began to play with long, serpentine lines and the arabesque in vivid hues, as seen in *The Dream* (1932) and *Young Woman with a Mirror* (1932). The introspective expressionism of Picasso's work again surfaced in 1937 with *Guernica*, a work that is considered to be one of his masterpieces. The huge painting, approximately eleven feet by twenty-five feet, represents the artist's outrage at the bombing of the Spanish town of Guernica during the Spanish Civil War. A monochromatic composition in black and white, it relies solely upon the manipulation of forms and dark and light. It does not attempt to depict the actual event, but, through the use of exaggerated forms, conveys the artist's sense of horror and tragedy.

Georges Braque

Georges Braque (1882–1963), like Picasso, was influenced by the work of Paul Cézanne. Along with Picasso, he was a leader of the Cubist style. As mentioned earlier, it was the art critic Louis Vauxcelles' reference to Braque's work as reduced to "cubes" at the 1908 Salon d'Automne that gave the movement its name. Braque's manner of painting was very disciplined and analytical. Whereas Picasso is considered to have worked intuitively, Braque's method was one of deduction. When Picasso was painting his *Les Demoiselles d'Avignon* (1907), Braque was working toward the elimination of the "subject" entirely. By 1911, his work represented sensations rather than subjects. In order to avoid his work's being perceived as completely decorative, he began to incorporate lettering, an element from the world of appearances, into his compositions, as in *The Portuguese* (1911). Soon after, the use of letters as a plastic element was adopted by other Cubist painters.

The incorporation of lettering into the composition as a concrete design element juxtaposed with his pure forms was not the only mechanism Braque used to maintain linkage with the world of appearances. In *Violin and Jug* (1910), he used the *trompe-l'oeil* style of depiction to paint a nail from which the image seems to hang. After a series of works that incorporated other imitated materials, other Cubists took his

method a step further and began to affix to the canvas itself various materials, although most often paper. This technique, *papier collé*, established by Braque, initiated the *Synthetic phase* (1912–1921) of Cubism. During this time Braque created a number of *papier collé* works, including *Fruit Bowl* (1912) and *Woman with Guitar* (1913). Soon after, he began to incorporate pieces of wood and cloth into his compositions as well.

Though Braque and Picasso worked closely together during the Cubist epoch, Braque, after recovering from wounds suffered in 1915 in World War I, chose not to follow the direction of Picasso and his devotees, but set out on his own course. Though his work retained a Cubist dimension as late as 1917, as seen in *The Guitarist* (1917), it began to take on more of a French Classical style. His painting *The Table* (1928), consisting of oil paint and sand on canvas, reflects this orientation [see illustration 18].

Fernand Léger

The French painter Fernand Léger (1881–1955), another Cubist who was influenced by Paul Cézanne, met Pablo Picasso and Georges Braque in 1910. Between 1912 and 1914, most of Léger's work represented his interest in reducing objects to basic geometric forms, an example of which is *July 14th* (1914). Drafted in 1914 to serve in World War I, Léger did many drawings of his fellow soldiers as well as of weapons, being attracted to their mechanical nature. Beginning in 1917, Léger based his compositions upon the symbols and products of the urban/industrial society in which he lived, and it was within these urban/industrial environments that he created that he placed his stylized human figures. Paintings such as *The City* (1919) are seemingly created with the same impersonal flawlessness as the products of mechanization, with humankind's role being limited to a mechanical function, devoid of humanity. After 1920, the role of the human figure in his compositions became much more prominent, as seen in his painting *Woman with Bouquet* (1921), but the manner of portrayal was still stylized in such a way that the figures seem to lack the substance we associate with humankind.

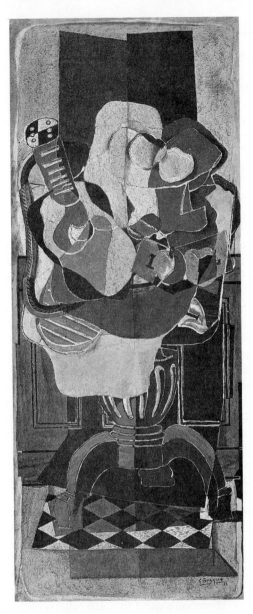

18. BRAQUE, Georges. *The Table.* (1928)
Oil and sand on canvas, 70¾ × 28¾".
Collection, The Museum of Modern Art, New York.
Acquired through the Lillie P. Bliss Bequest.

Juan Gris

Juan Gris (1887–1927) was born in Madrid but moved to Paris before the age of twenty. His early education was in the sciences, which provided a type of analytical training that would influence his theories throughout his artistic career. Gris was an admirer of Picasso, and his early works reflect the manner of the Analytic phase of Cubism. His scientific approach to art led to significant contributions to the development of the Synthetic phase of Cubism.

Piet Mondrian

The effects of Cubism were far-reaching. The preferred subject matter of the Dutch painter Piet Mondrian (1872–1944) was the Dutch countryside. However, after being exposed to the Cubists in Paris in 1911, he began to experiment with abstraction. His explorations eventually led him to a level where he was able to reduce everything to a composition of line and color that had no apparent reference to the world of appearances. Ultimately, he reduced his "working vocabulary" to basic vertical and horizontal lines, black and white, and the three primary colors of blue, red, and yellow.

Mondrian returned to Amsterdam just prior to the outbreak of World War I, and was unable to get back to Paris until after the war, in 1919. From 1912 to 1917, he worked on a theory of pure plastic art, or *Neo-Plasticism*, which was, for Mondrian, a natural outgrowth of Cubism. Mondrian's Neo-Plasticism was restrictive: he used only the three primary colors, plus black, white, and gray, and exclusively, as the design element, the right angle in a horizontal–vertical placement. From 1919 to 1922, he used gray and then light blue for the backgrounds of his Neo-Plastic paintings; after 1922, he used white, as seen in *Composition in Blue, Yellow and Black* (1936). What is illustrated in this composition as well as in his other works, including the well-known *Broadway Boogie Woogie* (1942–1943) [see illustration 19], is an extreme type of abstraction that evolved from his reasoning that since the surface of the canvas is a plane, then the painting on that surface should also be a plane. Mondrian's quest for universal expression led him to probe various visual relationships, and for him and Neo-Plasticism, the fundamental relationship was the one created by two straight lines meeting at right angles.

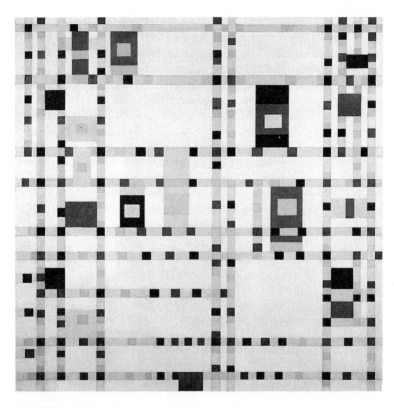

19. MONDRIAN, Piet. *Broadway Boogie Woogie.* (1924–1943)
Oil on canvas, 50 × 50".
Collection, The Museum of Modern Art, New York. Given anonymously.

Cubism in Sculpture

The Cubist principle of reducing forms to simple planes and depicting multiple points of view simultaneously was also manifested in sculpture in the work of sculptors such as Umberto Boccioni, Alexander Archipenko, and Jacques Lipchitz.

Unique Forms of Continuity in Space (1913), a bronze sculpture by the Italian painter and sculptor Umberto Boccioni (1882–1916), combines Cubist elements with the Futurist quality of movement [see illustration 20]. Boccioni's sculpture, though based upon the human form, is distinct in the manner in which it depicts a sensation of motion. The Russian sculptor Alexander Archipenko (1887–1964), in *Woman Combing Her Hair* (1915), exhibits many of the same principles seen in the work of Cubist painters in his manner of reducing the figure to geometric planes. What is strikingly innovative in this sculptural work, however, is Archipenko's decision to pierce the figure's head, creating an enclosed negative space. Another example of the planar quality achievable in sculpture is an early work by Jacques Lipchitz (1891–1973), *Man with Mandolin* (1917).

Futurism

Whereas earlier art movements had typically reflected the artist's attention towards and interpretation of "subjects," the Cubists attended to "objects." In Italy, the Futurists (adherents to Futurism) carried the value of the "object" even further, invoking the industrial machine age as a justification for breaking with tradition. In the February 1909 issue of *Figaro*, the Italian poet Filippo Tommaso Marinetti published the *Manifesto of Futurist Poetry*, which announced that the new measure of beauty was *speed*. In 1910, Marinetti met with the Italian artists Umberto Boccioni, Carlo Carrà, and Luigi Russolo to discuss the direction in which contemporary Italian painting was heading. The result of their discussions was the *Manifesto of Futurist Painters*.

The Futurist painters felt that Cubism was too static and that it did not reflect the dynamic nature of the contemporary world. Though they were willing to accept the Cubist manner of understanding and expressing space and object, they also sought to convey a sense of speed and movement to their compositions by repeating forms. Their efforts led

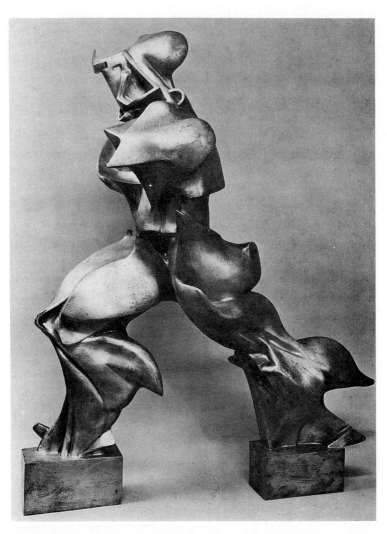

20. BOCCIONI, Umberto. *Unique Forms of Continuity in Space.* (1913) Bronze (cast 1931), 43⅞ × 34⅞ × 15¾".
Collection, The Museum of Modern Art, New York.
Acquired through the Lillie P. Bliss Bequest.

to a redefinition of the notion of space, an attempt to bridge the gap between the space of their artwork and the space of the viewer. They were also responsible for raising the issue of *simultaneity*, recognizing the psychological process of creation as engaging the artist's emotions and memories at the same time.

The Dada Movement

Chronologically, the Dada movement (1915–1922) followed the Cubist style, from which it borrowed the *papier collé* technique, and preceded the Surrealist movement, for which it laid a foundation. Appearing almost simultaneously in Zurich, New York, and Paris, the Dada movement did not represent a particular style of art as much as an intellectual rebellion of artists against the war and a general rejection of the formal traditions of culture and society. These artists dismissed the canons of the traditional arts as well, considering their work to be nonart and, in some instances, even antiart. The term *Dada* was selected for the movement by opening a dictionary at random and arbitrarily selecting a word. This use of chance as a factor of determination and decision making would become systematized by the Dadaists in their work.

Marcel Duchamp

A precursor of the Dada movement was Marcel Duchamp (1887–1968). Though he had painted in the Impressionist style between 1908 and 1910, Duchamp soon began to experiment with the reduction of forms to planes in the Cubist manner. His reputation was achieved with the exhibition of his painting *Nude Descending a Staircase #2* (1912) in the New York Armory Show of 1913. The painting combined elements of Cubism and Futurism in the manner in which five images of a Cubist-planar figure descending a staircase are overlapped. Like a series of photographs taken with a strobe light of an actual person descending a staircase, the image conveys a strong sense of movement and rhythm. Though considered shocking by some, many others were drawn to the painting because of its fresh, dynamic quality.

In 1915, Duchamp moved to New York City and soon after met and became close friends with Francis Picabia (1879–1953), with whom he

would initiate the Dada movement. Between 1915 and 1923, Duchamp created what would become one of his most famous works of art: a nine-foot-high sheet of glass affixed with cut and painted tin, entitled *The Bride Stripped Bare by Her Bachelors*. During his artistic career, he created a number of these glass panels, including *To Be Looked At (From the Other Side of the Glass) With One Eye, Close To, For Almost an Hour* (1918) [see illustration 21]. This particular piece consists of oil paint, silver leaf, lead wire, and magnifying lens on glass (cracked), mounted between two panes of glass in a standing metal frame on a wood base.

Duchamp was also responsible for what were called *readymades*, mass-produced objects that, with a minimal amount of modification (if at all), he presented as "art objects." In truth, they may, in fact, have served more as "antiart objects." Some of the best known of these readymades, exhibited in New York in 1916, are the *Bottle-Drier*, *Bicycle Wheel*, and *Porcelain Urinal*, which he signed "Mutt." His philosophy of negation and anti-aestheticism was also apparent in a work entitled *L.H.O.O.Q.* (1919), which consisted of a reproduction of Leonardo da Vinci's *Mona Lisa* upon which Duchamp had drawn a moustache!

Hans (Jean) Arp

The French painter Hans (Jean) Arp (1887–1966) was, in 1916, one of the founders of the Dada movement in Zurich. Having used chance as the mechanism for the placement of forms on canvas in 1915, he progressed in the following years to polychromatic reliefs and large collages of geometric cutouts, such as *Birds in an Aquarium* (1920).

Kurt Schwitters

After the defeat of Germany in 1918, Dadaism, with its inherent quality of disillusionment, seemed a natural movement for many German artists to adopt. Among them was Kurt Schwitters (1887–1948), who published the German Dadaist magazine *Merz* between 1923 and 1932. The title, *Merz*, is a part of the word *kommerziell*, German for "commercial," and was taken from a torn piece of newspaper that Schwitters used in one of his first collages. In his compositions, called *Merzbilder* or *Merz-Pictures*, he made use of commonly discarded

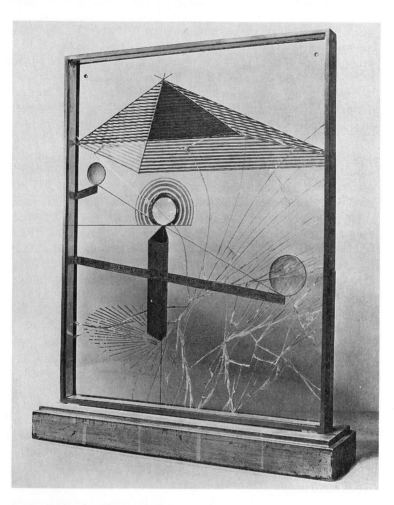

21. DUCHAMP, Marcel. *To Be Looked At (From the Other Side of the Glass) With One Eye, Close To, For Almost an Hour.* (Buenos Aires, 1918)

Oil paint, silver leaf, lead wire, and magnifying lens on glass (cracked), 19½ × 15⅝", mounted between two panes of glass in a standing metal frame, 20⅛ × 16¼ × 1½", on painted wood base, 1⅞ × 17⅞ × 4½"; overall height, 22".

Collection, The Museum of Modern Art, New York.

Katherine S. Dreier Bequest.

materials to create abstract works such as *Merz Picture 19* (1920) and *Collage in Blue and* White (1926).

Schwitters also applied his use of found objects to the medium of sculpture in the form of the *Merzbau*, a sculptural column made up of found items. The first of these Merzbau, which he constructed in his home during the 1930s, grew so large that it eventually extended through three floors. Unfortunately, this work was destroyed during World War II. Ultimately, Schwitters would begin but not complete two more of these Merzbau. His construction of one, near Oslo, was kept from completion by the Nazi invasion of Norway. The second, at a site in the Lake District, supported by funding from the Museum of Modern Art in New York, was interrupted by his death in 1948.

Surrealism

Dadaism, which systematically challenged and repudiated established norms and values, set the stage for Surrealism. The Surrealists' goal was to cause a shift from the traditional conscious rationality that had guided the practice of artists to the consideration of and experimentation with the unconscious and psychic states as creative sources, through such modes as automatism, paranoia, memory, and the exploration of dreams.

Giorgio de Chirico

The work of the Italian painter Giorgio de Chirico (1888–1978) may be seen as a precursor to the work of the Surrealists. Though born and raised in Greece, de Chirico studied in Munich from 1906 to 1910 and in 1910 relocated to Italy for a year before moving to Paris in 1911. The architecture and figure sculpture of Italy had a great impact upon de Chirico, as seen in his two 1910 paintings *Enigma of the Oracle* and *Enigma of an Autumn Evening*. While in Paris, de Chirico seriously explored the relationships between objects in order to identify hidden associations. Paintings such as his *Enigma of Arrival* (1912), *Mystery and Melancholy of a Street* (1914), and *Delights of a Poet* (1923) reverberate with silence and stillness in a way that is disturbing and creates a sense of anxiety in the viewer. His portrayal of plazas with stark architecture and isolated figures was so impersonal that the natural

associations one would make with the visual elements are lost. For the Surrealists, de Chirico's work represented images of a reality that were very different from one's normal experience of reality; they welcomed him and included him in their first group exhibition, held at the Galerie Pierre in 1925.

The Manifesto of Surrealism

The event that represented the formalization of Surrealism was the publishing of the *Manifesto of Surrealism* by the French poet André Breton (1896–1966) in 1924. This manifesto called for the elimination of rational vision and the acceptance of irrational vision, with humans acting as psychical beings rather than physical beings. Like de Chirico, the Surrealists believed in uncovering new relationships between objects. Their method for doing this, however, was through the unconscious, leaving behind traditional systems and norms. The overriding goal of the Surrealists was to remove from objects their ordinary meanings and, through the rejuxtapositioning of elements, to imbue them with new meanings.

Max Ernst

Though Max Ernst (1891–1976) was attracted to the work of Picasso and de Chirico, his association with Hans Arp led him to become actively involved in the Dada movement. After World War I, Ernst, along with several others, founded the Dadaist group of Cologne, during which time he created political–social works such as *The Massacre of the Innocents* (1921). In 1922 he moved to Paris, where he joined the Surrealist circle of André Breton. During that same year, he produced a portrait of the group entitled *Rendez-vous of Friends* (1922). Works created soon after, such as his *Two Children Are Threatened by a Nightingale* (1924), reflected his adherence to Surrealist doctrine. The impact of the dreamlike imagery is strengthened by his integration of three-dimensional objects with the two-dimensional surface of the canvas.

As a close associate of the Surrealist poets, Ernst was aware of a popular technique called *automatic writing*, which they utilized in the creation of their poetry. In turn, he sought and found a corresponding pictorial method, *frottage*, a rubbing technique that involved placing paper against an object and rubbing it with black lead. The resulting

textures and impressions were then used by the artist as mysterious landscapes, animals, and beings. *Paired Diamonds* (1926) is such a work. It appeared with many others of this technique in a volume by Ernst entitled *Histoire Naturelle* (1926).

Joan Miró

Joan Miró (1893–1983), from Catalonia, Spain, produced early paintings such as *Portrait of Ricart* (1917) that were influenced by the work of Van Gogh. After he became friends with Picasso in 1919, his work took on a distinctly Cubist dimension but remained representational. It was not until he met some of the early Surrealists, however, that he truly found his niche. As an anarchist and anti-intellectual with a passion for color, he found the perfect environment, one that was free from tradition, within the Surrealist circle. The year 1924 was a significant one for Miró, for it was then that he met André Breton, signed the first *Manifesto of Surrealism*, and completed his first subjective nonrepresentational painting, *Turned Soil*. In 1925, he exhibited his work in the first showing of the Surrealist group at the Galerie Pierre.

Miró's work, with its black shapes and brightly colored schematic forms, possesses a fresh, spontaneous, decorative quality and reflects a high level of craftsmanship. Anthropomorphic forms seem to float through his paintings, as seen in *Painting* (1933), *Person Looking at the Sun* (1942), and *Snob Evening at the Princess's* (1944). The freshness of Miró's work was perhaps due to the fact that the products of his efforts were not created in reaction to an established tradition, but were established in his own manner and direction.

Yves Tanguy

The French Surrealist painter Yves Tanguy (1900–1955) had never painted nor had he even considered doing so until he saw a work by de Chirico in the window of the Paul Guillaume Gallery in Paris in 1923. As a result of this encounter, he began to paint, and he found his brush and pigments the vehicles by which to enter, and reveal, a world unlike the visible one in which we live. When he met the Surrealists in 1925, he joined them and became an active and frequent participant in their exhibitions. His images represent environ-

ments and forms that are purely subjective and reflect an inner world separate from the real one.

Salvador Dali

A Surrealist whose work represents another of these separate realities, in this case the world of dream imagery, is Salvador Dali (1904–1989). Having mastered the techniques of academic drawing and painting, Dali was drawn to the writings of Sigmund Freud as well as to texts on the subject of philosophy. He became familiar with the work of the Cubists and Futurists, and his interest in exact realism led to the development of his skills in realism and trompe-l'oeil through the study of the seventeenth-century Dutch masters. Though his early works, produced at the beginning of the 1920s, already possessed some of the strange landscape imagery associated with his later work, it was not until the late 1920s that he formally joined the Surrealists.

Drawing upon his readings in philosophy and psychology, Dali sought to devise a new method of artistic creation, one that he labeled *paranoiac-critical activity*. This method, which he attempted to explain in a 1930 published volume, *La Femme Visible*, allowed him to look at one thing and to see another. It involved the artist's reflecting upon an object to such a degree that the act of painting it would accomplish two things, the first being a release of the subconscious's normal associations with the object, the second being a transformation of the common and normal meaning of the object to something new.

Though Dali used the images of common objects in his compositions, these objects quickly lose their ordinary, pedestrian meaning and gain a new one as a result of the manner in which he visually distorts them. This distortion is oftentimes seen in his work as forms that appear to be stretched or melting as they deteriorate, a process of decomposition that is frequently reinforced by the inclusion of flies or ants. These elements appear, for example, in one of his best-known works, *The Persistence of Memory* (1931), which portrays an image of a world that could only exist in one's dreams [see illustration 22]. Here again, it is the combination of concept, composition, and craftsmanship that has captured the attention of so many.

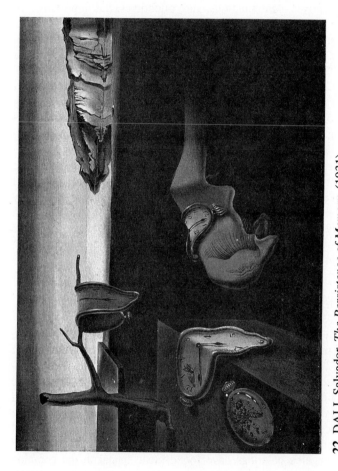

22. DALI, Salvador. *The Persistence of Memory.* (1931)
Oil on canvas, 9½ × 13".
Collection, The Museum of Modern Art, New York. Given anonymously.

René Magritte

The Belgian painter René Magritte (1898–1967) created Surrealist narrative works in a very realistic style that consisted of imagery full of visual paradoxes, contradictions, and, oftentimes, the impossible. To challenge the viewer's perception of reality, he transformed the meaning of everyday objects by portraying unlikely objects together, creating new ones, and altering others. This can be seen in *The Treason of Images* (1928–1929), a work he created after joining the Surrealists in 1925. The painting consists simply of an image of a pipe, with the phrase *Ceci n'est pas une pipe.* (This is not a pipe.) written beneath, and overtly makes the point that a painting is not the object it represents but remains a painting. This work exemplifies, too, Magritte's interest in the relationship between language and perception.

The relationship between object and image is also questioned in Magritte's painting *The Human Condition I* (1934), which portrays a canvas of a landscape resting upon an easel that has been placed directly in front of, and overlapping, a window that looks out on the view itself. For the viewer, it is difficult to initially distinguish between the image of the canvas with the picture of the landscape and the real landscape, that is, between what is real and what is an image.

Marc Chagall

Much of the work of Marc Chagall (1887–1985) was personal, focusing upon his childhood memories of life in the Russian village of Vitebsk. Though Chagall worked in a variety of styles, including Expressionism, Fauvism, and Cubism, the same themes of folk life and the cycle of life recur in his work. For Chagall, reality was best represented in relation to the past and the future, for memories as events that have already occurred or have not yet occurred are free from the restraints of gravity and the limitations of the concrete world. Although of his private world, Chagall's paintings have found great appeal in the common subjects they deal with, as seen in such works as *I and the Village* (1911), in which he has transmuted his experiences as a youth in Vitebsk to imagery upon canvas [see illustration 23]. The same may be said of other works such as *Pregnant Woman* (1912–1913) and *The Anniversary* (1915).

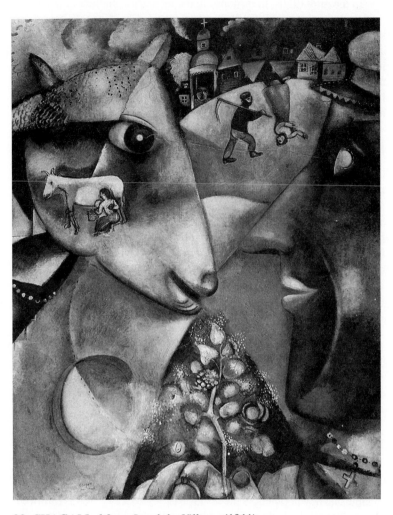

23. CHAGALL, Marc. *I and the Village.* (1911)
Oil on canvas, 6' 3⅝ × 59⅝".
Collection, The Museum of Modern Art, New York.
Mrs. Simon Guggenheim Fund.

In the mid-1930s, in response to the increasing amount of persecution and the inevitability of another world war, Chagall began to incorporate elements into his compositions that were of a more religious and social nature. Among these paintings are a series of Crucifixions, including *Crucifixion* (1943), which reflects the horrors of war and the need for faith and hope in such a world. Though the imagery is dreamlike, the symbols Chagall has used are not uniquely his own, and thus he openly shares his feelings with the viewer.

Paul Klee

Paul Klee (1879–1940) is another painter whose work is difficult to classify. Though his work may initially strike one as childlike and, at the same time, impenetrable, a closer look reveals a hidden world that stirs the imagination. Until 1914, Klee was primarily a draughtsman and had only painted in watercolor. After a trip to Tunisia in 1912, he became interested in the use of color in his painting. He always spent much time drawing, frequently from nature, which inspired many of his nonrepresentational drawings. An example is his *Twittering Machine* (1922), which though machinelike also has a birdlike quality and, for many viewers, facilitates associations that bring a smile [see illustration 24]. Color is integral to Klee's art; it represents the inner dimension and force of the objects and beings he created, as seen in *Landscape with Yellow Birds* (1923) and *Cosmic Flora* (1923). His skill as a draughtsman freed him to be spontaneous and allowed him to improvise and create a sense of mystery in such works as *Animals in the Underbrush* (1938) and *Death and Fire* (1940).

Abstract Expressionism

The decade or so following World War II was a period of continued change and development in the visual arts. Stylistically, trends followed the traditional dualistic paths of expressivism and formalism. Contemporary concerns including the effects of the war, the new atomic age, and ongoing social issues continued to influence the form that the visual arts would take. The commercialization of art also had its effect.

It was with Abstract Expressionism that America, for the first time, became a recognized leader in the international art world. As a group,

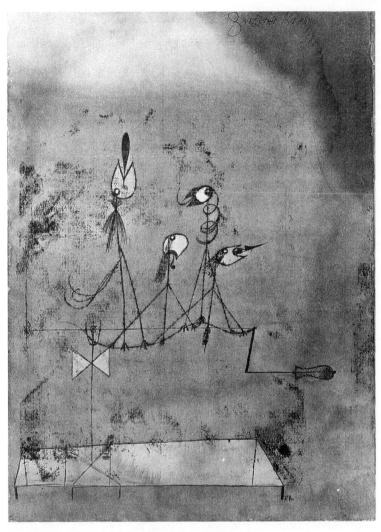

24. KLEE, Paul. *Twittering Machine.* (1922)
Watercolor and pen and ink on oil transfer drawing on paper,
mounted on cardboard, 25¼ × 19".
Collection, The Museum of Modern Art, New York. Purchase.

the post-World War II Expressionists, known as Abstract Expressionists, followed their predecessors in using abstraction as a means of expressing sensation and emotion, though nonrepresentationally. Some painters, like Francis Bacon (1909–1992), continued to use the human figure as the basis for their abstraction in the expression of feeling, though Bacon has said that expression was not his intent. In spite of his statement, Bacon's work is thought by many to have a very expressive quality, as seen in his paintings *Three Studies for Figures at the Base of a Crucifixion* (1944), *Painting 1946* (1946), *Number VII from Eight Studies for a Portrait* (1953) [see illustration 25], and *Study After Velázquez's Portrait of Pope Innocent X* (1953).

The work of Hans Hofmann (1880–1966) is considered by some art historians to be an immediate precursor of American Abstract Expressionism. Paintings such as his *Effervescence* (1944), with swells of color and thickly applied pigment, retain the action and immediacy of the process that the artist went through in order to create the work.

Abstract Expressionist art appeared in various forms but typically was large and powerful. It was also called *Action Painting*, a label that seems particularly appropriate for the work of Jackson Pollock. Pollock, along with Willem de Kooning, Franz Kline, and Lee Krasner (who was Pollock's wife), and several others involved in this movement, were referred to as the *New York School*.

Jackson Pollock

Jackson Pollock (1912–1956) is especially known for his method of working: splattering and dripping paint onto large canvases which were placed upon the floor of his studio. Paintings such as *Lucifer* (1947), *Number 27* (1950) [see illustration 26], and *Blue Poles* (1952) have this spontaneous quality of action. What many viewers are struck by is not so much the end-product of Pollock's endeavors, but the obvious process that went into the creation of the work. According to Pollock, his paintings were not an illustration of his feelings, but rather an expression of them. The lack of a focal point in these works, the vagueness between figure and ground, and the richness of his canvas surface all allow one to wander through his paintings. Pollock's Abstract Expressionistic works are bold and powerful, yet delicate in the intricate manner in which the paint has been dripped and layered upon the canvas.

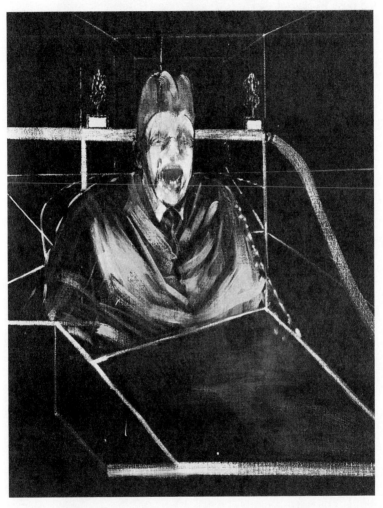

25. BACON, Francis. *Number VII from Eight Studies for a Portrait.* (1953)
Oil on linen, 60 × 46⅛".
Collection, The Museum of Modern Art, New York.
Gift of Mr. and Mrs. William A. M. Burden.

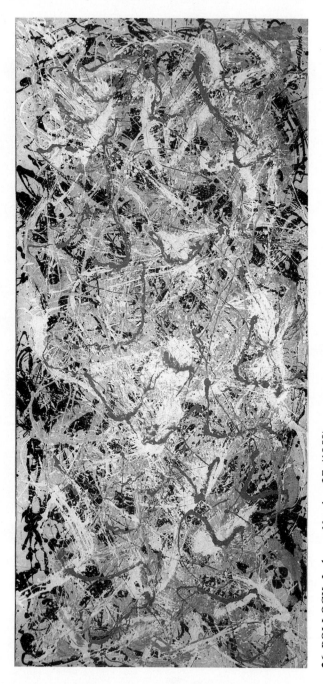

26. POLLOCK, Jackson. *Number 27.* (1950)
Oil on canvas, 49 × 106" (124.5 × 269.2 cm.).
Collection of Whitney Museum of American Art, New York.
Purchase. (53.12)

Lee Krasner

Lee Krasner (1908–1984), who married Pollock in 1945, did not receive the acclaim and recognition that her work deserved. Until the latter part of her career, she not only had to contend with being overshadowed by her husband and labeled as "Jackson Pollock's wife," she also had to compete in a male-dominated (and some would say sexist) art world that was not receptive to her aggressive Abstract Expressionistic style of painting, as seen in *The Bull* (1958) and *The Gate* (1959–1960). Krasner left the Abstract American Artists Group (which had been formed in the mid-1930s) in 1943 because she saw the group as dogmatic and inflexible regarding the parameters of Abstract Expressionism. She studied with Hans Hofmann, and he became influential in her work.

Willem de Kooning

Though Willem de Kooning (b. 1904) is perhaps best known for his "woman" series, painted between 1950 and 1953, many of his abstract nonrepresentational paintings such as *Composition* (1955) possess the same overpowering expression as his figural works. His female nudes, such as *Woman I* (1950–1952) [see illustration 27] and *Woman and Bicycle* (1952–1953), are quite large. Both these works measure more than six feet by four feet, and the images of the women are striking if not frightening in the manner in which they have been distorted. There is an urgency to the figures that belies the sketchy manner of their depiction. Like the work of Jackson Pollock, de Kooning's paintings reflect the artist's ability to focus attention upon the medium—the paint—over and above the imagery depicted, through the use of bright color and what some art critics have termed violent brushstrokes.

Jean Dubuffet

While Jean Dubuffet (1901–1985) is not considered to be an Abstract Expressionist, much of his work, such as his *Corps de Dame* series, is considered by some art historians to be similar to that of Willem de Kooning. Though Dubuffet did not originate the use of *haute pate* (a mixture of concrete, plaster, and glue imbedded with stone and other materials) applied to the canvas surface, his method of etching

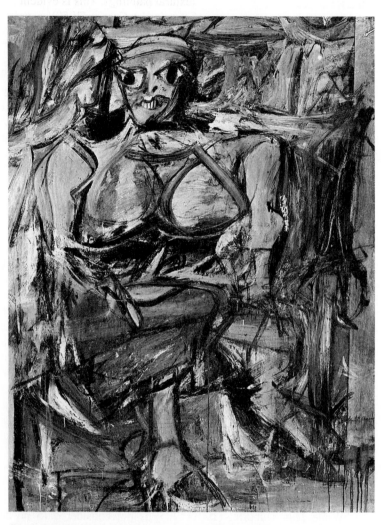

27. de KOONING, Willem. *Woman, I.* (1950–1952)
Oil on canvas, 6' 3⅞" × 58" (192.7 × 147.3 cm.).
Collection, The Museum of Modern Art, New York. Purchase.

into this melange resulted in very textural paintings. This is evident in such works as *Corps de Dame, Sanguine et Grenat* (1950), a nude female figure which has been described as appearing to have been run over by a steamroller. Like de Kooning, Dubuffet did not attempt to portray his figures in a lifelike manner, but rather sought to achieve heightened levels of expressive impact through the use of nontraditional materials and techniques. His technique and particular style of portrayal, which has frequently been characterized as childlike, owe much to his study of the art created by children and psychotics.

Franz Kline

The large black-and-white canvases of Franz Kline (1910–1962) are frequently recognized for their boldness. Works such as *High Street* (1950), *Chief* (1950), and *Mahoning* (1956) reflect Kline's ability to convey gesture through the use of brushstrokes. Until the mid-1950s, Kline rarely used color pigment in his compositions as he felt that color would detract from the impact of his imagery.

Mark Rothko

Though Mark Rothko (1903–1970) was a colleague of the group that made up the New York School of Abstract Expressionists, his own style of abstraction involved working with large planes or areas of color. His work, sometimes referred to as *Color Field Painting*, has been characterized as possessing a meditative quality, especially when contrasted with the highly charged work of the Abstract Expressionists. As exemplified by his paintings *Orange and Yellow* (1956) and *Four Darks on Red* (1958), his work is generally large, with one or more areas or fields of color, stacked horizontally and softly blended where they meet, occupying the canvas.

American Realism

Though the Realist style of painting has manifested itself historically in different ways, it is possible to identify two primary modes of distinction: one which focuses primarily upon a literal representation of visual reality; and the other, which only suggests a view of reality,

oftentimes through the use of metaphor and abstraction. Though it is difficult to characterize the work of Georgia O'Keeffe and Edward Hopper as belonging to particular "schools" or styles, their work may be loosely associated with the style that has come to be known as American Realism.

Georgia O'Keeffe

Georgia O'Keeffe (1887–1986) produced a substantial body of work during her years on the east coast. However, it is her semi-abstract paintings of the desert, sky, and mountains, created while she lived in Abiquiu, New Mexico, for which she is probably best-known. Paintings such as her *From the Plains* (1919), *Black Cross, New Mexico* (1929), *Cow's Skull: Red, White, and Blue* (1931), and *Cow's Skull with Calico Roses* (1931) reflect the sense of mystery that she was able to capture in her work. Common to both her cityscapes and her landscapes is a feeling of infinite space. O'Keeffe is also known for her lush close-ups of flowers, such as *Black Hollyhock, Blue Larkspur* (1929).

Edward Hopper

Edward Hopper (1882–1967) is considered by many art historians to be an "anti-academic" artist. He worked in a very precise manner, oftentimes completing only several paintings a year. His interest in the American scene, the city, is reflected in such works as *Early Sunday Morning* (1930), which portrays a row of storefronts devoid of people. The viewer confronts the storefronts directly, as though standing across the street, and almost feels the faint warmth of the early morning sun as it reflects off the barber pole, fire hydrant, awnings, yellow window shades and the red surface of the walls.

Hopper's simplified, precise style may be seen in an early work, *The El Station* (1908), and again in later works such as *Nighthawks* (1942), where a strong sense of isolation is conveyed through the image of patrons at an all-night diner enveloped by the blackness of a deserted street.

Alexander Calder

Alexander Calder (1898–1976), an American who was part of the Paris art world, worked in a variety of media, but is best known for his mobiles, an artform he created. Prior to entering the Art Student's League in New York City in 1923, he studied mechanical engineering. Drawings he made during visits to the Ringling Brothers and Barnum and Bailey Circus led to the creation of his animated construction *Circus* (1926–1931) during his stay in Paris in 1926. He also made toys using such materials as wood, wire, and found materials, as in his *Bird on Wheels* (1951). His ink drawings reflect his powerful use of line, as seen in such works as *The Circus* (1932) and *Tumbling Family* (1931). He was also quite talented in the creation of caricatures, such as that of *Sartre* (1944).

Calder also worked with gouache. Some paintings consisted of black pigment on paper, as seen in *Flying Saucers* (1969), while others were vivid in their color, such as *Yellow Equestrienne* (1975). He also illustrated a number of books including his own *Animal Sketchbook* published in 1926 by Bridgman Publishers, and *Fables of Aesop/According to Sir Roger L'Estrange* published by Harrison of Paris in 1931.

The mobiles he created, beginning in the early 1930s, include such works as *Lobster Trap and Fish Tail* (1939) and *Red Gongs* (1950). These mobiles typically were made of sheet aluminum, steel rods, and wire, and were suspended. As sculptures with a capacity for movement, they have a powerful impact on viewers. The tension created by the achievement of such delicate balance, combined with the unpredictability of the types of movements that will occur, provide the viewer an experience of changing relationships in both space and time.

Minimalism

Minimal art, seen especially during the 1960s and into the 1970s, was a trend whereby form, especially in sculpture, was reduced even more in an effort to achieve and portray the true essence of the artist's efforts. The style of Minimalism was typically abstract, oftentimes geometric. This effort sought to distance artwork even farther from its

traditional associations and roots and to create works of an impersonal and anonymous nature.

Donald Judd

The use of minimal forms can be seen in the sculpture of Donald Judd (b. 1928). *Untitled* (1965) is made up of an aluminum beam with attached L-brackets painted red [see illustration 28]. *Untitled* (1973) consists of ten cubes of stainless steel with oil enamel on plexiglass, mounted vertically upon a wall.

Robert Morris

Much of the work of Robert Morris (b. 1931) done during the 1960s was of a Minimalist style. *Untitled (L-Beams)* (1965), consisting of three stainless-steel L-beams placed in juxtaposition, is such a work.

Carl Andre

Another example of Minimal sculpture is a work entitled *Equivalent VIII* (1978), by Carl Andre (b. 1932), formed of bricks placed upon the gallery floor two deep, six across, and ten in length. In this case, in particular, it was the context in which the work was exhibited, that is, in a gallery, that allowed it to be perceived as "a work of art." The sculpture calls into question the role of the museum, typically seen as a place to house works of art. In this case, however, it is the museum that creates the work, because if *Equivalent VIII* were placed on the street it would likely be seen simply as a pile of bricks.

Pop Art

Whereas earlier styles of art had been based upon the artist's experience of his or her own inner expressive self or had been directed outwardly towards nature, the Pop Art movement was a manifestation of the artist's response toward a consumer economy in which mass-produced goods dominated the popular and mass media. As might be expected, a style of art based upon the like of advertisements, comic books, and the packaging of manufactured items was received with a

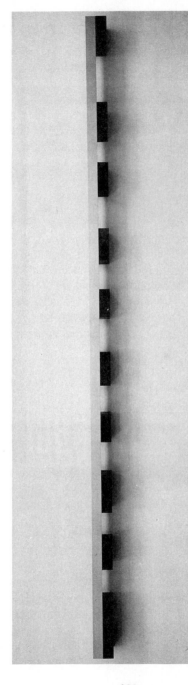

28. JUDD, Donald. *Untitled.* (1965)
Aluminum, 8¼ × 253 × 8¼" (21 × 642.6 × 21 cm.).
Collection of Whitney Museum of American Art, New York.
Purchase, with funds from the Howard and Jean Lipman Foundation, Inc.
(66.53)

303

certain amount of skepticism and criticism and was not taken seriously in some circles. However, Pop Art was successful in elevating common imagery, whose proliferation in itself made it obscure, to a conscious-ness-raising level, where it was looked at "anew."

Pop Art originated in England; it appeared in the United States with the work of Jasper Johns, Robert Rauschenberg, and others including Claes Oldenburg, Andy Warhol, and Roy Lichtenstein. Common to these artists was the ability to take something familiar and transform or place it in a new context that challenged people's assumptions about it.

Jasper Johns

Like his colleagues Robert Rauschenberg and the musical com-poser John Cage, Jasper Johns (b. 1930) has sought to narrow the gap between art and life by basing his art upon life's common, everyday artifacts and symbols. In *Target with Four Faces* (1955), he has used the image of the target; in *White Flag* (1955) and *Three Flags* (1958) [see illustration 29], he has used the symbol of the American flag; and in *Painted Bronze* (1960), he has used an old American favorite, the beer can.

Robert Rauschenberg

Robert Rauschenberg (b. 1925) creates two-dimensional collages and three-dimensional assemblage sculptures, which are called *com-bines* and consist of found objects, many of which are throwaways. For example, his combine *Odalisk* (1955–1958) consists of a stuffed rooster standing on a box covered with photos and clippings attached to a post mounted upon a pillow. *Monogram* (1955–1959) presents the viewer with a stuffed angora goat wearing a tire while standing upon a painted platform.

Claes Oldenburg

The work of Claes Oldenburg (b. 1929) is oftentimes met with a smile because of the manner in which he uses popular foods, common appliances, and household fixtures as the inspiration for his sculptures. What he does is create exaggerated, even shocking versions of these objects, often on a grand scale. His work ranges from the glorification

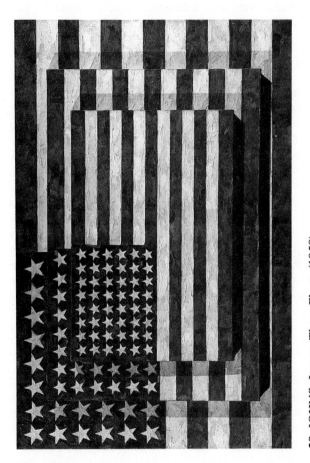

29. JOHNS, Jasper. *Three Flags.* (1958)
Encaustic on canvas, 30⅞ × 45½ × 5" (78.4 × 115.6 × 12.7 cm.).
Collection of Whitney Museum of American Art, New York.
50th Anniversary gift of the Gilman Foundation, Inc.,
The Lauder Foundation, A. Alfred Taubman, an anonymous donor, and purchase. (80.32)

of a symbol of American taste in *Two Cheeseburgers with Everything* (1962) through the transformation of a simple, taken-for-granted object, the clothes pin, into one of monumental proportions as a forty-foot sculpture, to *Soft Toilet* (1966) [see illustration 30], a kapok-filled vinyl representation, leading viewers to a different sort of confrontation with these objects than they are used to.

Andy Warhol

Andy Warhol (1928–1987), responding to the use of mass production and repetition in advertising and the mass media, made use of these techniques in many of his works. His silkscreens of *Marilyn Monroe* (1962), his *200 Campbell's Soup Cans* (1962), and his three-dimensional *Brillo Boxes* (1964) seem to capitalize upon mechanically produced items. Like his print of *200 Campbell's Soup Cans* (1962), Warhol's painting *Green Coca-Cola Bottles* (1962) presents an image of sameness [see illustration 31]. However, when the viewer realizes that there are in fact differences between the individual Coke bottles, the question whether the differences are due to the painting process (by accident or design) or whether a statement is being made concerning subtle differences is left unanswered. Though there is some debate among critics as to whether Warhol was glorifying or condemning the practice of sameness, Warhol was himself a media event during and after the Pop era, an artist who marketed himself as well as his work.

Roy Lichtenstein

Roy Lichtenstein (b. 1923), another Pop artist, utilized printed media, specifically the comic strip, as the source of his artwork. Though his early intent may have been to produce antipainterly works that would not be found aesthetically pleasing in the art market, it soon became apparent that his paintings, such as *As I Opened Fire* (1964) and *Little Big Painting* (1965) [see illustration 32], were, in fact, more than simply copies of comic strip imagery on a large scale. Through his stylized use of line, color, and printer's dots, Lichtenstein provided the public with large images whose style, subject, and imagery seemed antithetical to the kind of attention they seemed to demand by simply being works of art.

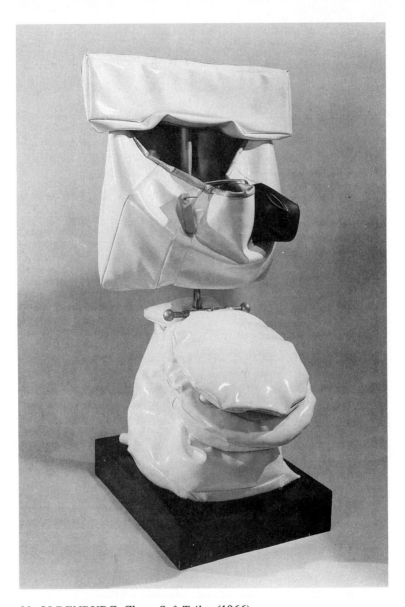

30. OLDENBURG, Claes. *Soft Toilet.* (1966)
Vinyl filled with kapok, painted with liquitex and wood,
52 × 32 × 30" (132.1 × 81.3 × 76.2 cm.).
Collection of Whitney Museum of American Art, New York.
50th Anniversary gift of Mr. and Mrs. Victor W. Ganz. (79.83)

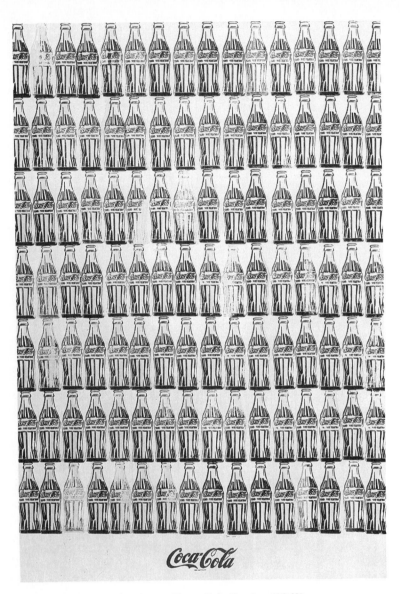

31. WARHOL, Andy. *Green Coca-Cola Bottles.* (1962)
Oil on canvas, 82½ × 57" (209.6 × 144.8 cm.).
Collection of Whitney Museum of American Art, New York.
Purchase, with funds from the Friends of The Whitney Museum of
American Art. (68.25)

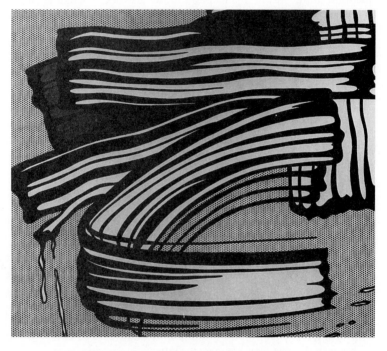

32. LICHTENSTEIN, Roy. *Little Big Painting.* (1965)
Oil on canvas, 68 × 80" (172.7 × 203.2 cm.).
Collection of Whitney Museum of American Art, New York.
Purchase, with funds from the Friends of The Whitney Museum of
American Art. (66.2)

Op Art

Op Art (Optical Art), popular especially during the 1960s, reflected a shift of interest among some artists from attention to the artwork to attention to the viewer's perception of the artwork. Though at first it may appear that this style of art does not fit within the evolution of the visual arts, upon further consideration, it makes perfect sense for it to have developed. As seen in earlier discussions, the construction of traditional paintings was based upon the concept of a "window" that the viewer would look into. With more contemporary painters, such as the Abstract Expressionists, the focus became the surface of the canvas itself, with attention being directed toward the process involved in the creation of the work. Op Art was a result of the application of the optical laws of nature to the elements of art and design in order to produce complex images and patterns that could deceive the brain into "seeing" vibration, color, and movement where there was none.

Bridget Riley; Richard Anuszkiewicz

The laws of optics are very much at play in the work of Bridget Riley (b. 1931), as seen in *Blaze I* (1962) and *Current* (1964) [see illustration 33], paintings which consist of precisely drawn undulating lines that, when looked at for a short time, seem to vibrate and oscillate. The same principles apply to Richard Anuszkiewicz's (b. 1930) work, for example, *Splendor of Red* (1965), in which he uses color and line in such a way that the work appears to flutter.

Victor Vasarely

Well known for his involvement in the inception of the Op Art movement, Victor Vasarely (b. 1908) has continued his investigation of this art style. From early Op Art works in black and white, such as *Jong* (*"Births"*) (1962), to more current pieces such as *V.P. Stri* (1973–1975) and *Sinfel* (1977), which incorporate color, his work seems to burst forth from the picture plane.

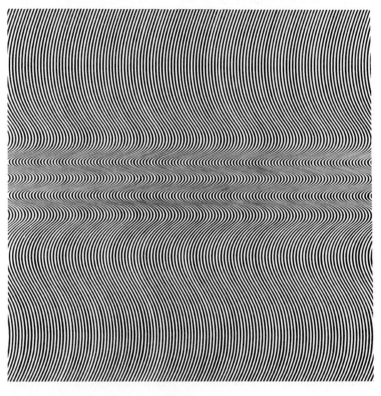

33. RILEY, Bridget. *Current.* (1964)
Synthetic polymer paint on composition board,
58⅜ × 58⅞" (148.1 × 149.3 cm.).
Collection, The Museum of Modern Art, New York.
Philip Johnson Fund.

Superrealism

Superrealism, sometimes referred to as photorealism or hyper-realism, was a style seen primarily during the 1970s in which the subject matter was represented in a very realistic, accurate manner. Most Superrealist painters worked in a similar fashion, either by copying images from photographs onto their canvas or by projecting color slides or transparencies of their subject upon a canvas, then sketching and painting the image in acrylic or oil pigments, sometimes applying the pigment with airbrush.

Examples of Superrealism in painting include such works as *Ansonia* (1977) [see illustration 34] and *The Solomon R. Guggenheim Museum* (1979) by Richard Estes (b. 1936), *Golden Girl* (1979) by Audrey Flack (b. 1931), and *Phil* (1969) and *Susan* (1971) by Chuck Close (b. 1940), to name but a few.

Conceptual Art

Popular during the 1960s and 1970s, Conceptual Art represented a movement espoused by a number of artists who emphasized the idea or process of artmaking rather than the object actually produced. The efforts of these artists were similar to those of the Minimalists in their striving to achieve a sense of purity in their work. For those involved in the Conceptual Art movement, however, the art object itself was seen as unnecessary and even distracting relative to the idea of the work. Here, partially in reaction to the commercialization of the art market, the art object, if indeed there was one, was merely perceived of as evidence or a record of the process and events that led to its creation. This focusing of attention away from the artwork toward the process of creation or the idea challenged traditional notions concerning the inherent value of "the object." Additionally, because many Conceptual artworks occurred in locations outside the traditional gallery and museum environments, this movement also challenged assumptions concerning the role of the art museum as *the* repository of *objects d' art*.

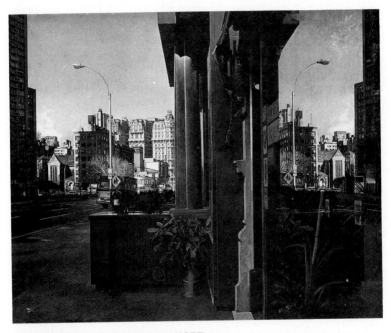

34. ESTES, Richard. *Ansonia.* (1977)
Oil on canvas, 48 × 60" (121.9 × 152.4 cm.).
Collection of Whitney Museum of American Art, New York.
Purchase, with funds from Frances and Sydney Lewis. (77.33)

Earthworks

Also sometimes referred to as Land Art, Earth Art, Site Sculpture, and Environmental Art, the Earthworks genre of art also challenged the relationship of the museum to art. The movement emerged in the 1960s and continues today. Because of the large scale, the site of the installation, and the material frequently utilized in Earthworks (i.e., the earth itself), major Earthworks have rarely been exhibited in museums. For the same reasons, though art collectors might "own" an Earthwork, they would likely not be able to possess it in the same way that they might a painting or a piece of sculpture.

Robert Smithson

Most Earthworks have been created in fairly remote, unpopulated areas. Perhaps one of the best known of these is by Robert Smithson (1938–1973). *Spiral Jetty* (1970) jutted one-quarter mile into the Great Salt Lake in Utah. Using a bulldozer, Smithson pushed tons of rock into the lake in the form of a spiral, high enough so that it was above water level and one could walk atop it. As part of the natural, changing environment, the work has been subject to the forces of nature, and with the rising water level of the past years, it now sits below the surface of the lake.

Walter de Maria

Another Earthworks artist is Walter de Maria, who is probably best known for his *Lightning Field* (1971–1977). Located in a fairly desolate region of southwestern New Mexico, the work consists of 400 poles of stainless steel set into the ground, forming a grid plane one mile long and more than one-half mile wide. The impact of *Lightning Field* does not rely solely upon the occasional instances when lightning happens to hit one of the rods; also effective is the reflection of sunlight off the rods and the shadows created.

Temporary Earthworks

Though the Earthworks discussed thus far are of a type that have been created and left to evolve or disappear in response to the forces of

nature, other Earthworks have been created with the intent that they be merely temporary, with planning sketches and photographic and video documentation serving as the only tangible record of the "event."

Christo

Famous for his temporary Earthworks, Christo Javacheff (b. 1935) has been responsible for such grandiose achievements as the *Running Fence* (1976), which consisted of eighteen-foot steel poles with nylon fabric panels in between, zig-zagging in an unbroken line over twenty-four miles across Sonoma and Marin counties in California. The popularity and impact of the work, which only stood in its entirety for fourteen days, relied upon media coverage and documentation. Another of Christo's well-known projects was his *Surrounded Islands* (1980–1983), for which he used over 6 million square feet of pink nylon fabric to encircle eleven islands in Biscayne Bay, Florida. Again, the preparation and process of developing the idea and then implementing it took far longer than the amount of time that the actual artwork existed.

Recommended Reading for Part V

The Modern World

Arnason, H. (1986). *History of Modern Art*. New York: Abrams.

Aston, D. (1980). *The New York School: A Cultural Reckoning*. New York: Penguin.

Battcock, G. (1975). *Super Realism: A Critical Anthology*. New York: Dutton.

Boime, A. (1968). *A Social History of Modern Art*. Chicago: University of Chicago Press.

Eitner, L. (1987). *An Outline of 19th Century European Painting: From David Through Cézanne*. New York: Harper & Row.

Eitner, L. (1970). *Neoclassicism and Romanticism, 1750–1850*. Englewood Cliffs, N.J.: Prentice Hall.

Fry, E. (1966). *Cubism*. London: Thames & Hudson.

Gaggi, S. (1989). *Modern-Postmodern: A Study in Twentieth-Century Arts and Ideas*. Philadelphia: University of Pennsylvania.

Herbert, R. (1988). *Impressionism*. New Haven, Conn.: Yale University Press.

Herbert, R. (1964). *Modern Artists on Art*. Englewood Cliffs, N.J.: Prentice Hall.

Holt, E. (1966). *From the Classicists to the Impressionists*. Garden City, N.Y.: Doubleday.

Hughes, R. (1981). *The Shock of the New*. New York: Knopf.

Hunter, S., & Jacobus, J. (1985). *Modern Art: Painting, Sculpture, Architecture*. New York: Abrams.

Kaprow, A. (1981). *Assemblage, Environments and Happenings*. New York: Knopf.

Levin, K. (1988). *Beyond Modernism: Essays on Art from the '70s to '80s*. New York: Harper & Row.

Lippard, L. (1966). *Pop Art*. New York: Praeger.

Lucie-Smith, E. (1984). *Movements in Art Since 1945*. New York: Thames & Hudson.

Nochlin, L. (1966). *Impressionism and Post-Impressionism*. Englewood Cliffs, N.J.: Prentice Hall.

Rewald, J. (1980). *The History of Impressionism*. New York: Museum of Modern Art.

Rosenblum, R. (1976). *Cubism and Twentieth-Century Art*. Englewood Cliffs, N.J.: Prentice Hall.

Rosenblum, R., & Janson, H. (1984). *Nineteenth-Century Art*. New York: Abrams.

Rubin, W. (1969). *Dada and Surrealist Art*. New York: Abrams.

Weston, N. (1969). *The Reach of Modern Art: A Concise History*. New York: Harper & Row.

Glossary

Abstract Expressionism A style of painting developed in New York during the 1940s and 1950s in which abstraction is used, often nonrepresentationally, to express sensation and emotion.

Academic art Art that reflects the canons, conventions, and traditions of a particular school or academy of art.

Action Painting A style of painting developed by the Abstract Expressionists in which paint is applied in a way requiring vigorous physical activity.

Ambulatory A covered walkway, typically the outer aisle in a church.

Amphora An ancient Greek vessel, with a large oval body, narrow cylindrical neck, and two handles, used for storing such goods as wine and oil.

Apse A semicircular recess in the wall of a Roman basilica and, later, in Christian churches.

Arcade An arched, covered passageway in church architectural design.

Architrave The lowest section of the entablature, which, in Greek architectural design, rested directly upon the capital, or top, of the column.

Art Nouveau A decorative art popular between 1890 and 1910, characterized by sinuous, serpentine line and organic, foliate forms, which was a reaction to the encroaching industrialization of the Western world. An international phenomenon known as the *Secessionstil* in Austria, *Jugendstil* in Germany, and the *Liberty Style* in England.

Assemblage A three-dimensional construction composed of already existing or found objects.

Asymmetrical balance A form of balance attained when the visual elements on either side of a vertical axis are not identical but are placed in positions within the pictorial field so as to create a felt equilibrium of the total form concept.

Atrium An open court in front of a church; the central court of a Roman house.

Balance A feeling of equality in weight, attention, or attraction of the various visual elements within the pictorial field as a means of accomplishing organic unity.

Baroque The style of art produced between 1600 and 1750, when the everyday activities of people, the landscape, and still life became acceptable subjects for artists to depict. It is characterized by the dramatic use of color, light, and ornamentation. In architecture, Baroque forms tend to be elaborate and ornate.

Basilica An elongated building with a semicircular apse at one end. In ancient Rome, it was used as a gathering place and court of justice. Early Christian churches, consisting of narthex, nave, aisles, transept, and apse, were based upon the earlier Roman design of the basilica.

Brightness See *Intensity*.

Buttress A projecting support built against a wall to counteract the lateral thrust of a building's arch or vault. A flying buttress is an arched bridge leading to a solid pier that receives the thrust of a nave vault.

Calligraphy Decorative handwriting; in painting, the use of flowing, rhythmic lines that intrigue the eye in the way they enrich a surface.

Capital The uppermost portion of a column.

Caryatid A sculpted female figure used as a supporting column.

Casting The reproduction of a piece of sculpture by pouring a liquid into a mold and allowing it to harden.

Chiaroscuro In painting, the use of light and dark to define form but not necessarily to create an illusion of depth. With chiaroscuro, one cannot identify a single light source common to all elements of the painting, though modeling may be used in certain areas; figures oftentimes emerge from a dark background.

Choir The area of a church between the apse and the transept reserved for the clergy and the choir.

Classical See *Classicism.*

Classicism The theory and canons of art based upon the formal order representative of the art of ancient Greece.

Clerestory The upper level of the nave wall of a church above the roof of the aisle, which is pierced with windows to provide lighting below.

Cloisonné A technique whereby fired enamel or semiprecious stones are set in small niches created by soldering thin metal strips edge up on a metal surface.

Coincidence of edge Visual closure of a line or shape's edge, usually through the use of overlay. A line may be broken by another shape, but the eye tends to see the two segments of the line as one.

Collage A two-dimensional composition made of bits of various materials glued to a flat surface.

Color A generic term that refers to all pigments (may include black and white).

Color-Field Painting A style of painting during the 1950s and 1960s consisting of fields or broad areas of color.

Complementary colors Hues that are directly opposite one another on the color wheel.

Conceptual Art An art movement during the 1960s and 1970s that placed emphasis upon the idea or process of artmaking rather than the art product, which, if there was one, would merely serve as evidence of the process and events that led to its creation.

Configuration Elements within any given environment that tend to group into the largest possible shape or form.

Contour A line that creates a boundary separating an area of space from its surrounding background.

Contrapposto A method of positioning the human body asymmetrically, particularly in sculpture, in which the weight is borne on one

leg while the other leg is relaxed or in which one part of the body is twisted in an opposite direction to another part of the body.

Cornice The uppermost of the three sections that together form the entablature of Greek architectural design.

Cromlech A circular arrangement of huge upright stone slabs, most likely the setting for special rituals and religious events. Stonehenge is probably the most famous of extant cromlechs.

Cross-vaulting A type of vault formed by the intersection of two or more simple vaults.

Cubism A style of art in which forms are reduced to geometric planes, allowing the viewer to see multiple views of the same object at the same time. Originated by Pablo Picasso and Georges Braque in Paris in the early 1900s.

Dada A movement of irreverence toward art that appeared almost simultaneously in Zurich, New York, and Paris between 1915 and 1922. Dada, which led to Surrealism, was more an intellectual rebellion of artists against the war and a general rejection of the formal traditions of culture and society than a particular style of art.

Decorative The quality that emphasizes the two-dimensional nature of any of the visual elements. Decoration enriches a surface without denying the essential flatness of its nature.

Divisionism A technique of painting developed by the Post-Impressionist painter Georges Seurat, in which small dots are analytically and systematically painted in color fields to create forms and images when viewed from a distance.

Dolmen A prehistoric stone tomb typically consisting of two or more upright stones capped by a horizontal stone slab.

Dominance The principle of visual organization that suggests that certain elements should assume more importance than others in the same composition.

Earthworks Also Land Art, Earth Art, Site Sculpture, and Environmental Art. A style of art that uses the natural landscape as the raw material for the work or places the work within or about the landscape of the earth as an integrated part of the surroundings.

Embrasures The flaring outward walls that flank the doorways of a church.

Encaustic A painting technique in which a "paint" made of pigment mixed with melted beeswax and resin is applied while hot.

Entablature In Greek architectural design, the superstructure that sits upon the columns, typically consisting of the architrave, the frieze, and the cornice.

Expressionism A style of art that does not attempt to represent an objective reality, but rather seeks to depict the subjective emotional response(s) that events or objects arouse in the artist.

Façade The front of a building.

Fauvism Literally, of "wild beasts"; a fairly brief movement in France during the beginning of the twentieth century that celebrated the intensity of pure color.

Fibula An ornamental pin or clasp.

Field A large area of the same or a similar hue that tends to close; several shapes of the same or similar values that tend to close (also called *value area*).

Figure–ground The relationship of shapes that are primary in attention (figure) and those that are secondary in attention (ground); corresponds to positive and negative shapes.

Flamboyant style The late Gothic style of architecture, characterized by a flamelike curve and countercurve decorative form reflecting a shift in emphasis from structural innovation to surface decoration.

Foreshortening A technique for creating the illusion that an object or figure on a two-dimensional surface is projecting or receding in space.

Form The total organization of a work of art; in sculpture, that portion of the work that has a certain degree of concavity or convexity.

Formalism A philosophy of art according to which, that art is best that makes best use of the formal elements of art.

Fresco A painting technique where water-based paints are applied to a wall of freshly spread lime plaster. The paint is applied before the plaster dries so that the color is absorbed as the plaster sets (dries).

Frieze In Greek architectural design, the middle division of the entablature, between the architrave below and the cornice above.

Frottage A pictorial method, the equivalent of automatic writing, developed by the Surrealist Max Ernst; it involved placing paper against an object and rubbing the paper's surface with black lead.

Futurism An art movement that developed in Italy in 1909, characterized by the notion that, in the industrial machine age, the new

measure of beauty was to be speed; rapid motion was manifested in Futurist compositions by repeating forms.

Genre paintings Works of art that portray subject matter from everyday life.

Gothic A term initially used to refer to the architectural style existing in Europe between 1150 and 1550 but also applied to the sculpture and painting of the period. In architecture, it is characterized by the converging of weight at isolated points upon slender vertical piers and counterbalancing buttresses and by pointed arches and vaulting.

Gouache Opaque watercolor paint.

Grave stelae Ancient Greek carved stone grave markers.

Groin vault A vault where the weight is not borne by the entire wall, but by four corner points, which makes the construction and distribution of weight and pressure difficult.

Harmony The unity of all of the visual elements of a composition achieved by the repetition of the same characteristics or those that are similar in nature.

Hieroglyphics The picture script of ancient Egypt; pictographs as well as symbols of the language of the ancient Egyptians.

Hue A visual attribute of color (its name) that allows for a sensation of, for example, "reddish" or "bluish," and distinguishes one color from another. Hue involves particular kinds of red, blue, and yellow, as opposed to broad categories of the term *color*.

Idealism A theory that upholds the imagination and its conception of the "ideal" above action based upon nature and observation.

Imitationalism A philosophy of art according to which, that art is best that is most real and most accurately represents the subject matter of reality as we perceive it.

Impressionism A style of art originating in late nineteenth-century France in which the goal is to capture the fleeting moment by evoking sensory impressions in the viewer. This is achieved through the use of strokes of unmixed pigments in order to simulate the effects of actual reflected light.

Instrumentalism A philosophy of art according to which, that art is best that most clearly conveys messages of a political, economic, or moral nature.

Intensity A word used interchangeably with brightness and saturation when referring to hue. Intensity refers, for example, to how red a hue is, that is, how much red pigment is in a certain hue's red.

Key A term that refers to a scale, high to low, with respect to the total character of the hues used in a painting. Location on this scale depends on saturation; the more highly saturated the colors used in a painting, the higher the key.

Kore Greek, "maiden"; an ancient Greek sculpture of a young woman.

Kouros Greek, "youth"; an ancient Greek sculpture of a young man.

Krater An ancient Greek wide-mouthed vessel used for mixing wine and water.

Kylix An ancient Greek drinking cup with horizontal handles.

Lekythos An ancient Greek jug, small with elongated neck, used to hold oil, frequently in burial rituals.

Line The path of a moving point, that is, a mark made by a tool or instrument as it is drawn across a surface. It is usually made visible by the fact that it contrasts in value with the surface upon which it is drawn.

Linear perspective The use of parallel lines in a drawing or painting, converging in such a manner as to provide the illusion of depth and distance.

Lintel A horizontal beam supported by two posts.

Lost-wax method A casting technique for metal sculpture. Molten metal is poured into a hollow form left after a layer of wax that duplicates the sculpture is heated and runs out.

Mannerism A genre of art that was produced between the end of the High Renaissance and the beginning of the Baroque period, characterized by artists' distortion of space and elongation of the human figure.

Mass A three-dimensional form or body that stands out from the space that surrounds it because of differences in color, value, or texture; the physical bulk of a solid body of material.

Mastaba An Egyptian tomb with an underground chamber and an above-ground square or rectangular mound with sloping sides and a flat roof faced with stone or brick.

Medium The liquid that carries the pigment and allows the artist to apply it to some surface, such that it will adhere to that surface.

Metope In the Greek Doric style frieze, the regularly repeated square spaces between the triglyphs. Probably a carryover from the time when temples were constructed of wood, where the triglyphs served as vertical beams supporting the cornice above the architrave and the metopes were the equivalent of the open areas between.

Minimalism During the 1960s and 1970s, a trend whereby form, especially in sculpture, was reduced to abstract, geometric forms, in an effort to distance artwork further from its traditional associations and roots and to create works of an impersonal and anonymous nature.

Modeling The construction of three-dimensional forms using clay or other pliable material; in painting the use of light and shadow to create the illusion of three dimensionality.

Modern art Though a relative term, it is used to refer to the art of the nineteenth and twentieth centuries.

Modulation Any change of hue within a given field of color; several different hues or kinds of reds, for example, may be contained in one shape.

Motif A visual element or combination of elements that is repeated often enough in a composition to make it the dominating feature of the artist's expression.

Narthex A vestibule through which one passes in order to enter the nave of a church.

Naturalism A theory that bases artistic action upon observation; realism rather than idealism.

Nave The long central hall and main gathering area of a church.

Negative areas The unoccupied or empty space left after the positive shapes have been laid down by the artist. However, because these areas have boundaries, they also function as shapes in the total pictorial structure.

Neoclassicism The artistic revival of Classicism and the Classical canons of Greece and Rome.

Neo-Plasticism A theory of art developed by Piet Mondrian from Cubism, characterized by the use of the right angle in a horizontal–vertical position as the design element and the use of the three primary colors only, along with black, gray, and white.

Object d'art An object of artistic worth or curiosity, usually a *minor* art such as ceramics, jewelry, or furniture.

Optical Art (Op Art) A style popular during the 1960s, in which complex images and patterns create visual illusionary effects intended to deceive the brain into seeing vibration, color, and movement where there is none.

Organic forms Forms in art work resembling the free-curved forms found in nature; some are simple, whereas others are extremely complex.

Overlay The physical or implied superimposition of one area or shape upon another.

Papier collé The collage technique developed by Georges Braque, which involved affixing various materials, most often paper, to the surface of a canvas.

Paranoiac-critical activity A method of artistic creation developed by the Surrealist artist Salvador Dali, which allowed him to look at one thing and to see another.

Patina A film, usually greenish in color, that results from the oxidation of bronze and other metallic materials; colored pigments, usually earthy, applied to a sculptural surface.

Pattern The obvious emphasis on certain visual form relationships and certain directional movements within the visual field. The term also refers to the repetition of elements or the combinations of elements in a readily recognized systematic organization.

Pendentive A form rising from a square space that supports a circular dome.

Perspective The technique of representing on a two-dimensional surface the illusion of the spatial relationship between objects as they appear to the eye in three-dimensional space.

Photorealism See *Superrealism.*

Picture plane The actual flat surface on which the artist executes the pictorial image. In some cases it acts merely as a transparent plane or reference to establish the illusion of forms existing in a three-dimensional space.

Pier An upright architectural support.

Plastic A quality that emphasizes the three-dimensional nature of shape or mass. On a two-dimensional surface, plasticity is always an illusion created by the use of the visual elements in a special way.

Pointillism See *Divisionism.*

Pop Art A style of art of the 1950s and 1960s that was based upon artists' responses toward, and use of imagery from, a consumer economy consisting of mass-produced goods dominated by the popular and mass media.

Portal The architectural elements that make up and surround the doorway or entrance to a church.

Positive shapes The enclosed areas that represent the initial selection of shapes planned by the artist. They may suggest recognizable objects or merely be planned nonrepresentational shapes.

Post and lintel A construction system in which two or more upright posts support a horizontal beam.

Post-Impressionism An art movement that developed out of and in reaction to Impressionism during the latter part of the nineteenth century.

Primary colors Red, yellow, and blue, the three colors that cannot be made by mixing other colors, but from which all other colors are mixed.

Proximity The phenomenon in which two or more elements of similar character tend to group when positioned near one another.

Pylon temple An ancient Egyptian temple with flat top and sloping walls, popular during the New Kingdom period.

Readymades Mass-produced objects "created" by Marcel Duchamp with a minimal amount of modification and presented by him as art objects.

Realism A movement in art that seeks to create works that are accurate representations of the world and nature based upon the artist's own sense perception rather than on idealized canons.

Refectory The dining room in a monastery.

Relief A technique in sculpture whereby figures project incompletely, that is, remain attached to some degree, to the background.

Renaissance The fourteenth through the sixteenth centuries in Europe, considered by many to represent the transitional period between the medieval world and the modern world; characterized by a revival of Classical art.

Repetition The use of the same visual element a number of times in the same composition. It may accomplish a dominance of one visual idea, a feeling of harmonious relationship, or an obviously planned pattern.

Rhythm A continuance, flow, or feeling of movement achieved by the repetition of regulated visual elements.

Rococo During the eighteenth century in France in particular, a court style characterized by curved forms and pierced shellwork ornamentation. Very ornate and intricate, the style was seen primarily in furniture design and architecture.

Romanesque A style of art and architecture in 1050–1200, which preceded the Gothic style. Its architecture is characterized by extensive use of the round arch and vault, piers instead of columns, ornamentation, and dark church interiors.

Romanticism A philosophical movement that originated in the eighteenth century and emphasized the imagination and emotions, likely a reaction against Neoclassicism.

Rosetta stone A black basalt stone found in 1799 that is inscribed in Greek, demotic Egyptian, and priestly hieroglyphic.

Saturation See *Intensity*.

Shape The silhouette of an object or a portion of that object with awareness of the forms within.

Silhouette The area existing between or bounded by the contours or edges of an object; the total shape.

Similarity The phenomenon in which like elements within a given frame of reference tend to be seen in groups.

Spandrel The area between the exterior curve of an arch and the enclosing right angle of the pier.

Stelae An upright stone slab with a carved inscription.

Stylobate In Greek architectural design, the uppermost level of the platform upon which directly sit the columns.

Superrealism A style of art that developed during the 1960s and 1970s, whereby the subject is represented in a photographic, very realistic manner.

Surrealism Especially in the literary and visual arts, a movement that sought to cause a shift from the traditional conscious rationality that had guided the practice of artists to consideration of and experimentation with the unconscious and psychic states as sources of art creation through such modes as automatism, paranoia, memory, and the exploration of dreams.

Symbolism Originating in 1885, a movement that aimed not at faithful representation of the outside world, but at an imaginative

suggestion of dreams through symbolic allusion and the apparel of decorative form. The Symbolist goal, additionally, was to remove from art any functional connotation.

Symmetrical balance A form of balance achieved by the use of identical compositional units on either side of a vertical axis within the confining pictorial space.

Tablinum A small room off the atrium of a Roman house where statues and family records were kept.

Tempera A water-based painting medium that makes use of an albuminous medium, such as egg yolk, to hold the pigment.

Tenebrism A painting technique in which light is contrasted with shadow.

Terra-cotta Fired clay.

Tesserae Small pieces of glass or ceramic tile used in mosaic work.

Texture The perceived quality of a surface, whether real or simulated.

Three dimensional Possessing the measurements of length, width, and thickness; a solid, surrounded by space.

Tone A word that refers to key in a more specific sense, in terms of how the value, hue, line, shape, and other attributes of an immediate locality support the immediately adjacent areas. If the localities support one another, a painting will have a tonal quality as well as a specific key.

Transept The crossarm of a church, an area that crosses at right angles to the nave, between the nave and the apse.

Triforium A contribution of early Gothic architecture, a gallery that formed an upper story to the aisle, typically of an arcaded story between the nave arches and clerestory of a church.

Triglyph In the Greek Doric style frieze, a raised, vertically oriented rectangular plane; probably a carryover from the time when temples were constructed of wood, where the triglyphs served as vertical beams supporting the cornice above the architrave.

Triptych A painting with three panels that fold together.

Trompe l'oeil Literally, "trick the eye," a technique of painting that depicts objects such that they appear to be "real."

Trumeau A column beneath a portal that supports the lintel.

Tympanum The area within the arch and above the lintel of a church portal.

Unity The whole or total effect of a work of art that results from the combination of all of its component parts.

Value The degree of lightness or darkness of a hue; involves light–dark relationships. A scale of graduating grays, with black at one extreme and white at the other.

Vault An arched structure that forms a ceiling or roof over a hall.

Vestibule The passageway or hall between the outer doors of a church and the nave.

Void The penetration of an object to its other side, thus allowing for the passage of space through it; an enclosed negative space.

Volume The space occupied by an object.

Wash Broad brush strokes of paint that have been diluted to the point that they are nearly translucent.

Zoomorphic Having the form of an animal; especially relates to deities represented in animal form.

Index